P9-DDZ-562

Lineberger Memorial Library

Lutheran Theological Southern Seminary Columbia, S. C.

Art in the White House

A Nation's Pride

White House Historical Association
in cooperation with
The National Geographic Society
Washington, D. C.

Art in the White House

A Nation's Pride

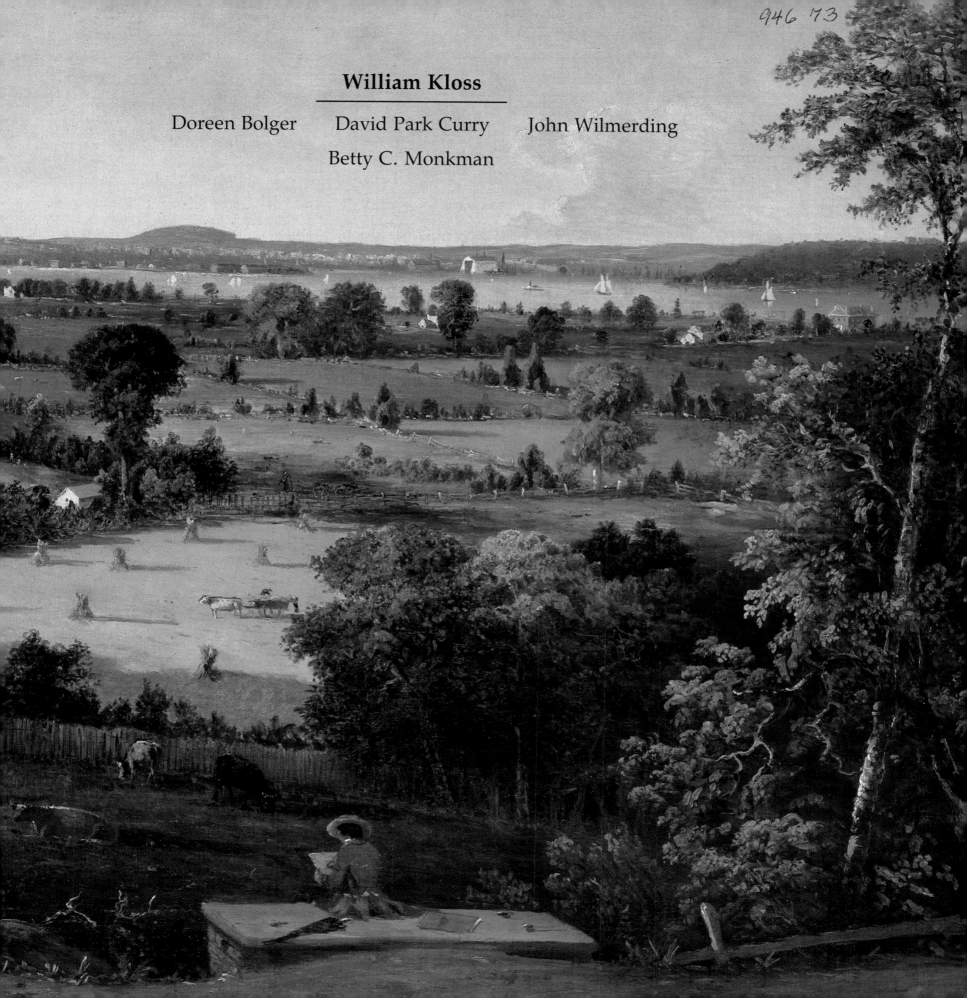

946 73

William Kloss

Doreen Bolger David Park Curry John Wilmerding

Betty C. Monkman

Staff for this book

Executive Editor: Donald J. Crump
Managing Editor: Jane R. McGoldrick
Consulting Editor: Philip B. Silcott
Art Director: Viviane Y. Silverman
Editorial Advisory Board: John Wilmerding,
Robert L. Breeden, Bernard R. Meyer

Editorial Assistant: Sandra F. Lotterman
Illustrations Assistant: Karen Dufort Sligh
Index: Susan G. Zenel
Administration: K. Ruth Corcoran, Gloria J. Hunter, John F. Trump
Type Composition: Martin G. Anderson, Kenneth G. Florence
Director, Engraving, Printing, and Product Manufacture: George V. White
Production Manager: Robert W. Messer
Production Project Manager: Heather Guwang
Art Reproduction Consultant: Michael E. Ventola

The White House

Office of the Curator: Rex W. Scouten, *Curator;* Betty C. Monkman,
Associate Curator; William G. Allman, *Assistant Curator;* Lydia S.
Tederick, *Curatorial Assistant;* Angela G. Horton, *Administrative Assistant.*

Usher's Office: Gary L. Walters, *Chief Usher.*

All photographs in Parts One and Two, unless otherwise noted, were
made by Erik Kvalsvik, with Niamh McQuillan, and are the property of
the White House Historical Association.

White House Historical Association

A nonprofit organization, chartered on November 3, 1961, to enhance understanding,
appreciation, and enjoyment of the Executive Mansion. Income from the sale of this book
will be used to publish other materials about the White House, as well as for the acquisition
of historical furnishings, works of art, and other objects for the Executive Mansion. Address
inquiries to 740 Jackson Place N. W., Washington, D. C. 20503.

BOARD OF DIRECTORS: Robert L. Breeden, *Chairman and Chief Executive Officer;* George M.
Elsey, *President;* James I. McDaniel, *Executive Secretary;* J. Carter Brown, *Treasurer;* Joy Carter
Sundlun, *Assistant Treasurer;* Robert McCormick Adams, Nash Castro, Clark M. Clifford,
Dorothy M. Craig, G. Franklin Edwards, Carson M. Glass, Gilbert M. Grosvenor, George B.
Hartzog, Jr., S. Roger Horchow, Elise K. Kirk, I. M. Pei, James M. Ridenour, Hugh S.
Sidey, Leonard L. Silverstein, Alfred R. Stern.
Members Emeriti: John Walker, Conrad L. Wirth.
Executive Vice President: Bernard R. Meyer.

Benefactors

Grants from The Henry Luce Foundation, Inc., and Mrs. John C. Newington
helped fund this publication.

Copyright © 1992 White House Historical Association, Washington, D. C.
Printed and bound in the United States of America. All rights reserved.
Reproduction or other utilization of the whole or any part of the contents without
written permission is prohibited.

Library of Congress Catalog Number 91–068463, CIP data: page 375
ISBN 0–912308–46–X

PRECEDING PAGES: William MacLeod, *View of the City of Washington
From the Virginia Shore* (detail)

Foreword

A special pleasure of living in the White House is being surrounded by so many wonderful works of art. A priceless legacy, these paintings and pieces of sculpture form the important and historic White House art collection.

I have long looked forward to the publication of this beautiful book—the first to document and illustrate this part of our national heritage. Often as work on the book progressed, I would notice author William Kloss here in the White House, intently studying one of the paintings. Now I can share in his insights about my favorite works.

Many of these paintings recall events that have taken place in this house or remind us of our nation's historic past. I cannot look at George P. A. Healy's portrait of Abraham Lincoln in the State Dining Room without reflecting upon the heavy burdens borne by this great leader amid the trials of civil war. President Bush selected for his office in the residence another work by Healy, *The Peacemakers.* It depicts Lincoln in a similar pose with his military leaders near the war's end. In the background a rainbow symbolizes the passing of the storm of battle and the hope for an enduring peace.

As I view the portraits of Presidents and First Ladies, I am reminded of the human elements of history and of the family relationships fostered within these walls. The portraits of Dolley Madison and her two sisters never fail to catch my eye. The sisters— Lucy Payne Todd (the first White House bride) and Anna Payne Cutts—helped Mrs. Madison in her duties as White House hostess.

Landscapes and seascapes of this vast country enhance the walls of many White House rooms. The President and I are partial to a painting showing one of our favorite areas of the country: Maine. It is a watercolor, *Surf at Prout's Neck,* by Winslow Homer. In our sitting room we often relax and contemplate exceptional scenes by the French artists Claude Monet and Paul Cézanne, who greatly influenced American painters.

Nearby hangs a portrait of a young girl, *Ruth,* by Thomas Eakins. I love to relate to our guests a story about this painting told to me by Mrs. Lyndon Johnson. She was leading a group on a tour of the White House and said of this portrait: "Isn't that the grumpiest little girl you've ever seen? Can you imagine a child more unhappy with what she is doing?" From the back of the group came an unexpected response: "You'll be glad to know that she became very nice when she got older," a soft-spoken man disclosed. "I married her."

With the publication of this book the works of art in the White House—many of them, like Eakins's *Ruth,* not now on public view—can be appreciated and enjoyed by all. I invite those who find beauty and inspiration in the works of our country's artists to look within these pages.

Barbara Bush

The Authors

William Kloss was educated at Oberlin College and the University of Michigan, and was a Fulbright scholar in Rome. A noted lecturer on art, he is author of *Treasures from the National Museum of American Art* and *Samuel F. B. Morse,* and was the major contributor to *Treasures of State.* In 1990 he was appointed by President George Bush to the Committee for the Preservation of the White House.

Doreen Bolger, curator of paintings and sculpture at the Amon Carter Museum, Fort Worth, Texas, received her Ph.D. from The City University of New York. The author of numerous books, articles, and essays on American art, she was previously curator of American paintings and sculpture and manager of The Henry R. Luce Center for the Study of American Art at The Metropolitan Museum of Art, New York.

David Park Curry, who holds a Ph.D. from Yale University, is associate director for research and collections at the Virginia Museum of Fine Arts, where he is also curator of American art. Dr. Curry has published widely on late 19th- and early 20th-century American painting, architecture, and decorative arts. He has served as curator of American art at the Denver Art Museum and the Freer Gallery of Art.

John Wilmerding is the Sarofim professor of American art at Princeton University and the author of more than a dozen books on American art. Currently the president of the Shelburne Museum in Vermont, he also serves on the board of trustees for Monticello and for the Wendell Gilley Museum in Maine. In 1990 he was appointed by President George Bush to the Committee for the Preservation of the White House.

Betty C. Monkman is associate curator of the White House collection of fine and decorative arts and has made the White House her specialty in writing and study. She received her Master of Arts degree from The George Washington University.

Explanatory Note

This book is in three parts. **Part One** offers an overview of the growth of the White House fine arts collection, from its inception to the present. In **Part Two,** large color plates provide readers with a look at nearly a hundred highlights from the collection. An essay accompanies each illustration. While most of the works in Part Two were done by American artists, or by foreign artists while in America, those following page 255 belong to a small group of works by modern European masters that have become part of the White House collection. The color plates are arranged in approximate chronological order. Notes and provenances for each of the works so highlighted begin on page 268. **Part Three** is a catalogue of the nearly 450 works that make up the collection, with the exception of prints. The entries are arranged alphabetically by artist, and each work is reproduced in black and white. The works are documented with the artist's name (when known), the title, date of the work, medium, measurements, inscriptions, donor, and White House accession number. (The first three digits of the accession number indicate the year of gift or purchase.) In measurements throughout the book, height precedes width. For sculpture, depth is also given. The signature or inscription line is included in cases where writing or other markings appear on any part of the work. The word "signed" is used only when the work is known to have been signed by the artist. The word "inscribed" indicates markings other than the signature and date applied by the artist.

Preface

Pride of the American nation, the White House collection of fine arts owes its existence to the scores of individuals and organizations that have nurtured and supported it. They have been diverse in outlook, taste, and purpose, but their vision and generosity have given coherence to the collection as a whole.

All the Presidents and First Ladies, including even the Washingtons, though they never occupied the Executive Mansion, have in one way or another made significant contributions. Gilbert Stuart's idealized portrait of the first President, cornerstone of the collection, both inspires us and evokes calm assurance of national continuity.

First Ladies of recent decades deserve great credit for much of the art featured in this book. Jacqueline Kennedy set the goal of collecting works by the country's finest artists. Lady Bird Johnson enthusiastically continued that pursuit. Patricia Nixon's efforts added 18 portraits of Presidents and First Ladies.

Elizabeth Ford, Rosalynn Carter, Nancy Reagan, and Barbara Bush also have taken a special interest in the history of the mansion. Each recent First Lady has worked tirelessly to encourage contributions of funds and gifts of art.

They, and the collection itself, have been immeasurably helped by former curators of the White House—Lorraine Pearce, William Elder, James Ketchum, and Clement Conger—and by the present associate curator, Betty Monkman, and other members of the curatorial staff. From the care of the White House paintings to the authentication of new acquisitions, these experts have implemented professional standards worthy of the best museums.

Exceptional contributions of time, knowledge, and personal resources on the collection's behalf have come from three men: the late James W. Fosburgh, an original member of Mrs. Kennedy's Fine Arts Committee for the White House; Robert L. McNeill, Jr., a longtime member of the Committee for the Preservation of the White House; and the late Dr. Melvin Payne, Chairman of the Board of the National Geographic Society, which cooperated with the White House Historical Association in the publication of this and other books about the presidential residence. The Association, chartered in 1961, has been a major benefactor, making possible the acquisition of dozens of outstanding works of art. Today it continues to "enhance understanding, appreciation, and enjoyment of the Executive Mansion."

REX W. SCOUTEN

Curator
The White House

Contents

Selected Works From the Collection by Modern European Masters
Text by
William Kloss 255

Notes 268

Part Three

*Catalogue of the White House Collection of Paintings,
Sculpture, and Works on Paper* 291

Introduction
by Betty C. Monkman 292

Acknowledgments 367

Index 368

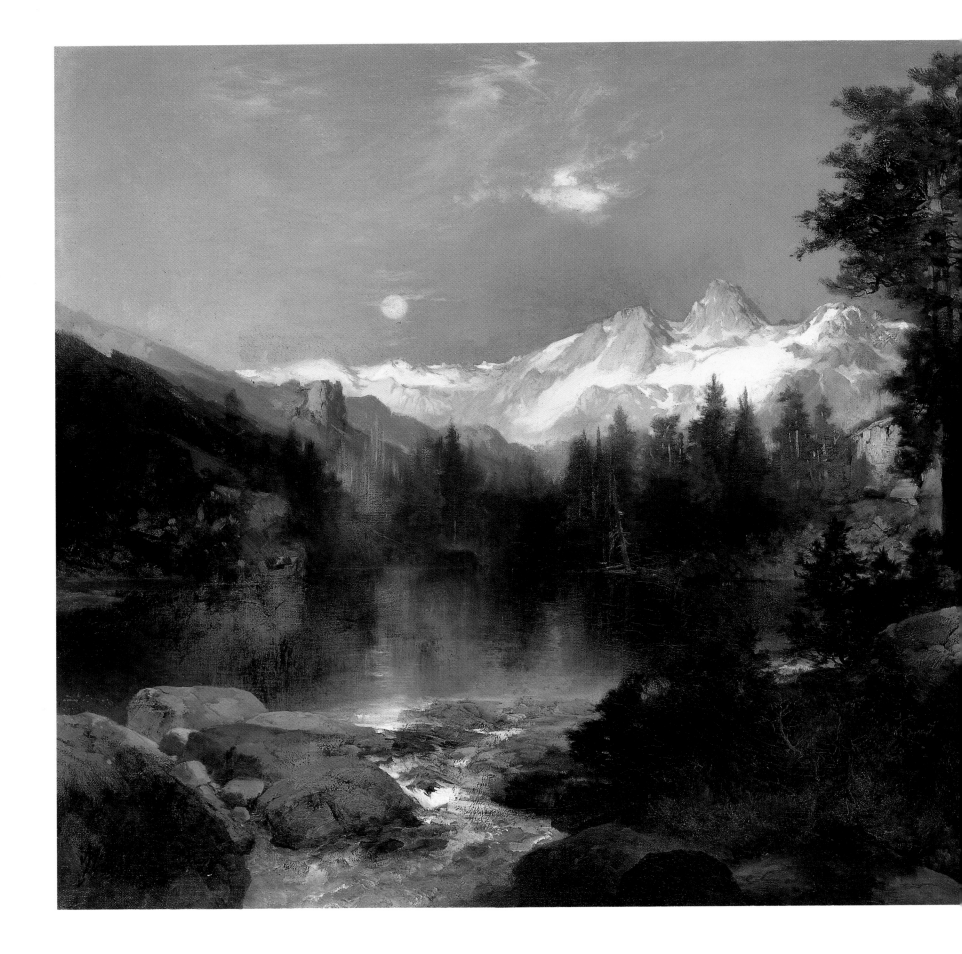

American Art in the White House

John Wilmerding

*I*n a museum city celebrated for its extensive holdings of visual arts, the White House collection stands apart, as distinctive in character as in location. Yet it is one of the lesser known collections of American art in the nation's capital—site of such major repositories as the National Gallery of Art, the several museums of the Smithsonian Institution, the Corcoran Gallery of Art, and the Phillips Collection. With the publication of this volume, all Americans can appreciate the importance of the White House collection within the totality of fine art in Washington, D. C., an unequaled constellation that reveals in full the richness and depth of America's artistic heritage.

Assembled primarily by gift, bequest, or occasional purchase, this collection of paintings, sculpture, historical prints, and a small number of drawings reflects the history of the residence and the personalities of the first families that have occupied it. In recent decades, with a professional curatorial staff and the support of outside advisers, the collection

Painted by Thomas Moran in 1895, **The Three Tetons** *reflects a recurring theme in the White House collection—America's beauty and geographic diversity.*

has more systematically broadened in scope to complement the historic public rooms, to include scenes of the American landscape and life in diverse regions of the country, and to represent the achievements and quality of American art at its best. The results of these efforts appear in this volume, which contains the highlights of the collection, handsomely illustrated, as well as the collection's full holdings (with the exception of prints) in catalogue form. *Art in the White House: A Nation's Pride* offers not only a view of the historical tastes and figures associated with the White House but also insights into some of the central aspects and themes in the history of American art.

Above all, perhaps the two great subjects that have consistently preoccupied American artists are figures and landscapes, not surprisingly in response to the early fundamental cults of individuality and nature. First, the long arduous periods of discovery, colonial settlement, revolution, and creation of the Republic highlighted the struggles and aspirations of individuals, whether humble and anonymous or heroic and celebrated; later, the expanding consciousness both of nature's spiritual power and the geographic vastness of the continent profoundly shaped the national identity and destiny.

We know that most colonial portraiture had a practical purpose: to record a likeness for posterity. By the time of the War for Independence and the establishment of the new nation, artists rose to the challenge of depicting people of great deeds as well as great ideas in styles that combined realism and idealism. Typical of such imagery is the fine early group of portraits of the Founding Fathers—George Washington, John Adams, and Thomas Jefferson—by the most distinguished portraitists of the period, Gilbert Stuart, Charles Willson Peale, and John Trumbull. Their occasional use of the full-length format reminds us of inherited English traditions, though with Peale especially and with his artistic offspring we increasingly see a greater informality of pose, setting, and presentation, more characteristic of the American sensibility for practicality and straightforwardness.

Other artists like John Vanderlyn and Samuel F. B. Morse would employ similar direct and self-confident styles for their sitters in much of the first quarter of the 19th century. The basic approach proved readily adaptable through mid-century to a range of subjects, including Native Americans, as recorded by Charles Bird King in Washington; a romantic interpretation of the ornithologist adventurer John James Audubon, by John Syme; fashionable images of Fanny Kemble and Angelica Van Buren, by Thomas Sully and Henry Inman respectively; and thoughtful characterizations of Presidents John Tyler and Abraham Lincoln, by George P. A. Healy.

Of just as much interest to American artists during the early 19th century was the inspiring variety of the national landscape, from views of towns and cities to dramatic wilderness sites or the endless picturesque textures of generic woodland paths and vistas. The purity and bounty of American nature were confirmation of beliefs in the new Eden and the optimism of the expansive national self-identity during the decades before the Civil War. The earliest landscapes, like Michele Felice Cornè's *Landing of the Pilgrims,* often were imaginary scenes enhanced by historical allusions or allegorical narrative.

Alternatively, artists celebrated the burgeoning of American commerce and industry, typified by the harbor views of maritime activity by Thomas Birch. Alvan Fisher and Asher Durand were among others who sketched directly in nature, assembling on their canvases all the essential components of a landscape —water, trees, skies, rock formations—in pleasing compositions, often with carefully framed views into the distance. Still other artists, like Frederic E. Church and John Frederick Kensett, were more interested in capturing the dramatic glories of nature at specific locales—see their views of Rutland Falls, Vermont, and Niagara Falls—as fascination with the outstanding features of the American landscape took hold by mid-century.

So popular was landscape painting and so identified with the nation's growth and sense of fruition that several broad subcategories of the subject emerged. City views are one, as evidenced in those of Washington by George Cooke and William MacLeod, of Boston by Fitz Hugh Lane, and of Philadelphia

by Ferdinand Richardt. A second was the regional scene populated by figures or human activity, in which the traditional elements of landscape and genre painting are fused: for example, George Henry Durrie's *Farmyard in Winter,* William Ranney's *Boys Crabbing,* George Caleb Bingham's *Lighter Relieving a Steamboat Aground,* and Richardt's *View on the Mississippi Fifty-Seven Miles Below St. Anthony Falls, Minneapolis.*

As westward movement began to dominate the popular consciousness later in the century, the romance of the frontier and the spectacle of western prairies and mountains inspired the work of Worthington Whittredge, Albert Bierstadt, Thomas Hill, Charles Russell, and Thomas Moran. Their panoramic scenes and compositional emphasis on vast expanses soon influenced the styles of eastern painters, among them, William Louis Sonntag, Jasper F. Cropsey, Alfred T. Bricher, and Martin Johnson Heade, who stressed low horizons, broad open skies, and light effects—in other words, the poetry of atmosphere rather than the prose of physical earth. But the representative works in the collection by George Inness, James McNeill Whistler, and Winslow Homer also make clear that during the latter part of the 19th century a pluralism of styles and visions was evolving, with the study of landscape serving as a vehicle variously for romantic introspection, abstracted design, and plein air immediacy.

*I*n some ways we might argue that still life was an aspect or distillation of the natural landscape, and although the White House possesses relatively few such works, they are representative of the major early types. For example, the still lifes by James Peale and Severin Roesen present the same imagery of implied abundance and well-being seen in Andrew Andrews's *View of Lake George* or in the woodland landscapes of Fisher and Durand. The fruit pieces in particular bear a sense of gracefully shaped volumes typical of the neoclassical style—as do portraits in paint and stone of the same period, notably those by King, Sully, Inman, and Hiram Powers.

Still life after the Civil War, more somber in expression, replaced the bounties of nature with the worn and used objects of daily life. William M. Harnett's *Cincinnati Enquirer* presents us with a picture of Victorian materialism: collected bric-a-brac, the pleasures of a man's den or library, and reminders of time's pressures in the candle and the daily paper. Its mood is more thoughtful than sensuous, an index in part of an unsettled nation during the later 19th century. Something of the same gravity of mood may be seen in portraiture of this later period, whether in the prematurely pensive face of Thomas Eakins's *Ruth,* John Singer Sargent's languorous *Mosquito Net,* or Mary Cassatt's *Young Mother and Two Children.* But like later landscape painting, these works, along with the presidential portraits by Sargent and Anders Zorn, also indicate a wide variety of painting styles emerging in the period, from the severe realism and precise textures of Eakins to Sargent's bravura brushwork and Cassatt's personal impressionistic manner.

By the turn of the 20th century Impressionism had grown enormously in popularity with American artists, many of whom went abroad regularly for training and inspiration, and brought back to native settings a great diversity of adaptations. The White House collection is notably strong here, with colorful and characteristic examples by Maurice Prendergast, William Merritt Chase, Ernest Lawson, Childe Hassam, Willard Leroy Metcalf, William Glackens, and Lilla Cabot Perry. Most reflect a shared love of fresh outdoor subjects, with immediate and incidental effects and broken dabs of brushwork and pure color, and a continuing delight in nature despite the encroaching hints of industry and urbanization.

While some of these works impart the sense of nostalgia at century's end, and others the leisurely pace in the period before World War I, still others— notably those by Hassam and Glackens—convey the dense energies, crowds, and structures of the new century's city landscapes. Capturing the animation of the urban world in the abstracted style of modernism is John Marin's *Circus No. 1.* With enthusiasm it depicts one of the pleasures of our own time comparable to earlier scenes of figures roaming the woods or promenading on a beach. And, as we survey the collection in its breadth, Marin's work serves as a reminder as much of the many changes in American art over two centuries as of its continuities.

Part One

Art for the President's House

A Historical Perspective

Doreen Bolger and David Park Curry

Art for the President's House

"I never forget that I live in a house owned by all the American people."

—Franklin Delano Roosevelt

The large white building that stands at 1600 Pennsylvania Avenue in the nation's capital city is familiar to most of us, yet few people are frequent callers there. When Franklin Roosevelt said that this house is owned by all the American people, he had something else in mind. Whatever our political views, family backgrounds, or special interests, we all live there in a sense—through shared history and citizenship.

To walk over the manicured grounds toward the White House entrance is to feel the significance of our nation's history. Those who do cross the threshold of the President's House renew a kinship with what must be understood as a widely extended family. Like a grand European house of three or four hundred years ago, the White House encloses both public and private rooms that serve multiple functions. Through the same hallways pass the casual vacationer, the hurried diplomatic adviser, and the current presidential family. Their common ground is the house itself and the history it represents.

First occupied in 1800, the White House has served as the official residence of all the Presidents of the United States except George Washington, who chose the site. Presidents and First Ladies alike have directed expansions, renovations, and redecorations. Many played important roles in shaping the appearance of the house and in forming its collections of fine and decorative arts. The aggregate of these decisions determined the direction and content of the Executive Mansion as it exists today. While the White House fine arts collection is now a permanent one and the State Rooms presently enjoy museum status, this was not always the case. The art and decoration of the house changed noticeably from administration to administration.

Not surprisingly, the families of the Presidents remained attached to the White House after leaving it.

Symbolic of a nation reunited, **Union** *(right) and its companion,* **Liberty,** *adorned the ceiling of the White House Entrance Hall. Italian-born Constantino Brumidi painted them in 1869 during the term of President Ulysses S. Grant.*

ABOVE: CHILDE HASSAM, *SOUTH FRONT OF THE WHITE HOUSE*, 1916

18

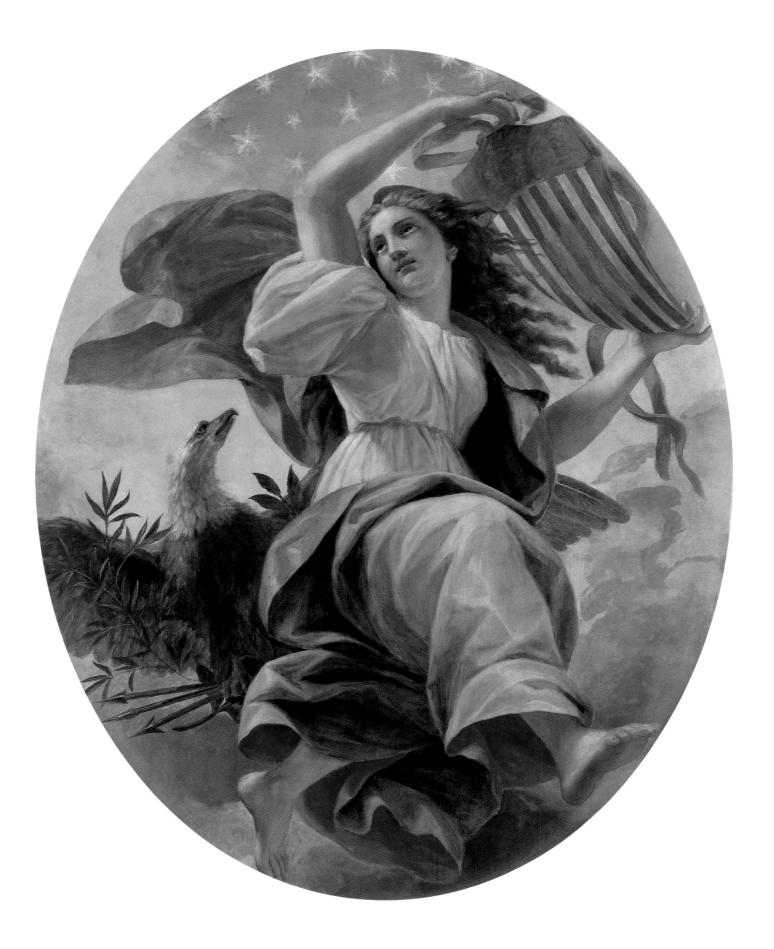

FRANCES BENJAMIN JOHNSTON, LIBRARY OF CONGRESS

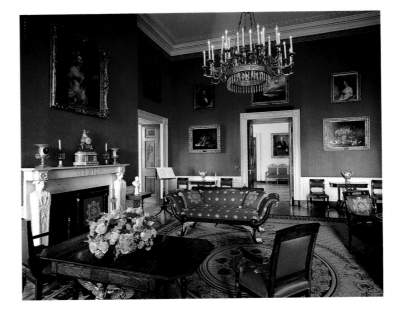

Some made gifts to the collection. The great-great-grandson of John Quincy Adams presented Gilbert Stuart portraits of his ancestors John Quincy and Louisa Adams. The works may have hung in the White House during the John Quincy Adams Administration. Zachary Taylor's daughter gave a portrait of her father. A descendant of Martin Van Buren's bequeathed a marble bust of him, as well as an elegant oil portrait of his daughter-in-law and hostess, Angelica Singleton Van Buren. Members of Abraham Lincoln's family presented portraits of both Lincoln and his wife. Theodore Roosevelt's family gave a black-and-white illustration by Frederic Remington that features one of Roosevelt's adventures. In 1963 the family of John F. Kennedy contributed a painting by French Impressionist Claude Monet as a tribute to President Kennedy's great love of the out-of-doors. These gifts from presidential families, however, account for only a small number of works acquired over the years. More recently the growth of the fine arts collection has depended heavily on the generosity of the American public, and today the Executive Mansion houses nearly 450 examples of painting and sculpture.

A number of works by important artists—Jasper Cropsey, William Glackens, and Maurice Prendergast among them—have been given by their descendants. Other individuals too have become participants in the national collecting enterprise, securing works of art for the "house owned by all the American people." One donor, upon learning that the Executive Mansion wanted to acquire a particular view of the Rocky Mountains by Albert Bierstadt, purchased it, placed it on loan, and eventually gave it to the collection. When a newspaper reported that the White House had been the unsuccessful bidder for a genre scene by George Caleb Bingham, a citizen of the artist's home state, Missouri, offered a contribution. He donated a share in the river scene by Bingham that he owned, and funds from a second donor completed the purchase. Aware of President Jimmy Carter's admiration of William M. Harnett's *Cincinnati Enquirer*, on loan to the White House, a donor bought it for the collection. In 1976 two sisters from Kentucky presented Frederic Remington's *Bronco Buster*, believing its display in the White House would "inspire a feeling of strength and

First Lady portraits enhance the Red Room in the 1890s (above, top). Julia Tyler started the First Lady collection by donating her own image, seen on the far wall. Above her hangs a portrait of Angelica Singleton Van Buren, which remains in the Red Room today (bottom). Other First Ladies grace the Ground Floor Corridor, converted to a gallery by Edith Roosevelt in 1902.

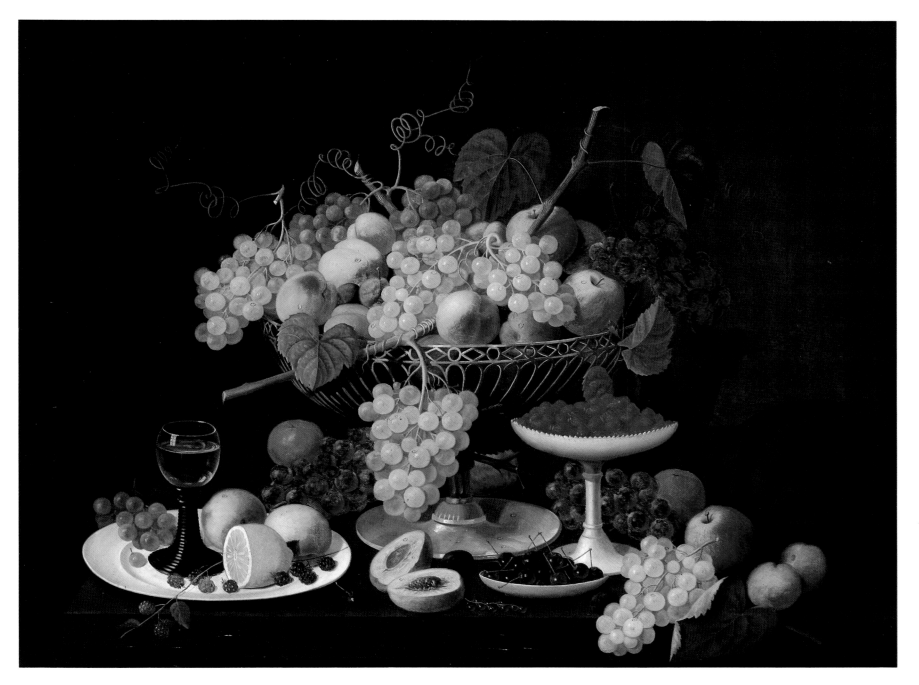

A luxuriant **Still Life With Fruit** *of 1850 celebrates the bounty of the American nation. This oil painting, by German-born artist Severin Roesen, hangs in the Red Room (opposite, on far wall), one of three Roesen still lifes in the White House collection.*

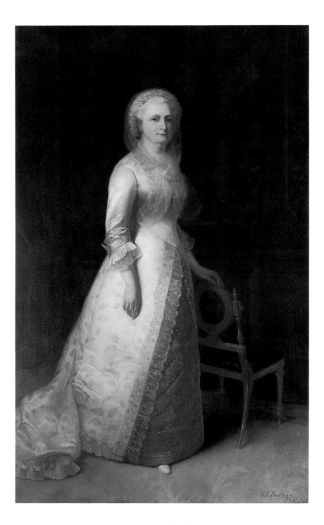

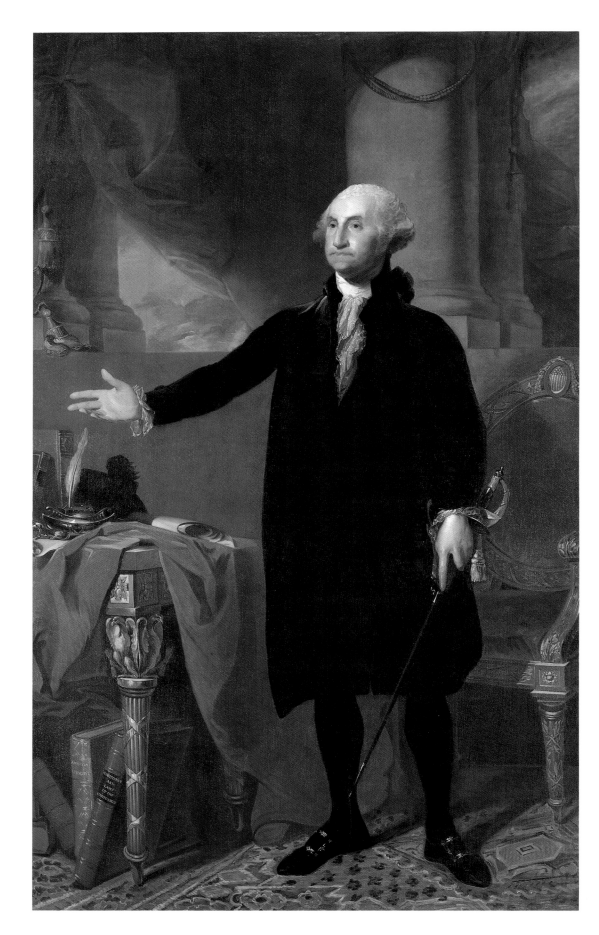

George Washington's public image (right) gained immortality through this 1797 work by master painter Gilbert Stuart. Above: Eighty years later Eliphalet Frazer Andrews used an earlier work by Stuart to capture the facial features of Martha Washington. Andrews borrowed other elements as well, copying the subject's hands from those of a live model and dressing her in a gown designed for a socialite of his own day.

determination of the American spirit" characteristic of their father, the previous owner.[1] The formation of the White House collection has involved not only Presidents and First Ladies but also politicians, curators, collectors, librarians, interior decorators, and others, working in concert and in conflict over some 200 years. Yet the collection remains unified by three basic concerns: art—chiefly American art—as historical document, as decoration, and as vehicle for celebrating American values and achievements. All three themes appear again and again in the subject matter of the art, in the intentions of its creators, in the taste of its donors, and in the eyes of the beholders. These threads have been constantly interwoven throughout the past two centuries, but the historical has been the strongest and the most evident collecting criterion.

For much of the time subject matter took precedence over the artist's reputation or the work's quality of execution. Portraits of early Presidents were copied during the 19th century to provide the White House with suitable likenesses. This documentary emphasis resulted in paintings that vary widely in quality and often lack the vitality and character of the life portraits they replicated or interpreted.

*B*y the 1880s Presidents and First Ladies began commissioning grander portraits from nationally known and even internationally famous artists.[2] Perhaps our turn-of-the-century leaders wished to have more of a hand in how they were remembered, a change that itself indicates the rise of art consciousness. As the collections policy of the White House became more clearly articulated and as the field of American art matured as well, acquisitions criteria were greatly expanded to give artistic considerations more weight, balancing the documentary excesses of previous generations. Yet the acquisition of life portraits of the Presidents and First Ladies consistently remained the first priority for the collection.

A full-length portrait of George Washington (left, and page 67), purchased for $800—a significant sum when expended on July 5, 1800—set the policy for gathering works of art that served primarily as historical documents. Indeed this 1797 painting is actually a replica by Gilbert Stuart of the portrait of Washington he had painted the previous year. From time to time, the identity of the artist has been questioned,[3] but the iconic significance of the image far outweighs any question of attribution. Stuart's multiple portraits of George Washington—he made two of them from life and many replicas—established the first President's countenance firmly in the public mind, as an idealized exaltation of a great national hero. Exhibited in New York in 1798, one of Stuart's Washington portraits was appreciated as much for its subject as for its artistic quality:

> While the intrinsic merit of the picture alone presented an admirable specimen of the fine arts for the gratification of the chaste connoisseur, recollection naturally called to mind the unparalleled services and eminent virtues of this illustrious sage.[4]

Hanging in the East Room, the most prominent ceremonial space in the White House, the Father of his Country presides over bill-signing ceremonies, official entertainments, and press conferences.

Nineteenth-century residents of the White House so desired these historic icons that they were willing to re-create them if necessary. The companion to Stuart's *Washington*, a portrait of the President's wife, Martha (far left), was painted in 1878 by Eliphalet Frazer Andrews, director of the newly founded Corcoran School of Art. This pastiche hangs as a testament to the policy of collecting for historical rather than aesthetic reasons. Andrews's combination of various sources, new and old, did not go unremarked when the portrait was exhibited at the Cincinnati Industrial Exposition the following year:

> [Martha Washington] is one of those historic pictures that hold the inherent immortality of history rather than purely of art. [Gilbert] Stuart's original portrait of Lady Washington was simply of the head and bust. . . . [W]hile the likeness is taken from that . . . the rest [is] original with Mr. Andrews.[5]

That the head replicated an earlier painting by Stuart, while the hands were taken from studies of a live model, explains the somewhat disembodied quality of Andrews's grand manner portrait. After the exposition the canvas was displayed at the White House, where another journalist noted that the dress seen on Martha Washington in the painting was designed by the Parisian couturier Worth—and made for a New York socialite to wear during the nation's Centennial, a century after Martha's time.[6] Nonetheless, the reporter found the portrait "without doubt the central object of attraction in the White House."[7]

Today the White House collection includes canvases of First Ladies far surpassing Andrews's work in artistic quality, but the monumental portrait still occupies a place of honor in the East Room. The figure rests her hand upon a gilt fancy chair that was not produced until years after Martha Washington's death. That the chair is incongruous, or that the dress was designed in 1876 rather than 1776, is not particularly disturbing to most visitors who encounter Mrs. Washington's regal image in the East Room. She is there not as a great portrait, but as an important presence.

Lucy Hayes, wife of then President Rutherford B. Hayes, lobbied for this purchase as a companion piece to the much older image of George Washington. Eventually Congress purchased Andrews's canvas for the not inconsiderable sum of $3,000.[8]

Years later, when Theodore Roosevelt's wife, Edith, established a First Ladies portrait gallery in the Ground Floor Corridor, this image remained enshrined on the State Floor. "There is just one likeness of a woman which has not been consigned to the ill-lighted basement gallery," commented a writer for *Munsey's Magazine*. "This is the portrait of Mrs. Washington—who was never mistress of the White House—by Andrews, which has the honor of hanging . . . near the Stuart portrait of her illustrious husband."[9]

More than three-quarters of a century stretches between the acquisition of portraits of George and Martha Washington. During that period, and especially from 1800 to 1850, the Executive Mansion experienced a succession of expensive redecorations but acquired little art through gifts or purchases. During Andrew Jackson's two terms alone, Congress appropriated nearly $50,000, an enormous sum, for refurbishing the house and adding the North Portico; none of the money seems to have been used to commission or purchase artwork. Certainly there was no dearth of available painters, for artists such as John Trumbull, John Vanderlyn, and Samuel F. B. Morse were at work on important portraits and historical paintings commissioned for other locations, notably the United States Capitol. But at 1600 Pennsylvania Avenue presidential images were as transient as the decor. The much admired furnishings of one administration quickly became the castoffs of the next, and Presidents usually retained their personally commissioned portraits upon leaving the White House.

In 1826 Trumbull, desiring a commission to paint historical pictures for the Capitol, begged for the "patronage of government." He observed that with such support "the fine arts may be stimulated and encouraged, the national edifices decorated, authentic monuments of national history preserved, elegant and attractive rewards bestowed on the meritorious servants of the public, and the national glory essentially advanced."[10]

Trumbull's words set out many of the goals later espoused by the White House in the formation of the permanent collection, but at this early date, few commissions seem to have been considered. A notable exception came during the James Monroe Administration, when John Vanderlyn actually set up a studio in the East Room, which the President had asked him to adorn with painted wall decorations. The plan was thwarted in 1819, two years into the administration, by lack of funding.[11]

*I*n the early years of the 19th century, no portrait but Washington's was commissioned for the White House by Congress. Perhaps the first few Presidents, John Adams and Thomas Jefferson among them, suffered neglect because of the reverence accorded their predecessor. Moreover, public acquisition of their portraits at that time would have reflected an interest in current events rather than in

LIBRARY OF CONGRESS

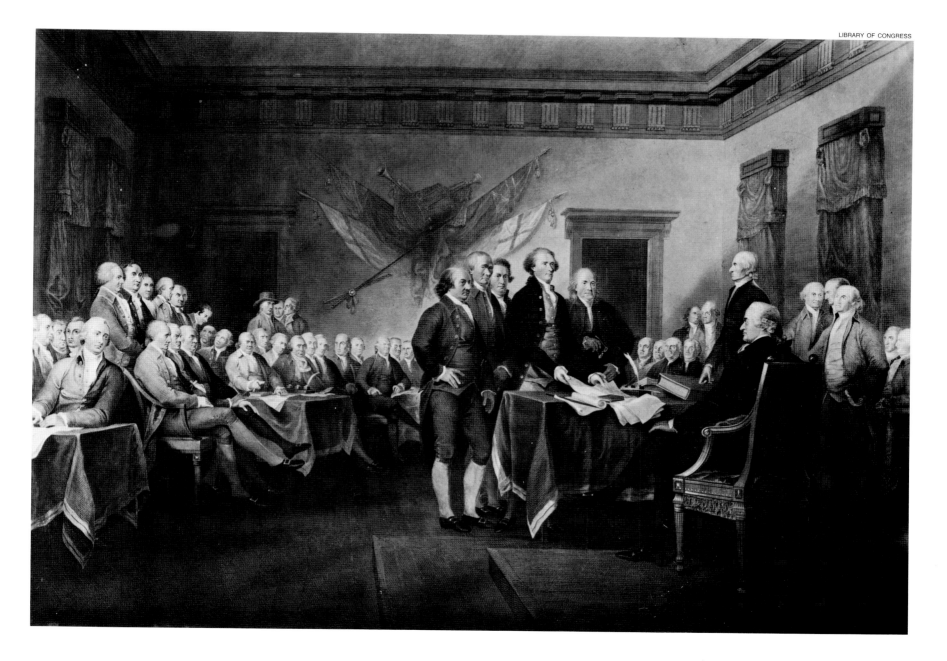

In a 19th-century engraving based on a John Trumbull painting, President of the Continental Congress John Hancock, seated, receives the draft of the Declaration of Independence from delegates, left to right, John Adams, Roger Sherman, Robert Livingston, Thomas Jefferson, and Benjamin Franklin. Waterman Lilly Ormsby made this engraving. A similar one was among the few artworks in the White House in the early 1800s.

history. Ultimately, this inattention may have been a result of the way the White House itself was viewed—as a home, not as a public building. Since the early 19th century the Executive Mansion has mirrored democratic attitudes toward domestic fashion and decoration, making a self-conscious departure from the grander tradition of the great state residences of the Old World.[12]

In 1817, during the Monroe Administration, the son of Tobias Lear, Washington's secretary, sold the government marble busts representing Washington and two figures closely associated with the New World: Christopher Columbus and Amerigo Vespucci (page 71). Yet inventories taken in the first half of the 19th century document how few examples of the fine arts were then in the White House. The inventories reveal the government's modest response to the lofty aspirations of John Trumbull and others: an engraving (see page 25), most likely after Trumbull's painting *The Declaration of Independence, 4 July 1776* (Yale University Art Gallery, New Haven), and two anonymous panoramas of Niagara Falls, which was widely considered the country's greatest natural wonder.[13]

Following its establishment as the nation's capital city, Washington, D.C., grew steadily (right) and after the mid-19th century began to attract more American painters, becoming a center of artistic

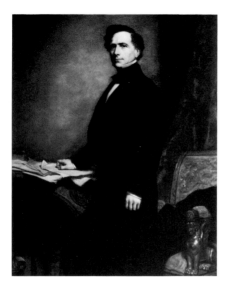

George Healy used dark, bold tones for Franklin Pierce's image in 1858 (left).

A rare period view, painted by Washington artist George Cooke, depicts the nation's capital in 1833 (right).

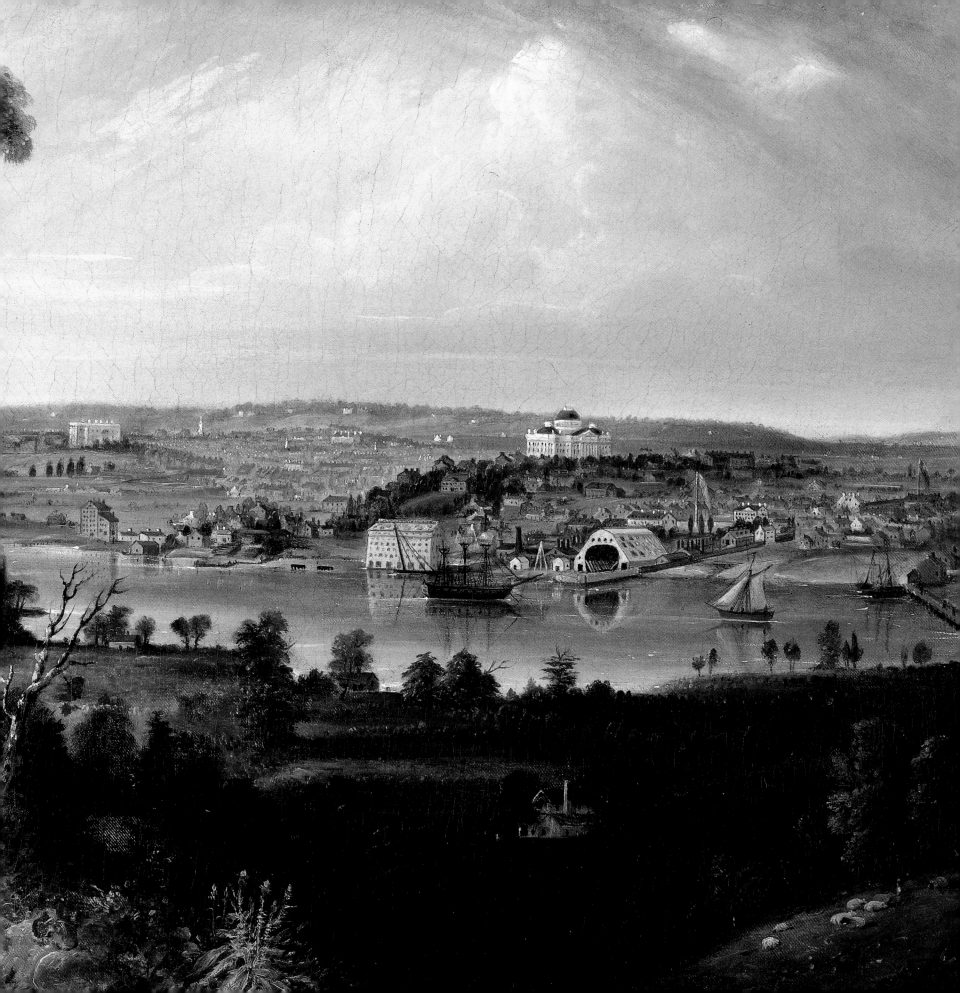

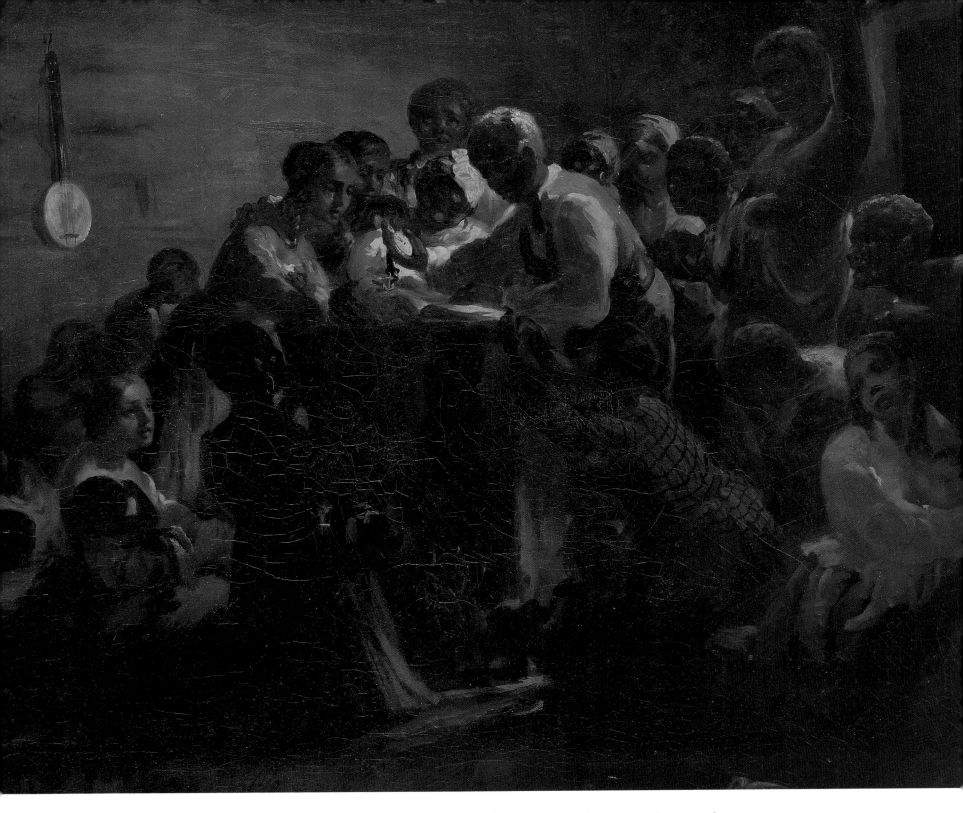

Torch flare highlights a hand-held pocket watch, the focal point of William Tolman Carlton's Watch Meeting—Dec. 31st 1862— Waiting for the Hour. *The scene shows slaves on the eve of January 1, 1863. They are anticipating midnight, when Abraham Lincoln's Emancipation Proclamation would take effect.*

activity. In 1858 artists founded a National Art Association to encourage government support for the arts. The year 1860 witnessed the founding of a National Gallery and School of Arts, a short-lived organization that sponsored lectures and annual exhibitions. Painters and sculptors were also drawn to the city by federal building projects, by the establishment of the Smithsonian Institution, and by the United States government's involvement in western exploration.[14]

George P. A. Healy arrived on the Washington scene in the midst of this new period of activity when Congress commissioned him in 1857 to paint a series of presidential portraits. The series was the first effort to obtain for the White House a visual record of its prior inhabitants. Healy had just returned from Paris, where he had achieved a significant reputation and won the patronage of Louis Philippe, Citizen King of the French, and Lewis Cass, American minister to France. A sophisticated artist accustomed to mingling with politicians, diplomats, and royalty, Healy had already painted such American notables as Andrew Jackson, Henry Clay, and John C. Calhoun. In 1842 he had worked in the White House, making a copy of Stuart's *Washington* for Louis Philippe, and he had already met and even painted some former Presidents whose likenesses were still needed for the White House. In just a few years Healy completed portraits of John Quincy Adams, Martin Van Buren, John Tyler (page 140), James K. Polk, Millard Fillmore, and Franklin Pierce (page 26).[15]

The series was an imposing one. Healy's Presidents were portrayed in the grand manner: full length, standing or seated, surrounded by opulent accessories, their gestures commanding and their demeanor grave. The artist's work was interrupted by the Civil War, however, and his unframed paintings were temporarily relegated to the attic.

During the Lincoln Administration the portrait and history painter Francis B. Carpenter was accorded a studio in the White House to work on a picture of the first reading of the Emancipation Proclamation. This political milestone was, as Lincoln told Carpenter, "the central act of my administration, and the great event of the 19th century."[16] Carpenter was given complete freedom and often sat sketching as

WHITE HOUSE COLLECTION

French wallpaper and borders, chosen by Andrew Johnson's daughter Martha Patterson, recast the Blue Room in high style in 1867.

Lincoln conducted meetings. "You need not mind him," Lincoln assured his visitors. "He is but a painter."[17] Carpenter worked as history unfolded, struggling to present a recent event rather than to glorify the distant past. "I wish to paint this picture now while all the actors in the scene are living and while they are still in the discharge of the duties of their several high offices," he wrote.[18] And, like Gilbert Stuart, whose name is closely associated with that of his best-known subject, Washington, Carpenter strove to join his name to Lincoln's. He wanted his rendering of Lincoln to be "the *standard* authority."[19] Carpenter's *First Reading of the Emancipation Proclamation* did not remain in the White House; rather it found its way to the Capitol in 1877.

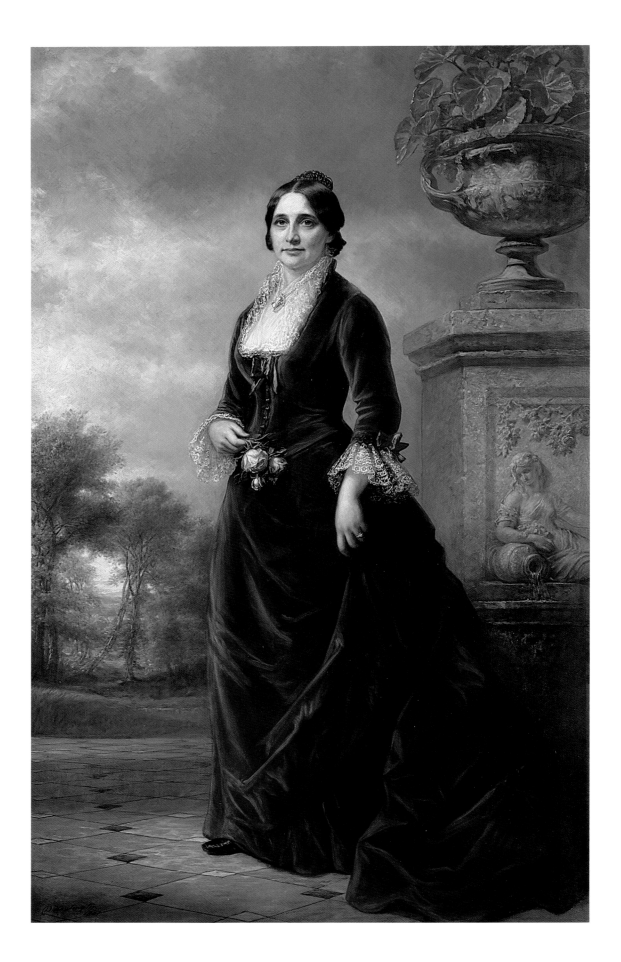

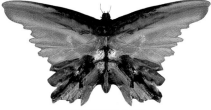

RUTHERFORD B. HAYES
PRESIDENTIAL CENTER

**Butterfly, by Albert
Bierstadt (above), and a
Haviland platter (below)
symbolize new aesthetics
in the Hayes term. Daniel
Huntington's artistic
flair led Lucy Hayes to
select him to paint her
portrait (left) in 1881.**

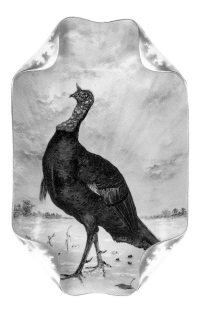

A work that captured the pathos of this historic event was William Tolman Carleton's *Watch Meeting—Dec. 31st 1862—Waiting for the Hour,* which depicted slaves eagerly anticipating the moment when the proclamation would take effect. The version of this painting presented to Lincoln by William Lloyd Garrison on behalf of a group of abolitionists left the Executive Mansion after the President's assassination. An earlier version of the same painting by Carleton (pages 28, 153) was acquired more than a century later. Moreover, no portraits of Lincoln were secured for the collection until after his death, perhaps because his contemporaries found that available portraits inadequately represented his actual appearance and character. The poet Walt Whitman, for one, complained:

> None of the artists or pictures have caught the deep, though subtle and indirect expression of this man's face. There is something else there. One of the great portrait painters of two or three centuries ago is needed.[20]

The trauma of civil warfare shook America's growing confidence as an international power, and a pervasive spirit of historicism governed the collecting and decorating instincts of the next three Presidents: Andrew Johnson, Ulysses S. Grant, and Rutherford B. Hayes. When Johnson moved into the White House during the summer of 1865, the expensive plushes and brocatelles Mary Lincoln had chosen were already shabby. Upon Lincoln's death, ruthless collectors in search of souvenirs had carried off silverware and china, and had vandalized furniture, drapes, and carpets. Johnson's daughter Martha Patterson refurbished the Blue Room, continuing the tendency toward fashion-conscious turnover in White House decor. She placed rococo revival furniture from the prewar Buchanan Administration against blue wallpaper relieved by panels bordered in black and gold (page 29). It was she who discovered in the attic the series of presidential portraits that Healy had painted before

the Civil War. She showed them to her delighted father, who secured an appropriation for framing them. In 1867 they were hung in the transverse hallway on the State Floor, where Johnson enjoyed discussing the accomplishments of his predecessors with his guests.[21]

During Johnson's term the seed was planted for the First Lady portrait collection. Julia Gardiner Tyler proposed to Johnson the idea of a portrait collection of the wives of Presidents (the term "First Lady" had not yet come into popular use). To that end, she donated a portrait of herself, painted by Francesco Anelli in 1848, three years after she had left the White House.

With the subsequent Grant Administration came a return to lavish entertainment and an ebullient redecoration of the Executive Mansion.[22] Enormous crystal chandeliers were hung in the East Room, and golden ornament embellished a White House dressed up for the Gilded Age. The Entrance Hall celebrated the achievements of the Republican Party, with a color scheme of red, white, and blue carried out in flag, shield, and eagle motifs. Two oval paintings representing the allegorical figures Liberty (page 162) and Union (pages 19, 165), by Constantino Brumidi, were installed as ceiling decorations. During the Grant Administration the White House was first considered historical by visitors to the capital city. By calling at the north door, weekdays from ten to three,[23] visitors could view presidential portraits beginning with Stuart's *Washington* and ending with William F. Cogswell's posthumous portrait of Lincoln, selected by Grant in 1869.[24]

By 1876, the nation's centennial year, public fascination with American history was growing and a colonial revival was in full swing. The events, people, and artistic heritage of the past century assumed a revitalized place in the present. United States history was now considered especially worthy of study; American artifacts were deemed suitable for collection and imitation. Symbolically as well as stylistically, colonial and early federal motifs were adopted and adapted by both painters and designers.

This passion for the past affected the residents of the Executive Mansion. "I love this house for the associations that no other could have," exulted First Lady Lucy Hayes in 1878, the year she acquired Martha Washington's portrait.[25] Eager to commemorate the house's occupants, Mrs. Hayes consulted A. R. Spofford, the Librarian of Congress, and decided to complete the historical collection of presidential portraits begun by Healy before the Civil War. The very selection of a librarian as an art adviser underscores Mrs. Hayes's desire to pursue documentation rather than art. Spofford's attempts to acquire Stuart portraits of John Adams and Thomas Jefferson from their families failed,[26] so he soon embarked on a predictable course, commissioning copies to fill the void left by the unavailability of original life portraits. He first secured the services of the Boston painter Edgar Parker, an accomplished copyist of Gilbert Stuart, to replicate portraits of Adams, Madison, and Monroe.[27]

President and Mrs. Hayes, whose impatience to complete the series was known, were approached by Eliphalet Frazer Andrews, the painter of Martha Washington's portrait and of an earlier portrait of President Hayes. Andrews wanted to produce impressive canvases suited to the scale of the East Room. He undertook full-length posthumous portraits—including images of Jefferson and Jackson—based on careful research. And he carried the replication process to further extremes by using earlier portraits by other artists and even photographs as models to make not one copy but multiple images of individual sitters.[28] Less appealing to 20th-century eyes than the originals, such copies must be viewed in the spirit that motivated their creation. At that time works were added to the White House collection because of the eminence of their sitters, not the eminence of their creators. That copies could satisfy was the result of a once commonplace feature of artistic education. Painters routinely learned to paint by copying the work of established artists. Imitation was encouraged until a would-be painter demonstrated mastery over the essentials of his technique.

Mrs. Hayes did not select Andrews to paint her own image, however. When the National Woman's Christian Temperance Union (WCTU) offered to fund a suitable memorial to her, she settled on a portrait and made a more artistic choice of painters. He was Daniel Huntington, then president of the National Academy of Design and one of the most fashionable portraitists of his generation. The likeness (page 30), presented to the White House in 1881, was hung just as the Hayes Administration ended. After President Hayes left the White House he followed his wife's example, selecting Huntington to execute a companion piece. Mrs. Hayes was the first presidential wife to have her portrait painted for the White House collection, and the Hayeses' portraits are the first pair—President and First Lady—to enter the collection in reasonable proximity. It is not mere chance that their large-scale and grand manner poses beg for comparison with the more memorable Stuart *Washington* and its belated companion by Andrews. The Hayeses' slightly grandiose portraits, as well as their White House memorabilia and copious scrapbooks of clippings,[29] suggest that this presidential couple sought for themselves the same exalted place in White House history that they had helped secure for George and Martha Washington.

*M*rs. Hayes, who along with her husband had agreed to ban liquor at the White House, was widely admired, even hailed as representing "the new woman era."[30] The First Lady and her contemporaries, including the WCTU donors of her portrait, seem to have endorsed the tradition begun by Julia Tyler of building a portrait collection of the wives of the Presidents. With Mrs. Hayes's portrait, they established more firmly this fresh direction for the White House fine arts collection.

During the eight years between the Hayes Administration and that of Benjamin Harrison, the collection changed little beyond the addition of presidential portraits. This was partially the result of circumstance. Shot by an assassin, James A. Garfield died in September 1881, only months after taking office. His successor, Chester A. Arthur, was preoccupied with a major redecoration of the White House. And Grover Cleveland so openly disliked the lack of privacy at the White House that he used it

FRANCES BENJAMIN JOHNSTON, LIBRARY OF CONGRESS

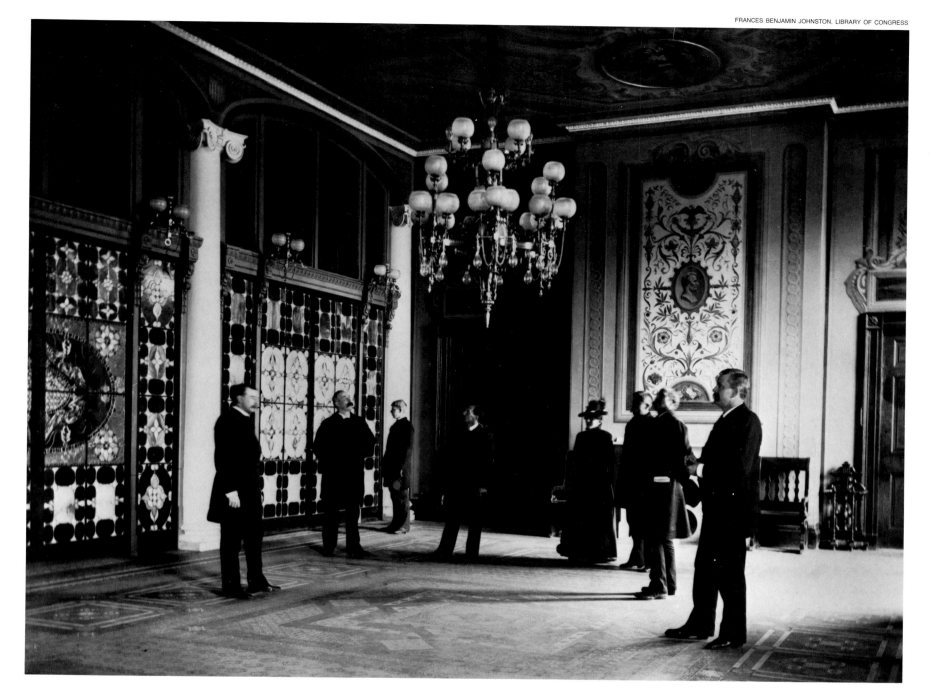

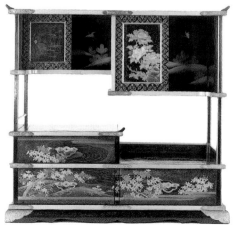

Elaborate Tiffany glass screen adds luster to the White House Entrance Hall, shown in 1891.

Lacquered and gilded Japanese cabinet, presented to the White House in 1860, foreshadowed the 1880s vogue for Oriental design.

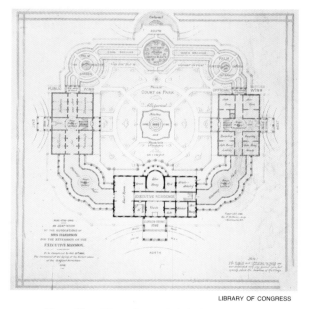

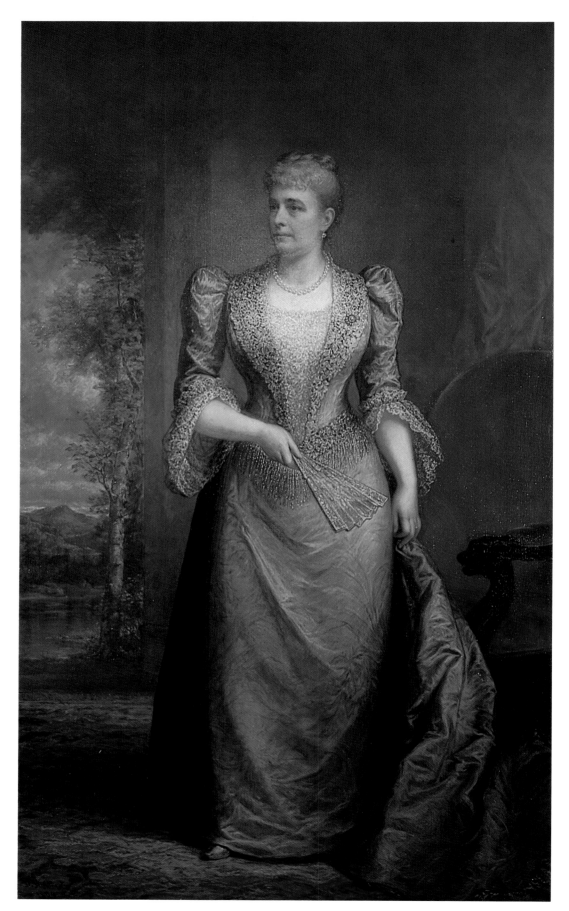

LIBRARY OF CONGRESS

Caroline Harrison (right) used watercolors to produce **Flowering Dogwood** *(top). She contributed to the growing role of women in the arts by conducting china-painting classes at the White House. An 1890 plan for an expansion of the house (above), made at her request, included a public gallery for historical art. The project never came to fruition.*

primarily for official functions, preferring to live in his nearby summer retreat.

For the fine arts collection an important trend of the 1880s and 1890s was a pronounced interest in highly fashionable decoration. The occupants of the President's House were not immune to the American Aesthetic movement, which had begun to stir under British inspiration during the mid-1870s. It introduced art principles into the production of furniture and other decorative objects; fostered collaboration among architects, painters, and craftsmen; and placed heavy emphasis on the artistic unity of the interior. Each piece, even a painting or a sculpture, was integrated into a visually complex whole. While this reform movement sought to overturn generations of borrowing from previous styles (neoclassical, rococo, and Renaissance revivals had followed in rapid succession), it also imaginatively reinterpreted the past, finding a special stimulus in Oriental art.

Greater interest in the artful interior was eventually to have impact on the White House collection, as aesthetics began to play a larger role. Choices of paintings and sculpture made on the basis of historicism were tempered as "art for art's sake" gained widespread popularity. Albert Bierstadt, in general an unsuccessful promoter of his own work for the collection, had created several aesthetic tokens, colorful butterflies, in the White House for the Hayes family. Bierstadt would apply oil paints directly to the paper to form one wing of a butterfly, then fold the paper to produce a mirror image and complete the shape (page 30; see also page 205).[31] A departure from the portraiture that then dominated the collection, the butterflies symbolize the decorative-interior priorities of the Aesthetic movement. The occupants of the White House would test their aesthetic sensibilities on interior decoration, however, long before they addressed the more complex activity of collecting American painting and sculpture as works of art rather than as historical documents.

Excursions into high-fashion decor stimulated a new art consciousness. The first pieces to be gathered for the White House with an aesthetic eye were decorative objects. Their accumulation eventually changed attitudes toward both the collecting and display of painting and sculpture. As early as 1860 a Japanese delegation had visited the United States capital, presenting the White House with state gifts that included a handsome lacquered cabinet (page 33) ornamented with abstract embellishments. Two decades later, when Louis Comfort Tiffany and his decorative firm, Associated Artists, undertook a renovation of the White House, they were inspired by motifs from Japan.

This up-to-the-minute aesthetic redecoration of the house was commissioned in 1882 by President Arthur, a sophisticated New Yorker who was himself familiar with the extravagant domestic interiors then being fashioned for merchant princes and captains of industry. The Blue Room ceiling was covered with a shield-and-star pattern, while hand-pressed wallpaper twinkled with colored glass. The mansion's stately transverse hall (today known as the Cross Hall), articulated by the original marble columns, was interrupted for the moment by a sparkling colored glass screen designed by Louis Tiffany (page 33) and described in this way for the readers of *Century Magazine*:

> The light coming through the partition of wrinkled stained-glass mosaic makes a marvelously rich and gorgeous effect, falling upon the gilded niches where stand dwarf palmetto trees, the silvery net-work of the ceiling, and the sumptuous furniture. Indeed, the only dark tints in the apartment are found in the portraits, which become the more conspicuous by reason of their contrast with their brilliant setting.[32]

The enthusiastic reporter concluded that Tiffany's changes had "metamorphosed" the President's House, which had until that time displayed a "hotel character."

The journalist's comment about portraits—"more conspicuous by reason of their contrast with their brilliant setting"—is a telling one, for it indicates that in artistic matters presidential taste was still governed

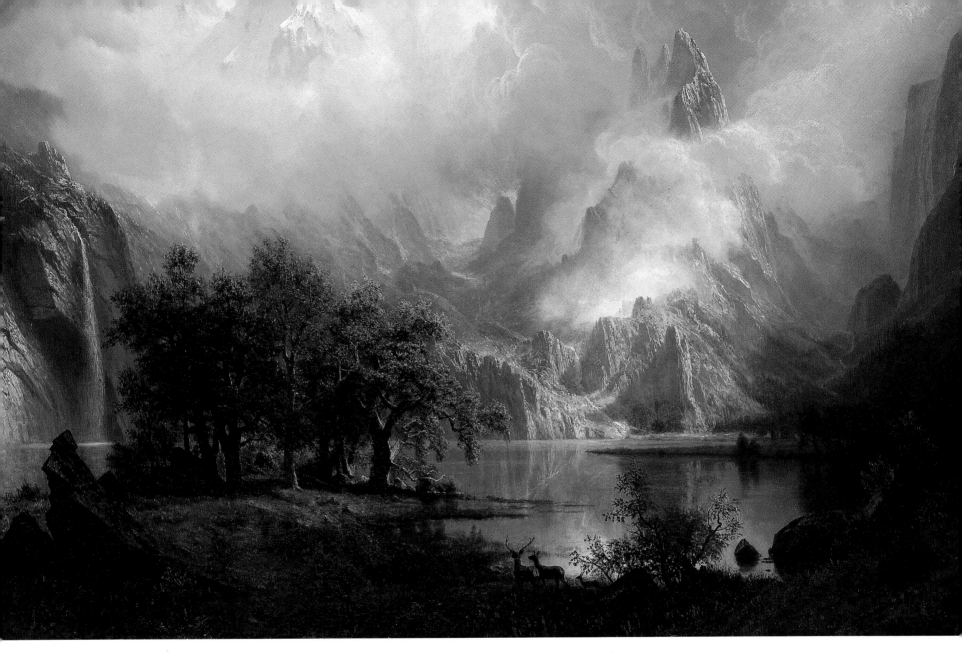

FRANCES BENJAMIN JOHNSTON, LIBRARY OF CONGRESS

Theatrical use of light and shadow imbues Albert Bierstadt's **Rocky Mountain Landscape** *(above) with drama. This painting was added to the collection in 1981. Several Bierstadt landscapes hung at the White House in the 1880s (some visible at left), but were removed after Congress failed to fund their purchase.*

The controversial **Love and Life** *(right), by George Frederick Watts, was banished from the house in 1895. It returned occasionally until 1932, its appearances dependent on public taste and mores.*

COURTESY OF A PRIVATE COLLECTOR, TOKYO

by long-established tradition. Arthur's official portrait, predictably by the fashionable Huntington, was dark and dignified, painted in the conservative grand manner format already established by the patronage of the stodgier Hayeses. The Aesthetic movement celebrated the value of art in the home. Women collected bric-a-brac avidly, transformed their houses with new decorative schemes, and increasingly became amateur or professional artists and artisans. Decorative arts, such as wood carving, china painting, and needlework, became important creative outlets for talented women seeking socially acceptable occupation and employment.

The artistic pursuits of several First Ladies typify the often feminine orientation of the movement. Mrs. Hayes had commissioned the creation of an elaborate set of presidential china, designed by the artist Theodore Davis. Rather than displaying the usual emblematic eagle, more than 400 pieces of Haviland china realistically captured American flora and fauna (see turkey platter, page 30). A century later a concentrated interest in American themes such as those depicted on the china would drive the White House's collecting of painting and sculpture.

In the early 1890s Caroline Harrison, wife of President Benjamin Harrison, conducted a series of china-painting classes in the White House conservatory. An amateur artist, she decorated china blanks with floral motifs similar to those she executed on paper (see watercolor, page 34). Interest in portraits of First Ladies now increased as women began to play a more public role in the arts and in American culture.

Caroline Harrison established the collection of historic china associated with the White House and supported the addition of paintings to the fine arts collection. Besides a portrait of her husband's predecessor, Grover Cleveland, by the distinguished artist Eastman Johnson, significant additions included Mrs. Harrison's image (page 34) by Daniel Huntington and two Van Buren-related works bequeathed by a descendant of that President. Yet contemporary art was neglected. Albert Bierstadt had lent oils of the American West to the White House in the hope that Congress would purchase them (see photograph, page 36). The legislators disappointed the artist,

purchasing instead in 1890 a modest watercolor by James Henry Moser. Virtually forgotten now, Moser had taught watercolor painting to Mrs. Harrison. The Moser, a less-than-impressive substitute for one of the Bierstadts, somewhat timidly serves as the first example of a nonportrait purchase by the United States government for the White House.

Clearly, historicism was still dominant under President Harrison. It is logical that he and his wife were preoccupied with history. The 23rd President was named for his great-grandfather, who was one of Virginia's signers of the Declaration of Independence. His grandfather William Henry Harrison had been President—though only for a month before he died after suffering exhaustion and exposure to winter cold. Caroline Harrison undertook a detailed inventory of the contents of the White House and carefully surveyed those items believed to be historic, as she prepared for a renovation.

The 100th anniversary of George Washington's inauguration was celebrated in 1889, the year Harrison took office. Public interest focused afresh both on the nation's highest office and on its official seat, the White House. Discussion of an expansion of the house, in the wind during the Arthur and Cleveland years, was renewed. Mrs. Harrison pressed for the expansion in historic terms. Her model was Mount Vernon, with its central block and side wings connected by colonnades. She proposed a complex of buildings that would preserve the original residence, yet better serve the private and public requirements of the President. She recognized the need for an official residence, which in her own words, "may be creditable to the Executive of the greatest nation on the globe."[33] Frederick D. Owen, a civil and mechanical engineer and Mrs. Harrison's personal friend, produced a schematic drawing that reflected the First Lady's plan (page 34). The east building was to be a public gallery for historical art. As designed, the "public art wing" would have high ceilings and rooms that opened into each other through spacious doorways. Mrs. Harrison saw this both as a public gallery and as an area that could be adapted for large receptions. While the project did not come to fruition, her suggestions for expansion prompted future changes in the President's House. Her activities,

moreover, were important harbingers of the professional curatorial operation introduced during the Kennedy Administration some 70 years later.[34]

Grover Cleveland, back in the White House for a second term from 1893 to 1897, was preoccupied with the nation's financial problems and his own precarious health. His young wife, Frances Folsom Cleveland, made some halfhearted attempts to pursue Mrs. Harrison's scheme for expanding the White House, but those plans were abandoned after the financial crash of 1893. Mrs. Cleveland simply rearranged paintings, including presidential portraits, on the State Floor. During these years British painter George F. Watts presented the White House with his painting *Love and Life* (page 37), which had been exhibited to great acclaim at the World's Columbian Exposition in Chicago and admired by President Cleveland. Its allegorical use of the nude made it the target of groups such as the powerful Woman's Christian Temperance Union. As a result, it was transferred to the nearby Corcoran Gallery of Art in 1895, from whence it made brief but controversial sorties to the White House.[35] As Cleveland left office in 1897, in a moment of humility decidedly uncharacteristic of Presidents, he ordered the removal of his portrait from public view. He did not wish to impose it on William McKinley, his successor.

McKinley was deeply involved with international developments that led to the Spanish-American War, and neither he nor his wife devoted much energy to the White House or its collection. Once the war began, much of his time was spent in the Cabinet Room (right), where portraits of the Presidents hung on two walls, and where the incumbent President might seek the reassurance of history in a time of crisis.

With McKinley's assassination at the Pan-American Exposition in Buffalo, New York, Vice President Theodore Roosevelt took the oath of office. The White House, now more than a hundred years old, entered a new era with the Roosevelts, who loved the residence for its many associations. As the President once responded when asked whether

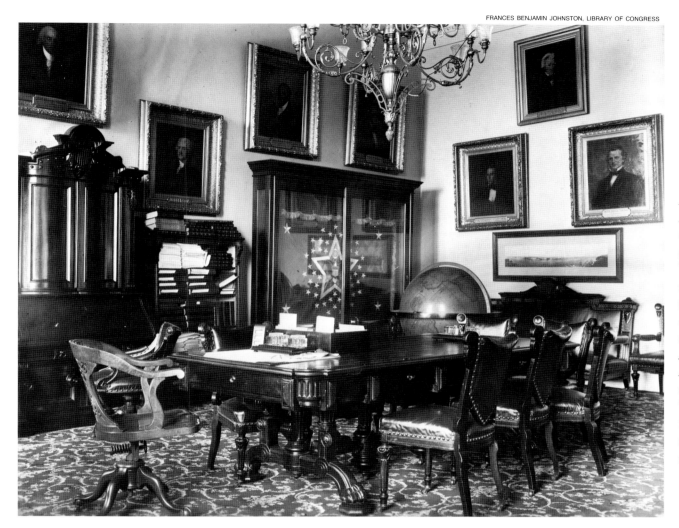

FRANCES BENJAMIN JOHNSTON, LIBRARY OF CONGRESS

Images of past Presidents in the Cabinet Room, shown during William McKinley's term, provide reassurance in times of crisis. In 1898, during the Spanish-American War, McKinley met here often with advisers. The following year the peace protocol ending the war was signed in the room.

the Executive Mansion should be abandoned to office space: "Mrs. Roosevelt and I are firmly of the opinion that the President should live nowhere else than in the historic White House."[36] Historicism once again became the dominant ideal for the State Rooms.

During the Roosevelts' tenure, in 1902, the prestigious firm of McKim, Mead, & White began extensive renovations by sweeping away the exuberant Victorian decorations—by then seen as free-wheeling incongruities—and returning the mansion to a simpler, if equally stately, neoclassicism. The Ground Floor Corridor and the rooms opening off it had been used as a behind-the-scenes work area for years. As early as the Lincoln Administration an aide had complained that the White House basement

reminded him of "something you have smelled in the edge of some swamp."[37] Now the elegant vaulted ceiling originally designed by James Hoban was restored, transforming the Corridor into a gallery for the First Ladies portraits that had been collected at the end of the 19th century.

Mrs. Roosevelt wrote to McKim:

The President and I have consulted, and we hope it is possible for you to put all the ladies of the White House, including myself, in the down-stairs corridor that the dressing rooms open on; also the busts. It could then be called the picture gallery, and you know a name goes a long way. I am afraid the

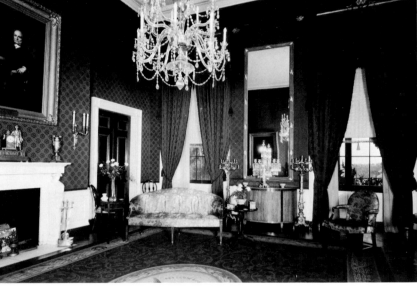

THE HERBERT HOOVER PRESIDENTIAL LIBRARY

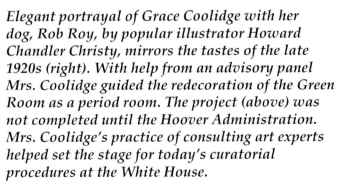

Elegant portrayal of Grace Coolidge with her dog, Rob Roy, by popular illustrator Howard Chandler Christy, mirrors the tastes of the late 1920s (right). With help from an advisory panel Mrs. Coolidge guided the redecoration of the Green Room as a period room. The project (above) was not completed until the Hoover Administration. Mrs. Coolidge's practice of consulting art experts helped set the stage for today's curatorial procedures at the White House.

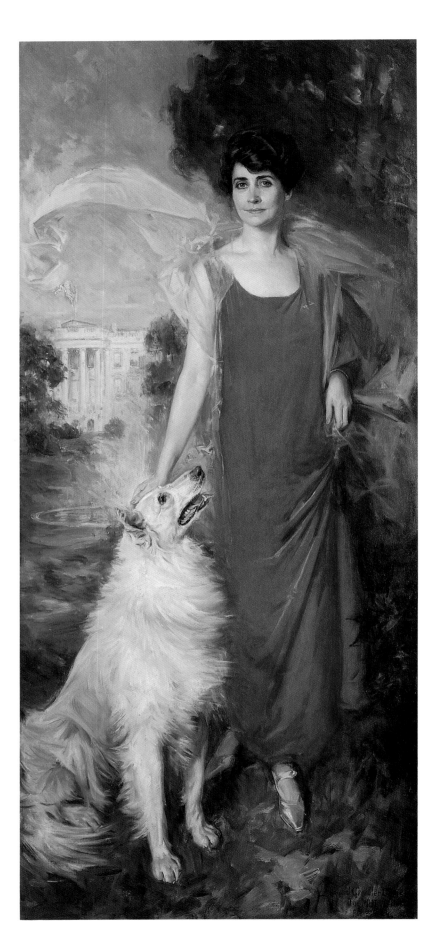

Presidents will still have to hang in the red and green rooms, and I suppose Washington and Mrs. Washington and Lincoln must remain as before, in the east room.[38]

Although some critics objected to her decision to place the portraits of First Ladies in a "basement" corridor, the general reaction was favorable. "It seems to me it has rescued those admirable females from oblivion," wrote Ellen Maurey Slayden, wife of a senator from Texas. "The light is good, there is plenty of room and anyone who wants to gaze at Mrs. Van Buren's bobbing curls or Mrs. Hayes's blue velvet dress 'all buttoned down before' can do it at leisure without incommoding other people."[39]

While the Roosevelts paid homage to the past, they did not neglect the present. Theobald Chartran, a then fashionable French portraitist who had already recorded the signing of the peace between the United States and Spain (page 218), came to Washington again to paint a magnificent, casually posed portrait of Mrs. Roosevelt (page 223) in a large, wide-brimmed hat. The genteel and self-assured sitter occupies a garden bench. The columns in the background tell the viewer that Mrs. Roosevelt is on the White House grounds. It is worth remarking that the Executive Mansion appears as a recognizable backdrop in several First Lady portraits, but never in the official image of a President. This is perhaps a reminder that, since the Aesthetic movement, the fortunes of the White House fine arts collection had been furthered more often by First Ladies than by Presidents.

Chartran also painted a portrait of Roosevelt, but it was disliked by the family and later destroyed. Archibald Butt, a close aide to Roosevelt and chronicler of White House life, recalled:

I wonder what Chartran would think if he could see the portrait of the President being destroyed. . . . neither the President nor his wife has ever liked the portrait. It was hung in the upper corridor, in the darkest spot on the wall, and by the family it has always been called the Mewing Cat.[40]

In 1903 the commission for Roosevelt's portrait was given to American expatriate John Singer Sargent. Perhaps the leading international portraitist of his generation, Sargent was a departure from the provincial American artists often selected during the previous century. The President's pose reflects the artist's confidence; a believable posture with little in the way of setting or accessories, it suggests the vigor and charisma—perhaps even arrogance—of the man (page 224). Despite the informal pose, Sargent himself described the portrait as one "in the historical series of the Presidents of the United States." And President Roosevelt had acknowledged Sargent's preeminence in a letter the preceding year: "He is of course the one artist who should paint the portrait of an American President."[41]

While Sargent's may have been the official portrait of Roosevelt, the popular President is represented by many other images, too. Roosevelt was a President whose exploits captured the imaginations of both artists and the public. Like his predecessors Washington and Lincoln, the legendary Roosevelt has served as a focal point for the White House collection.

For a decade and a half following Roosevelt's term—although Presidents and First Ladies sat for distinguished portraitists—little attention was paid to fine arts collecting at the White House. Then, in 1925 during the Coolidge Administration, Congress appointed an official who was given the authority to accept gifts for the Executive Mansion with the President's approval.

Mrs. Coolidge herself chose a distinguished advisory committee that included the fashionable residential architects Charles Adams Platt and William Adams Delano as well as Robert W. DeForest, the founder of the American Wing of the Metropolitan Museum of Art. A plan for "historical" State Rooms, with the involvement of the advisory panel, illustrates subtle changes in the way the White House was now perceived. The long-lasting interest in historical matters had fostered attention to curatorial procedures, and the house was evolving into a museum as well as a monument.

BOTH: ABBIE ROWE, NATIONAL PARK SERVICE

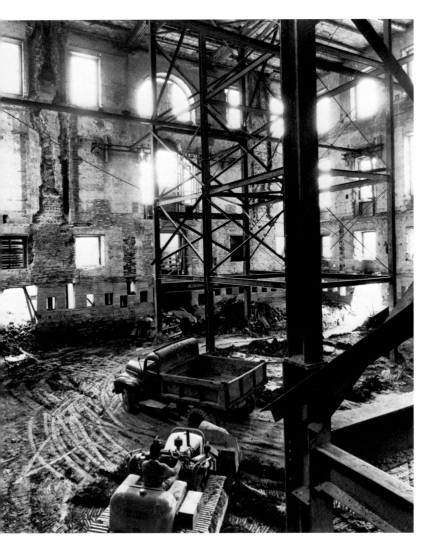

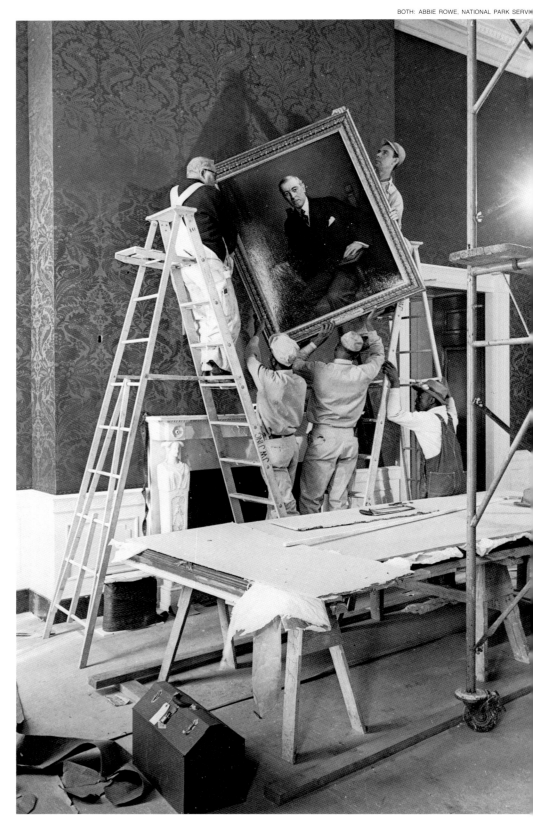

Gutted to its stone shell in 1950 during the administration of Harry S. Truman, the White House undergoes its first major reconstruction since 1817, after it was burned by the British. Bulldozers scooped out a new two-story basement (above), then reinforced foundations were laid to support unstable walls. Opposite: A portrait of Woodrow Wilson is returned to its place on a wall of the Red Room. Though the house took on a more contemporary look, its art collection remained traditional.

But in the Coolidge era the White House was not yet an art museum. Although Mrs. Coolidge's portrait (page 40) captures her arrayed in the latest fashion, the First Lady was more interested in adding colonial-style furniture—inspired by period rooms in the American Wing—than she was in collecting paintings and sculpture. In the hope that the American people would aid in furnishing the Executive Mansion, she helped persuade Congress to authorize the acquisition of appropriate antiques as gifts. As with copied portraits, reproduction furniture sufficed when antiques were not available.

A serious effort to document White House furnishings was led by the next First Lady, Lou Henry Hoover. An enthusiast of memorabilia and old photographs, she occasionally directed her energies toward the collection of paintings and sculpture. Mrs. Hoover agreed in 1930 that the White House portraits be photographed and documented by researchers from the prestigious Frick Art Reference Library. Researcher Katharine McCook Knox's description of her own work on this project demonstrates a professional attitude toward the White House and its history, reflecting the enthusiasm for documentation characteristic of early efforts in the field of American art history. Mrs. Knox recalled entering the White House and glimpsing the portrait of Julia Gardiner Tyler far down a corridor:

I welcomed this opportunity of examining the back of the canvas, somewhat to the wonderment of the nice electricians [who were working nearby and removed the portrait from the wall]. . . . On the back of the canvas, Francesco Anelli had spelled the fair Julia's name Giulia, as in the Italian manner. He dated the canvas 1848 and signed it F. Anelli. The merchant stamped on the back the following: "J. W. Hawkhurst's Paint and Art Store, 114 Grand Street, New York. Artists and Painters Brushes and materials of every description."[42]

The result of this research was a loose-leaf volume, presented to the White House in 1931, and much used by the President's staff to answer inquiries about works in the collection.[43] The Frick provided photographs of White House paintings for 38 years, a period when, as former curator Clement E. Conger said, "the collection was insufficiently organized to meet the requests of the public."[44]

Mrs. Hoover made use of President and First Lady portraits in continuing the renovations of the rooms. Though the portraits of George and Martha Washington had been displayed in the Red Room since 1902, she had them reinstalled in the stately East Room. In transforming her second-floor drawing room into the "Monroe Drawing Room," she installed a portrait of Elizabeth Kortright Monroe, copied in 1932, slightly more than a century after that First Lady's death.[45] A portrait of Abraham Lincoln replaced a tapestry hung in the State Dining Room during Roosevelt's renovation, and one of John Quincy Adams was hung prominently in the Green Room. That room had finally been completed (see photograph, page 40) by the advisory committee convened by Mrs. Coolidge.

The committee continued its work on the Red Room during the tenure of Franklin Roosevelt, choosing a number of presidential portraits to hang on the walls.[46] The creation of these period rooms, using professional advisers, indicated a growing sophistication in the management of the collection; procedures associated with museum curatorship were being adopted.[47]

*E*ven as late as the 1940s and 1950s a historical perspective still guided collecting at the White House. Harry Truman, a devoted student of American history, proclaimed, "There is really not anything new if you know what has gone before."[48] Truman was fascinated by the White House and its former inhabitants. With the construction on the south front of the second-floor balcony that came to be called the Truman balcony, he made the first major change in the main block of the building since the Jacksonian period. Even more dramatic was the total renovation of the White House (left) undertaken during his term. For more than three years, beginning late in 1948, the Trumans lived in Blair House while

the aged, dangerously shaky house was gutted to its stone shell and rebuilt.

During Harry Truman's Presidency the historical emphasis of the collection was maintained. In 1947 the White House acquired George Healy's painting *The Peacemakers* (page 157). It depicts the conclusion of the Civil War, but the acquisition was laden with contemporary significance, for another great conflict, World War II, had ended just two years earlier. A more direct reminder of the war came with the 1949 gift of yet another Gilbert Stuart portrait of George Washington from a couple whose son had died in World War II.

Since Truman's Presidency the White House has experienced few architectural changes, but in the age of television it has assumed an even greater symbolic importance for the American public. The collection housed there has been expanded both in size and concept, while its growth, care, and interpretation have been systematized.

In its post-World War II renovation the house had lost much of its original patina. During the administration of John F. Kennedy a concerted effort was made to recapture, even re-create, it. Jacqueline Kennedy appeared before millions of Americans in a televised tour of the house, presenting plans for renovation. She sought the advice and cooperation of antiquarians and collectors by appointing a Fine Arts Committee chaired by Henry F. du Pont, founder of the Winterthur Museum, the leading repository of early American decorative arts. New Yorker James W. Fosburgh, who had been on the staff of The Frick Collection for two decades, was named chairman of the special committee for White House paintings. He worked tirelessly to build the collection, which was significantly expanded during the Kennedy term.[49]

An act of Congress, passed in 1961, made objects belonging to the White House part of its permanent collections and designated the State Rooms as having a museum character. The care and the growth of the collections, previously left somewhat to chance, were finally formalized. In the same year the Office of the Curator was established.

For the first time truly professional standards were applied to the works in the collection.[50] The nonprofit White House Historical Association was also formed that year to enhance understanding and provide for the interpretation of the house and its collections. The association's founding was followed in 1964 by that of the Committee for the Preservation of the White House. To this group falls the responsibility of advising the President on the acquisition, use, and display of historic and artistic objects for the White House.

The very heroes and heroines who had been the centerpiece of the fine arts collection—the Presidents and First Ladies—remained so. The clear favorites were Presidents whose individual achievements symbolize universal values of the nation: George Washington, of course, and Thomas Jefferson, Abraham Lincoln, and Theodore Roosevelt. In recent years at least ten images representing these illustrious Presidents have been added to the collection, several by artists of the first rank.

Eventually, as more and more life portraits of actual White House residents have been secured, the collection has also embraced likenesses of those who helped build the residence itself. Additions have included two portraits of architects who worked on the house—James Hoban and Benjamin Henry Latrobe (page 76). Images of distinguished visitors to the Executive Mansion have been collected as well.

Some paintings that may have temporarily hung in the White House during earlier administrations have been recovered for the collection. These include the Gilbert Stuart portraits of President John Quincy Adams and Mrs. Adams (page 91) and the Constantino Brumidi paintings, *Liberty* (page 162) and *Union* (pages 19, 165). Brumidi's works, featured in the Entrance Hall redecorated by the Grants, were removed by Mrs. Harrison's decorator in 1891. The pictures were rediscovered in 1978 by the new owners of the home of the decorator in Connecticut and brought back to Washington.

The program begun by Mrs. Kennedy endowed artistic quality with as much weight as historic

In the Blue Room Mrs. John F. Kennedy (left) calls attention to a late 18th-century marble bust of George Washington by Giuseppe Ceracchi. Above it hangs an 1877 Washington portrait by Luis Cadena. Largely because of Mrs. Kennedy's efforts, the artistic quality of works for the White House gained equal status with their historical importance. Below: In 1970 Mrs. Richard Nixon, left, and Mrs. Lyndon Johnson unveil a newly acquired John Vanderlyn portrait of James Madison. Presidents and First Ladies of each administration have continued the effort to add significant works to the collection.

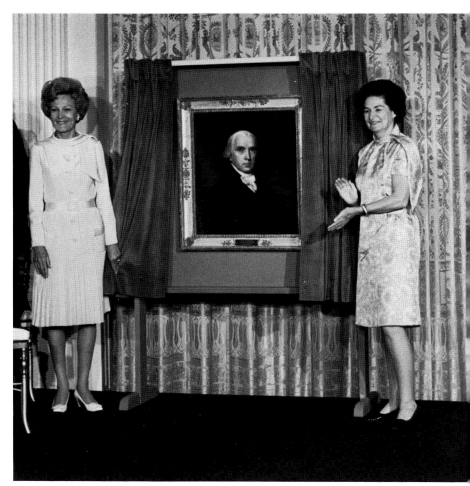

ED CLARK, LIFE MAGAZINE © TIME WARNER INC.

WHITE HOUSE PHOTO

importance for building the White House collection, and many of the artistic masterpieces we encounter today have been acquired since that time. The emphasis on quality has inspired a number of important gifts from leading collectors since 1961. Among these are John Singer Sargent's *The Mosquito Net* (right, and page 227), James McNeill Whistler's *Nocturne* (page 172), Thomas Eakins's *Ruth* (page 217), and Mary Cassatt's *Young Mother and Two Children* (page 228).[51] James Fosburgh explained: "The White House is the setting in which the Presidency of the United States is presented to the world and must be a reflection of the best in American history and art."[52]

*U*nder the guidelines established during the Kennedy Administration and refined over time by the Committee for the Preservation of the White House, the expansion of the collection has continued. The works acquired by the White House represent the geographic diversity of the nation and reflect the values and accomplishments of American society.[53] Views of picturesque scenery, familiar vacation haunts, and dramatic natural wonders take the White House visitor from sea to shining sea. As is generally true of traditional American art, the collection features more scenes of leisure than of industry and only a few urban images. Many examples celebrate old ways and bygone days in idealized fashion, and a small gathering of still life paintings evokes the abundance of American life. From representations of revered political leaders, the collection has broadened to include images of the generic American hero: the cowboy, symbol of independence, freedom, and self-reliance. Nonfigurative work has never been a collecting goal, and virtually none of the pictures in the collection depart from representational artistic traditions.

From its limited origins in historicism the fine arts collection at the Executive Mansion has grown to become "a reflection of the best in American history and art." In recent years documentary emphasis has been tempered increasingly by greater concern for aesthetics, introduced through awareness of America's artistic achievements and supported by the growth of scholarship in the field of art history. Not only the quality but also the preservation and care of the collection are delegated to the Office of the Curator. Since 1961 the standards applied to the holdings of the White House have been those of the museum, not of the usual domestic interior. The decorations and collections, enhanced and expanded by each succeeding presidential generation, will continue to evolve as we move into the next century, the third during which this much-changed building has served its enduring function, as a home for our nation's leader, a symbol of the office he holds, and a repository of art for the American people.

The Mosquito Net, *by John Singer Sargent, entered the collection not for historical reasons, but for its exquisite style and profound beauty. Dark wire ribs arc beneath the net, riveting attention on the calm center of interest, the quiet face of the young woman. Evolving sensitivity to artistic quality opened the White House fine arts collection to such treasures as this early 20th-century work.*

Notes

1. "President Greets Hatfield Sisters," *The Kentucky Post,* July 14, 1976, Office of the Curator, the White House.

2. Among these painters were Daniel Huntington, Eastman Johnson, John Singer Sargent, and Anders Zorn.

3. William Dunlap, *A History of the Rise and Progress of the Arts of Design in the United States,* 2 vols. (1834; reprint, New York: Dover, 1969), 1: 201; Milton Esterow, "Who Painted the George Washington Portrait in the White House?" *Art News* 74 (Feb. 1975): 24–28; Sylvia Hochfield, "Portrait of a President," *Art News* 74 (Feb. 1975): 28–30; Sylvia Hochfield, "The White House Washington Portrait: Did Gilbert Stuart Tell a Lie?" *Art News* 81 (Jan. 1982): 61–66. Information supportive of the portrait's authenticity appears in Marion F. Mecklenburg and Justine S. Wimsatt, "The Full Length Portrait of George Washington by Gilbert Stuart—Conservation Treatment Report and Commentary," 1978, Office of the Curator, the White House.

4. *The Spectator,* Feb. 24, 1798, Office of the Curator, the White House.

5. "The Exposition: Total Attendance to Date, 110,304," *Cincinnati Commercial,* Sept. 21, 1879, supplement, 1. *Official Catalogue of the Art Collection, Cincinnati Industrial Exposition,* 1879, no. 70. Portrait of Martha Washington listed for sale at $3,000.

6. "The dress is that of a lady of Martha Washington's position in her time . . . the dress being made by Worth from the best authorities for Mrs. Darling, of New York, and worn by her during the centennial tea party season nine years ago." "Portraits of Presidents," *New York Herald,* Oct. 5, 1884.

7. Ibid.

8. "The big picture of Martha Washington was lobbied out of Congress by Mrs. Hayes. Eliphalet Andrews, of Ohio, came to Washington to found the Corcoran School of Art, and his first work was a life-size portrait of Mrs. Washington. Mrs. Hayes had it hung in the East Room opposite the Washington portrait, and every time a member of Congress came to the White House she made a point of taking him in to admire it and of saying wasn't it a shame that it couldn't remain here. Her scheme worked." Irwin H. (Ike) Hoover, "Hail To The Chief," *Saturday Evening Post,* May 5, 1934, 15, 42.

9. Helen Corinne Hambidge, "The White House collection of Presidential Portraits," *Munsey's Magazine,* Aug. 1908, 591.

10. Quoted in Lillian B. Miller, *Patrons and Patriotism: The Encouragement of the Fine Arts in the United States 1790–1860* (Chicago: Univ. of Chicago Press, 1966), 37; John Trumbull, *Letters Proposing a Plan for the Permanent Encouragement of the Fine Arts by the National Government Addressed to the President of the United States, by John Trumbull, President of the American Academy of the Fine Arts* (New York, 1827). Letter no. 1, Dec. 25, 1826, 5; Letter no. 2, Dec. 28, 1826, 8.

11. William Seale, *The President's House: A History,* 2 vols. (Washington, D. C.: White House Historical Assn., 1986), 1: 159.

12. Lonnelle Aikman, *The Living White House,* 9th ed. (Washington, D. C.: White House Historical Assn., 1991), 15.

13. Inventory, 1849, National Archives; copy, Office of the Curator, the White House. Some of the works listed in the inventories of 1809, 1825, and 1849 have since disappeared.

14. See Josephine Cobb, "The Washington Art Association: An Exhibition Record, 1856–1860," *Records of the Columbia Historical Society,* 1966; and Andrew J. Cosentino and Henry Glassie, *The Capitol Image: Painters in Washington, 1800–1915* (Washington, D.C.: Smithsonian, 1983), 125.

15. For information on Healy and his distinguished sitters, see Marie de Mare, *G. P. A. Healy: American Artist: An Intimate Chronicle of the Nineteenth Century* (New York: David McKay Co., 1954).

16. Seale, *President's House,* 1: 405.

17. Quoted in Seale, *President's House,* 1: 413.

18. Quoted in Harold Holzer, Gabor S. Boritt, and Mark E. Neely, Jr., "Francis Bicknell Carpenter (1830–1900): Painter of Abraham Lincoln and His Circle," *American Art Journal* 16 (Spring 1984): 69.

19. Ibid.

20. Virginia C. Purdy and Daniel J. Reed, *Presidential Portraits,* ed. J. Benjamin Townsend (Washington, D.C.: Smithsonian, 1968), 34.

21. Seale, *President's House,* 1: 434.

22. William Ryan and Desmond Guiness, *The White House: An Architectural History* (New York: McGraw-Hill Book Co., 1968), 140.

23. Seale, *President's House,* 1: 472.

24. This modest image remained the only easel portrait of Lincoln in the White House until 70 years later, when his family presented another by George P. A. Healy. A painted cameo was also included as a part of the decorative scheme of the White House Entrance Hall, completed in 1869 by Hubert Schutter, a partner in the decorating firm Schutter & Rakeman (Seale, *President's House,* 1: 468–69).

25. Quoted in Seale, *President's House,* 1: 499.

26. Seale, *President's House,* 1: 500.

27. Ibid.

28. "Portraits of Presidents" (see n. 6). In 1879 Andrews twice copied a portrait of William Henry Harrison by James H. Beard, once for the White House and once for the Corcoran Gallery, each time inscribing an explanation on the front of the portrait. Then in 1880 he painted a posthumous portrait of Andrew Johnson, Lincoln's successor, using a photograph and another painting as models. Five years later he duplicated the Johnson image for the Corcoran's collection. See Herman Warner Williams, *A Catalogue of the Collection of American Paintings in The Corcoran Gallery of Art* (Washington, D. C.: Corcoran Gallery of Art, 1966), vol. 1, *Painters Born Before 1850,* 134–35.

29. Seale, *President's House,* 1: 507.

30. Margaret Brown Klapthor, *The First Ladies,* 6th ed. (Washington, D. C.: White House Historical Assn., 1989), 46.

31. Seale, *President's House,* 1: 499.

32. E. V. Smalley, "The White House," *Century Magazine,* Apr. 1884, 806–07.

33. Quoted in Seale, *President's House,* 1: 589.

34. *The White House: An Historic Guide,* 17th ed. (Washington, D. C.: White House Historical Assn., 1991), 137.

35. Seale, *President's House,* 2: 613–14. In 1921 the painting was transferred to the National Gallery of Art (now the National Museum of American Art). In 1987 it was deaccessioned and sold at auction.

36. Quoted in Seale, *President's House,* 2: 657.

37. *White House Guide,* 12.

38. Edith Roosevelt to Charles F. McKim, Aug. 21, 1902, Theodore Roosevelt papers, Library of Congress; copy, Office of the Curator, the White House. The Washington portraits and the one of Lincoln did not remain in the East Room, however. They were removed for the 1902 renovation and rehung elsewhere in the house.

39. Quoted in Sylvia Jukes Morris, *Edith Kermit Roosevelt: Portrait of a First Lady* (New York: Coward, McCann & Geoghegan, 1980), 260.

40. Butt to Mrs. Lewis F. Butt, Feb. 7, 1909, Lawrence F. Abbott, ed., *The Letters of Archie Butt, Personal Aide to President Roosevelt* (Garden City, N. Y.: Doubleday, Page & Co., 1924), 328–29.

41. Roosevelt to Henry White, May 15, 1902, *The Letters of Theodore Roosevelt,* 8 vols. (Cambridge: Harvard Univ. Press, 1951), 3: 264.

42. Katharine McCook Knox, *The Story of the Frick Art Reference Library: The Early Years* (New York: Frick Art Reference Library, 1979), 139–40; quotes anecdote previously published in *Spence Alumnae Bulletin,* 1974.

43. The book was returned to the Frick Art Reference Library in 1953, and acquisitions since 1951 were added (Knox, *Frick Art Reference Library,* 143–44).

44. Quoted in Knox, *Frick Art Reference Library,* 144.

45. Seale, *President's House,* 2: 908–12.

46. Ibid., 955.

47. Ibid., 956.

48. Ibid, 1: 10–11.

49. Added to the collection were 72 paintings and drawings, 121 prints, and 16 pieces of sculpture.

50. To date, five individuals have served as curator of the White House, each making a mark on the collection under his or her stewardship. Lorraine Pearce served in 1961 and 1962; William Elder, in 1962 and 1963; James R. Ketchum, from 1963 to 1970; Clement E. Conger, from 1970 to 1986; and Rex W. Scouten, since 1986.

51. Even great examples of European art were acquired. A group of eight paintings by the French Impressionist Paul Cézanne had been left to the United States government by Charles A. Loeser, an American expatriate who died in 1926. Under the terms of Loeser's will, the paintings did not come into White House possession until 1950. Difficult to absorb into the White House's decorating scheme, the works were first hung in 1961. In receiving the paintings, Jacqueline Kennedy expressed her hope that the gift "will serve as an example to other collectors, so that one day this much loved house will be as great a repository of historical and beautiful objects as any other official residence in the world." (White House press release, May 3, 1961, Office of the Curator, the White House.) Today some of these works are on view in the National Gallery of Art. They are rotated, one or two pictures at a time, to the White House.

52. Quoted in memorandum on collecting goals, Lyndon B. Johnson Administration, 1965, Office of the Curator, the White House.

53. "Report of the Committee for the Preservation of the White House 1964–1969" and "White House Collections Policy and Procedures," 1992, Office of the Curator, the White House.

Part Two

Selected Works From the Collection

William Kloss

Michele Felice Cornè (1752–1845)
Landing of the Pilgrims c. 1803–07

Oil on canvas, 36 x 52¼ inches (91.4 x 132.7 cm)
Gift of Mr. and Mrs. John P. Humes, 1984

The Sons of the Pilgrims, an organization of patriotic Bostonians, was founded in 1800. The invitation to their first meeting was illustrated with Samuel Hill's engraving of the landing of the Pilgrims in 1620. His image became the inspiration for this fanciful painting by the recent Italian immigrant Cornè.[1] In truth, it is an odd assortment of Pilgrims who arrive at Plymouth in Cornè's picture. In place of the somber garb of Puritanism their bold leader wears a hat of the Napoleonic era, and a group of British redcoats sits staidly behind him!

The storm-tossed refugees are greeted by a number of incurious Indians rather than the desolate shore that actually awaited them. The Indians, decidedly not dressed for the winter season, stand on different levels of a high rocky bank that replaces the marshes of reality. Otherwise, the topography is generally correct, with Clark's Island in the distance, and Plymouth Rock in the foreground of the painting. On the latter is a two-line inscription, now faint, with the traditional landing date: "Dec. 22 / 1620."

Cornè was also accurate in depicting the flag flown by the British merchant ship *Mayflower* (the merchant flag is at the stern). It is flying the Grand Union flag—not the later Union Jack—from the jack staff on the bow of the ship. The Grand Union was in use from 1606 until 1801, therefore equally correct for the Pilgrims and for Cornè, whose first experience of British ships was prior to 1801.

The emigration of Michele Felice Cornè, a native of Elba, was one of the minor consequences of the French Revolutionary wars. He was among the soldiers, certainly a conscript, resisting Napoleon's invasion of Naples in early 1799. Although nothing is known of his artistic career before he left Naples for America, it is assumed that he was already working as a decorative painter there, embellishing homes or carriages with floral and landscape motifs. He may have provided portable souvenirs of the city, such as

views of the bay or of Mount Vesuvius in eruption. These were something of a Neapolitan specialty in the 18th century, when the city was an essential stop for foreign tourists making the Grand Tour.

The French army occupied Naples until the arrival of Lord Nelson's fleet in June. Confusion reigned. Cornè shipped passage for America in November 1799 on the *Mount Vernon* of Salem, Massachusetts, captained by Elias Hasket Derby, Jr. The artist apparently paid his way by making "portraits" of the ship for Derby and depicting its recent naval engagements. In New England, under the patronage of Captain Derby, Cornè enlarged his clientele and established a local reputation as a decorative painter as well as a creator of ship's portraits and landscapes.

He painted *The Landing of the Pilgrims,* his best known work, at least five times. The earliest example is presumably that in the collection of the Diplomatic Reception Rooms, United States Department of State. It is signed and dated 1803. One other version, for many years on deposit at the Peabody Museum in Salem, Massachusetts, is signed although undated.[2] The White House painting is neither signed nor dated. These latter two paintings also differ from the State Department one in width and positioning of figures and in the intensified stylization of their drawing.

The White House version is the most stylized. Its schematic simplifications are often delightful. The clouds are rendered in strong, almost abstract shapes; the snow covers the shore like frosting on a cake; and the squiggly waves might have been applied with a pastry tube. The naive slap and dash of waves against the rocks and ship's boat has the same cartoonlike character as the careful but comical drawing of the many faces. But in the brittle drawing of the barren winter trees, Cornè deftly projects the chill of a northern winter, as though he were measuring the climatic distance between Naples and New England.

Benjamin Wilson (1721–1788)
Benjamin Franklin 1759

Signed and dated lower right: B. Wilson / 1759·
Oil on canvas, 30 x 25 inches (76.2 x 63.5 cm)
Gift of Albert Henry George Grey, 1906

The earliest of the three important images of Benjamin Franklin (1706–1790) in the White House, this portrait is the first of countless likenesses of Franklin produced abroad. As a young man in the printing trade, Franklin had visited England for 18 months in 1724–26. By 1757 he was deputy postmaster general for the Colonies, a household name as "Poor Richard," and famous for his research in electricity and other scientific areas.

In that year he traveled to London as an agent of the colony of Pennsylvania. There he argued successfully for the right to tax the estates of the absentee Penn family for funds to defend those lands during the French and Indian Wars. Shortly after his arrival he must have met Benjamin Wilson. In addition to being a painter, Wilson had published a paper on electricity in 1746 when Franklin was beginning his own experiments. In 1752 Franklin wrote to commend Wilson after reading the paper.

Wilson's reputation as a portraitist was on the rise, and Franklin commissioned a likeness in 1758. Completed in 1759, the portrait must soon have been shipped home to Franklin's wife in Philadelphia. It shows a bewigged middle-aged gentleman, slightly fleshy but vigorous, with a firm mouth and a direct gaze. Wilson conveys a strong personality through the forceful structure of the head, especially in the modeling of the nose and eyes. It is an even-tempered, alert, unpretentious, and commanding presence.

At the left, from the depths of the impenetrably dark background, a great lightning bolt flashes earthward, striking a church steeple. It is safe to assume that the church steeple is protected with one of Franklin's lightning rods, whose invention and perfection between 1748 and 1752 garnered public applause enjoyed by few scientists of the 18th century. We may smile at the implicit irony of the deist Franklin saving a church from natural destruction.

The portrait was not to remain undisturbed in the Franklin family. During the British occupation of Philadelphia the house was used to billet officers, one of whom took the portrait of the world-famous American when the troops withdrew. Franklin's son-in-law, Richard Bache, wrote to him in France on July 14, 1778:

> I found your house and furniture . . . in much better order than I had any reason to expect from such a rapacious crew. . . . Some books and musical instruments were missing. A Captain André also took with him the picture of you, which hung in the dining room. The rest of the pictures are safe. . . .[1]

Franklin returned to Philadelphia in late 1785 and three years later wrote to Mme Lavoisier, wife of the great chemist, that the theft of his own portrait had left that of "its companion, my wife, by itself a kind of widow" on the wall.[2]

Capt. John André was on the staff of Maj. Gen. Sir Charles Grey, to whom he presented the portrait. It descended in the Grey family at Howick House, Northumbria, until 1906, the bicentennial of Franklin's birth. In that year the fourth Earl Grey, Albert Henry George, then Governor General of Canada, returned the picture to the United States, presenting it to President Theodore Roosevelt.

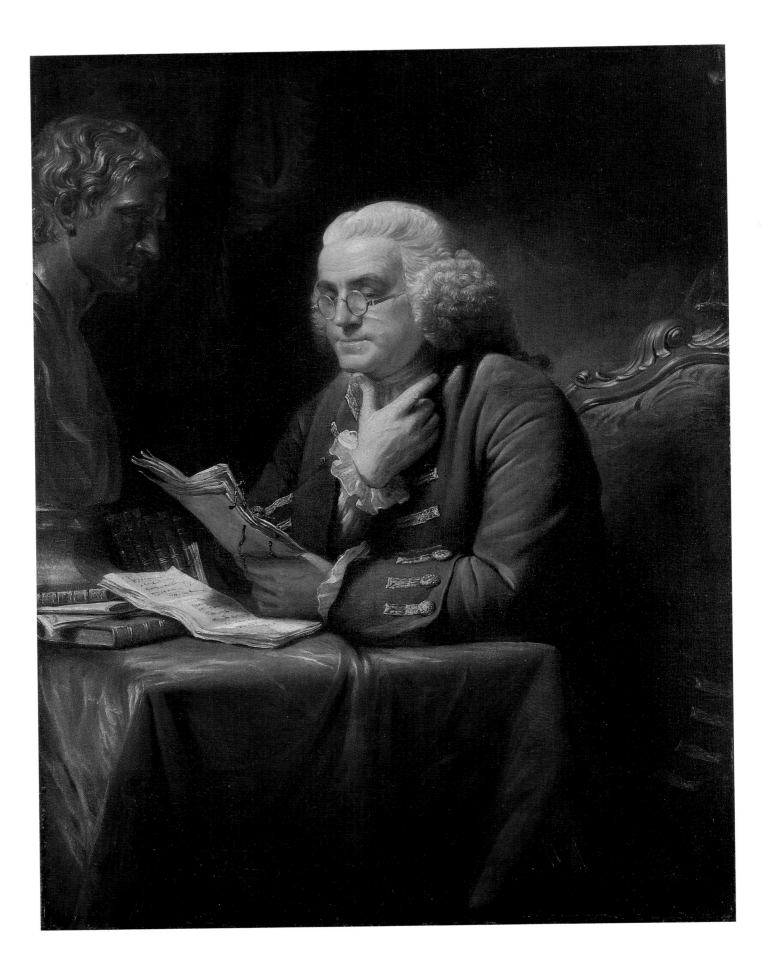

David Martin (1737–1798)
Benjamin Franklin 1767

Oil on canvas, mounted on panel,
50$\frac{1}{16}$ x 39$\frac{15}{16}$ inches (127.2 x 101.4 cm)
Gift of Mr. and Mrs. Walter H. Annenberg, 1962

Although Franklin's likeness was recorded by many artists, to Martin belongs a special distinction. He created the portrait most consonant with our conception of Franklin, the unaffected pragmatist who wrote *Poor Richard's Almanac*. David Martin was a Scotsman who had studied with Allan Ramsay and accompanied him to Rome between 1754 and 1757. Returning to Great Britain, Martin then settled in London, where he studied at St. Martin's Lane Academy and subsequently established a studio.[1]

Franklin (1706–1790) also arrived in London in 1757 and was cordially welcomed for his publications on electricity. The influential American, who had already been made a member of the Royal Academy (1752), remained in Great Britain until 1761, working successfully to secure the right for the colony of Pennsylvania to tax the estates of the Penn family. He was also awarded honorary degrees by Oxford University and by the University of St. Andrews. After a triumphant homecoming in America, Franklin returned to London in 1764, where his testimony in the House of Commons in 1766 led to the repeal of the Stamp Act. He was now the most famous of all Americans, at home and abroad. It was at this apogee that Martin painted him.

But it was not for this reason. Rather, the portrait was commissioned by Robert Alexander, of the firm of William Alexander & Sons, Edinburgh. According to family tradition, Robert had had a disputed claim to property, and he and the other claimant had agreed to refer the matter to Franklin and to abide by his decision. It had favored Robert Alexander, hence the commission. The impressive beribboned document held by Franklin in the portrait is not a treaty or an Act of Parliament, but one of Alexander's deeds! The other books and pamphlets suggest the learned evidence brought in support of the wise man's decision. And as the coup de grace the bust of Isaac Newton, whose gaze is directed toward Franklin, invokes the greatest English voice of Reason.[2]

If Benjamin Franklin's fame has been co-opted for a merchant's pride, the portrait nonetheless sits squarely in the broader tradition of the Enlightenment, an image of reason. All vanity is set aside: Observe the sage's facial moles. The pressure of the thumb against the chin excellently expresses the pressure of concentrated thought (the painting has sometimes been called the "thumb portrait"), and the refracted light of Franklin's spectacles on his cheek furthers the effect. He is not musing, but studying the document. Every faculty is focused and directed to the matter at hand.

Moreover, the matter—property—was one that much concerned Ben Franklin: "Small capitals laid out in lands, which daily become more valuable by the increase of people, afford a solid prospect of ample fortunes thereafter for [one's] children."[3] Or, as Poor Richard said, "Keep thy shop and thy shop will keep thee."

Charles Willson Peale (1741–1827)

George Washington 1776

Oil on canvas, 50 x 39¹⁵/₁₆ inches (127 x 101.4 cm)
Gift from the collection of Mr. and Mrs. Lansdell K. Christie, 1979

On May 15, 1776, the Second Continental Congress announced that the power of government in the Colonies should be vested in the American people, not in the British crown, and instructed its president, John Hancock, to invite George Washington to a military conference in Philadelphia. The next day, in a transparently political ploy to gain a military command, Hancock invited the general to stay in his home and "bespoke [commissioned] the portrait[s] of Gen. Washington and Lady" from Charles Willson Peale.[1] Washington refused Hancock's hospitality but agreed to sit for his portrait.

There were only two sessions, on May 29 and May 31, and they were probably mostly confined to Peale's painting of the head; drapery and background were added later. The pose is a somewhat angular derivative of that in a Gainsborough portrait of Augustus Hervey, 3rd Earl of Bristol, as a naval officer, painted and exhibited in 1768 at the Society of Artists of Great Britain, where Peale saw it.[2] The portrait of Washington was finished in late September, and on November 9 Peale "Began a copy of Gen. Washington for a French gentleman," which he completed on the 25th. This replica, long thought lost, is the White House picture.[3]

Washington, with the light blue sash of Commander in Chief, is shown on Dorchester Heights after the siege of Boston. Two soldiers and two cannon do service for the American troops. Across the harbor lies Boston, with Beacon Hill prominent, and Charlestown burning in the distance. The siege had begun in July 1775 following the Battle of Bunker Hill and had ended with the British evacuation of Boston on March 17, 1776. It was thus the triumphant—and recent—culmination of Washington's first campaign.

Peale painted seven life portraits of Washington, from 1772, as a colonel of the Virginia Regiment, to 1795, as President of the United States. As a contemporary of Washington's and a Revolutionary soldier, Peale saw the general in a realistic light and seldom idealized him. The candor of Peale's approach is immediately apparent in the full face view of Washington. Still, there is a sense of detachment, a pensiveness, that may reflect Washington's mood on the eve of the Declaration of Independence and the full onset of the war.

Peale excels in the crisp design of costume details, especially of the pockets and the hemline of the waistcoat. Accented and energetic, these passages also achieve a convincing illusion of volume. Since the first portrait commissioned by Hancock (now in the Brooklyn Museum) has been cut down by six inches at the bottom, the replica now in the White House has added value, for only it reveals Peale's compositional scheme of curves modifying angles.

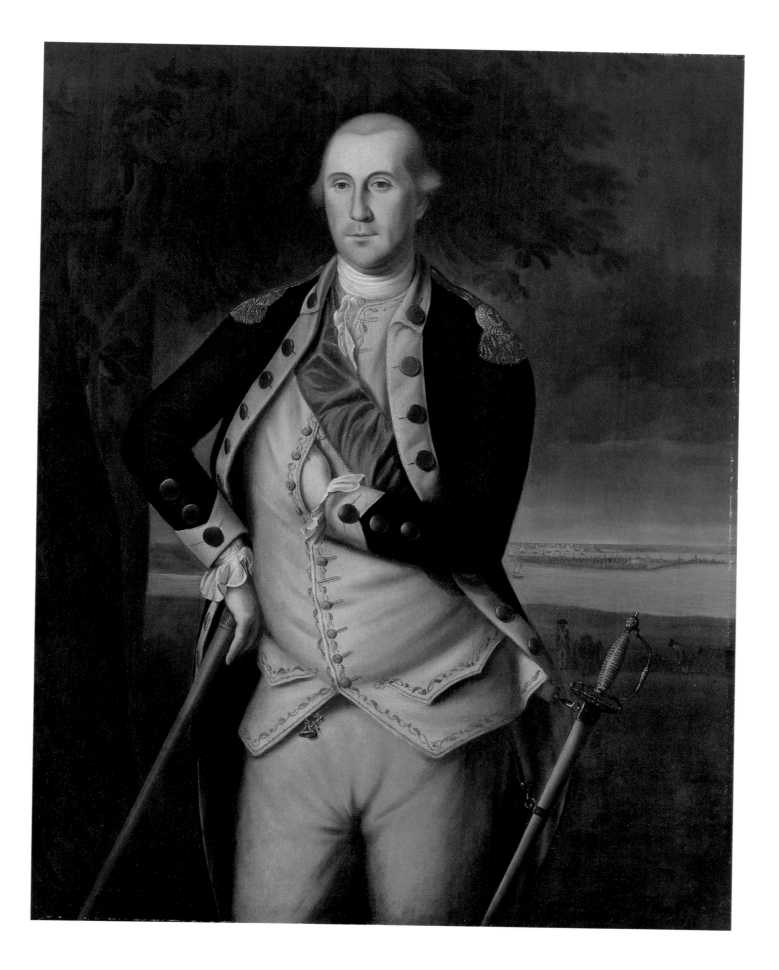

Jean-Honoré Fragonard (1732–1806)
To the Genius of Franklin *c.* 1778

Signed lower right: fragonard
Pencil and sepia wash on paper, 21⅝ x 17⅛ inches (54.9 x 43.5 cm)
Gift of Georges Wildenstein, 1961

Benjamin Franklin's arrival in France in December 1776 as envoy from the self-proclaimed United States of America was greeted with instant enthusiasm. The shrewd elder statesman had laid aside his fashionable wig (see page 56) and shone in republican plainness among "the powdered heads of Paris" and Versailles. Not many months after his arrival he paid a visit to "the artists at the Louvre," where many of the leading painters were granted apartments by the king. Forewarned of the visit, the artist Fragonard, then 45 and at the height of his powers, made this superb pencil and sepia wash drawing to honor Franklin.[1]

While the sepia has undoubtedly faded, the dazzling effects of light are still apparent. The robed and laurel-wreathed figure seated amid clouds bears no resemblance to Franklin, because the drawing was intended only as a model for a subsequent print. With the rapidity for which he was famous, Fragonard generalized the face, knowing that Franklin's features would be added later, when the print was made for the public. Franklin's likeness was known far and wide through a flood of images then sweeping across France.

The etching and aquatint print was made by Fragonard's sister-in-law Marguerite Gérard (1761–1837) with the artist's close assistance—"under his eyes" according to the announcement for the print.[2] She probably received more than a little help, for Fragonard was generous; he also is thought to have been in love with her.

The title used for the White House drawing is the English translation of the French title that appears on the print: *Au Génie de Franklin.* The title is preceded on the print by a Latin epigram composed by A. R. J. Turgot, economist, statesman, and friend of Franklin's: "*Eripuit coelo fulmen, sceptrumque tyrannis*—He stole the thunderbolt from the sky and the scepter from tyrants" (referring to Franklin's invention of the lightning rod and his role as a revolutionary). The epigram was mentioned in the press in April 1778, although the print was not issued until November, so Fragonard must have discussed the drawing and its meaning with connoisseurs to generate interest.[3]

Notice of the publication of the print included a detailed description of the allegory:

New print, dedicated to the Genius of Franklin. The ingenious author of this composition, M. *Fragonard*, Painter to the King, has sought to depict the Latin verse applied to *Franklin*: *Eripuit coelo fulmen, sceptrumque tyrannis.* . . .

Inspired by this verse, which summarizes the spirit & profound understanding of *Franklin* & his wisdom in the New World revolution, the painter has represented him at once turning aside the lightning with Minerva's shield, as his lightning rods have done, and with the other commanding Mars to attack Avarice and Tyranny; while America, nobly attendant on him and holding a fasces, symbol of the united provinces, calmly watches the overthrow of her enemies.[4]

This masterful drawing was the first major acquisition of the newly constituted White House Fine Arts Committee during the Kennedy Administration. It is both a superior work of a master of French art and a stirring emblem of the Franco-American alliance during the War of Independence.

John Trumbull (1756–1843)

Thomas Jefferson 1788

Oil on panel, 4¾ x 3 inches (12.1 x 7.6 cm)
Gift of the Italian Republic, 1976

"Wish me joy for I possess your Picture," wrote Maria Cosway to Thomas Jefferson in 1788. "Trumbull has procured this happiness which I shall be ever grateful for."[1] This vivid likeness, liquidly painted with a light, fresh touch, was to serve for the remainder of her life as a remembrance of the *affaire de coeur* that had flared between them in France during the late summer of 1786 when Maria—with her husband, Richard—was introduced to Jefferson by John Trumbull.

After the Cosways (both artists) had returned from France to England in October, the American diplomat sent to Maria his celebrated letter containing the internal "dialogue . . . between my head and my heart": "You [heart] will be pleased to remember, that when our friend Trumbull used to be telling us of the merits and talents of these good people, I [head] never ceased whispering to you . . . that the greater their merits and talents, the more dangerous their friendship to our tranquillity, because the regret at parting would be greater."[2]

This long letter initiated the Jefferson–Cosway correspondence. Jefferson wrote: "That you may not be discouraged from a correspondence which begins so formidably, I will promise you, on my honor, that my future letters shall be of a reasonable length. . . . But, on your part, no curtailing. If your letters are as long as the Bible, they will appear short to me. Only let them be brimful of affection."[3]

By 1788, however, Jefferson had his ardor under control, and his letters became less frequent, to Maria's irritation. Trumbull, the intermediary in the Jefferson–Cosway correspondence, wrote on March 6: "She is angry, yet she teases me every day for a copy of your little portrait, that she may scold *it* no doubt." On the same day Maria wrote Jefferson to ask: "Will you give Mr. Trumbull leave to Make a Coppy of a certain portrait he painted at Paris? It is a person who hates you that requests this favor."[4] On April 29 she wrote impatiently: "I cannot announce the portrait of a friend of mine in my Study yet, Trumbull puts me out of all patiance [*sic*]. I allways thought painting slow work, 'tis dreadfull now." But a letter of July 21 from her friend Angelica Church to Jefferson announces that "Mr. Trumbull has given us each a picture of you. Mrs. Cosway's is a better likeness than mine, but then I have a better elsewhere, and so I console myself."[5] Maria's joyful letter of August 19, already quoted, then followed.

The painting is the first and finest of three replicas made by Trumbull from his life portrait of Thomas Jefferson, which he had painted directly into the small *Declaration of Independence* (Yale University Art Gallery, New Haven). That painting would much later serve as the model for Trumbull's mural in the Capitol Rotunda (1818). The artist had begun the background of his composition in Paris in 1786 and started adding portrait heads; Benjamin Franklin and John Adams were among the first in the summer of 1787. He added Jefferson sometime after he returned to Paris from London on December 19, 1787. Jefferson was then in his third year as minister to France. Trumbull was Jefferson's guest for two months. He was in Paris to paint the likenesses of the French officers who had been at Yorktown directly into the small painting of the *Surrender of Lord Cornwallis* (Yale University Art Gallery).

Maria Cosway and Jefferson were never to meet again. Maria, whose parentage was Italian and English, founded a school for girls at Lodi in northern Italy in 1812. On her death in 1838 many of her possessions became the property of the school, including this precious portrait.[6] It was lent to the National Gallery of Art for its bicentennial exhibition, "The Eye of Thomas Jefferson," and at the close of the exhibition, it was generously presented to the White House as a gift to the American people from the government of Italy.

OPPOSITE: PHOTOGRAPH COURTESY OF THE NATIONAL PORTRAIT GALLERY

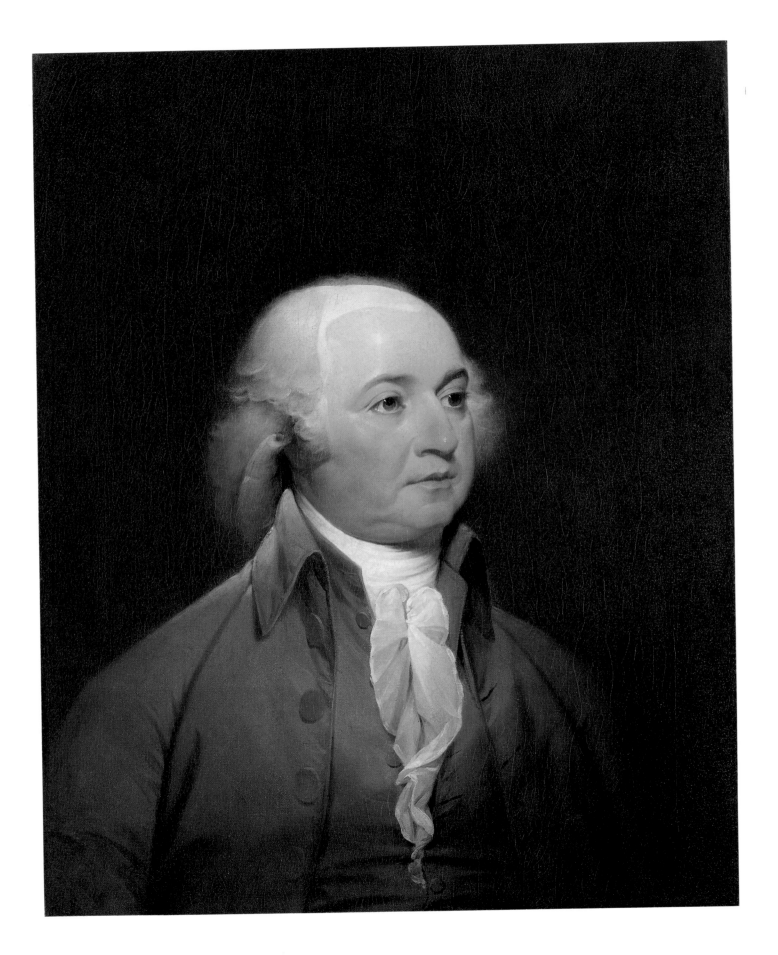

John Trumbull (1756–1843)
John Adams c. 1792–93

Oil on canvas, 30¹/₁₆ x 24 inches (76.4 x 61 cm)
Gift of the White House Historical Association, 1986

*I*t was during John Adams's tenure as Vice President that John Trumbull painted this fresh and authoritative portrait in Philadelphia. In his late 50s but still vigorous, Adams (1735–1826) felt severely frustrated by the limitations of his office: "My country has in its wisdom contrived for me the most insignificant office that ever the invention of man contrived or his imagination conceived." It requires, he wrote to his son John Quincy, "a kind of duty which . . . is not quite adapted to my character— I mean it is too inactive and mechanical."[1]

Ever conscious of manners and appearances, he presents himself to us with dignity and immaculate dress and coiffure. Turned three-quarters to his left, he does not meet our gaze. His hair is powdered (soon to be out of fashion) and softly curled, but the roll or side puff of hair behind the ear may be added hair, a partial peruke. He wears a distinctive coat (brown-gold with hints of olive, a shade used often by Trumbull) and a waistcoat cut low to reveal a deftly painted ruffled shirt front, a match for the hair in lightness of touch.

One of three versions of the portrait, this work was commissioned from Trumbull by John Jay, together with portraits of Washington and Alexander Hamilton. It is generally believed to be the first of the versions, and its greater subtlety and attention to detail support this conclusion. It is unusual to find the torso of Adams set so low on the canvas that the tip of his nose lies on the horizontal midline. But the volume of the simple torso supports the head, and the head is so forthrightly conceived that it holds firm in the center of the canvas.[2]

Trumbull turns a florid complexion into a warm, attractive focal point, and the highlights on the paler forehead serve as a transition to the gray-white hair. Slightly parted lips and a strong nose underlie Adams's most characteristic feature—the liquid blue eyes, clear and prominent, set within large eye sockets. Trumbull was judicious in the pose, for it de-emphasized the chubbiness of the man some called "His Rotundity," and the avoidance of eye contact allowed Adams to appear as he was not, dispassionate rather than disdainful.

Gilbert Stuart (1755–1828)
George Washington 1797

Oil on canvas, 95 x 59¹³/₁₆ inches (241.3 x 151.9 cm)
United States government purchase, 1800

On the afternoon of August 24, 1814, Dolley Madison received word at the White House from her husband the President that the British were about to march on Washington. He urged her to leave quickly. The British troops set fire to the Capitol Building that evening, then a naval contingent moved on to the White House. While the naval officers ate the dinner that had been laid out for the Madisons, the sailors explored the house. After piling up the furnishings, they set them ablaze. The President's House was reduced to a shell, its contents consumed by the fire.

But Mrs. Madison had been determined that, in addition to official papers, the full-length portrait of George Washington painted by Gilbert Stuart must be kept from British hands. There was no time to unscrew it from the wall, so the frame was broken and the canvas on its stretcher carried from the house into the safety of the countryside. Not until 1817 was it returned to the rebuilt White House.[1]

Although others had painted George Washington as military hero, it remained for Gilbert Stuart to create the authoritative image of the first President. No other portrait so conveys the unyielding resolve and severe dignity that made him the embodiment of the young Republic. Washington grasps a sheathed sword, emblematic of his military past and his present position as Commander in Chief. His civilian clothes remind us that after the peace was achieved in 1783 and the army disbanded, he had resigned his commission. This renunciation of power was so novel that it astonished Europeans as well as his own countrymen. A folio volume of the *Constitution and Laws of the United States* leans against (symbolically, supports) the table leg whose design joins elements of the fasces—the bound rods that symbolized authority and justice in the Roman republic—and the American eagle. Next to the Constitution is a history of the American Revolution. We know from another version of the portrait that the title of the book next to that one

is Washington's *General Orders,* also recalling his military career. Likewise, the two books on the table are *The Federalist* and *The Journal of Congress.* These remind us of his steadfast support of the federal union and its Constitution.

The President's right arm is extended in one of the ancient Roman oratorical gestures, through which it echoes the ideals of the Roman republic. But the arm has been lowered and an imperious gesture modified by the contemporary English model of "conversation-piece" paintings in which men and women converse as equals.[2] This is the man who had addressed Congress at his 1789 inaugural as "fellow-citizens."

Garry Wills, in *Cincinnatus: George Washington and the Enlightenment,* has deftly summarized most of the other symbolic elements in this painting:

> The regalia of office are here—the column of order, the drapes of court, the seat of authority, the opening onto vistas of power. Yet Washington's chair gives the literal basis of his authority—thirteen stars for the states, woven together with the binding yet bending ribbons of federal connection. The rainbow of the new political covenant circles that chair, not the holder of it.[3]

Stuart's portrait derives from the grand manner style of court painting in Europe during the 17th and 18th centuries; the artist borrowed freely from an engraving of a late 17th-century French portrait in composing this painting.[4] But by introducing different objects and symbols and by substituting an attitude of plain speaking for one of aristocratic hauteur, Stuart changed the meaning of the borrowed forms.

The portrait has been criticized for lacking animation and for the impassivity of the President's face. Some have attributed this to Washington's well-known aversion to having his portrait made, or to

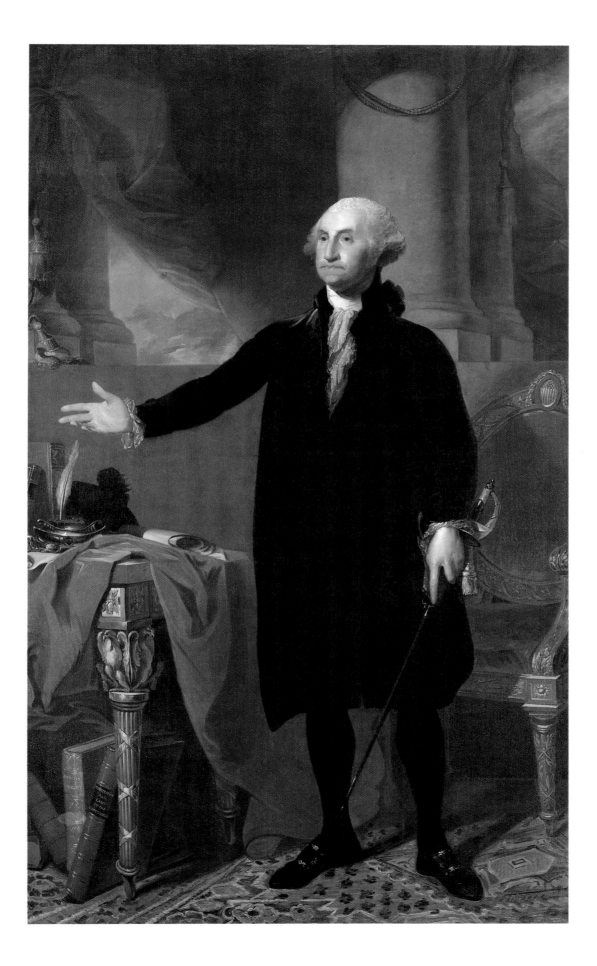

the new dentures that disfigured his mouth. But Washington's expression, though remote, is not the remoteness of boredom, nor of injured vanity, but of the controlled temperament Stuart himself described: "All his features were indicative of the strongest passions; yet like Socrates his judgment and self-command made him appear a man of different cast in the eyes of the world."[5]

Washington never posed for the standing figure. This was in accordance with standard portrait practice: The sitter posed for the head only, with perhaps some quickly drawn notations of the torso and the extremities, while the body was painted from a surrogate model or even invented. The White House portrait is probably the last of four nearly identical versions painted by Stuart, though there is no unanimity on the order in which the portraits were created.[6] Since one of the four was painted as a gift to the Englishman Lord Lansdowne, all four are commonly referred to as being of the "Lansdowne type." The head derives from a sitting in April 1796, requested specifically for use in painting the first full-length portrait.

This is the probable history of the White House portrait: The newly appointed minister to France, Charles Cotesworth Pinckney, had arrived in Philadelphia in September 1796 to receive credentials before his departure. While having his own likeness painted by Stuart, he must have seen in the artist's studio three full-length portraits of Washington in various stages of completion (for none had yet been delivered)—and decided to order yet another replica to be sent to France for the official American residence in Paris. Completed by July 1797, it was purchased by the U. S. government for the sum of $500.[7] But Pinckney's credentials were not accepted in France. He returned home early in 1798, and the painting of Washington was not delivered.

Instead, as extraordinary as it seems, Stuart must have sold the Pinckney replica a second time. In early 1798 Gardner Baker, the owner of a popular public museum at Broad and Pearl Streets in New York, advertised that "a full-length of General Washington . . . by Mr. G. Stewart" would be on view for a month before beginning a national tour. It can only have been the Pinckney picture, since the others had been delivered to their owners. Perhaps Stuart intended to paint another replica for Pinckney, while collecting

an additional fee. (This would not have been out of character for the unreliable and habitually improvident Stuart.)[8] There is evidence to support this conclusion. Upon Baker's unexpected death the portrait of Washington went to a creditor named Laing, who offered it for sale to the U. S. government.[9] A purchase order dated July 5, 1800, and signed by General Henry (Light-Horse Harry) Lee, then a member of Congress, directs payment of $800 "To one portrait full length of the late Genl. Washington by Stewart with frame bought from Thos. Lang."[10]

Before the payment was made, William Winstanley, an English painter recently settled in New York, had apparently been engaged to see to the delivery of Baker's painting.[11] Arriving in Washington on June 24, 1800, he was a guest at the home of Dr. William Thornton, the architect of the Capitol Building, and Mrs. Thornton. The latter's diary records that boxes of Winstanley's paintings, including "an original likeness of Genl Washington by Stewart," arrived with his luggage on July 5, the same day as that of the purchase order issued by Lee. When the Thorntons went together to view the full-length portrait at the Executive Office (in the Treasury Department) in September they did not "think it a good likeness."[12] Nonetheless, by November 1 the portrait had been installed in the still unfinished White House.[13]

Pinckney, meanwhile, had not forgotten the portrait. A letter of December 13, 1804, reported that Pinckney "has *repeatedly* written to Stuart on the subject, but cannot even get an *answer*."[14] These letters had obviously made Stuart wary of acknowledging paternity of the White House portrait. When the artist had visited Washington in 1802, Mrs. Thornton had written to Dolley Madison: "We have been gratified by seeing the celebrated Stewart . . . he denied most pointedly having painted the picture in the President's House, and says he told Gen. Lee that he did not paint it. . . ."[15] Stuart later compounded the deception. He told William Dunlap, whose biography of him would appear in the writer's history of American art in 1834, that Winstanley had substituted a copy of his own for Stuart's original.[16] Clearly Stuart disowned the painting to cover his duplicity; just as clearly it is his. Stuart's American icon has reigned in the White House throughout its history, a symbol of the Presidency and the continuity of democratic government.

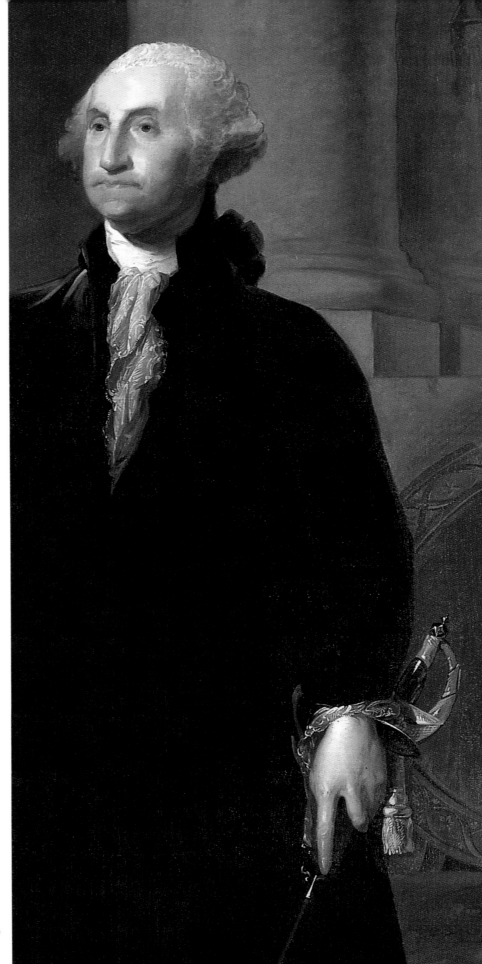

Giuseppe Ceracchi (1751–1801)

Amerigo Vespucci modeled *c.* 1790–94, carved *c.* 1815

Marble, 21 x 12½ x 10 inches (53.3 x 31.8 x 25.4 cm)
United States government purchase, 1817

Although his voyages of 1499 and 1501 were preceded by those of Columbus, only Vespucci (1454–1512) realized that he had "arrived at a new land which . . . we observed to be a continent."[1] He was more celebrated than Columbus in the 16th century, yet many more images of Columbus were created.

Nonetheless, there is a consistent tradition for the representation of Vespucci, as there is *not* for Columbus. As a rule Vespucci was depicted as an older man, mostly bald or wearing a cap, with curly hair on the forward crown and sides of his head. He was shown with a wide mouth; distinctive cords and folds of the neck; a furrowed, sharply delineated face; and a pronounced jaw muscle beneath his right ear. His head was turned slightly to his left and upward. Ceracchi's sculpture exemplifies this tradition.[2]

Early in 1791 the Italian-born Ceracchi, noted sculptor and ardent republican, had arrived in Philadelphia, where he hoped to receive a Congressional commission for an equestrian monument of George Washington.[3] Although this commission was never awarded, Ceracchi returned to Europe in the summer of 1792 with numerous portraits of prominent Americans he had modeled in terra-cotta. He wrote on March 27, 1794, to Thomas Jefferson from Florence that he had now carved marble busts of Washington, Alexander Hamilton, David Rittenhouse, and Jefferson himself. He took a large marble bust of Washington back to Philadelphia in the autumn of 1794. A marble variant of that portrait is also in the White House collection.[4] It was acquired, together with the Vespucci bust and one of Christopher Columbus, in 1817 during the Monroe Administration. (The identities of Ceracchi's *Amerigo Vespucci* and *Christopher Columbus* have sometimes been mistakenly transposed.)[5]

Terra-cotta busts of both Vespucci and Columbus may have been modeled before Ceracchi's first trip to America, but certainly not later than the first half of 1794. When Ceracchi left Florence in August 1794, he entrusted all his terra-cotta models to the Pisani brothers, Florentine artisans. It was from their statuary shop that marble replicas of Ceracchi's originals emerged after his death. The sculptor himself never returned to Florence.[6]

Ceracchi's life, that of a politically engaged artist, had an extraordinary denouement. Ceracchi had begun a colossal bust of Napoleon the military hero in Paris in 1796. But Napoleon's 1799 coup d'état had alienated the artist completely. Now he joined radical anti-Bonapartists in an attempt to assassinate Napoleon at the Paris Opéra on October 11, 1800, but was arrested at the scene. Offered a pardon if he recanted, Ceracchi passionately refused and, on January 31, 1801, he was guillotined.[7]

The arrival of Ceracchi's sculptures in the White House may have been occasioned by the intervention of President Monroe—a friend of the artist's. The busts were purchased for $100 each from Benjamin L. Lear.[8] Benjamin was the son of Tobias Lear, Washington's personal secretary. In honor of his service to the late President, Tobias Lear had been made U. S. consul, first at Santo Domingo and then at Algiers.[9] In the latter post he had arranged the purchase in 1808 of a "Tomb Stone" for his predecessor from Thomas Appleton, U. S. consul at Livorno. Appleton did a brisk business supplying Italian art for the American market, and he had been commissioning objects from the Pisanis since 1802. After Tobias returned to the United States, he purchased from Appleton in 1816 "6 Marble Busts of Washington, Vespucius & Columbus" at $80 per bust. (These newly carved busts had been received by Appleton in June 1815 from Carrara, site of the famous marble quarries.) Payment was recorded in May 1817, after Tobias's death by suicide on October 11, 1816. The busts were then in the possession of Benjamin, who sold the three now in the White House to the government.[10]

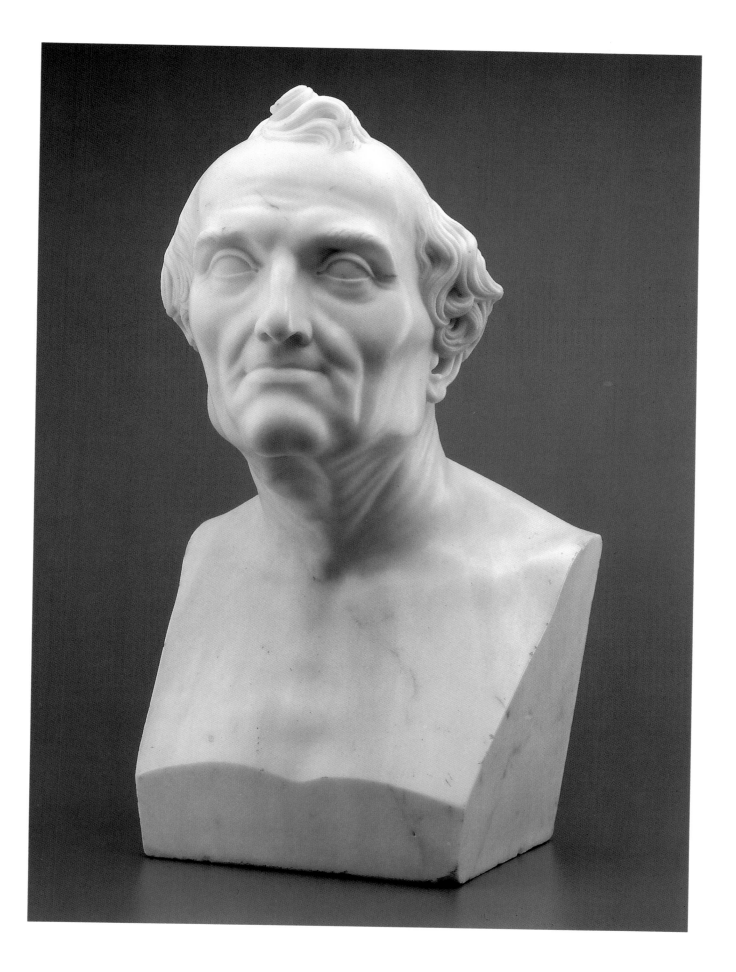

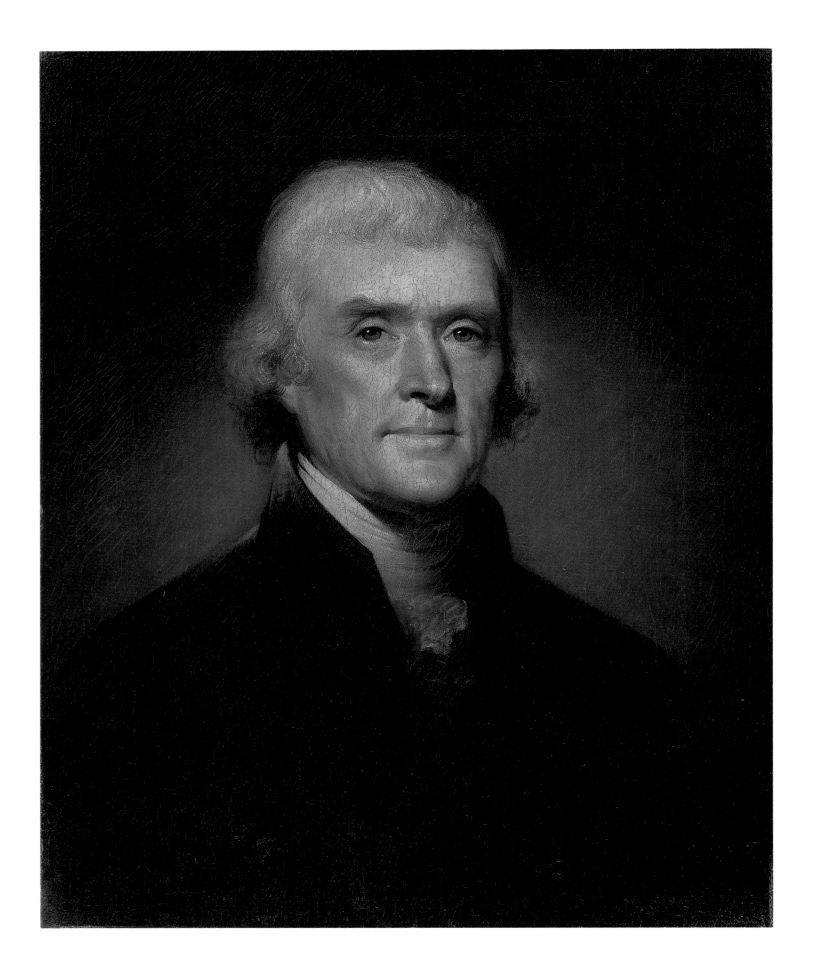

Rembrandt Peale (1778–1860)

Thomas Jefferson 1800

Oil on canvas, 23⅛ x 19¼ inches (58.7 x 48.9 cm)
Gift of Mr. and Mrs. Paul Mellon, 1962

*T*his compelling likeness of Thomas Jefferson as Vice President, together with the artist's 1795 portrait head of George Washington (Historical Society of Pennsylvania, Philadelphia), is the triumph of Peale's career. He painted both his early masterpieces before study in Paris in 1808–10, which denaturalized his fresh, direct vision and infected his style with a classicizing manner.

The portrait of Jefferson was completed in Philadelphia before mid-May 1800, when he left that capital for Monticello. An engraving of the portrait by Cornelius Tiebout was published on February 20, 1801, less than two weeks before Jefferson became the first President to be inaugurated in the new capital city of Washington. The engraving, widely circulated in the United States and abroad, became the public image of Jefferson the President (1801–09).[1]

Again and again one reads of Jefferson's serenity; this portrait confirms it. As a presentation of the harmonious nature and balanced intellect of the man, it is unequaled. The face has the glow of health, a warm complexion that bespeaks a warm personality. In contrast to the subjects in many early presidential portraits, the sitter here looks directly at us and does so with candor, as our equal. The splendid eyes and mouth convey reason and tolerance. It is an inherently democratic picture and a fitting summation of the century just concluded, the Age of Enlightenment.

But it is equally an announcement of a new age in America's political life. During the John Adams Administration the deep rifts between the Federalists and the Jeffersonian Republicans had taken a bitterly personal turn, and the animosity of the campaign of 1800 was intense. When the election was thrown into the House of Representatives, where it remained deadlocked for 35 ballots, civil war was spoken of. Jefferson's election on February 17, 1801, could not end the turmoil, but Jefferson himself could. It is an easy matter to match the face in this portrait with the sentiment expressed in Jefferson's first inaugural address on March 4, a reasoned and ungrudging reminder that

> every difference of opinion is not a difference of principle. We have called by different names brethren of the same principle. We are all Republicans, we are all Federalists. If there be any among us who would wish to dissolve this Union or to change its republican form, let them stand undisturbed as monuments of the safety with which error of opinion may be tolerated where reason is left free to combat it.[2]

Jean-Antoine Houdon (1741–1828)
Joel Barlow c. 1804

Marble, 27½ x 19 x 12½ inches (69.8 x 48.3 x 31.8 cm)
Gift of an anonymous donor, 1963

A head of intellectual penetration and psychological force confronts us in this bust. Poised above a powerfully carved torso with daringly deep cutting between frock coat and vest and between vest and neckcloth, Barlow's head turns to his left in an attitude of grim readiness. As the head turns, the lips tighten, the eyebrows rise in a scowl, and the flesh is pulled taut on the right cheek and gathered into deeper folds on the left. With acute observation the great French sculptor Houdon created a vivid, living image. It embodies the definition by his contemporary Crèvecoeur of an American as "a new man, who acts upon new principles; he must therefore entertain new ideas and form new opinions."[1]

Such a man was Joel Barlow (1754–1812). The last of six Americans of the revolutionary and early federal era to be portrayed by Houdon, Barlow was at least as honored in France as in his own country. It is not surprising, for he spent all but two of the years between 1788 and 1805 there, earning a fortune in bond speculation and a reputation as a liberal thinker whose political pamphlets had enraged the British government and delighted the French. For these and other manifestations of his zeal for the French Revolution, he was made an honorary citizen of France. Barlow's view of young America's place in the world is summed up in his Fourth of July oration of 1787: "Every free citizen of the American empire ought now to consider himself the legislator of half mankind." It was a view that the French Republic under the leadership of Napoleon took to heart.

Near the end of his sojourn in France, Barlow posed for Houdon. A bust was exhibited in the Salon of 1804, though whether it was this marble or one of three plaster replicas is not known.[2] Probably all four busts were produced in 1804, and the marble taken back to America by Barlow in 1805.

For his retirement Barlow purchased an estate near Washington that he named Kalorama, where he could be near his friends Jefferson and Madison. He wrote to Houdon in April 1808: "My poor wife who is frequently unwell presents her respects to you. She tells me that you have made her husband too glum, that is to say too true to life." The marble bust has always been regarded as one of Houdon's finest late portraits, although its effect is somewhat marred by black flecks in the white marble. This was commented upon by Benjamin Latrobe (page 77) in a letter of 1816 in which he argued for the superiority of American over Italian marble:

> I feel an objection to the Carrara Marble which is subject to black specks in the body of the stone, which sometimes hit upon the nose or under the eye and disfigure the finest Statues. Nor may they be discovered until the work is too far advanced to be thrown away. Mrs. Barlow has a bust of Carrara Marble by Houdon, of her husband. The likeness is strong, but the face has many black spots about it.[3]

Barlow, also a lawyer, diplomat, and poet, traveled to Philadelphia in 1807. There he oversaw the publication of his epic poem, *The Columbiad*, a milestone in American bookmaking. But his retirement ended abruptly when President Madison prevailed upon him to undertake a mission to France on the eve of the War of 1812. Hoping to ensure French neutrality in the struggle with Britain, he attempted to meet with Napoleon in Poland. There he penned his last poem. As Napoleon's armies passed him in full retreat from Russia, leaving "all the dreadful road / From Minsk to Moskow with their bodies strow'd," he bitterly repudiated Bonaparte: "Hurl from his blood-built throne this king of woes, / Dash him to dust, and let the world repose." Joel Barlow died of pneumonia in Zarnowiec near Krakow on December 24, 1812.[4]

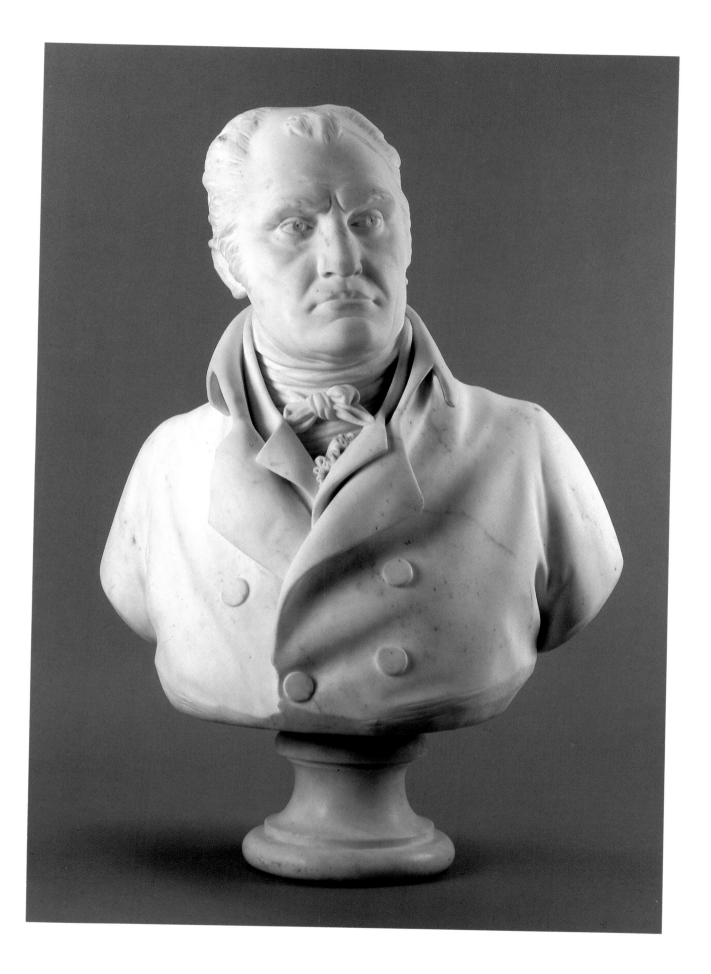

Charles Willson Peale (1741–1827)

Benjamin Henry Latrobe *c.* 1804

Oil on canvas, 22½ x 19½ inches (57.2 x 49.5 cm)
Gift of The Morris and Gwendolyn Cafritz Foundation, 1979

During his first term as President, in March 1803, Thomas Jefferson appointed Benjamin Latrobe Surveyor of Public Buildings. It may have been in recognition of this honor that Latrobe's good friend Charles Willson Peale painted this portrait for his Philadelphia gallery of distinguished persons. Peale was equally the friend of Jefferson, whom he had painted a decade earlier, and the three men were united in their enthusiasm for the polygraph, an invention of the Englishman John Hawkins that enabled a letter writer to make simultaneous copies. Peale had acquired the American rights to the invention, improved upon it, and sold the machines to both Latrobe and the President, thus accounting in part for the large preserved correspondence among the three men.

In 1792 James Hoban of Ireland and South Carolina had won the competition to select an architect for the President's House. But his Georgian design did not entirely please Jefferson, whose architectural taste had been formed by French neoclassical ideas. Latrobe agreed with him, and especially criticized the entrances as "undistinguished" and "disproportioned." In his post as Surveyor of Public Buildings, Latrobe, in close consultation with the President, designed new porticoes and added colonnades to connect the house with the proposed executive offices. Between 1809 and 1811, during the Madison Administration, Latrobe turned interior designer. He introduced classical-revival furnishings into the White House; all of them perished in the burning of the house in 1814.[1]

Between 1795 and 1804 Peale had largely given up painting to clear the field for his sons Raphaelle and Rembrandt, and to concentrate upon his museum. But in the summer of 1804 he began painting again. The Latrobe portrait is not listed in his museum *Accession Book*, begun about the same time, so it was probably painted later that year or early in 1805.[2]

Peale here is at the top of his form, the bust strongly constructed, subtly modeled, and freely painted. There is a certain bravura in some passages. The artist boldly blocked in the ear, and he deftly brushed in the curly hair, sometimes dragging a nearly dry brush in short arcs. The silver-rimmed spectacles pushed back into the hair are incompletely indicated, almost improvised.

The face is handsome, but the artist is concerned first with character and mind. It is a moody, introspective likeness, alive with intellect. Artist and sitter shared impassioned ideals and a practical interest in the "improvements of the convenience of life," and their friendship was profound and enduring.[3] This penetrating portrait documents it convincingly.

John Vanderlyn (1775–1852)
James Madison 1816

Oil on canvas, 26 x 22³/₁₆ inches (66 x 56.4 cm)
Gift of Mrs. Vincent Astor, the George Brown Foundation, Inc.,
 The Charles W. Engelhard Foundation, The Ruth P. Field Fund, Inc.,
 Laurence Rockefeller, and the White House Historical Association, 1968

"MODERATION on one side, and PRUDENCE on the other." The phrase is Madison's, writing as "Publius" in Number 43 of *The Federalist,* and it might serve as his motto, so concisely does it express his fundamental principle of political and personal conduct. Rarely has a man's character been more clearly expressed in his face. "Truth has such a face," in John Dryden's words, and Madison's penetrating, dispassionate intellect is as much in evidence in this head as is his aristocratic aloofness.

The portrait was commissioned not by the sitter, but by James Monroe, who succeeded Madison as President within the year. (It descended in the Monroe family until it was purchased for the White House collection.) The commission was the confirmation of a remarkable friendship. Of quite different temperaments, Madison and Monroe had not always agreed politically. At the Virginia convention in 1788 Monroe, with a majority of delegates, opposed ratification of the Constitution. Madison, however, through force of intellect and reasonable presentation, persuaded the convention to vote for ratification. As one of the authors of *The Federalist*—"the best commentary on the principles of government, which ever was written," according to Jefferson—he also convinced many others.[1] In the first national election that followed, Madison was elected to Congress, defeating Monroe. Their friendship grew over the next 25 years, and Monroe's respect for his erstwhile opponent may have peaked when Madison, less than a year after victory in the War of 1812, unilaterally and magnanimously reduced U. S. naval forces on the Great Lakes to avoid further conflict with Britain.

Vanderlyn may have been the ideal artist to record Madison at this moment of his passage from the Presidency to private life. Although Vanderlyn had been studio assistant to Gilbert Stuart, he had a reserved temperament that was nurtured by five years' study in Paris when neoclassicism was the dominant style. In 1815 he returned permanently to the United States; but though he was at the height of his powers, he met with little encouragement or success in his chosen field of history painting. In portraiture he was more successful, but his cool, at times frigid, manner was at odds with the warm animation of Stuart, then at the acme of his fame.

In Madison, Vanderlyn found a sitter whose personal reserve matched the artist's style. The portrait's strength is in its simplicity. Cameo-like, with firm planes and a carefully controlled range of values, it does not rely on deep shadow or strong contrast for its sculptural effect, but works mostly in light tones. The face, despite its impassivity, reveals the toll exacted by the War of 1812—a war that had clouded the President's reputation until its proud conclusion. It is set above a high-collared black coat between a freely painted cravat and the simple powdered hairstyle favored by Madison.

Such simplicity had political overtones. Wits of the time remarked that all barbers were Federalists, because leaders of the Federalists wore long powdered queues and gave much business to barbers, whereas Whigs wore short hair or small pigtails. When Madison was nominated, a barber was purported to have exclaimed: "The country is doomed; . . . this little Jim Madison, with a queue no bigger than a pipe-stem! Sir, it is enough to make a man forswear his country."[2] In this splendid portrait the simplicity of Madison's hairstyle seems to reflect the direct and unerring logic of his mind.

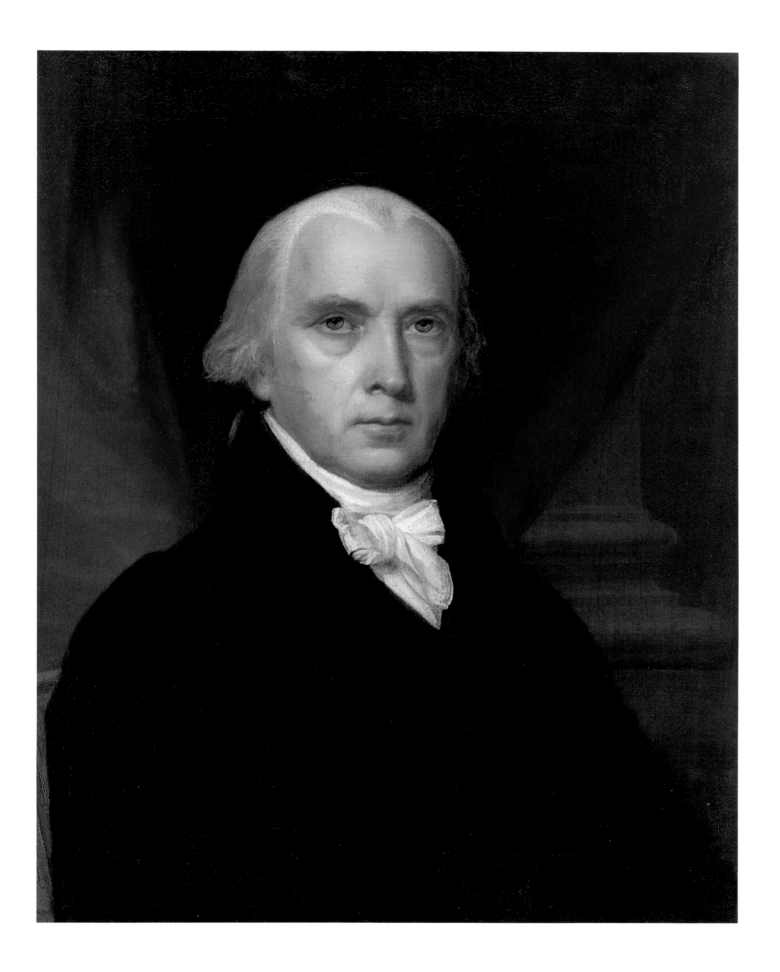

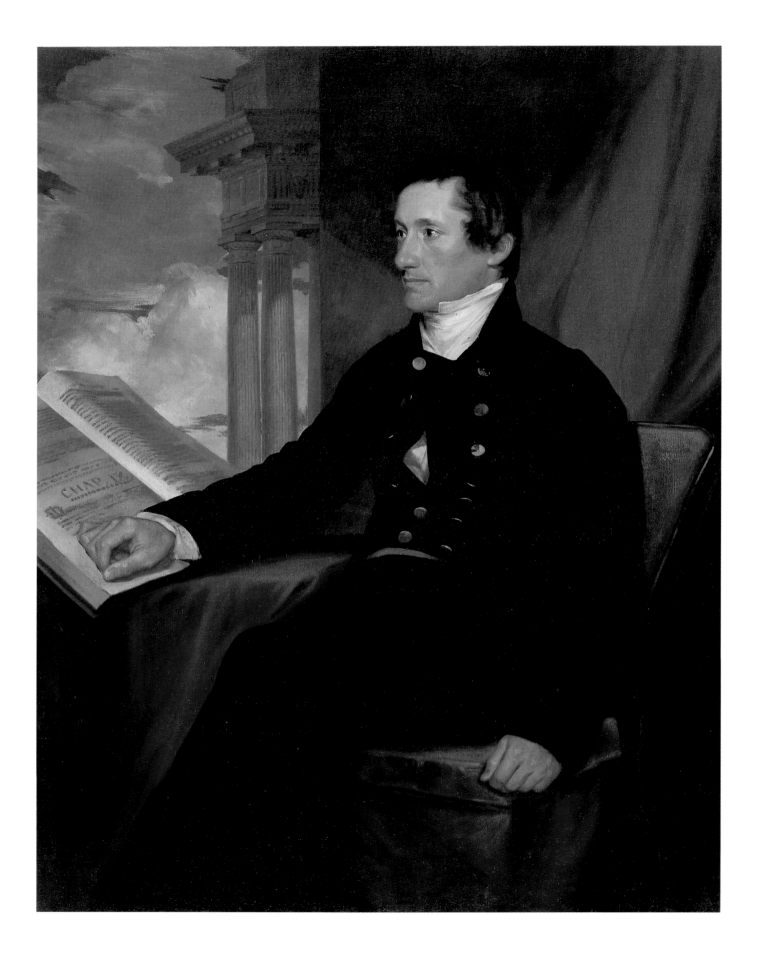

Samuel F. B. Morse (1791–1872)
Colonel William Drayton 1818

Oil on canvas, 48⅛ x 38⅜ inches (122.2 x 97.5 cm)
Gift of an anonymous donor, 1962

Although portraiture was not his preferred genre, Morse was gratified by the number of commissions he received in Charleston, South Carolina, in 1818. He had arrived in late January at the invitation of an uncle. The portrait Morse painted of his host stimulated a spate of commissions. The artist's own list shows 54 of them, including one from William Drayton (1776–1846), for which the sitter paid $300. In exchange for the fee—the highest yet earned by the artist—Drayton received the largest and most elaborate portrait thus far painted by Morse in his budding career.

Drayton, posed in the formal yet asymmetrical grand manner style borrowed from English portraiture, is seated among accessories carefully chosen to heighten his dignity. The diagonally flowing red drapery that sweeps downward behind him and covers the table lends drama to the work. The subject's impassive head is silhouetted against a neutral wall that gives way to a view of an intensely blue sky with fluidly painted pink-and-white clouds. Interposed between wall and sky is a grand architectural elevation. Decidedly *not* a South Carolina plantation house, it is a borrowed aggrandizement, most probably from one of the many books on ancient architecture widely known and readily available to Morse.[1]

The folio on the table has not been identified, but its prominence seems to indicate that it had personal, not merely symbolic, significance for the sitter. It is illegible save for the clear "CHAP. IX," to which our attention is drawn by the placement of Drayton's hand. Whether the tome relates to his legal profession, his military career, or his political convictions remains to be discovered.

William Drayton shared many of the historical contradictions and conflicts experienced by his contemporary Charlestonians. Of English descent and educated in England, he had opposed the War of 1812,

yet had served in it, reaching the rank of colonel before promotion to inspector general. After refusing an offer of the post of secretary of war under James Monroe, Drayton had returned to his successful law practice following the war.

In 1819, the year after the portrait, Drayton was appointed recorder (criminal magistrate) of the City of Charleston, a judicial post that he held until 1823. A contemporary lawyer considered Drayton "eminently well qualified, very clear in his conceptions . . . ripe in judgment. . . . Altogether, he was a model Judge, and it was a privilege to practice before him."[2]

Drayton was to serve in Congress from 1825 to 1833, during the heated debates over John C. Calhoun's nullification doctrine. As he had placed country above sentiment during the War of 1812, so was he to hold the federal union above the sectionalism embodied in nullification. While his integrity was undoubted, his stance was to prove so unpopular at home that he would move permanently to Philadelphia upon leaving Congress.

There, in his last public office, Drayton would once again be involved in controversy. He accepted Andrew Jackson's appointment as president of the Second Bank of the United States. Jackson, with Drayton's concurrence, worked to bring monetary policy under federal control. Their solution in the end was to close the bank, with lasting economic consequences for the nation.

Samuel F. B. Morse (1791–1872)

James Monroe c. 1819

Oil on canvas, 29⅝ x 24⅝ inches (75.2 x 62.6 cm)
Gift of Michael Straight, 1965

*V*igorous and resolute, President James Monroe looks like a man in early middle age, although he was 61 when Morse painted him. Morse has idealized him to a degree (a prominent mole below his right eye is suppressed), and the low viewpoint lends a romantic aspect appropriate to the man whose administration (1817–25) had been dubbed the "era of good feeling."

The genesis of this portrait was a commission for a full-length portrait from the City of Charleston, South Carolina. Morse had been wintering in that cosmopolitan city for two years and had established himself as the leading artist there. In anticipation of the first presidential visit since that of Washington, the Common Council on March 1, 1819, resolved to

> solicit James Monroe, President of the United States, to permit a full-length likeness to be taken for the City of Charleston, and that Mr. Morse be requested to take all necessary measures for executing the said likeness on the visit of the President to this city . . . [and] that the sum of seven hundred and fifty dollars be appropriated for this purpose.[1]

The President's Charleston schedule was too full for portraiture, but he and Morse met and arranged for sittings in Washington in December. Morse wrote:

> I began on [December 13] to paint the President and have almost completed the head. I am thus far pleased with it, but I find it very perplexing, for he cannot sit more than ten or twenty minutes at a time, so that the moment I feel engaged he is called away again. . . . Is not this trying to one's patience?[2]

The bust-length portrait was finished on December 18. To Morse's obvious pleasure it was a great success with Monroe and his family—

so much so that one of his daughters wishes me to copy the head for her. . . . The daughter told me (she said as a secret) that her father was delighted with it, and said it was the only one that . . . looked like him; and this, too, with Stuart's [portrait] in the room.[3]

The White House painting is assumed to be the replica for the daughter; it descended in the Monroe family until the beginning of this century. Morse took the life portrait with him to Charleston, where he produced the full-length portrait for the city. He based the head of Monroe on the life portrait; for the body of the President he used another model. The Charleston portrait is an ambitious painting, yet despite its size and elaborate accessories, it is an awkward one.

The White House portrait, by contrast, is forcefully painted. Morse modeled the head with flowing, curving strokes that probably reflected Thomas Sully's recent work. The combination of formality and zest, elegance and liveliness that marks the portrait was also characteristic of the Monroe White House. After noting that the President "and his family have been very sociable and unreserved" toward him, Morse commented on the house itself which, burned by the British in 1814, had just been rebuilt and newly decorated: "The drawing-room and suite of rooms at the President's are furnished and decorated in the most splendid manner; some think too much so, but I do not. . . . Plainness can be carried to an extreme."[4]

The focal point of the decoration was the set of carved and gilded furniture from French cabinetmaker Pierre Antoine Bellangé for the "elliptical saloon" (now the Blue Room). Combining "Strength with Elegance of Form," it contributed, wrote a contemporary, to an effect of "resplendency and simplicity which is very admirable."[5] These are phrases equally appropriate to Morse's portrait of Monroe.

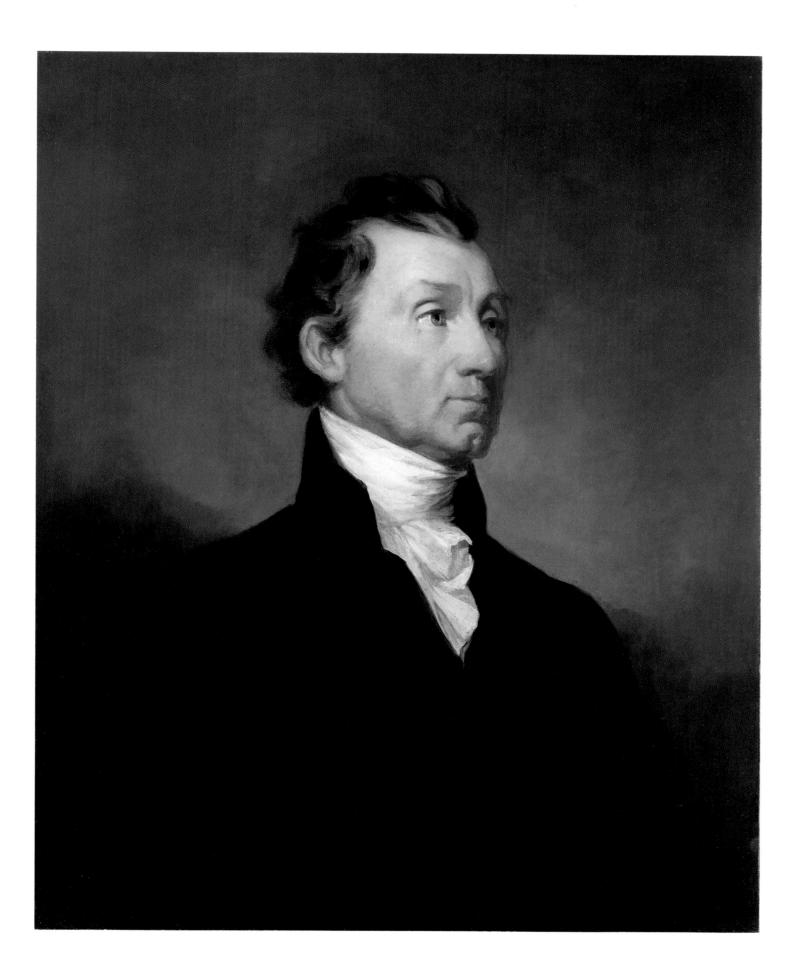

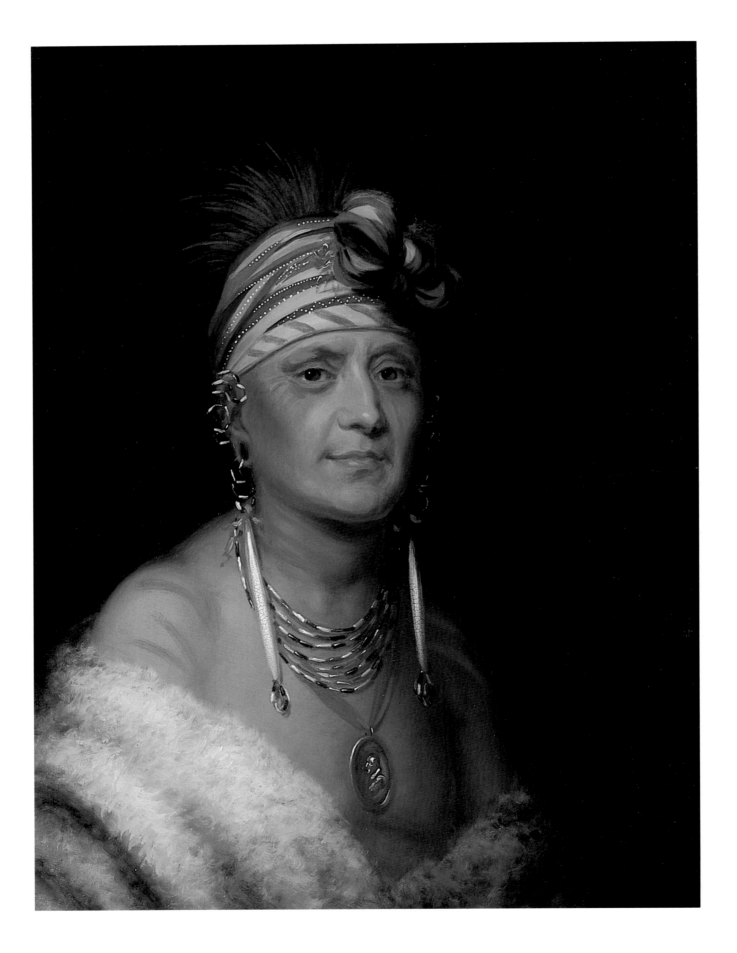

Charles Bird King (1785–1862)
Monchousia (White Plume), Kansa c. 1822

Illegible inscription, upper reverse
Oil on panel, 17½ x 13¹³⁄₁₆ inches (44.4 x 35.1 cm)
Gift of Sears, Roebuck & Company, 1962

*I*n 1821 Benjamin O'Fallon, Indian agent for the Upper Missouri, suggested that a delegation of Indian dignitaries be invited "to visit the great American Chief, and to see the wealth and strength of our nation, about which they have heard so much, when they are still unwilling to believe, that it does far exceed their own." John C. Calhoun, Secretary of War under James Monroe, issued the invitation. At the end of November 1821, 17 Indians from the more militant tribes of the area arrived in Washington, then visited other eastern centers before settling back into the capital in late December. They remained in Washington until late February 1822, visiting Monroe at the White House during their stay.[1]

Five rare and wonderful portraits of Native Americans hanging in the White House were painted by Charles Bird King from sittings at that time. Among them, that of Monchousia, chief of the Kansa tribe, is distinguished for the bright, clear hues of the vividly patterned turban, tied in a blossomlike bow and surmounted by a dyed deer-hair crest. He wears wampum necklaces and ornaments laced through slit ears, from which dangle two extraordinary pendants made of marine mollusk shells (dentalia) widely traded among the Indians. A buffalo robe lies loosely around his arms, revealing a silver peace medal with President Monroe's profile; these medals were given to all the male Indian delegates.

The Kansa tribe, at war with most of its neighbors, was considered "impudent" by O'Fallon, a characterization belied by the chief's engaging expression. Indeed, ten years later the painter George Catlin met "White Plume" in his homeland and described him as "a very urbane and hospitable man, of good portly size, speaking some English, and making himself good company for all white persons who travel through his country and have the good luck to shake his liberal and hospitable hand."

Regretting that he had not had the opportunity of painting him, Catlin added that most of this tribe had a "European outline of features," an observation that certainly applies to Monchousia.[2]

The portraits of the O'Fallon delegation were the earliest of 200 or more Indian portraits King painted. At least 143 of them were commissioned by the U. S. government, through the sponsorship of Thomas L. McKenney, first as superintendent of Indian trade, then, from 1824, as the first director of the Bureau of Indian Affairs. He had already, in 1816, established his "Archives of the American Indian," Washington's first museum. King had recently moved to the city and, with the promise of annual Indian visitations, readily agreed to paint portraits of the Indian delegates for McKenney's archives. By 1830, 130 of the federal portraits had been painted.

Eventually the government assembled a vast collection of Indian paintings by King and John Mix Stanley that were transferred to the new Smithsonian Institution Building after mid-century. On January 24, 1865, a fire devastated the exhibit hall, destroying all but a few of the portraits. Fortunately King had made replicas of many of his pictures, and a substantial number of those survive today.[3]

The White House paintings were originally owned by one Patrick Macaulay of Baltimore. In 1826 he gave them to a friend, Christopher Hughes, chargé d'affaires in the Netherlands, with the comment: "I do not know whether you take the same interest in these people that I do, but I commit the Redskins wholly to your charge to do with as you think fit."[4] They remained in Europe and then in Canada until 1962, when they were given to the White House during the Kennedy Administration.

Charles Bird King (1785–1862)
Petalesharro (Generous Chief), Pawnee *c.* 1822

Illegible inscription, upper reverse
Oil on panel, 17½ x 13¹³/₁₆ inches (44.4 x 35.1 cm)
Gift of Sears, Roebuck & Company, 1962

One of the most lionized Indian chiefs ever welcomed to Washington was Petalesharro, of the Pawnee Loups. He, like Monchousia (page 85), was among the Native American delegation that visited there in 1821–22 during the Monroe Administration. Probably in 1818 Petalesharro had rescued a captive Comanche woman from being burned at the stake by his own tribe in sacrifice to the Morning Star. Petalesharro had cut her loose; together they had galloped to her homeland. When the story reached Washington and was published in the *National Intelligencer*, Petalesharro, the "bravest of the braves," achieved considerable renown.[1]

The Reverend Jedidiah Morse retold the tale in his *Report to the Secretary of War . . . on Indian Affairs* in 1822, and as an additional tribute commissioned an engraving of King's portrait as the frontispiece.[2] His son, Samuel F. B. Morse, included a miniature portrait of Petalesharro (after King) next to one of his father in his painting of *The House of Representatives* (Corcoran Gallery of Art, Washington, D. C.). The subject of all this attention, a 25-year-old man of "fine size, figure, and countenance," appeared especially exotic to society in the fledgling capital city. According to Jedidiah Morse, the hero had received some curious— or so it must have seemed to Petalesharro—attentions:

> The publication of [Petalesharro's rescue of the Comanche] led the young ladies of Miss White's seminary . . . to present this brave and humane Indian with a handsome silver medal, with appropriate inscriptions, as a token of their sincere commendation of the noble act of rescuing one of their sex . . . from a cruel death. Their address . . . [concluded]—
> "Brother—Accept this token of our esteem—always wear it for our sakes; and when again you have the power to save a poor woman from death and torture—think of this and of us, and fly to her relief and her rescue."[3]

King's painting of Petalesharro was among the federal portraits he completed at the request of Thomas L. McKenney, the first director of the Bureau of Indian Affairs. The great chief wears the warbonnet fringed with ermine tails and crowned with down-tipped eagle feathers in which he appeared at Monroe's New Year's Day reception. Also prominent are his necklaces of trade beads and the treasured Monroe peace medal. He looks solemn, even introspective, and oddly slight of build, though this may be the result of King's concentration on the head.

Despite the popularity of McKenney's Indian gallery, by 1828 a Kentucky congressman objected to funding the "pictures of these wretches the use of which it would be impossible to tell."[4] The Indian Removal Act was passed in 1830, after which the English traveler Frances Trollope sardonically reported:

> the bureau for Indian affairs contains a room of great interest; the walls are entirely covered with original portraits of all the chiefs who . . . have come to negotiate with their great father, as they call the President. . . . The countenances are full of expression, but . . . I should say that they have but two sorts of expression; the one is that of very noble and warlike daring, the other of a gentle and naive simplicity, that has no mixture of folly in it, but which is inexpressibly engaging, and the more touching, perhaps, because at the moment we were looking at them, those very hearts which lent the eyes such meek and friendly softness, were wrung by a base, cruel, and most oppressive act of their *great father*.[5]

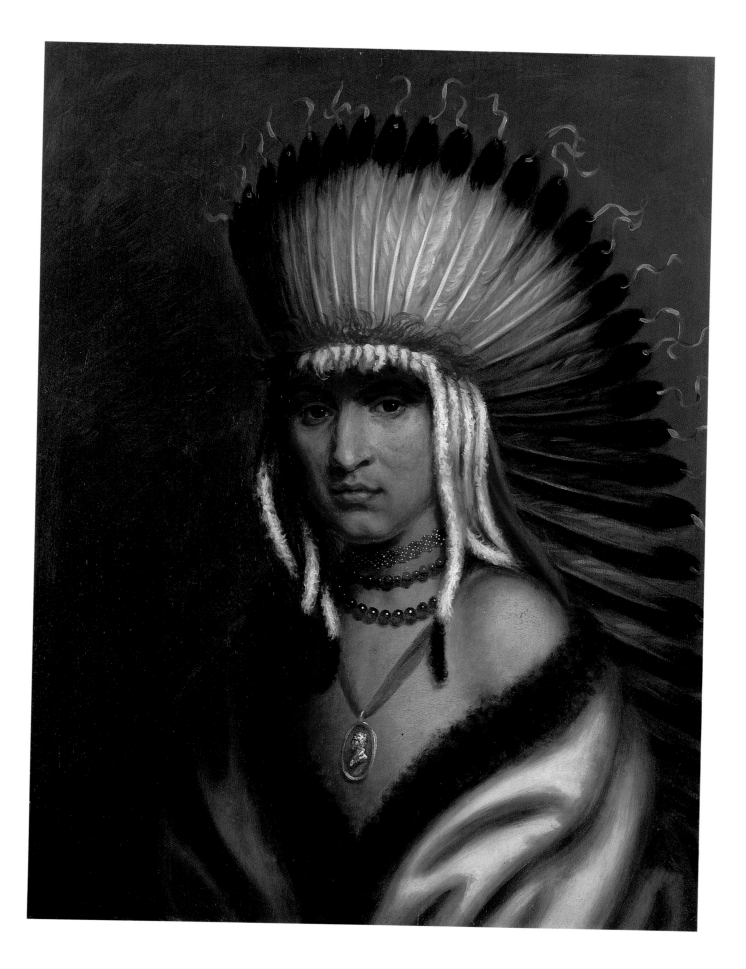

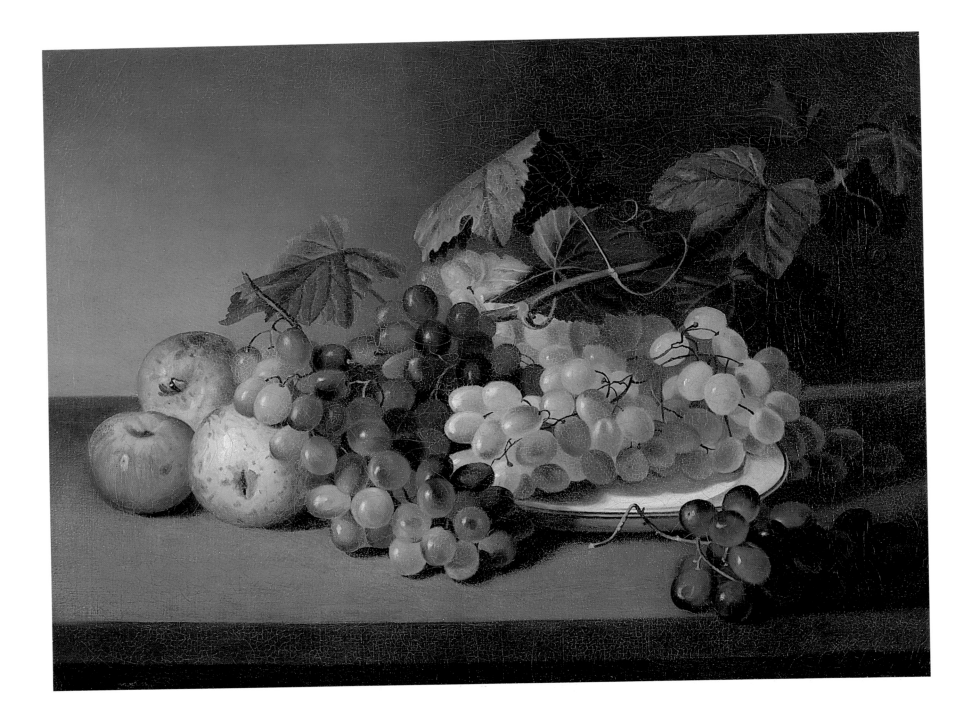

James Peale (1749–1831)

Grapes and Apples *c.* 1825–31

Oil on canvas, 16¼ x 22 inches (41.3 x 55.9 cm)
Gift of an anonymous donor, 1962

*T*ogether with his nephew Raphaelle, James Peale deserves credit for establishing still life painting as a subject in American art. Raphaelle (1774–1825), whose strikingly spare compositions would seldom be confused with those of his uncle, exhibited still lifes as early as 1795. He then turned to miniature portrait painting until 1812, when still lifes again became his specialty. Each of the many painting Peales was supportive of the others' careers, and James Peale did not exhibit his still lifes until after Raphaelle's death, apparently to leave the field free for his kinsman. Instead he worked as a portraitist, especially in miniature. Most of his still lifes he probably produced in the six years between Raphaelle's death and his own.

Grapes and Apples typifies in its characteristics and high quality the still life paintings of James Peale.[1] The fruits are life size, seen close up and frontally from the moderately high viewpoint of the artist seated beside the table. There is a naturalness about this presentation that contrasts with Raphaelle's compositions, whose formality results from an artful low viewpoint and an exaggerated closeness to the distinctly separate objects. James instead prefers to combine his fruits into rather complex units with overlapping objects suggesting volume and with warm patches of light and shadow conveying a sense of an organic reality.

Lovely pale green grapes on a gold-rimmed porcelain plate are enveloped by vine leaves and bunches of red grapes that lie mostly upon a gray wooden table. The red grapes spill over onto an apple, one of a comfortable cluster that lies at the convergence of the diagonal cutting of grapevine and the implicit diagonal established by the bunch of grapes in the right foreground. James Peale's skill is nowhere more apparent than in his painting of the grapes, whose tones are continually varied: reds from pink to crimson, purples from amethyst to wine, and browns and grays for the overripe spots. He values

color and a flowing brush, and he is never rote nor mechanical in his rendering of the textures and colors of the fruits. Overripeness extends to the apples, especially the yellow one, which looks as if it had fallen from the tree some time ago.[2]

The Peale family had a pervasive interest in the natural world, and a still life is a slice of that world, a microcosm in which selected aspects of nature can be isolated. In *Grapes and Apples* it is the autumnal harvest season that is spread before us in the fruits of the vine and the orchard. There is a metaphorical aspect to this choice, for it was the agricultural fecundity of the New World that preoccupied many of its first citizens. Long before gold rushes there were land rushes, not to acquire real estate but to garner the harvest of the "wide and fruitful land" hymned by the agrarian, Thomas Jefferson. In his *Notes on Virginia* he wrote of America's "immensity of land courting the industry of the husbandman," and proclaimed that "those who labor in the earth are the chosen people of God."[3]

Jefferson, who had planted a vineyard at Monticello as early as 1771 and drawn up the plan for his orchard in 1778, was close to the Peale family (pages 73, 77). In a letter of August 20, 1811, he shared his love of the land with Charles Willson Peale, James's brother:

> I have often thought that if heaven had given me choice of my position and calling, it should have been on a rich spot of earth, well watered, and near a good market for the productions of the garden. No occupation is so delightful to me as the culture of the earth, and no culture comparable to that of the garden.[4]

89

Gilbert Stuart (1755–1828)

Louisa Catherine Johnson Adams 1821–26

Oil on canvas, 30¹/₁₆ x 25 inches (76.4 x 63.5 cm)
Gift of John Quincy Adams, 1971

*T*his portrait, together with Stuart's 1818 likeness of Louisa's husband, John Quincy Adams, descended in the family to a great-great-grandson, who presented both of the works to the White House. That of John Quincy, then the secretary of state, is somewhat perfunctory, but the penetrating image of Louisa Catherine Johnson Adams (1775–1852) epitomizes the high achievement of the last years of Stuart's career. Although always capable of rendering the character of his sitters, Stuart usually preferred to flatter them. Only in the 1820s, when past the age of 65, did he consistently measure the character of his subjects, his perception of the human condition deepened by his own apprehension of mortality.

Stuart, notorious for unconscionable delays, took five years to complete this painting, from 1821 to 1826. In Louisa's letter of May 4, 1821, to her son Charles is the first mention of the portrait: "My Time has however been very much occupied in sitting for a picture which is not quite finished and which it is probable will employ me the whole summer."[1] We know that the portrait remained unfinished at Christmastime of 1825, even though it was complete enough to inspire Louisa to send her son George some verses entitled "To my Sons with my Portrait by Stewart." She seems to have expected the portrait to follow closely.[2] Stuart must have reneged on the delivery, for on September 9, 1826, John Quincy Adams wrote in his diary: "I stopped at Mr. Stuart, the Painter's, and there saw the Portrait of my wife for the first time. It is unfinished and he promised to finish it but asked that she would give him another sitting." By the middle of November it was at last finished.[3]

Since Louisa's hands are not shown, since the details of costume did not require her presence, and since the background is sketchy, Stuart must have requested the sitting to observe her features then and to modify them accordingly in the portrait. As wife of the secretary of state (1817–25), Louisa had been

relatively happy, but since February 1825 she had been First Lady. She disliked the change. Her grandson Henry Adams put it plainly: "Next she lived four miserable years in the White House."[4] When Louisa saw the finished portrait at the Boston Athenaeum in the summer of 1827, she wrote to her son's fiancée:

> I saw my portrait at the exhibition. . . .
> Nobody likes it and Stewart is quite vexed.
> It looks very much as I looked, like a woman
> who was just attacked by the first chill of
> death and the features stiffning into torpor.
> The hair is as white as the face and the fine
> lilac bows in the Cap seem to mock the
> general frigidity of the half Corps. It speaks
> too much of inward suffering and a half
> broken heart to be an agreeable
> remembrancer. Mais n'import—'tis but a
> speaking tell tale which may in time of need
> long after I am gone . . . give a lesson both of
> feeling and wisdom.[5]

Her devoted son Charles found it "a likeness but not a good painting. Her face wears a sorrowful appearance too common to her. . . . But I shall value that picture. . . . For hereafter there will be nothing."[6]

Louisa Adams was about 50 when this incisive head was painted. The rest of her long life was divided between Quincy, Massachusetts, and Washington (neither congenial to her), since her husband served nearly 18 years in Congress after his Presidency. Stuart's portrait is definitive in simultaneously presenting "the Madam" of Henry Adams's childish memory—"a little more remote than the President, but more decorative . . . her delicate face under . . . very becoming caps"—as well as the image he later knew to be as true, of a woman whose interior life was "one of severe stress and little pure satisfaction."[7]

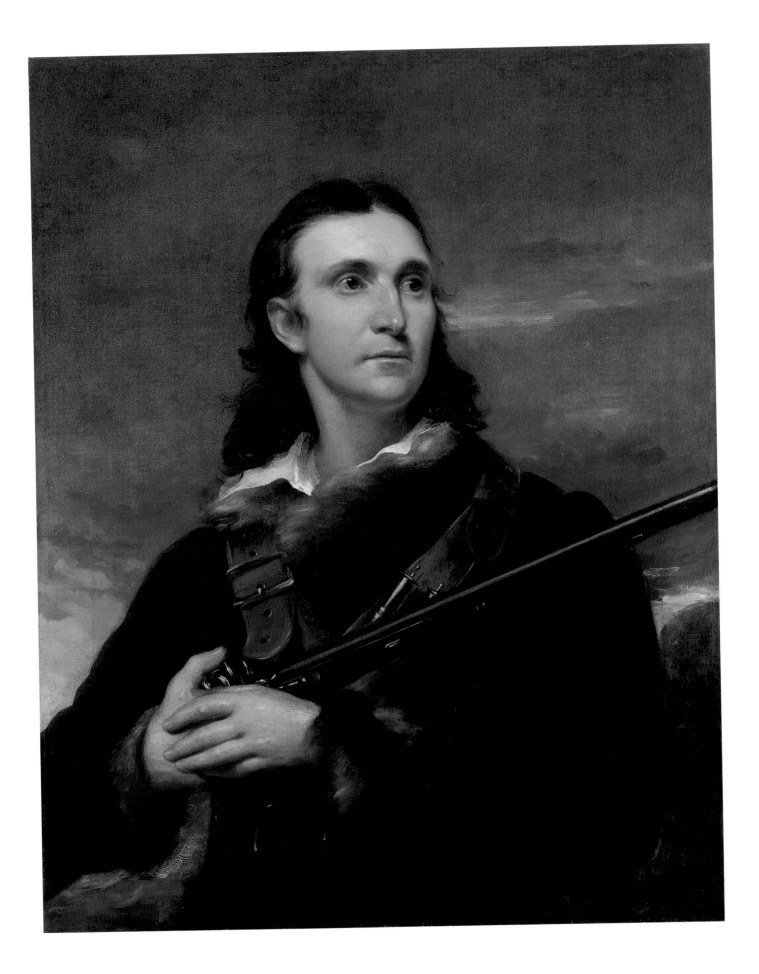

John Syme (1795–1861)
John James Audubon 1826

Oil on canvas, 35½ x 27½ inches (90.2 x 69.8 cm)
Gift of Roland S. Bond, Mrs. Alex Camp, Mrs. Maxine S. Carr,
 Mrs. Nenetta Burton Carter, Miss Nina J. Cullinan, Bert Fields,
 Mrs. William P. Hobby, Mrs. John Leddy Jones, J. W. Link, Jr.,
 Mr. and Mrs. Roy R. Neuberger, Mr. and Mrs. John M. Olin,
 Mae Caldwell Rovensky Trust, Miss Margaret Batts Tobin,
 M. Knoedler & Co., and an anonymous donor, 1963

Among those who ranged America's frontier and entered her wilderness, none cut a more romantic figure than did John James Audubon (1785–1851). The illegitimate son of a French sea captain and planter, Audubon was born in the West Indies, raised in pampered ease near Nantes in France, and sent to America in 1803 to oversee Mill Grove, an estate outside Philadelphia owned by his father.

Property management did not interest the 18-year-old, but the New World and its wildlife, above all its birds, became his obsession. With little formal training he developed a secure technique in pencil, pastel, and watercolor, with a feeling for bold shapes and compositions. In 1820, bankrupt but with hundreds of bird drawings, Audubon conceived his "Great Idea" of having his "Birds of America" engraved and published in book form.

Finding little support in his adopted country, he went abroad in 1826 in search of subscribers and an engraver. He was to dedicate the next 13 years to the realization of this project, which when completed ran to five volumes with 1,065 birds of 489 species.[1] In the Scottish capital of Edinburgh, an intellectual and scientific center, Audubon hoped to find sympathetic support. In fact his reception surpassed his dreams: "I came to this Europe fearful, humble, dreading all, scarce able to hold up my head and meet the glance of the learned, and I am praised so highly!"[2]

While there he met William H. Lizars, who agreed to engrave his work. Although Lizars fell behind schedule and was forced to abandon the project (it was subsequently engraved in London by Robert Havell, Jr.), he did arrange for Audubon to have his portrait painted by John Syme.[3] This was so that Lizars could engrave it for distribution, undoubtedly to promote Audubon's "Birds." On Monday, November 27, 1826, Audubon recorded in his journal that he had to *"stand up"* for his portrait, wearing his wolf-skin coat at Lizars' request. "If the head is not a strong likeness," he wrote, "perhaps the coat may be." The next day he again *"stood"* for his picture—"two dreadfully long hours"—and the following day he recorded that "my portrait is now growing under the pencil of the ablest artist of the science here. It is a strange-looking figure with gun, strap, and buckles, and eyes that to me are more those of an enraged Eagle than mine." On November 30 the portrait was finished: "I cannot say that I think it a very good resemblance, but it is a fine picture, and the public must judge of the rest."[4]

John Syme has never attracted much attention outside Scotland; on the basis of this striking portrait, he deserves better. A student of Henry Raeburn, some of whose unfinished works he completed after his master's death, he shared Raeburn's suavity and his preference for strong, simple poses. It is a style perfectly in harmony with Audubon's own.

Although Audubon questioned the resemblance, it is only in a slight emphasis of the length of the head over its breadth that the artist deviated from his model. This is borne out by comparison with Audubon's charcoal *Self-Portrait* (private collection) made two months earlier. As for his "enraged Eagle" eyes, they were commented upon by others. Together with his beaklike nose and flowing hair, they made an indelible impression upon all who met the artist–naturalist. As his name "has become synonymous with the love and care of the natural world," so was his appearance in contemporary eyes.[5]

Thomas Birch (1779–1851)
Mouth of the Delaware 1828

Signed and dated on drift log, lower left: T. Birch Esqr 1828
Oil on canvas, 20 x 30 inches (50.8 x 76.2 cm)
Gift of the White House Historical Association, 1962

*T*he scene may be near Lewes, Delaware, at Cape Henlopen, where the harbor pilots who guided ships safely through the shallows were brought aboard as the vessels entered Delaware Bay. Or the painting may instead depict the channel nearer the mouth of the Delaware River, perhaps at Deepwater Point.

Storm clouds approach from the ocean. We know its direction, since the tide rolls inland here from left to right. Of the four boats shown, only the topsail schooner at the left is leaving harbor to challenge the weather. The burst of white water beneath her prow accents her intrepidness. Heading upriver with the current, a nearly full-rigged merchant ship passes the schooner. The two sailors aboard the small sailboat appear to be furling its sails as the wind rises, while the sturdy fishing dinghy rowed by four men on single oars, with the coxswain reclining on nets in the stern, makes for shore.

Thomas Birch emigrated from England with his artist father, William Russell Birch, at the age of 15. He soon developed into a fine marine painter, the first to achieve wide popularity in America, although he painted other subjects as well.[1] The primary models for his mature work were Dutch paintings of the 17th century, by such artists as Jan van Goyen, Salomon van Ruysdael (the elder Birch owned paintings by both), Jan Porcellis, and Willem van de Velde. These artists and others were represented in American collections and known to a wider audience through engravings.

By assisting his father in making engraved views of Philadelphia, Thomas Birch learned precise, descriptive drawing. From the Dutch masters he learned composition, looser brushwork, and the creation of atmospheric effects. His work remained fresh, indebted to but not captive of his sources. *Mouth of the Delaware* epitomizes his achievement, in the ease with which the artist conveys the shifting forces of wind and water, and in his sure placement of the boats in the picture space. These vessels are accurately but not self-consciously depicted. They are not "portraits" but actors in the passing scene.

Birch skillfully rendered the translucent, blue-green waters, and he imbued the swells and troughs with a convincing, visceral sense of ebb and flow through strong pictorial rhythms. Relatively simple compositional formulas underlie the painting—for example, the ships are ranked in receding planes against the horizontal bands of water and sky, and there is an unobtrusive ordering of diagonals—but Birch applied the formulas with an uncommon degree of subtle skill.

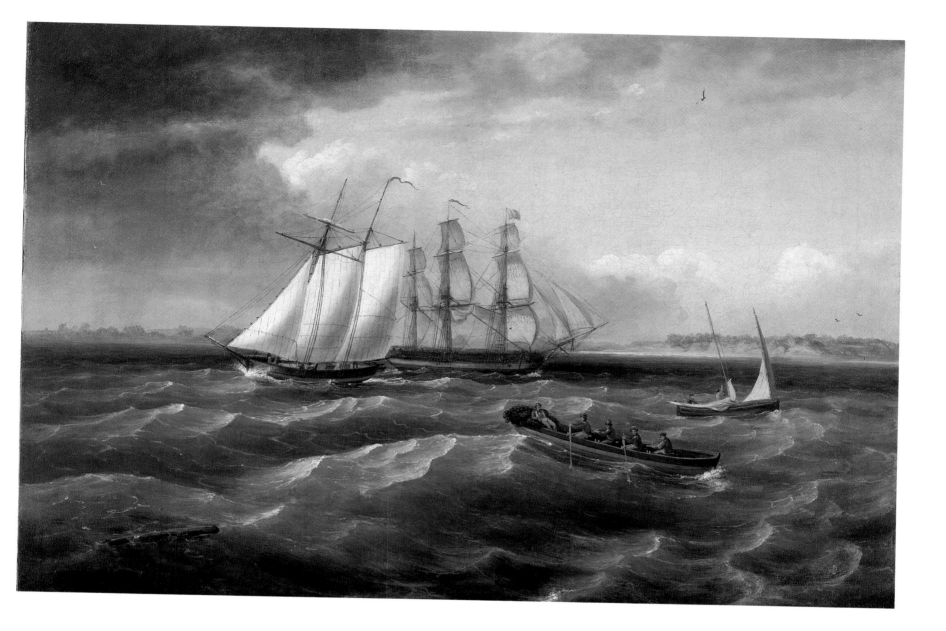

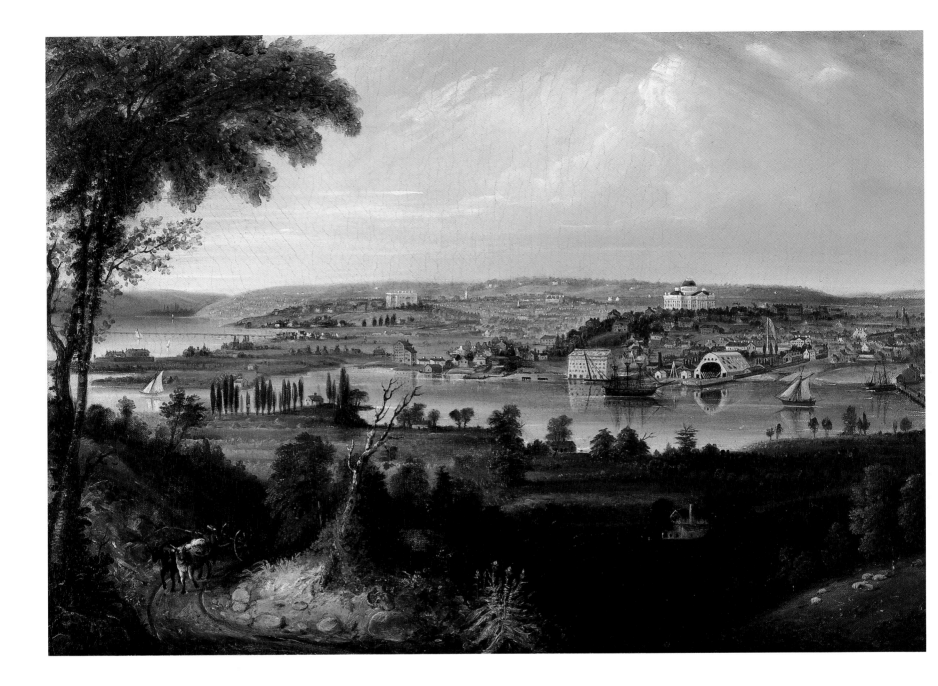

George Cooke (1793–1849)

City of Washington From Beyond the Navy Yard 1833

Oil on canvas, 18 x 25 inches (45.7 x 63.5 cm)
Gift of The Morris and Gwendolyn Cafritz Foundation, 1976

Although the Maryland-born Cooke showed early artistic talent, he did not begin painting full-time until about 1820, when he received his only instruction, from Charles Bird King in Washington, D. C. A five-year sojourn in Europe (1826–31), with its accompanying exposure to European art, left Cooke with the ambition to make a reputation as a painter of grand historical subjects. For paintings of this kind, however, there was no market in America.

He turned to portrait painting, but displayed a greater talent for landscapes, especially views of cities and towns, including Washington, Richmond, and Charleston. To the traditional principles of landscape construction he added a close attention to topography. In his *City of Washington* Cooke carefully rendered the architecture of the city as well as the contours of the riverbanks and the elevations of the hills.

This painting (which, together with three others by Cooke, gained wide popularity through aquatint copies by William J. Bennett) is rich in imitative detail and in well-considered artistic touches.[1] Two large dry docks flank a three-masted schooner at the Navy shipyard on the Anacostia River below the Capitol. Our attention is drawn to them not only for their descriptive interest but also for their deftly painted reflections in the placid river. This grouping serves as a strong base for Capitol Hill and the Capitol Building as it appeared in 1833, with the dome designed by Charles Bulfinch. While this is the principal focus of the view, it is balanced by the White House in the distance at left center. To make sure that this balance is seen as symbolic of the balance of democratic powers between the executive and the legislative branches, Cooke enlarged the White House.

Between these two large buildings the city lies on lower ground, composed mostly of two- and three-story houses and several steepled churches. To the left is the confluence of the Anacostia and the Potomac, whose broad waters stretch to the port of Georgetown. We are reminded that Washington was once known as a port city, with attendant prosperity and strategic importance.

The sky is as serene as the rivers, lending an aura of contentment to the scene. The painting is a document, at once descriptive and symbolic, of the capital city in 1833. Andrew Jackson's second term had begun with his successful opposition to South Carolina's nullification ordinance, once more forestalling that threat to the Union. Thus this painting seems to carry symbolic overtones of the harmony of democratic government and of a people in accord with the land.

Thomas Sully (1783–1872)
Fanny Kemble 1834

Signed lower right: TS 1834. [TS in monogram]
Oil on canvas, 36⅛ x 27¹⁵⁄₁₆ inches (91.8 x 71 cm)
Gift of The Daniel W. Dietrich Foundation, 1965

This superb, deeply felt portrait surely derived much of its conviction from Sully's intimate knowledge of the theater, a world to which both his family and his subject, Fanny Kemble, belonged. His parents were actors in England, where he was born. They emigrated to America in 1792 and settled eventually in Charleston, South Carolina, in 1794.[1] The great actress Frances Anne (Fanny) Kemble belonged to one of the illustrious families of the English stage. Her parents, like Sully's, were actors. Fanny in fact once played Juliet to her 57-year-old father's Romeo! He was Charles Kemble, whose reputation did not equal that of his renowned siblings, John Philip Kemble and Mrs. Sarah Siddons.

Thomas Sully was to paint the portraits of many actors and actresses during his career, but Fanny Kemble ranked first in his affections. The Kembles, father and daughter, arrived in New York in September 1832, and Sully first saw Fanny on stage in October in Philadelphia. He soon after painted her as Juliet from his recollections of that evening.[2]

In January 1833 the Kembles appeared in Washington, where the audience included Chief Justice John Marshall and Associate Justice Joseph Story, who wrote that Fanny's acting "threw the whole audience into tears. The Chief Justice shed them in common with younger eyes."[3] The celebrated actress was soon presented to Andrew Jackson at the White House, finding him to be "a good specimen of a fine old battered soldier. His hair is very thick and grey; his manners perfectly simple and quiet, therefore very good."[4]

Back in Philadelphia Fanny Kemble and Thomas Sully met, probably introduced by Pierce Butler of Georgia and Germantown, Pennsylvania. Butler and Sully were cousins, and Butler had been wooing Fanny Kemble since her appearance in Philadelphia. They married in June, and Fanny retired from the stage. She first posed for Sully on March 10, 1833; that portrait was given to Sully's wife. More than a year later, Sully began two portraits of her. According to Sully's notations, one was "to accompany [Fanny Kemble] to England" (finished June 17), and the other was painted for Pierce Butler (finished June 18).[5] The former, which passed to Fanny and Pierce's daughter, Frances (Mrs. James Wentworth Leigh), in London, is probably the White House painting.

Sully's tendency, visible here, was to soften and idealize his sitters. The actress's softly brushed, loosely contoured, impossibly long shoulder and her right arm are put into virtually the same plane, close to the picture's surface. This unusual, contrived pose—the upper body is a tall narrow lozenge, the right elbow its insubstantial base—injects a wistful, ephemeral note, complemented by the exquisite transparency of the organdy sleeve.

That there was as much of the artist as the sitter in this portrait was perceived by Fanny Kemble: "I do not feel very sanguine about it for Sully's characteristic is delicacy rather than power, and mine may not be power, but it is certainly not delicacy."[6]

Opposed to the slavery she witnessed on Butler's Georgia plantation, Fanny Kemble left her husband in 1846 and sailed for England, where she returned briefly to the stage. Divorced in 1849, Mrs. Kemble, as she was then known, decided to make her home primarily in Massachusetts. In lieu of acting, she began giving public readings. Those from Shakespeare especially moved her listeners, among them Longfellow: "O Precious evenings! all too / swiftly sped! / . . . How our hearts glowed and trembled / as she read. . . ."[7] A prolific writer, she published *Journal of a Residence on a Georgian Plantation* in England in 1863 in the hope of turning British opinion against the slave trade and in support of the Union cause.

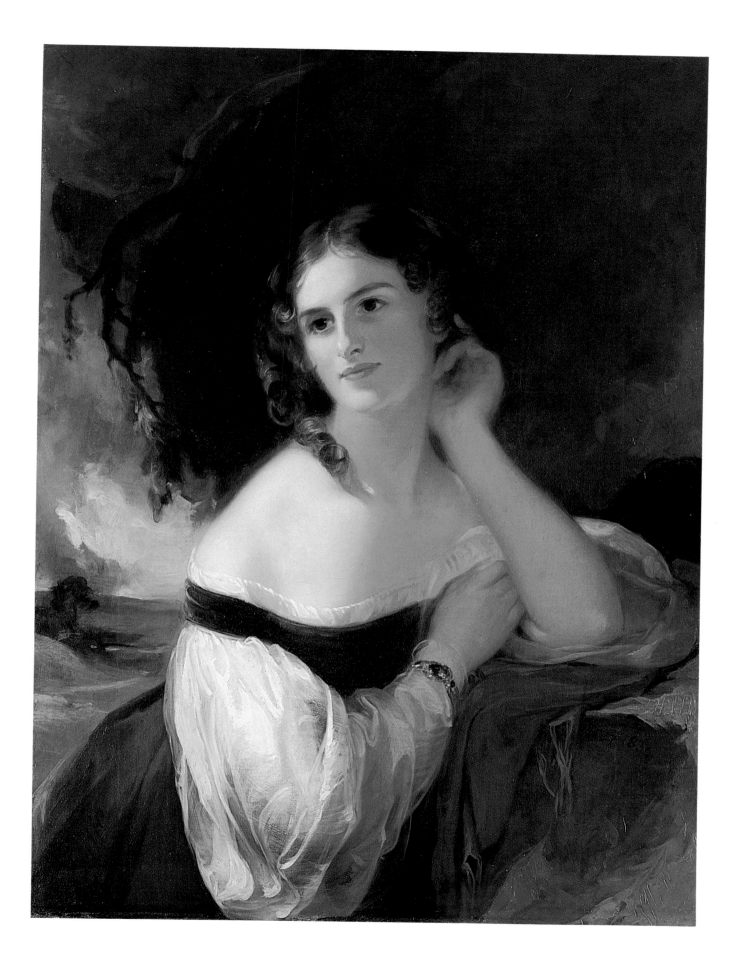

Hiram Powers (1805–1873)
Martin Van Buren modeled 1836, carved 1840

Inscribed on rear of socle: HIRAM POWERS. / *Sculp.*
Marble, 24⅛ x 21⅜ x 13½ inches (61.3 x 54.3 x 34.3 cm)
Bequest of Travis C. Van Buren, 1890

During three years in Washington, from 1834 to 1837, Powers launched a prodigiously successful artistic career that brought him wealth and renown. He had come from Cincinnati where he had learned his craft, bearing valuable letters of introduction from Nicholas Longworth, the city's principal art patron. Thus enabled, Powers obtained sittings with President Andrew Jackson that resulted in a startlingly naturalistic bust, contrasting with other notables such as John Marshall and Jackson's Vice President Martin Van Buren, whose likenesses he modeled with the restrained neoclassicism then in vogue.

The genial face of the courteous Van Buren bespeaks the political skill that earned him the nickname "Little Magician" while serving as attorney general and governor of New York, and as United States senator, secretary of state, and vice president. Nonetheless, his election to the Presidency would be more a tribute to the aged Jackson's influence than to his own popularity, and the financial panics that were to follow Jackson's bank policies ensured that Van Buren would be a one-term President.

Van Buren posed for Powers in January 1836, and the clay bust was finished by the end of the month. When the artist moved permanently to Florence, in 1837, he took his clay originals with him. Plaster casts were made from these, and the marble replicas were carved by Italian artisans under Powers's direction, a common practice among 19th-century sculptors. Studio records show that Powers's chief stonecutter, Ambuchi, carved the marble replica in 1840 during Van Buren's Presidency. It was not shipped to America until September 1841, when the sitter had already retired to "Lindenwald," his home in Kinderhook, New York.[1]

Carved from the mellow-toned marble of Seravezza that Powers preferred for its suggestion of flesh, the bust evidences the sculptor's careful observation in the delineation of the bags under the eyes, the fleshy eyebrows, and the crow's-feet. Still, Van Buren's features are de-emphasized and generalized, as is the modeling of the head. The blank eyeballs reflect the neoclassical misconception that ancient sculptors had done the same.

Late in 1841 the painter Henry Inman wrote to Van Buren at Kinderhook: "I have been so fortunate to obtain a sight of Mr. Powers' bust of yourself and . . . I have to express to you the unqualified pleasure it has given me both as a work of Art and as the very best likeness I have ever seen."[2] Inman had been commissioned to paint the portrait of Van Buren's daughter-in-law, Angelica Singleton Van Buren, also now in the White House (page 103), and he included the Powers bust of Van Buren in the painting.

In his will dated January 18, 1860, Van Buren directed that the bust, "which I had previously presented to [Angelica Singleton Van Buren]," now be transferred "by her direction" to his grandson Martin, son of Angelica and Abraham Van Buren. Abraham had served as his father's private secretary and Angelica as official White House hostess for the widower President, who died on July 24, 1862. Another son, John, ordered other marble replicas from Powers shortly after Van Buren's death. When the grandson Martin died in 1885, the 1840 bust must have passed to his brother, Travis C. Van Buren, under whose bequest it went to the White House after his death in 1889.[3]

Henry Inman (1801–1846)
Angelica Singleton Van Buren 1842

Signed and dated, vertically at left edge on balustrade: H. Inman. / 1842.
Oil on canvas, 42¼ x 33⅝ inches (107.3 x 85.4 cm)
Bequest of Travis C. Van Buren, 1890

Martin Van Buren, eighth President, had been a widower for 18 years when he moved into the Executive Mansion in 1837. He was never to remarry, so the Van Buren White House lacked a hostess until that role was filled in 1839 by Angelica Singleton Van Buren (1817–1878). She was a native of South Carolina, the daughter of a wealthy and well-connected cotton planter and a relative by marriage of Dolley Madison, social doyenne of the capital. It was through Mrs. Madison that she met Van Buren's son and private secretary, Abraham, at the White House. They were married in November 1838, and on New Year's Day 1839 Angelica became the President's official hostess.[1]

Painted a year after the Van Buren Presidency ended, this likeness of Angelica is a portrait of great skill and charm. The charm is obvious: She is the embodiment of forthright femininity. Henry Inman, who had emerged as America's leading portrait specialist during the 1830s, responded readily to female sensuality, and here he emphasized the palpable swell of her bosom, the pale flesh of her shoulders, and the powdered ivory oval of her face. He was equally attuned to the allure of feathers and fabrics, which he captured with an exquisite palette and a delicate touch. Her ebony hair contrasts with the fluff of her pure white headdress; the moiré pattern of her dress is freely drawn; the pale green stole is enlivened with a lovely abstraction of yellow highlights. Inman excels in effects of transparency, as in the shadow cast by the lace trim upon her arm. The skill that made such passages possible is remarkable. The modeling of that memorable bosom ranges from the subtlety of the nacreous tints of the material to the bold shelf of shadow beneath the bodice.

Inman displays artistic diplomacy in his treatment of the marble bust of Martin Van Buren (by Hiram Powers; page 101) on the right. Tricks of perspective make the sculpture appear to be farther back in the picture space than in fact is logical. Inman reduces the sculpture's actual size as well, so it does not compete with the head of Angelica. At the same time he strongly—and arbitrarily—spotlights it, thus ensuring that the President will not fade into insignificance.

Inman's Angelica is so winning in her frank expression and her womanly warmth that a dominant trait of her personality is quite obscured—hauteur. She and her husband had gone in the spring of 1839 to Europe, as ambassadors-without-portfolio. Angelica had been mightily impressed with the customs at the courts of Queen Victoria and Louis Philippe, where queens and even bourgeois "princesses" did not stand in receiving lines and shake the hands of the citizenry, the custom at the White House. Rather, they stood on platforms and received the homage of their subjects. Angelica briefly introduced the practice at the White House. When a Whig congressman branded her a "Democratic peacock in full court costume, strutting," she abandoned the attempt.[2] Despite the elegance of her costume in this portrait, the vital, accessible human being of Inman's vision *is* Angelica Van Buren to all who have seen it.

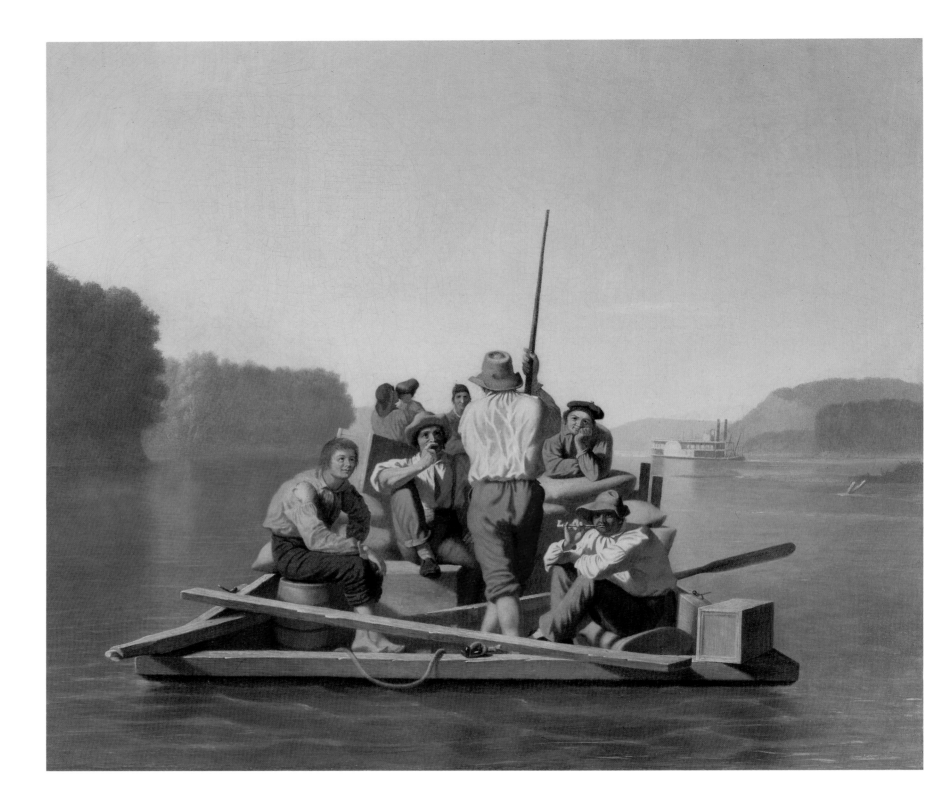

George Caleb Bingham (1811–1879)

Lighter Relieving a Steamboat Aground 1847

Oil on canvas, 30⁵⁄₁₆ x 36³⁄₁₆ inches (77 x 91.9 cm)
Partial gift of an anonymous donor, 1978,
 and Mr. and Mrs. Walter Shorenstein, 1981

This painting brings to life an era and a region in which storytelling was at once a way of life and an art form. Bingham was raised on the banks of the Missouri River near St. Louis, and he became its historian. He knew the river well, and as a young man he witnessed the change in its character as the flatboats that drifted with the current or were poled against it were supplanted by steamboats in the 1830s.[1] Like George Catlin, who chronicled the vanishing frontier with brush and pen during that same decade, Bingham must have mused on the changes taking place. Writing of the "rich alluvial shores . . . studded with stately cotton wood and elms," Catlin said of the future:

> I have contemplated these boundless forests melting away before the fatal axe, until the expanded waters of this vast channel, and its countless tributaries, will yield their surplus to the thirsty sunbeam, to which their shorn banks will expose them; and I have contemplated, also, the never-ending transit of steamers, ploughing up the sand and deposit from its bottom, which its turbid waters are eternally hurrying on to the ocean. . . . All this is *certain*. Man's increase, and the march of human improvements in this New World, are as true and irresistible as the laws of nature.[2]

Although Bingham, like Catlin, may have regarded such changes as certain, it is doubtful that he saw them as improvements. For instead of painting "the never-ending transit of steamers" that was the reality of the 1840s, he has wrapped his picture in a dream of the past, embodied in his monumental group of idle boatmen raptly listening to stories. The scene is unhurried, indeed motionless, locked in place by the

artist's customary geometry—a pyramid of strikingly foreshortened, interlocked figures carefully aligned with the picture plane.

Here as morning gathers on the river, a passage from Mark Twain's *Life on the Mississippi* demands to be invoked:

> One cannot see too many summer sunrises on the Mississippi. They are enchanting. First, there is the eloquence of silence; for a deep hush broods everywhere. Next, there is the haunting sense of loneliness, isolation, remoteness from the worry and bustle of the world. The dawn creeps in stealthily; the solid walls of black forest soften to gray, . . . the water is glass-smooth, gives off spectral little wreaths of white mist; there is not the faintest breath of wind, nor stir of leaf; the tranquillity is profound and infinitely satisfying. . . . Well, that is all beautiful; soft and rich and beautiful; and when the sun gets well up, and distributes a pink flush here and a powder of gold yonder and a purple haze where it will yield the best effect, you grant that you have seen something that is worth remembering.

Twain's pinks and purples agree with Bingham's. Though a New York reviewer disparaged the artist's "monotonous, dull, dirty pink" palette, writer and painter knew firsthand the characteristic pastels and grays of the river mists.[3] Bingham's color scheme is a subtle and complex array of pale blue, mauve, lichen green, orange, and ivory.

Twain was writing nearly 40 years after Bingham painted his scene. Twain's tone and theme are in response to the calamity of the Civil War; Bingham belonged to the prophetic generation of artists and

writers working before the war. Their concern was over the loss, then in progress, of the New Eden that had nurtured them. One need only read tall tales from Bingham's period—usually raucous, often cruel—to realize that the artist has dictated the mood of gentle nostalgia and benevolent inaction.

This is, as far as we know, the first painting in which Bingham depicted an accident on the river. The steamboat in the distance has run aground on a shoal (see the small detail), and this boat in distress probably alludes to a key political issue of the day.[4] Obtaining federal funds to improve navigation and thus facilitate trade on the western rivers through the removal of snags, shoals, and sawyers was a primary goal of the Whig party in Missouri. In 1846 Bingham ran as a Whig for the Missouri House of Representatives. He was elected, but the results were contested. The Democrat-controlled legislature decided against him, and he was forced from office. Shortly afterward, to the fury of the Whigs, the Democratic President James K. Polk vetoed the River and Harbor Bill.

Although Bingham may indeed have had a political subtext in this painting, his primary focus is on the self-sufficient boatmen, his heroes (large detail). Having removed cargo from the steamer

("lightened" it so it can float free from the shoal), they have turned from it to listen to their storyteller. In the words of Henry David Thoreau, Bingham's contemporary, they are "building castles in the air for which earth offered no worthy foundation." Of this and another picture, a St. Louis reporter wrote that the artist has chosen "the simplest, most frequent and common occurrences on our rivers . . . precisely those in which the full and undisguised character of the boatmen is displayed."[5]

John Frederick Kensett (1816–1872)

Niagara Falls *c.* 1852–54

Oil on canvas, 32¾ x 48¹/₁₆ inches (83.2 x 122.1 cm)
Gift of Mr. and Mrs. James W. Fosburgh, 1961

While other artists interpreted the awesome spectacle of Niagara Falls in terms of Romantic grandeur, Kensett's reticent temperament led him to paint it in the picturesque manner of the 18th century, in turn derived from the 17th-century landscapes of Claude Lorrain.

The long view, the carefully controlled recession, the skillful tonal gradation, even the oval format—rare in Kensett's work—all attest the influence of Claude Lorrain's cool classicism. It is not surprising that the painting appealed to the visiting Earl of Ellesmere, who purchased it in 1854 and took it home to England, where the love of Claude's landscapes was widespread.[1]

The oval is precisely bisected horizontally by the top of the falls, and vertically by the towering plume of spray. This structural regularity, together with the decorative format, emphasizes the more detached record of nature preferred by Kensett. While voluntarily sacrificing drama, his calculated approach produces passages of great sophistication. In the rocks and trees the brushwork is dense and complex, the palette quite variegated. The many small squiggles of paint, sometimes applied wet into wet, contribute to the structure as well as to the vitality of the surface.

As in others of his paintings, Kensett here seems to be contemplating the opposing natures of earth and water, then uniting them pictorially in the most direct way. The dark mass of the projecting shoreline is played directly against the silvery, luminous tones of the falls. Through tonal nuance—for example, in the water and in the half-lights in the red foliage—he relates these contrasting areas.

By taking a closeup, water's-edge viewpoint, he calls our attention to the intertwining of rocks and water. This he effects by leaving uncovered small patches of the creamy white primer or by a thin scumbling—a blending of the browns of the rocks and the aquas of the water over partially covered primer.

Like threads of a tapestry, these patches of primer weave disparate elements of nature into an integrated paint surface. It was a technique much loved by the artist.

Although he is known to have drawn his compositions directly onto primed canvas, usually with graphite pencil, and he may sometimes have done this on location, the special character of *Niagara Falls* suggests a more formal approach. Kensett was at the falls in August 1851, and in 1852 he spent nearly three months there, from August through October. A pencil drawing dated October 1852 (private collection) resembles this painting in many respects. Although the viewpoint of the drawing is high rather than waterside, it has a similar tower of spray and the same diagonal division between the foreground land mass and the distant falls.[2] There is also a much smaller oil of Niagara Falls by Kensett at the Mead Art Museum at Amherst College. Its low viewpoint is like that in the White House painting, but the dominant water and rocks are the focal point. The informality of the Mead painting suggests that it too precedes the White House painting, which is the formal studio marriage of the drawing and the small oil.[3]

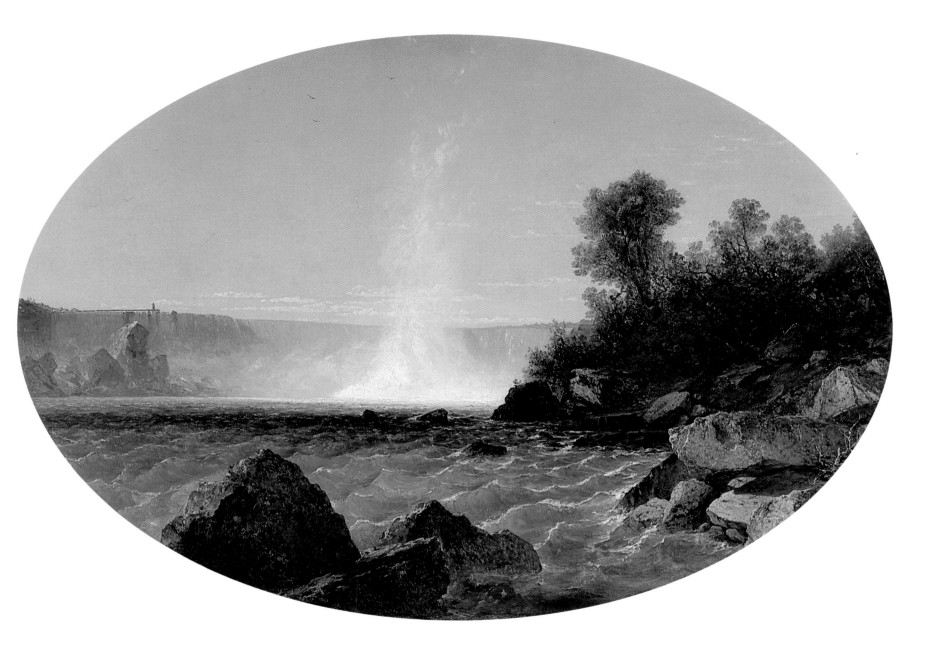

Frederic E. Church (1826–1900)
Rutland Falls, Vermont 1848

Signed and dated lower left: F. CHURCH / 1848
Oil on canvas, 20 x 29 ¾ inches (50.8 x 75.6 cm)
Gift of the White House Historical Association, 1976

*W*e are first struck by the distinctive colors that glow in *Rutland Falls, Vermont*.[1] The luminous pinks and mauves of the towering clouds and the foreground pool give an expressive voice to a landscape that is otherwise naturalistically drawn. In literary terms the vivid prose of the landscape is surmounted by the epic poetry of the sky.

Painted just months after the death on February 8 of Thomas Cole, his mentor and the paragon of American landscape painters, this scene may indirectly refer to that loss. Cole had imbued nature with symbolic significance. His style had profoundly influenced Church, who continued to paint landscapes that resonated with meaning, even after such allegorical overtones had become unfashionable.

The twin themes of this painting may be said to be transience and duration. We see the day ending with the moon ascending; moving water and still water; and the sawmill, epitome of modern busy-ness, here empty and inactive. Such contrasts were the commonplaces of Romantic poetry, in which nature's endless round of days and seasons served as metaphors for mortality and immortality. It was to such metaphors that a landscape painter would predictably turn to honor the memory of another landscape painter. A few months earlier Church had painted the explicitly commemorative *To the Memory of Cole*, in which a similar landscape is the setting for a cross symbolizing Cole's grave at Catskill, New York.[2]

Both the celebrated funeral oration to Cole's memory delivered by William Cullen Bryant and Cole's own poetry parallel many features of *Rutland Falls, Vermont* and support the notion that the painting may share an implicit burden of remembrance. Bryant had concluded his eulogy with the lament that with Cole's death "we see that something of power and greatness is withdrawn from the sublime mountain tops and the broad forests and the rushing waterfalls."[3] And in fact the mountains in the painting are darkened and diminished beneath the clouds, the forests pushed to the edges of the scene, and the rush of the waterfall strangely blocked by the still pool that fronts it.

Cole in his poetry often used light as a religious symbol. For example, in "The Cross," a poem written shortly before his death and possibly known to Church, he wrote:

> At Eve he sank beneath the shade;
> But on dark Calvary's height
> Thy form a moon refulgent made
> By his transforming light—

In *Rutland Falls* the rising moon may also carry with it the assurance of salvation, especially in combination with the clouds, which are like those elsewhere described by Cole as "embodiments of glory."[4]

The waterfall is flanked by the tiny figure of a trout fisherman—the sole human being—and by the prominent mill. It would not be safe to say that the mill is abandoned, since sawmills were in use for only a short period each year and were apt to appear dilapidated. Nevertheless its present inactivity is notable. It has been observed that "the sawmill, like the axe, was a double-edged symbol. It was both a destroyer of nature and a tool of civilization."[5]

Church had an optimist's faith in progress, but Cole had taken a decidedly pessimistic view. It is therefore a strong indication of Church's commemorative intention in this painting that he paints a disused sawmill as a symbol of the vanity of mankind's prideful ingenuity, and overwhelms it with the cloud-capped grandeur of the heavens.

Asher B. Durand (1796–1886)
The Indian's Vespers 1847

Signature, lower right, now virtually illegible;
 the date has disappeared
Oil on canvas, 46⅛ x 62¼ inches (117.2 x 158.1 cm)
Gift of the Alfred and Viola Hart Foundation, 1963

With *The Indian's Vespers* Durand made a major statement in theme as well as in size, recombining nature's elements in a grand, symbolic canvas. The artist had been notified by a letter of February 26, 1847, that the American Art-Union wished to commission him "to paint for the institution to be distributed at the next annual meeting a landscape for the price of $500. The subject and size to be left to your own choice."[1] He must have devoted his efforts to it, for he finished the work in less than three months.

Durand seized the opportunity, departing from the modest rambles in intimate woods, in friendly fields, or beside serene streams that had earlier dominated his work. In so doing, he took liberties with reality that were disapproved of by the critics:

> His pictures now want truth. . . . In many
> respects the painting is a mystery to us.
> We do not know why it should be called
> "Vespers" any more than "Orisons;" for if the
> right of the picture has a sunset sky, that of
> the left is the grey of early morning. . . .
> Beautiful as the scene is, and in composition
> so excellent, we would rather see one touch
> of nature than so much of Durand.
> —*Literary World*

> [*The Indian's Vespers* has] huge objects in the
> foreground, and dwarfish objects in the
> middle ground and distance; . . . one end of
> the picture is flooded by strong sunlight, the
> other is very dense and dark; . . . [since]
> the figure of the Indian . . . gives name to
> the picture, it should have been of more
> importance, as the leading object.
> —*American Literary Gazette and
> New York Weekly Mirror*[2]

Both critics missed Durand's intention. The latter writer should have pondered the couplet from Alexander Pope's *Essay on Man* (Epistle I, ll. 99–100), appended to the catalogue entry: "Lo! the poor Indian, whose untutor'd mind / Sees God in clouds, or hears him in the wind"—in which the poet prefers the Indian's pantheism to the carping of "proud Science." This recurrent belief in the immanence of God in nature was given emphasis in America by the Unitarian writings of William Ellery Channing and, of greater significance for Durand, by the commanding voice of his own generation, Ralph Waldo Emerson.

If the literal-minded critic wanted a larger Indian for the *Vespers*, Durand (and Emerson) knew better. Emerson's essay "Nature," reissued in 1847, leaves no question that God's Nature is dominant, and that man's duty is to harmonize with it. In a rapturous passage, strongly echoed in Durand's painting, Emerson exclaims:

> In the woods, we return to reason and faith.
> There I feel that nothing can befall me in
> life—no disgrace, no calamity (leaving me my
> eyes), which nature cannot repair. Standing
> on the bare ground—my head bathed by the
> blithe air and uplifted into infinite space—
> all mean egotism vanishes. I become a
> transparent eyeball; I am nothing; I see all;
> the currents of the Universal Being circulate
> through me; I am part or parcel of God.

The Indian, his arms raised to the sun in praise, is bathed in a yellow- and pink-hued light. He is further emphasized by the brilliant path of the sun's reflections on one of those "lakes embosomed in ancient forests" that Durand praised as original features of the American landscape, a landscape

"fraught with lessons of high and holy meaning, only surpassed by the light of Revelation."[3]

In the same passage, from his once famous "Letters on Landscape Painting" of 1855, Durand speaks of "the varying phases of cloud and sunshine, time and season." Both critics of *The Indian's Vespers* were struck by the contrasts in the light of the sky, but deduced nothing from them. We may suggest that Durand intended to symbolically compass within one canvas the full round of hours and days. Following the example of Thomas Cole, he had earlier painted a complementary pair of works, *The Morning of Life* and *The Evening of Life* (1840; National Academy of Design, New York); now he merged them into a single image.

Though the sunset has overtones of the 17th-century landscapes of Claude Lorrain, the close-pressing central stand of trees dividing the canvas is far removed from the calm unity of that hospitable style of painting. This, the forest primeval, was beyond Claude's imaginings. The central stand mediates between the fallen trees, tangled growth, and misty hills on the left and, on the right, the blossoming plants and the young trees on the shore of the unspoiled lake. At its base, like a cenotaph, is a blasted tree trunk. This is not merely the passage from morning to evening, but from the uncleared forests of life to the redemption of eternal light. Ambitiously and reverently, Durand has summoned virgin forests, vast waters, insubstantial mists, man in his natural state, and the sun's unifying eye to evoke the ancient roots and yearnings of mankind.

Durand wrote that Raphael was called "divine" because "he saw through the sensuous veil, and embodied the spiritual beauty with which nature is animate." And he added: "There is to be seen a corresponding soul and depth of expression in the beauty of landscape nature, which dignifies the Art that embodies it, and improves and elevates the mind that loves to contemplate its pictorial image."[4]

Alvan Fisher (1792–1863)

Pastoral Landscape 1854

Signed and dated on rock, lower left: AF [in monogram] / 1854
Oil on canvas, 24$^{1}/_{16}$ x 20$^{1}/_{16}$ inches (61.1 x 51 cm)
White House Acquisition Fund, 1973

In his lifetime Fisher, a Massachusetts artist, was well known and widely exhibited. He turned primarily to landscape painting in the 1820s (often including in his works the everyday elements of genre painting) and specialized in this field thereafter. Although his expressive range was relatively wide, he favored tranquillity over drama. This was especially true in his late works, of which *Pastoral Landscape* is one.[1]

To some extent the reflective mood of the painting is shared by other landscape paintings of the 1850s, in which a lull before the civil storm of the sixties seems to prevail. In a protected glen Fisher interjects three cows and three sheep that graze, drink, or stand quietly under the care of a seated shepherd and his dog. Nothing moves, save a distant mountain cataract whose sound does not reach us. Nothing disturbs the calm.

Everything contributes to the quietude. Fisher's palette has no vivid hues but is tonal in the dominant American tradition, its pale blue, pink, green, and salmon modified by gray. Fisher uses many stock elements, such as trees, dead branches, and rocks, yet his painting does not feel contrived. Secure in his modest picture-making, he succeeds in pleasing us. He allays our anxieties and soothes our nerves.

The artist has in some places blurred the leaves of the trees, probably by splaying the bristles of his brush, producing a sense of air and delicacy. The apparent fragility of the moment is sustained like a held breath, preserved from the shocks of the inaccessible world beyond.

Severin Roesen (active in the United States 1848–72)

Floral Still Life With Nest of Eggs *c.* 1851–52

Oil on canvas, 26⅞ x 22⅛ inches (68.3 x 56.2 cm)
Gift of the White House Historical Association, 1976

*L*ittle is known of the German-born artist Severin Roesen.[1] We may surmise that the turmoil throughout Europe during the revolutionary year 1848 led him to emigrate from Cologne. But it is also probable that, like many of the immigrant portrait painters of the colonial era, he sought political or religious freedom and a better market for his skills. A fine craftsman, Roesen was trained as a porcelain painter (as was Renoir a few years later). Perhaps because of this training, his attempts at rendering different textures were often mannered. But in the less competitive American market Roesen's paintings stood out for their crisp, vivid character.

Although Roesen's horizontal still lifes featuring ambitious compositions of fruit are more numerous and better known, his vertical flower pieces, dating from his early years in America, have a sheer loveliness that delights the eye. In full bloom, a white flower—perhaps a peony—stands at the center of the energetic, colorful, compact core of this floral cornucopia. In contrast, the flowers and leaves at the edges are not only more freely placed but also dropped into the shadow and played against a neutral background—very dark at the left and light putty-toned at the right. There too they often fade in vigor, some drooping on broken stems.

The progression from bud to full flower to waning life is one of the hallmarks of the European tradition of still life painting and carries with it a commentary on the transitory human condition. Some have questioned whether Roesen understood the symbolic implications of the tradition as well as its forms. The prominent bird's nest with three eggs in conjunction with the trumpeting morning glories—flowers whose beauty fades as they fold in midday—leaves little doubt that he understood it well.

Severin Roesen (active in the United States 1848–72)

Still Life With Fruit, Goblet, and Canary (Nature's Bounty) 1851

Signed and dated lower right: S. Roesen. 1851.
Oil on canvas, 28¾ x 36 inches (73 x 91.4 cm)
Gift of Mr. and Mrs. Wickersham June and the J. M. Kaplan Fund, Inc., 1962

*I*t is known that even before he left Cologne, Roesen had exhibited a floral still life in 1847. In America he at first continued making flower pieces like the *Floral Still Life With Nest of Eggs* (preceding pages) in the White House. Gradually he undertook more ambitious compositions of fruit with baskets, plates, goblets, and other conventional props. This early dated example of Roesen's fruit paintings reveals an artist who is a little uncertain. He does not know exactly how to compose a large number of objects, but he is bold in the rare inclusion of the bird and in the calligraphic spirals of the grapevine tendrils that would become habitual in his art.

Like tightly coiled springs, the tendrils supply the energy that drives the painting. Their tautness is echoed elsewhere, especially in the canary that focuses intently on a tiny white moth. Although grapes are the dominant fruit, they are less persuasively painted than the segmented orange beside the white porcelain plate. This area of the painting is that of greatest interest, with plate, wineglass, bird, and orange elegantly arranged— a still life within a still life.

In the late 1850s Roesen left New York for Philadelphia, then Harrisburg, Huntingdon, and Williamsport, Pennsylvania. He spent about ten years in Williamsport, where he must have found the large German-American community congenial.[1] When he left in 1872 he may have intended to return to New York, perhaps confident that his provincial success could be repeated there. But he apparently never reached Manhattan, and the end of his career and of his life remains a mystery.

Fitz Hugh Lane (1804–1865)

Boston Harbor 1854

Signed and dated lower right: F H Lane / 1854
Oil on canvas, 23¼ x 39¼ inches (59.1 x 99.7 cm)
Gift of Mr. and Mrs. Lew Wasserman, 1963

*M*ore often than not Lane's charmed marine paintings exude an atmosphere of contentment. In *Boston Harbor* the artist shows the end of a busy day of commerce in the great port. The far focal point of the scene is the State House with the sun setting behind it. The glow illuminates the many church towers that punctuate the skyline. From the cloud bank above the city a forward sweep of darker clouds grandly marks the spaciousness of the harbor. Most of the many boats and ships that occupy the great expanse of water seem to move slowly if at all. The gentle motion of the water, painted without formula or stiffness, also lulls the viewer into the twilight mood.

But tranquillity, though dominant, is not the whole picture. Lane, a self-taught painter from Gloucester, Massachusetts, reached his artistic maturity in the 1850s, a decade of national malaise during which internal stresses grew daily. If the institution of slavery was the most life-threatening of these, everywhere one could find evidence of economic, social, and political inequality incompatible with the fundamental ideals of the nation. Much of this was linked to the ceaseless expansion of the country; as a consequence, the very notion of *progress* was viewed with ambivalence or suspicion by many.

In *Boston Harbor* the drowsy calm is partly disrupted by an alien intruder—the steam-powered side-wheeler that slices toward us, the only boat in motion that is not quietly aligned with the shore.

More strongly lit than any other foreground boat, it is busy with figures, and its red flag and coal-black smokestack are in striking contrast to the blue-gray-salmon tonality of the rest of the painting. A maritime historian has observed that the two boats in the right foreground have furled their sails rather sloppily, and that the artist may have depicted them with humorous intent.[1] But it might also be that Lane's message is simply a nostalgic one, in that the two older boats are literally overshadowed by the aggressive newcomer.

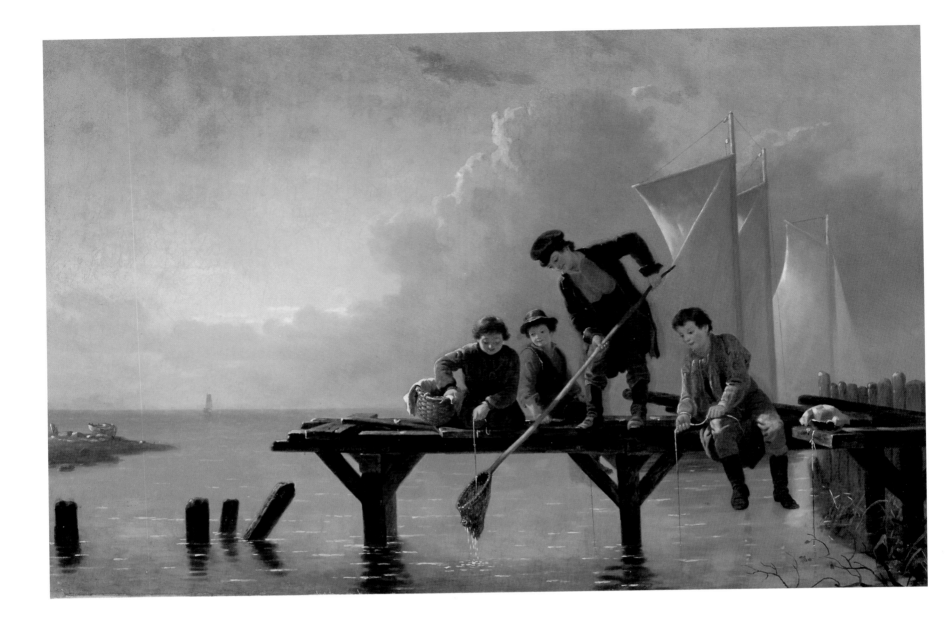

William Ranney (1813–1857)
Boys Crabbing 1855

Signed and dated on left side of dock: WmRanney 55
Oil on canvas, 23¼ x 36⅜ inches (59.1 x 92.4 cm)
Gift of The Charles E. Merrill Trust, 1972

Ranney's modern reputation rests on his paintings of Western trappers and pioneers. Often highly charged with action or pathos, they were greatly admired by his contemporaries, one of whom noted that in painting Ranney had "the same position that FENIMORE COOPER did in literature."[1] But the ten most productive years (1845–55) of his short life were lived mostly in Weehawken and West Hoboken, New Jersey, then idyllic locales well suited to attract an artist as devoted to nature and rural America as Ranney was. There, when not imaginatively re-creating the West he had known only briefly, he painted subjects near at hand in the New Jersey meadows and along the state's rivers and coastline.[2]

Boys Crabbing may well be the finest of these paintings. Among images of childhood in mid-19th-century America none is more convincing and winning in its combination of daydream and reality, gentleness and solidity. Appropriately, it is a morning scene. Ranney's delicate palette of light blues, pink, lemon yellow, and mother-of-pearl (in the sails) forms the backdrop for the brown pier and the cohesive group of boys on it. The boys are charmingly characterized and skillfully composed, buttressed by the sails and given relief by the darker cloud mass that the sun has not yet dispersed. A cleverly contrived series of interlocking diagonals and triangles gives a geometric structure to the painting that is comparable to the work of his contemporary and friend, William Sidney Mount. Ranney modifies this angular structure with softly modeled forms and soft circular shapes: a crab basket at the left; the dripping, drooping net; the round heads; the cloth-covered pan at the right.

Ranney produced a more atmospheric outdoor setting than did Mount at the same date. While Mount's most famous painting of figures in a landscape, *Eel Spearing at Setauket*, 1845, is more monumental, it is decidedly less airy and less barometric—without suggestion of changing coastal weather. Mount's late *Catching Crabs*, 1865, his most vaporous landscape with figures, may well have been influenced by Ranney, for when Ranney died of tuberculosis in 1857 Mount completed at least one of his unfinished works. He carefully noted in his diary that "in some of [Ranney's] skys he changes the tint very often—blue and white, red and white, and yellow and white—and when the atmosphere is hazzy, he also scumbles different tints upon his figures and animals—colors broken—in patches."[3]

The innocence of childhood was a theme of great significance before the Civil War, an embodiment of the view of America as the New Eden. "In the woods is perpetual youth," wrote Emerson in *Nature*; and as Americans began to feel their relation to nature evaporate, they replaced it with evocations of virginal landscapes and unsullied childhood. A painting by Henry Inman, *The Young Fisherman*, was engraved for *The Atlantic Souvenir* in 1830 and accompanied by anonymous words that make the nostalgia explicit: "Thou recallest to me, rosy boy, the careless moments of my early youth. . . . Who that has enjoyed the pleasures of wandering free and far among scenes of rural beauty, has not learned to loathe more deeply the irksome bondage of a city life."[4]

In exactly the same way *Boys Crabbing* is an adult's retrospective view of childhood that exists in the glow of memory. With deceptively simple means, from the easy brushwork of the sparse water grasses to the rapt concentration of the boys upon their sport to the graceful asymmetry of the composition, Ranney draws us into his visual poem. Sophisticated indeed is the obscuring of the boats so that their sails belong solely to the sky and to the children. "To speak truly," added Emerson, "few adult persons can see nature. . . . The sun illuminates only the eye of the man, but shines into the eye and the heart of the child."

Clark Mills (1815–1883)
Andrew Jackson 1855

Marked with an initial under the tail: M;
 marked on the base, rear: PATENTED / MAY 15 / 1855;
 foundry mark on base, front: CORNELIUS & BAKER / PHILADELPHIA
White metal, 23¾ x 19¾ x 7¾ inches (60.3 x 50.2 x 19.7 cm)[1]
United States government purchase, 1859

A payment voucher "For one Equestrian Statuette of General Jackson for the President's House" records the purchase of this sculpture. The voucher, from the Commissioner of Public Buildings, bears the date of December 15, 1859, and the price of $50.

This statuette is a small version of a life-size bronze one. The large equestrian sculpture of Andrew Jackson (1767–1845) has reared proudly since 1853 in Lafayette Park, across Pennsylvania Avenue from the White House. Unveiled to great acclaim on January 8 of that year, the 38th anniversary of General Jackson's crushing defeat of the British at New Orleans, it was a reminder of the pride engendered by that "Second War of Independence," the War of 1812. That triumph had led to Jackson's two terms as President (1829–37), so Mills depicted Jackson as the hero of New Orleans reviewing his troops before the great battle. The reference also had a contemporary relevance that was underscored by the motto that Mills intended for the pedestal: "Our Federal Union, It Must Be Preserved." The Compromise of 1850— a series of acts regarding the extension of slavery into new states and territories that averted the dissolution of the Union for a decade—was fresh in every mind when Mills unveiled his sculpture.

It was the first life-size bronze equestrian statue ever cast in America. Mills had never set eyes on a large equestrian sculpture, much less made one. That he selected the rampant pose with its enormous problems of balance and support is all the more remarkable. It is possible that he had seen an engraving of Étienne-Maurice Falconet's equestrian statue of Peter the Great (1770s; St. Petersburg) and was inspired to emulate the bold pose, but that would not have helped him technically. It is equally likely that he felt the dramatic composition was appropriate to his heroic subject, and that he tackled the problem of its design and casting with the bold ingenuity born of naïveté. He had a studio and foundry built in the capital city just south of the Treasury Building at 15th Street and Pennsylvania Avenue. By the spring of 1850 he had completed a full-scale plaster model. But when Mills, casting the metal himself, began work on the statue, he had to make six attempts before succeeding in December 1852. The popularity of the finished cast was such that a second one was later ordered for New Orleans and a third for Nashville, near Jackson's home.

Because of the handsome sums earned through these commissions, Mills must have quickly realized that small casts at modest prices would bring in continuing revenue and spread his reputation, just as engravings did for painters. Thus in 1855 he patented his design (patent issued May 15). Production soon began at the Philadelphia foundry of Cornelius & Baker, acting on Mills's behalf.

The North Carolina State Museum in Raleigh has a small plaster model that has been called the original. Several metal casts, including the one in the White House, also exist—some in white metal, others in bronze. They vary in details. For example, some of the horse blankets have tassels; others do not. The rocky base is sometimes long, as it is in the White House cast, and sometimes abbreviated. In his patent application Mills stated that "the size of the whole [depends] upon the fancy of the maker or user," and "it may be placed on a pedestal or not, as may suit the circumstances of the case."[2]

William MacLeod (1811–1892)

View of the City of Washington From the Virginia Shore 1856

Signed and dated lower left: Wm MacLeod / 1856
Oil on canvas, 38¼ x 54¼ inches (97.2 x 137.8 cm)
Gift of Mr. and Mrs. Richard M. Scaife, 1972

*I*n the foreground of a placid agricultural landscape an artist, a surrogate for MacLeod, sits upon a culvert sketching a panoramic view of the city of Washington. Cows graze and rest in a pastoral setting just in front of him, and people converse quietly at the picket fence. The month may be September, for the brightly lit field in the near middle ground has been harvested and is dotted with corn shocks.

The river in this painting was long thought to be the Anacostia, but a close comparison with George Cooke's *City of Washington From Beyond the Navy Yard* of 1833 (page 97) seems to rule this out. Cooke's painting is unquestionably from the Anacostia shore, with the Potomac on the left. The two dry docks in Cooke's work (they flank the three-masted schooner) are seen from a hillside southeast of the Capitol Building at no great distance. The upstream dry dock is viewed frontally; the taller dry dock downstream is viewed from the side. In the MacLeod painting, on the other hand, the downstream dry dock is presented frontally from a hillside at a great distance from the water, which must therefore be the Potomac.

It was a city in transition that MacLeod painted. The viewer can discern on the far bank the Capitol Building (in addition to the Navy Yard) shortly before the Bulfinch-designed dome was replaced by Thomas U. Walter's dome. At left stands the just-completed red sandstone Smithsonian Institution Building, and at the far left, grouped together, the half-finished Washington Monument, the incomplete Treasury Building, and the White House.[1]

MacLeod, a native of Alexandria, Virginia, must have been especially interested in recording this moment. The capital to which he had just returned after some ten years in New York City was much changed. Even Alexandria, which had been incorporated into the new District of Columbia, had recently been retroceded to Virginia.

Most of MacLeod's career in art lay ahead of him, and it coincided with the notable growth and maturation of Washington in the post-Civil War era. MacLeod was an active participant in the flowering of the city's artistic life, particularly as the first curator (1874–88) of the Corcoran Gallery of Art, one of a handful of great American museums founded in the same decade.

Andrew Andrews, attributed to (dates unknown)
View of Lake George c. 1850–60

Signed lower right: A Andrews
Oil on canvas, 25$\frac{1}{8}$ x 35$\frac{1}{16}$ inches (63.8 x 89.1 cm)
Gift of the White House Historical Association, 1975

*T*his idyllic landscape seems to fit into a decade, more or less, in American painting when the landscape was shown as serene and harmonious. There is a careful balance between left and right, near and far, dark and light. The oval format reinforces the introspective mood first announced by the artist sketching in the foreground. His coat laid aside revealing his red vest, intent on his sketchbook, he is witness to the expressive variety of nature: the craggy cliff with its waterfall and nestling mill; the stream flowing under a wooden bridge with a tiny figure on it; the distant lake seen at a narrow point with small islands scattered on it; the distinctive contour of the mountain; above all, the lovely grove at his back, through whose gently dancing trees the radiance of the sun reaches out to illumine the waning day.

When acquired for the White House, *View of Lake George* was believed to have been painted by *Ambrose* Andrews, active in New York City as a portrait painter in oil and watercolor. He was, it seems, only occasionally a landscape painter. More recently, the White House painting has been attributed to one *Andrew* Andrews who taught landscape painting in Buffalo, New York, and is said to have studied with Jasper Cropsey (pages 178, 208). Moreover, it has been suggested that he is the "A. Andrews" who exhibited landscapes in New York at the American Art-Union from 1847 to 1852 and at the National Academy of Design in 1848 and 1853.[1]

View of Lake George is in fact stylistically akin to Cropsey's work—for instance, in the relatively soft brushwork. The self-contained composition and the pensive tone are also consonant with the New England paintings of Frederic E. Church around 1850 (page 111). Other comparable second-generation Hudson River artists born in the 1820s are David Johnson (who studied with Cropsey in 1850) and James and William Hart (page 133). Still, the identification of "A. Andrews" of Buffalo remains uncertain, and the authorship of the White House picture cannot be substantiated without further research. Whoever its maker, *View of Lake George* remains a charming pastorale in paint, an unpretentious gem of mid-century American landscape art.

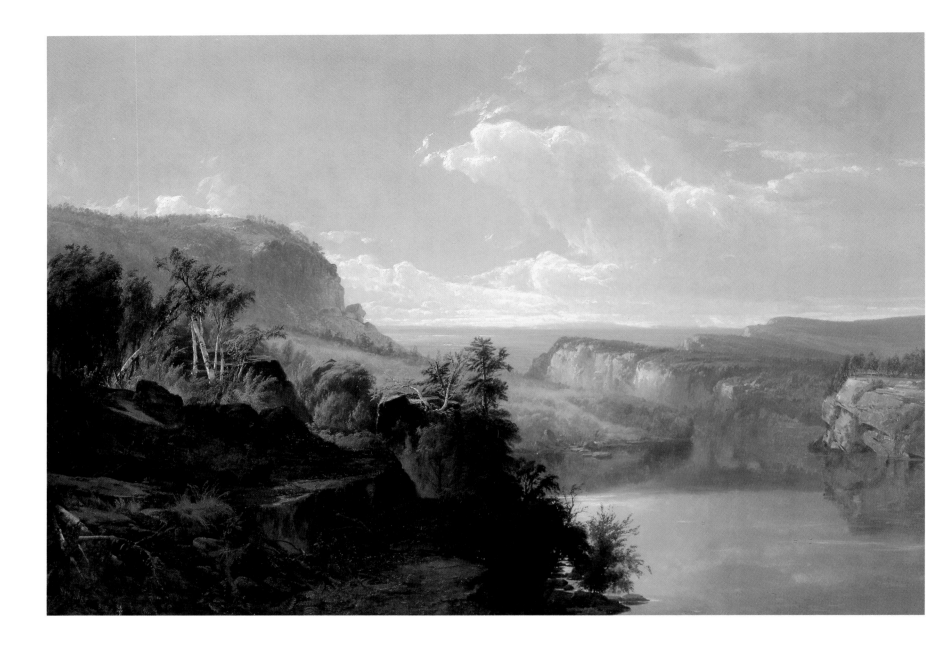

William M. Hart (1823–1894)
Lake Among the Hills (Lake Mohonk) 1858

Signed and dated lower left: WM. HART 58
Oil on canvas, 40⅛ x 60¼ inches (101.9 x 153 cm)
Gift of the White House Historical Association, 1976

*T*his large and spacious landscape combines a peaceful, intimate foreground and middle ground with a panoramic view of the plains in the distance. It is capped with a sweep of sky where azure blue alternates with the mother-of-pearl and fleecy white of the clouds. The whole is freshly painted in a light pastel palette, except for the contrasting darker, richly toned left foreground, which anchors the composition and provides entry into the pictorial space.

The narrow lake has been identified as Lake Mohonk near New Paltz, New York.[1] The lake lies in the Shawangunk Mountains, some 1,200 feet above the Hudson River Valley. The river can be seen meandering in the distance, far below. The canvas is freely painted throughout, often with delicate scumbles and blendings of color, as in the cliff faces along the river and the dreamy reflections of rock and sky in the water. Two black bears are the only living creatures. There is no sign of humankind, but there is an abiding sense of the wonder, the quiet amazement that the scene produced in the artist.

William Hart and his brother, James, who also became a landscape painter, were born in Kilmarnock, Scotland, emigrating with their family to Albany, New York, in 1831. After apprenticing as a decorative painter, William became an itinerant portrait painter in Michigan and in other midwestern states for several years. Back in Albany by 1849, he found a patron who financed three years of art study in Scotland. He established a studio in New York City in 1853, where he advertised as a landscape specialist and soon met with success.

Hart worked up his oils from superb pencil and white wash drawings—little-known gems of American art. Such detailed preparatory drawings must surely have been used in composing *Lake Among the Hills,* with its sharply focused stands of trees, its deliciously painted rock surfaces, and its grand cloud banks. The painting may be the one exhibited as *Lake in the Hills* at the National Academy of Design in 1858, the year in which Hart's artistic achievement was recognized by his election to the academy.[2]

After such youthful accomplishment Hart, in his post-Civil War work, took a surprising turn. Under the influence of the French Barbizon school and, more to the point, the influence of the wealthy Americans who doted upon Barbizon landscape paintings, both William and James increasingly favored cattle in pastures over pure landscapes, and a darker, Barbizon-inspired tonality over the fresh high-toned canvases typified by *Lake Among the Hills.*[3]

George Henry Durrie (1820–1863)
Farmyard in Winter 1858

Oil on canvas, 26 x 36⅛ inches (66 x 91.8 cm)
Signed and dated lower right: G. H Durrie / 1858
Gift of the Richard King Mellon Foundation, 1971

*I*nitially self-taught, Durrie studied briefly with portrait painter Nathaniel Jocelyn of New Haven, Connecticut. Although he journeyed to other states in search of portrait commissions, Durrie spent most of his life in New Haven. There, about 1850, he turned his attention to scenes of rural life and landscape, at which he excelled.

Farmyard in Winter is a large painting with a solid structure to match. The sloping roof of the saltbox house points toward the tops of a pair of great trees, crisply and delicately painted. They are the central focus. The barn and the snowcapped cones of hay anchor the composition at the left. Together with the tree and rocks in the right foreground, they fix the limits of the space, enclosing the heart of the farm and leaving only a small protected entrance.

The security of this arrangement, the physical and psychological well-being that it projects, is enhanced by the unhurried discharge of farm duties: a man pitching hay in the barn (detail), a boy carrying it to the cattle, another man with a yoke of oxen, and a woman drawing water from the well.

The sense of composure—of an implicit pact between man and nature—that suffuses *Farmyard in Winter* is not a reflection of the reality of 1858, of an industrialized America. Where are the railroads, the New England textile factories? Where is the exploding population and the accompanying doctrine of Manifest Destiny? The national issue of slavery, then a central concern of many New Englanders, does not impinge upon Durrie's winter solitude.

At mid-century many New England writers— among them Emerson, Thoreau, Alcott, and Whittier—shared similar ideals: self-reliance, family unity, and a Utopian dream of community. Whether reflectively or through breathing the air of shared sentiment, Durrie adopted unreservedly these ideals. Winter for these New Englanders was a favorite

season, carrying with it an invocation of an idealized past. Later in *Snowbound* (1866) Whittier was explicit:

> The worldling's eyes shall gather dew,
> Dreaming in throngful city ways
> Of winter joys his boyhood knew;
> .
> Sit with me by the homestead hearth,
> And stretch the hands of memory forth
> To warm them at the wood-fire's blaze!

George Henry Durrie ignored the crowded city and chose instead to depict a soundless, self-contained, and nearly anachronistic corner of American life.

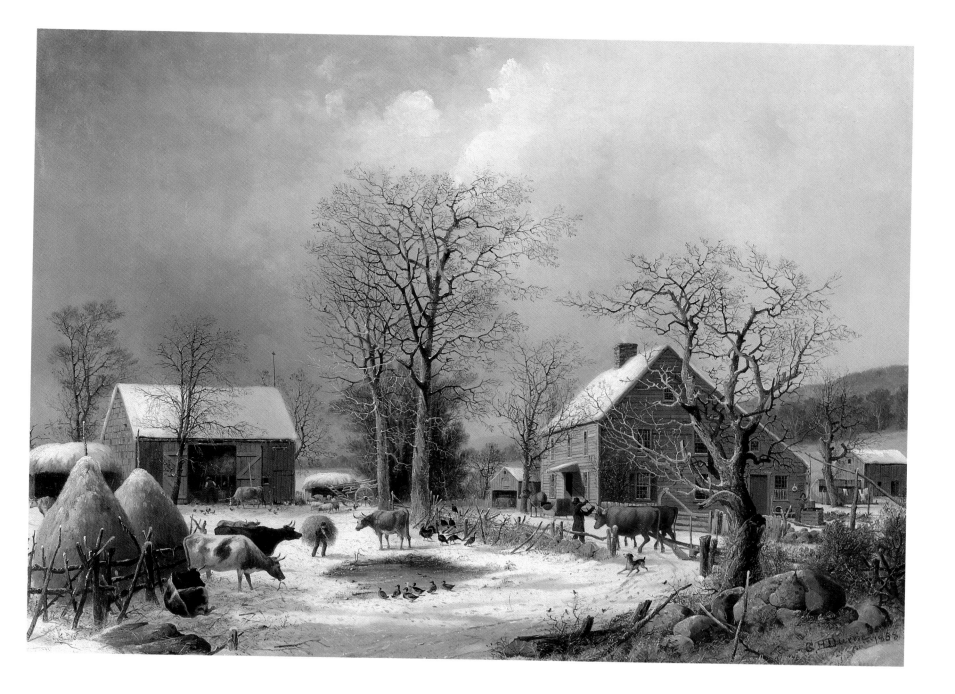

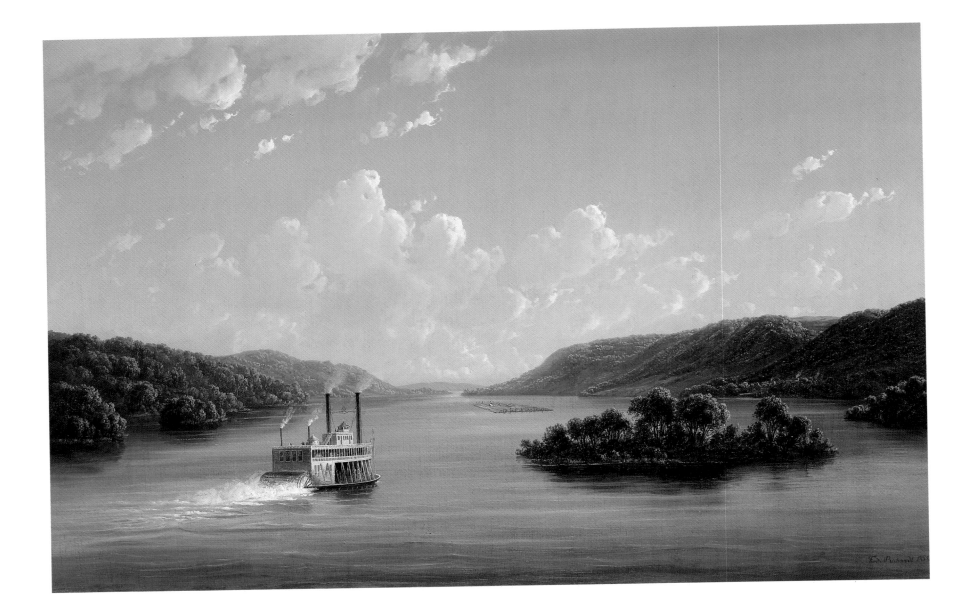

Ferdinand Richardt (1819–1895)
View on the Mississippi Fifty-Seven Miles Below St. Anthony Falls, Minneapolis 1858

Signed and dated lower right: Ferd: Richardt 1858 ~
Oil on canvas, 31¼ x 48¹³/₁₆ inches (79.4 x 124 cm)
Gift of Mr. and Mrs. Donald G. Dayton, 1971

A sternwheeler with double smokestack, hallmark of the Mississippi river steamer, plies its way upstream. Crisply painted in gray and white, it has the festive appearance of a wedding cake afloat. As it approaches the narrows, it closes on a large raft—almost an anachronism on the river by mid-century. The raft is empty—its "cargo" the logs with which it was constructed. It is a floating timber yard.

As Richardt explored America, he must have been fascinated by the western landscape and the then fashionable tour of the expanding frontier. Of Germanic ancestry, the Danish-born Richardt came to America in 1855. His decision to leave Denmark may have been related to the Schleswig-Holstein territorial dispute, a controversy fueled by ancient ethnic hostilities between Germans and Danes.

"Richardt" was the Americanized version of "Reichardt." The artist usually spelled his surname without an "e" when he worked in America, doubtless to simplify pronunciation. He established residence in New York City, though he traveled widely in North America, recording cities and natural wonders of his adopted country. These trips, between 1855 and the outbreak of the Civil War, have not been documented. His many paintings of scenes from the eastern seaboard to the Northwest Territory indicate his presence, but not the date of his travels. He was a prolific draftsman whose myriad sketches—"and his collections of them appear to be almost inexhaustible," a contemporary critic observed—became the grist for his painting mill in his Brooklyn studio.[1]

Sometime in 1856–57 he traveled westward to the Mississippi, where he made sketches of the river from Rock Island, Illinois, to St. Anthony Falls at Minneapolis. This region had been opened dramatically by the completion of the railroad line from Chicago to Rock Island in 1854. Even 20 years earlier artist George Catlin had proclaimed it a part of the Far West "which is now made so easily accessible to the world, and the only part of it to which *ladies* can have access." Catlin, dismissing the traditional "stale and profitless [probably European] 'fashionable tour,'" recommended to travelers the latest " 'Fashionable Tour,' a trip to St. Louis; thence by steamer to Rock Island, Galena, Dubuque, Prairie du Chien, Lake Pepin, St. Peters, Fall of St. Anthony, back to Prairie du Chien, from thence to Fort Winnebago, Green Bay, Mackinaw, Sault de St. Mary, Detroit, Buffalo, Niagara, and home."[2]

Catlin wrote of "the magnificent bluffs, studding the sides of the river, . . . [that] give peculiar pleasure, from the deep and soft green in which they are clad up their broad sides." He specifically mentioned "Lake Pepin, between whose magnificently turreted shores one passes for twenty-two miles." A scholar at the Minnesota Historical Society has suggested that Richardt's *View on the Mississippi* depicts a spot at the head of Lake Pepin where the waters again narrow to the river channel. If so, the small settlement on the right where chimney smoke can be seen would probably be Bay City, Wisconsin.[3]

A closely related painting by Richardt in the collection of the Minnesota Historical Society, dated 1857, may show the same northern part of Lake Pepin from a little farther downstream. There are two steamers in that painting; one appears to be the same as that in the White House's *View on the Mississippi*. The two works were, in all likelihood, based on the same drawing from the artist's "almost inexhaustible" collection. It should be added that 1858, the year of the White House painting, was also the year that Minnesota was granted statehood.[4]

Ferdinand Richardt (1819–1895)
Independence Hall in Philadelphia *c.* 1858–63

Signed lower right: Ferd: Reichardt.[1]
Oil on canvas, 37¼ x 65⅝ inches (94.6 x 166.7 cm)
Gift of Mr. and Mrs. Joseph Levine in memory
 of President John F. Kennedy, 1963

We are in the literal and symbolic heart of a famous and prosperous American city. Scores of citizens from every walk of life throng the scene at Sixth and Chestnut Streets. It is a quarter before noon on a warm summer day (see the clock on the tower and the open windows of the Philadelphia County Court House—now known as Congress Hall—at the right). The painted sides of the public carriage announce that it runs along Chestnut Street and then to the Fairmount Water Works, a popular spot for leisurely outings, while an up-to-date horse-drawn streetcar is just coming into view at the right along the tracks laid in 1858 on Sixth Street.[2]

Ferdinand Richardt's penchant for the precisely characteristic detail is evident everywhere. At the right, for example, he deftly stages a seven-figure scene that is a small cross section of Philadelphia. A black child with dog and basket stands slightly apart from two white boys with their delivery cart. In front of them stand a pair of handsomely dressed ladies and their equally elegant escort; a little behind them is the distinctive figure of an Italian immigrant peddler with a tray of terra-cotta figurines balanced upon his head. Another immigrant with hurdy-gurdy and monkey strolls with his family in the left center foreground.

Although the facades of all the buildings except the courthouse are obscured by trees, Richardt has included a glimpse of the top of the Jayne Building in the distance at the left, beyond the classical portico of the former Second Bank of the United States. The Jayne Building, at 242–44 Chestnut Street, was the tallest structure in Philadelphia. Built in 1849–50 and demolished only in 1958, this prototypical skyscraper rose eight stories and was crowned by a two-story tower. Richardt has placed it and another recent addition to the city—the horse-drawn streetcar—at the painting's margins. At the center the tower and spire of Independence Hall rise dramatically. The artist's patriotic intention can hardly be doubted, since the tower and spire of the already legendary structure are spotlighted, together with the flag, by shafts of sunlight breaking through dark clouds.

Richardt had come to America from Denmark in 1855 to paint Niagara Falls. He did so dozens of times, earning a wide reputation for his "Great Niagara Gallery." Although *Independence Hall in Philadelphia* must have been sketched in 1858, it probably was not painted until several years later. It was not included in a January 1859 exhibition staged by the artist at the National Academy of Design in New York, nor was it among the works for sale on March 10 at the auction of what Richardt ("being on the point of leaving the country") advertised as his "entire collection of Paintings of American and Danish Scenery."[3]

Richardt did leave the country; he moved to London. In late 1863 he mounted a critically acclaimed exhibition in his studio that included, in the words of a reviewer, "some of the principal streets and edifices in New York and Philadelphia, and other cities with eminently characteristic groups of figures."[4]

Independence Hall in Philadelphia was probably among these city paintings. Richardt must have completed it in London from sketches. In the London review just cited, his name is spelled "Reichardt," as it is on the painting. Had the artist painted the work in America, he would most likely have signed it "Richardt," as he had his *View on the Mississippi* (page 137). After the Civil War Richardt returned to the United States, and by 1873 he had settled in San Francisco.

His Independence Hall painting must have traveled from London to India, then under British dominion. It made a startling reappearance in the 1960s in an estate sale in Hyderabad, where it was purchased by an American antique dealer for seven dollars!

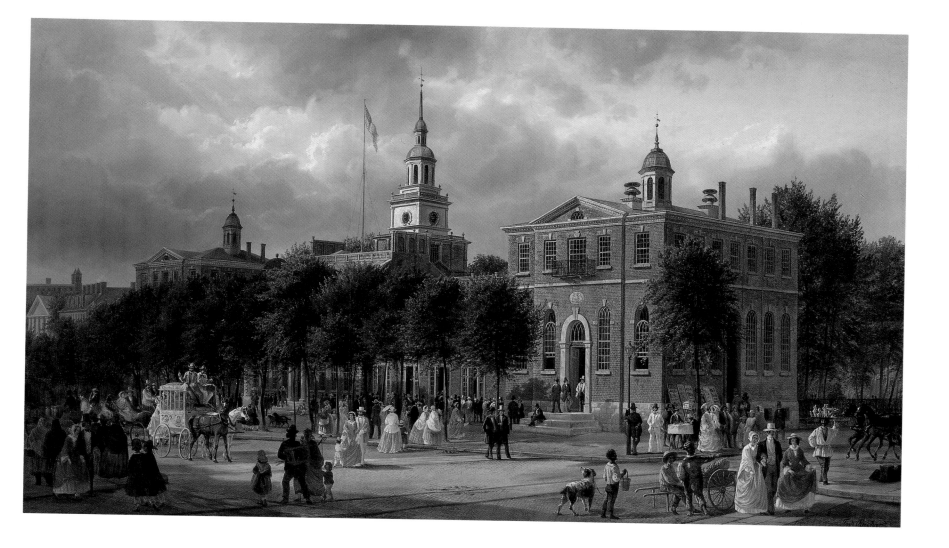

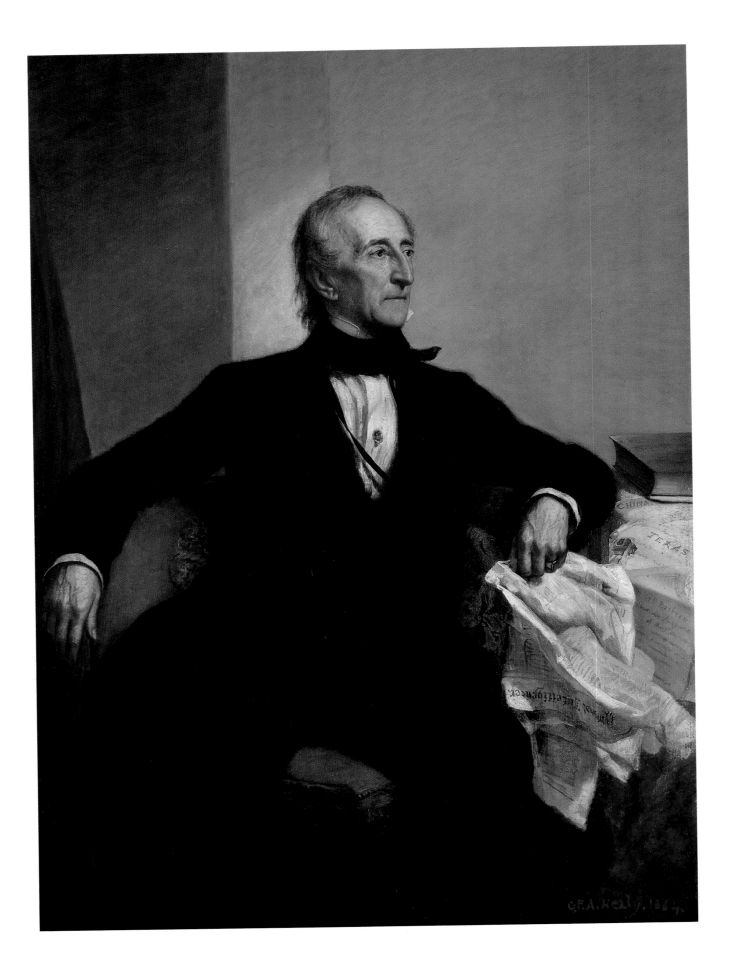

George P. A. Healy (1813–1894)
John Tyler 1859

Signed and dated lower right: G.P.A. Healy. 1864.
Oil on canvas, 62 x 47⅛ inches (157.5 x 119.7 cm)
United States government purchase, 1859

On April 4, 1841, John Tyler became the first Vice President to succeed to the Presidency upon the death of his predecessor. Tyler (1790–1862), a Virginian, had been nominated to attract the southern vote to the Whig candidacy of William Henry Harrison. Naturally, he had differed radically with the Whigs on the thorny question of states' rights. Now he asserted his presidential prerogative, the veto, with authority—especially on the bill for a national bank, which he opposed. Although his vetoes were upheld until the last day of his Presidency in 1845, the Whigs had already read him out of the party in mid-September 1841 for his refusal to do its will. The man already popularly dubbed "His Accidency" became known as the "President without a party."[1]

No wonder that when Charles Dickens was presented to Tyler at the White House in 1842, the eminent novelist reported that the President "looked somewhat worn and anxious, and well he might; being at war with everybody—but [Dickens added] the expression of his face was mild and pleasant, and his manner was remarkably unaffected, gentlemanly, and agreeable. I thought that in his whole carriage and demeanour, he became his station singularly well."[2]

The White House portrait, despite its prominently displayed date of 1864, was actually painted in 1859. It was one of six presidential portraits by George P. A. Healy commissioned by an 1857 act of Congress in an attempt to assemble a complete collection of Presidents for the White House. Healy must have inscribed "1864" on this painting to make it seem more up-to-date, since the Civil War had delayed the framing and hanging of the group until 1867. Three of them were painted from life; two were posthumous; and this one of John Tyler was an updated and enlarged version of a much earlier portrait with the aid of another sitting.

In 1842 Healy had gone to Washington to paint

a copy of Gilbert Stuart's full-length *George Washington* (page 66) for Louis Philippe, the King of the French. The so-called Citizen King had commissioned the American artist to paint a gallery of American notables for his collection. It was reported that while there he also undertook "other work for public institutions and private individuals."[3] The king asked for a portrait of President John Tyler, and so did the National Institute, one of the capital's earliest cultural organizations. To the latter petition of May 30, 1842, Tyler replied the following day: "In answer to your note . . . requesting me to sit for my portrait to Mr. Healy, a distinguished American Artist, I have to say, that I do not feel myself at liberty to decline a request so flatteringly made."[4] Although the 1842 portrait of Tyler is unlocated, it was probably a smaller half-length portrait similar to that now in the National Portrait Gallery, without the more elaborate setting and accessories. Healy is known to have visited Tyler in retirement at Sherwood Forest, his home in Virginia. There he painted the Portrait Gallery version on February 25, 1859 (inscribed on the back), obviously after he had already completed the large composition for the White House (for which he acknowledged payment on February 28).[5]

Healy was a keen student of history, both political and personal. He clearly understood Tyler's political dilemma and admired the integrity with which the President had confronted it. The two men are known to have enjoyed each other's company at their first meeting; in the winter of 1858–59 they met again and this time embarked upon a pictorial exercise in historical justification.

The picture is a large three-quarter-length one, inherently commanding, that Healy uses fully to suggest an innately patrician and dispassionate character. The President firmly straddles the corner of his chair, his spread arms virtually spanning the

picture's breadth. His head and shoulders are set in relief against the cool gray wall and pure, pale blue sky that seem to lift him serenely above the tumult of political life represented by the jumble of documents beside him.

But those documents also represent his convictions and the achievements of his administration. Beneath the book a paper titled "CHINA" refers to the 1844 treaty, negotiated by Tyler's commissioner Caleb Cushing, that gained for Americans access to Chinese ports already open to European trade and, just as importantly, guaranteed Americans in China extraterritorial jurisdiction in civil and criminal matters. Below that a document with a pink and blue seal bears the headline "TEXAS." It refers to the event that Tyler regarded as the capstone of his administration, the annexation of Texas by joint resolution of Congress on March 1, 1845, three days before he left office.

Farther down, hanging over the edge of the table, is a manuscript document on which we can clearly read only "Eastern." It must refer to the Webster-Ashburton Treaty of August 1842 that adjusted the northeastern boundary between the United States and Canada and averted the possibility of another war with Great Britain. Negotiated by Secretary of State Daniel Webster, this was the earliest diplomatic success of the Tyler Administration, strongly supported by the Senate. None of these papers could have been in the 1842 portrait of Tyler, because Healy painted it before the events occurred.

The symbolically weighted documents are visually outweighed by the newspaper that Tyler holds in his hand (detail). Its irregular shape is splendidly alive, sending a jolt of energy through the painting and providing a perfect foil to the impassive head. But surely this is no way to treat a newspaper— especially the venerable *National Intelligencer*. In crumpled disarray, it suggests that the President was displeased with that day's (or every day's) edition of the paper. So he was.

The paper, edited for the previous 30 years by Joseph Gales and William Seaton, was the precursor of the *Congressional Record* and the official administration organ during six Presidencies, not through partisanship but through integrity and an acquired knowledge of the workings of government and patronage. But the editors were longtime supporters of Henry Clay, and Clay led the anti-Tyler faction in the Whig party (and became its next nominee for the Presidency). The policy clash over a national bank (strongly supported by Clay) that precipitated the September 1841 debacle for Tyler had resulted in the resignation of the entire Cabinet except for Daniel Webster, who was deep in treaty negotiations. Gales and Seaton had been forced to choose between Clay and the administration; they had opted for Clay. Tyler had responded without hesitation:

> I can no longer tolerate the Intelligencer, as the official paper. Besides assaulting me perpetually, directly and indirectly, it refuses all defensive articles. . . . There is a point beyond which one's patience cannot endure.[6]

Healy and Tyler had obviously agreed, in 1859, to recall and fix that point of exasperation for future observers. The *Madisonian*, edited by Thomas Allen, thenceforth became the administration's paper.

This portrait is as complex in its characterization as in its composition. It displays the sitter's aristocratic "carriage and demeanour" so admired by Dickens as well as his pride in his accomplishments. There are passages of exquisite painting here, such as the delicately veined hands and the soft, unruly hair. Tyler's imperial head is held high, and his mouth hints of defiance, his aspect like that of an eagle in its aerie.

Thomas Ball (1819–1911)
Daniel Webster (right) 1853 and *Henry Clay* (left) 1858

Daniel Webster: Inscribed on reverse of drapery: T Ball Sculpt / Boston Mass / 1853 /
 Patent assigned to / G W Nichols; foundry stamp on base (cast separately),
 lower center: J T AMES / FOUNDER / CHICOPEE / MASS / 17
Bronze, 30 x 13 x 11 inches (76.2 x 33 x 27.9 cm)
Henry Clay: Inscribed on reverse of drapery: T. BALL Sculpt Boston 1858;
 inscribed on reverse of base (cast separately): PATENT assigned to G W Nichols /
 Ames Co. Founders / Chicopee / Mass ~
Bronze, 31 x 12 x 10 ¾ inches (78.7 x 30.5 x 27.3 cm)
Gifts of Mr. and Mrs. James W. Fosburgh, 1961

*T*hese posthumous, cabinet-size sculptures of the two preeminent political orators of their era are important documents in Thomas Ball's early career as a sculptor. Born in Charlestown, Massachusetts, Ball first worked as a miniaturist and portrait painter, with a studio in Boston. He turned to sculpture in 1850. *Daniel Webster* and *Henry Clay*, made five years apart, bracket his first trip to Europe, where he studied and worked in Florence from 1854 to 1857.

The small bronze *Daniel Webster* in the White House is fourth in a series of likenesses of Webster (1782–1852) created by Ball. He had already painted a full-length cabinet-size portrait, a cabinet bust (which he had deemed a failure and destroyed), and a life-size bust. "His face was constantly before me in colossal form," he wrote. While working on the life-size bust, Ball heard that the great man was to pass through Boston. "You may be sure," wrote the artist, "I was at the door to have a good look at him."[1]

Ball's timing was fortuitous but melancholy, for Webster died on October 24, 1852, just after the life-size bust was completed. Using this bust, Ball produced the cabinet-size sculpture as a model for a proposed life-size statue for a Boston park. Failing to receive the commission, he sold the model, from which the statuette now in the White House was cast, and the reproduction rights for $500.[2]

The stoic, stolid, and slightly stout figure of the retired senator seems marked by fatigue. The beetle-browed, cadaverous face is as unanimated as the body. In part, this iconic character reflects the "kingly, majestic, godlike" presence of Webster, noted by many. But Webster, whose last years were shadowed by sectional vilification for his principled role in the Compromise of 1850, was a man in sorrow and decline when Ball portrayed him.

The matching bronze of Henry Clay (1777–1852) was cast in 1858, the year after Ball's return to Boston. Ball created it, he wrote, "as a companion to my Webster." The greater vigor and authority of his *Henry Clay* must be due in part to the lessons of his Italian sojourn. In contrast to the Webster, the figure of Clay is presented in an animated, fluid stance. The head, especially finely modeled in the temples and brow, projects an alert intellect.

Each of the figures stands beside a broken column, a symbol of fortitude alluding to the biblical tale of Samson. At the cost of his own life, the hero had crushed his enemies, the Philistines, by pulling down the columns supporting their house. For Ball, the twin Samsons Webster and Clay—who worked heroically for national compromise and died in the same year—were saviors of the democratic order and of the Union.[3]

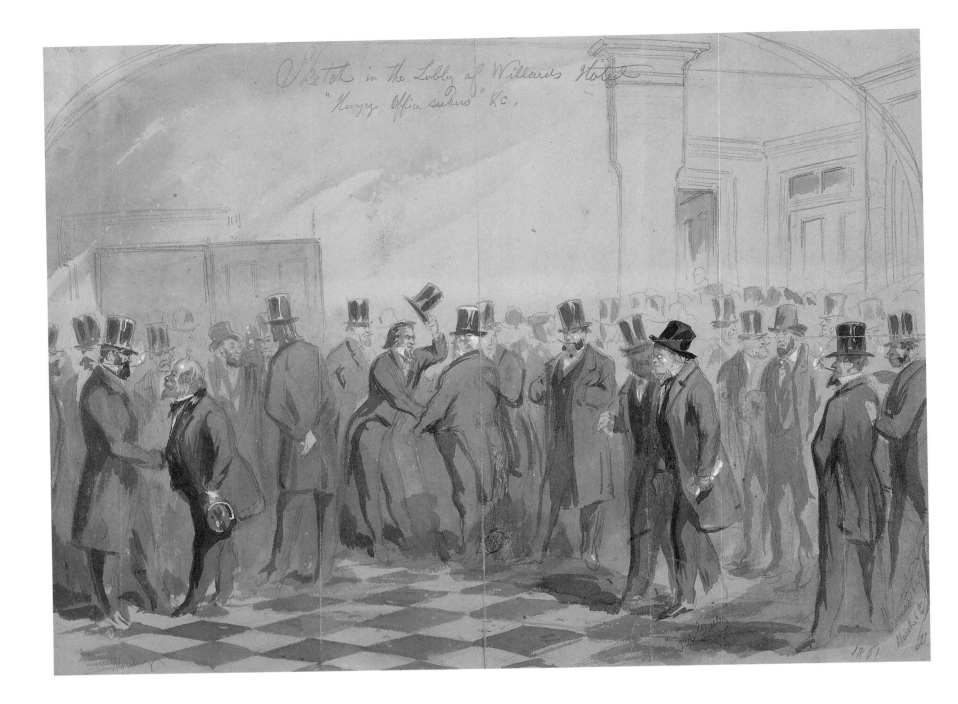

Sketch in the Lobby of Willards Hotel
"Hungry Office seekers" &c,

Thomas Nast (1840–1902)
Hungry Office Seekers 1861

Signed and dated lower right: 1861 / Thomas Nast / March 6th 1861
Pencil, ink, and wash on paper, 10 x 14 inches (25.4 x 35.6 cm)
Gift of Mr. and Mrs. Walter Fillin, 1964

This delightful "Sketch in the Lobby of Willards Hotel" is a paradoxically spirited aside in the unfolding drama of the Civil War. The scene is Washington's leading hotel; the time, two days after the inauguration of Abraham Lincoln as President of a nation in crisis. Lincoln had announced his determination to preserve the Union, but he had also made known his willingness to compromise to achieve his aim. One man prominent in this drawing had been instrumental in the Republican nomination of Lincoln. He was Horace Greeley, the influential editor of the New York *Tribune*, and he had come to Washington for the inauguration. An intransigent antislavery man, he believed that Lincoln would make abolition central to his administration. He was soon angered by the President's compromise posture.

Although his name is penciled below him, "Old Greely" [*sic*] would have been instantly recognizable by his "mild, pink face, fringed by throat whiskers, his broad-brimmed hat, . . . crooked cravat, his shambling gait and absent-minded manner. . . ."[1] Here he is seen in the right center, holding a rolled paper in his hand and listening to the urgings of a top-hatted gentleman.

Willard's Hotel was just two blocks from the White House, and it was there that Lincoln stayed and spent almost all his time during the pre-inauguration week. As a historian of the city has written: "Willard's held an unprecedented collection of men notable in public affairs, civil, military and naval. Republican leaders were there to confer, and delegations to press their advice. . . . Past the new President, from early morning until late at night, streamed minor politicians, place seekers, editors, reporters and handshakers."[2] At the end of March, with the President in the White House, a diarist could still record: "The great employment of four-fifths of the people at Willard's at present seems to be to hunt senators and congressmen through the lobbies. . . . There are men at Willard's who have come literally thousands of miles to seek for places which can only be theirs for four years. . . ."[3]

Another name, "Morrissey," is penciled onto the drawing in the lower left corner. It refers to the man in the left foreground shaking hands with a shorter, rather Dickensian gentleman. Many people had gathered near Willard's to catch a glimpse of Lincoln, but when he did not appear "the sight-seers had to content themselves with the spectacle of the pugilist, John Morrissey, promenading in a stovepipe hat."[4] Morrissey was a champion bare-knuckle fighter who was later elected to Congress. The Dickensian gentleman is Frank Leslie, editor of *Frank Leslie's Illustrated Newspaper,* who had given German immigrant Thomas Nast his first job as an illustrator when he was only 15.[5]

Thomas Nast, who would later become famous for his crusade against the notorious Tweed Ring—politicians who defrauded New York City—through his political cartoons in *Harper's Weekly*, was just 20 and working as a pictorial reporter for the *New York Illustrated News*. He spent some weeks in Washington preparing a series of drawings that were reproduced as wood engravings. One closely related drawing by Nast in the Library of Congress shows the ladies' parlor at Willard's Hotel, also dated March 6, 1861.[6] The young illustrator was deeply stirred by the sense of foreboding that pervaded the capital, amid fears that an attempt would be made on Lincoln's life: "It seemed to me that the shadow of death was everywhere. . . . It was as if the whole city were mined, and I know now that this was figuratively true." His ardent support of the Union through his cartoons would lead Lincoln, near the end of the war, to call him "our best recruiting sergeant."[7]

Wordsworth Thompson (1840–1896)

Cannonading on the Potomac, October, 1861 *c. 1868–70*

Signed lower right: Wordsworth Thompson
Oil on canvas, 33³/₁₆ x 70⁹/₁₆ inches (84.3 x 179.2 cm)
Gift of The Edward and Mary Warburg Fund, 1962

The events of the Civil War were widely pictured through engraved illustrations in periodicals but much less often in paintings. Thompson gave us both. Born in Baltimore, Maryland, he left his father's law office after two years, setting up a studio there in 1861. In that first year of the war, with Confederate troops advancing on the capital, the youthful Thompson spent much time in Maryland and Virginia, sketching the Union troops and the sites of battles for engravings in *Harper's Weekly* and the *Illustrated London News*.

Such sketches were the basis for this painting, which almost certainly depicts an episode of October 20, 1861, that had serious consequences for the Army of the Potomac.[1] It occurred near Leesburg, Virginia, some 40 miles upriver from Washington. Hoping to cause the Confederates to withdraw by making them think a full-scale attack was imminent, Gen. George B. McClellan made a suggestion to division commander Gen. Charles P. Stone on the Maryland side of the river: "Perhaps a slight demonstration on your part would have the effect to move them." That afternoon at Edwards Ferry, east of Leesburg and just below Harrison's Island, Stone had his artillery fire several shells across the river.

The casualness in Thompson's rendering of the scene reflects the reality. That only one cannon seems to be firing indicates the desultory nature of the maneuver. The commanding officer astride a white horse calmly scans the distance with his field glasses, while soldiers converse with a black man. Members of the drum corps lounge about, and the air of nonengagement is in keeping with the softly painted autumnal centerpiece of the scene, pumpkins scattered among corn shocks. This passage typifies the artist's palette of lilac, strawberry pink, slate green, russet, and an intense pale blue. All the details are subordinated to the panoramic sweep of the landscape, itself calm and peaceful despite the puff of smoke

from the cannon. In fact, it had been a humdrum day. But then General Stone sent a patrol from Harrison's Island to the Virginia shore. Climbing a 100-foot-high bank called Ball's Bluff after dark, the soldiers thought they spotted an unguarded Confederate encampment. They dispatched their report to Stone who, on his own initiative, sent additional reconnaissance troops. The troops discovered that the "encampment" had been a moonlight illusion, but they continued to advance.

A chance encounter with a detachment of soldiers from a Confederate battalion stationed not far away resulted in the first clash "in a field where corn was standing in shocks." Under pressure the Federal troops retreated to the high ground of Ball's Bluff from which, in the early evening of October 21, they were disastrously driven over the edge and into the Potomac. More than a hundred drowned. The battle ended with the capture, wounding, or death of more than 850 Union men. The lazy October scene of the previous day painted by Thompson seems terribly ironic in the face of the succeeding tragedy.[2]

Although the action depicted occurred in October 1861, the painting, so poised and accomplished, must have been executed much later from sketches, since Thompson left America before the end of 1861. He spent some six years studying in Paris and traveling widely in Europe. *Cannonading on the Potomac* is sufficiently skillful to suggest the benefit of his European training, so we may assume that it was painted after his return (probably in late 1867) to America. He settled in New York City in 1868, where he at once began to exhibit at the National Academy of Design. There, in 1870, he showed a painting called *Reminiscence of the Potomac—Cannonading across the river ten miles below Point of Rocks*. Edwards Ferry is in fact about ten miles below Point of Rocks; therefore, the painting must be the one now in the White House.[3]

148

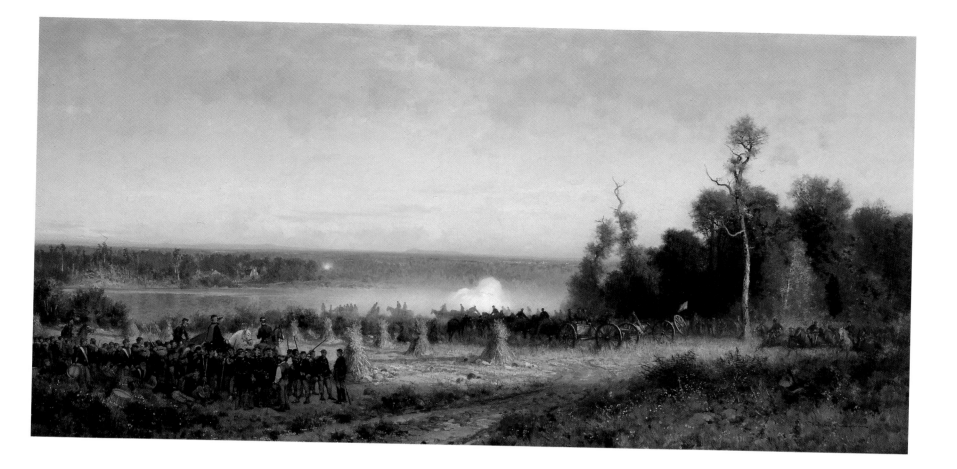

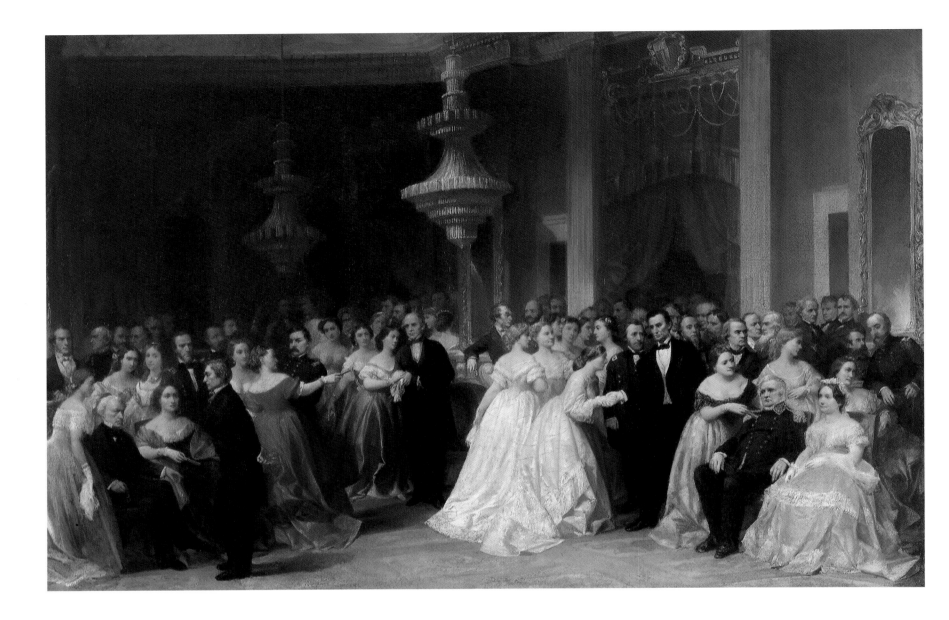

Peter F. Rothermel (1812–1895)

The Republican Court in the Days of Lincoln *c.* 1867

Oil on canvas, 23⅝ x 37⅛ inches (60 x 94.3 cm)
Gift of Mr. and Mrs. Winslow Carlton in memory of Maj. William J. Carlton, 1962

This rare depiction of a formal reception in the East Room of the White House during the 1860s represents not an actual occasion but an imaginary one. Rothermel brings together many important persons— statesmen, soldiers, and civilians—who might have attended such a gathering, though they would not all have attended the same event.[1] "Republican Court" refers not to the political party but to the American Republic. The title echoes that of an earlier painting, *Republican Court in the Days of Washington,* by Daniel Huntington (1861; Brooklyn Museum).

An undated broadside published in New York announced a projected engraving of Rothermel's painting, deeming it a companion work to Huntington's. The two together were billed as representing "the two great epochs of the Country's history, 'The Revolution and the Rebellion.'" Of the Rothermel piece the broadside stated:

> This great historical work has engaged the attention of Mr. Rothermel for nearly two years, and is intended to give to the present generation and to posterity, portraits of the prominent personages of the time, in the most pleasing manner possible.
>
> The scene is laid at the "Second Inauguration." The picture is to be engraved in the highest style of the art.[2]

Rothermel's history paintings were generally large; the White House painting must have been the model for the engraver. It is approximately the same size as the *engraving* of the Huntington (21 x 35 inches). The engraving of the Rothermel, if executed, is unknown.

In a review in the *New-York Daily Tribune* of March 12, 1867, Rothermel's *Republican Court* was linked with Huntington's. It was obviously a large version, since Huntington's painting measures 5½ x 9 feet. The writer praised Rothermel's work as superior and

among the "best of the long history of similar pictures painted in our country." Less than two years later the large picture was destroyed by fire.[3]

Rothermel's gathering is divided by the great chandelier, with the emphasis on the right half. There a bright cluster of gowns frames the dark figures of President Lincoln and of General Grant, who presents his wife. To the President's left, Mary Todd Lincoln touches her fan to the shoulder of the corpulent Gen. Winfield Scott, who is unresponsive. In fact, Scott was dead (May 29, 1866), as the broadside for the engraving duly noted. While Rothermel must have used photographs or other visual records for most if not all his figures, he failed to breathe life into Scott.

In the left half the dominant foreground figures include the seated statesman and orator Edward Everett (who had died on January 15, 1865, even before the Second Inauguration that the painting was said to represent) and the standing Secretary of State William Seward; the red-haired Gen. William T. Sherman stands between and beyond them. In the center the man nearest the chandelier is Chief Justice Salmon P. Chase.

Rothermel must have re-created the East Room from prints and photographs. The earliest known photograph of the room, from 1861, shows a different carpet but the same chandeliers, which had been installed during the Jackson Administration and subsequently converted to gas.

Born in Luzerne County, Pennsylvania, and raised in Philadelphia, Rothermel studied art briefly. He began as a portraitist but turned to historical subjects in the early 1840s. He went to Europe in 1856, lived in Rome for two years, exhibited at the 1859 Paris Salon, and returned to Philadelphia. Active in the affairs of the Pennsylvania Academy of the Fine Arts, Rothermel was extravagantly admired for his use of color and for his skill in managing large, multifigure compositions.[4]

William Tolman Carlton (1816–1888)

Watch Meeting—Dec. 31st 1862—Waiting for the Hour 1863

Inscribed lower edge: the title as above, in capital letters
Oil on canvas, 29⅜ x 36¼ inches (74.6 x 92.1 cm)
Gift of the Republican National Finance Committee, 1976

*W*aiting for the Hour—the abbreviated title of this painting—depicts a congregation of slaves on the eve of January 1, 1863, moments before the Emancipation Proclamation would take effect. Carlton may have conceived his painting when the preliminary announcement of the proclamation was made, on September 22. The composition is profoundly simple, but the red-brown palette cloaks the scene in obscurity, especially in reproduction. Set within a barnlike space is a crowd of figures, illuminated by a flaring torch. Through a doorway at the left, one glimpses others; above them glows a cross with a star in its center in the night sky. In the doorway stands a man with the Union flag draped over his arms. At his feet a woman prostrates herself in awe and supplication. From this point a rising diagonal orders the throng. A handsomely dressed white woman, with tears in her eyes, gazes at the black woman beside her. The only white person present, she is picked out by the light, suggesting that she may be the slaves' mistress, joining them for the moment of deliverance. For the artist she also embodied the abolitionist movement.

At the center a half dozen figures cluster around a crate turned on end. Partly visible lettering reveals that it contained supplies of the Sanitary Commission, the precursor of the Red Cross. Now it has become a kind of altar, promising spiritual rather than physical succor. An old man in white shirt and red vest holds a large pocket watch with a fob in the shape of an anchor, a Christian symbol of hope. Most eyes are turned toward the watch, whose hands proclaim five minutes before midnight—before emancipation. The watch is the compositional center of the picture, spotlit and framed in the dark hand. The left hand lightly touches a book, presumably the Bible. The diagonal rise culminates in the torchbearer, whose nude torso and togalike drapery recall classical allegorical figures, and whose brand illuminates not only the scene below but also the Emancipation Proclamation itself nailed to the wall. The selectively legible words begin "PROCLAMATION/I Abraham LINCOLN" and conclude "SHALL BE EVER FREE ON JANUARY 1. 1863." Most moving of all, perhaps, is the inscription that gives the painting its title on links of chain across the bottom. In the composition and in some individual figures are found echoes of Italian art, but it is a native spirit, informed by passionate belief, that resonates from this painting.

Largely unknown today, Carlton in 1863–64 could count among his students and patrons many abolitionists, including the prominent Lowell clan of New England.[1] A number of these patrons subscribed to the purchase of his *Waiting for the Hour*, sending it to President Lincoln under the aegis of the leader of the antislavery movement, William Lloyd Garrison. The painting was delivered to the White House in early July 1864.

When the President, preoccupied during the closing months of the war, failed to acknowledge receipt of the gift, Garrison wrote to him (January 21, 1865) about the picture, "deemed by critics and connoisseurs, artistically speaking, an admirable painting," whose donors had contributed "upwards of five hundred dollars." He continued, "This meritorious picture [was] executed by a most conscientious and excellent artist."[2]

The painting apparently left the White House with Mrs. Lincoln after the assassination. The version now in the White House is neither signed nor dated. Hanging in the Lincoln Bedroom (which was actually Lincoln's office), it came into the collection during the Nixon Administration, having descended in the artist's family. It was probably the artist's first, sketchier study; the Garrison–Lincoln painting most likely is another canvas, presently unlocated.[3]

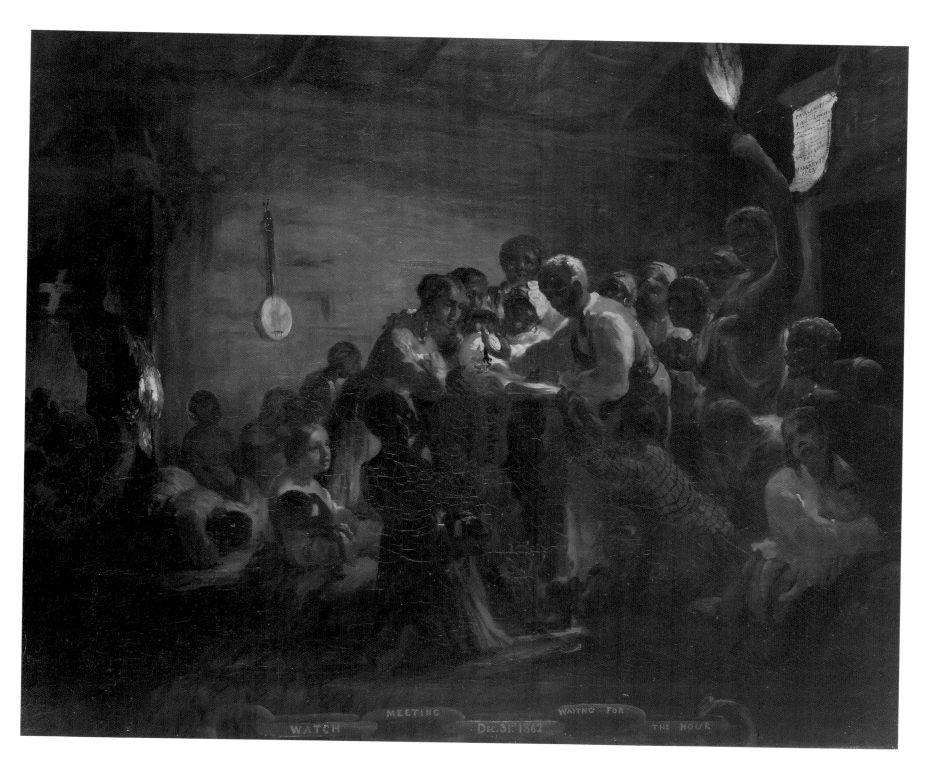

WATCH MEETING — DEC. 31ST 1862 — WAITNG FOR THE HOUR

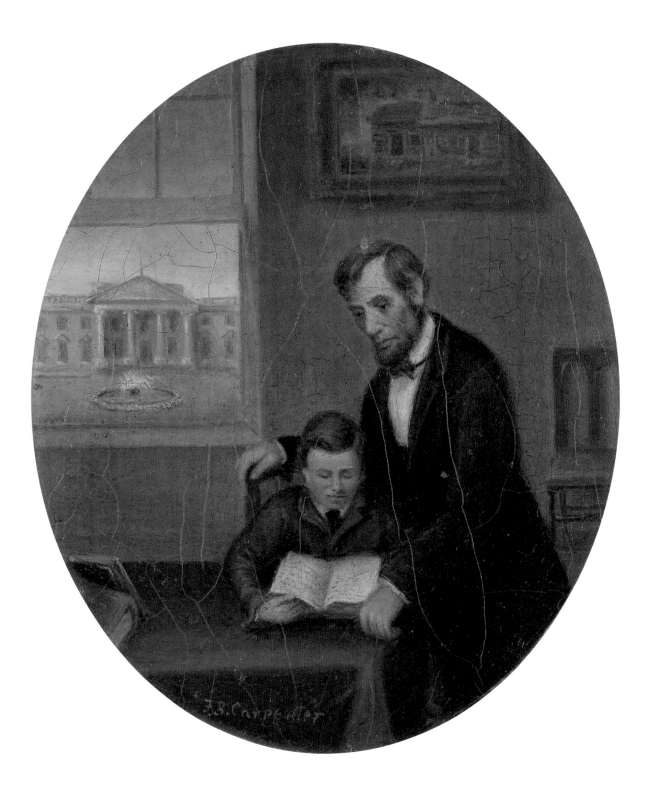

Francis Bicknell Carpenter (1830–1900)
Lincoln and Tad c. 1873–74

Signed lower left: F.B. Carpenter
Oil on paperboard (oval), 3¾ x 3³⁄₁₆ inches (9.5 x 8.1 cm)
Gift of The A. Jay Fink Foundation, Inc., 1963

There is no more touching evocation of early presidential families than this sober miniature of President Lincoln and his youngest son, Tad (Thomas). At once realistic and symbolic, it possesses a power to move and to stir the imagination that might be the envy of more noted painters.

A native New Yorker, Carpenter had already earned recognition for his portraits of prominent political and civic contemporaries. He sought and gained an invitation to be a guest in the White House, where he stayed for several months in 1864 to portray the first reading of the Emancipation Proclamation to Lincoln's Cabinet. (The painting now hangs in the U. S. Capitol.)[1] To aid in the composition, the artist arranged for photographs of Lincoln and the other participants to be taken at Mathew Brady's studio and in the White House. On February 9 a photograph was made by Brady's assistant Anthony Berger; through a woodcut in *Harper's Weekly* this photograph—the seated Lincoln looking at a photograph album with Tad standing beside him—became central to the Lincoln iconography.[2] And this picture, taken in Carpenter's presence, was to serve the artist years later as the stimulus for the small painting of *Lincoln and Tad*. It is possible that Carpenter was moved to do the miniature by Tad's premature death in 1871 at age 18.

Seated at the corner of a table covered with a green cloth, the boy looks intently at his book. Two other volumes lie at the left. Lincoln stands beside him, father and tutor, his arm on the chair back and the curved fingers of his left hand resting tentatively on the table near the book. Though the President's head is inclined, his gaze does not fall on the pages. Instead, he is shown in a moment of introspection, his meditative expression removing the scene from the everyday and suggesting the symbolic.

Just above his head is a framed painting of a log cabin, recalling Lincoln's wilderness childhood.

Through the open window is a much brighter scene, the north front of the White House with its lawn and fountain.[3] This transformation epitomized the classless, democratic ideal of great achievement through education. But the mood is more complex for, as the artist knew firsthand, Lincoln had faced many grim challenges during the first half of 1864. The circumstances of close and prolonged contact with the President at a period of crisis and Carpenter's empathetic response resulted in a heartfelt image.

While Carpenter was staying in the White House—when the photograph of Lincoln and Tad was made—the President was under attack from his own party over the form emancipation would take under Reconstruction. He was threatened with replacement as the Republican candidate in the next election. Although the Civil War had seemed to turn in favor of the Union, the outmanned Confederate troops achieved some bloody victories early in 1864. In one week in May the North, according to James McPherson, "lost some 32,000 men killed, wounded, and missing—a total greater than for all Union armies *combined* in any previous week of the war."[4] It was precisely at that time that Carpenter described the President,

> clad in a long morning wrapper . . . pacing back and forth a narrow passage leading to one of the windows, his hands behind him, great black rings under his eyes, his head bent forward upon his breast,—altogether such a picture of the effects of sorrow, care, and anxiety as would have melted the hearts of the worst of his adversaries. . . .[5]

This homespun painting is memorable precisely because it distills this experience. That it now resides in the Lincoln Bedroom, which was then the President's office, is profoundly appropriate.

George P. A. Healy (1813–1894)

The Peacemakers 1868

Oil on canvas, 47⅛ x 62⅝ inches (119.7 x 159.1 cm)
United States government purchase, 1947

*T*he title is the only clue to the import of this solemn painting, a prelude to the end of the Civil War. Seated in the after cabin of the Union steamer *River Queen* are Maj. Gen. William T. Sherman, Lt. Gen. Ulysses S. Grant, President Abraham Lincoln, and Rear Adm. David D. Porter. Less than a week before the fall of Petersburg, Virginia, the four men met to discuss the nature of the peace terms to follow.

The events leading up to the scene recorded in *The Peacemakers* are these. Following his march through Georgia, Sherman with his army had turned to the Carolinas and, on March 19, 1865, had taken Goldsboro, North Carolina. Petersburg, the last defense of Richmond, where Gen. Robert E. Lee had gathered his forces, had been under siege by Grant's army for nine months. The end of the Civil War was at last imaginable.

On March 20 Grant invited Lincoln to visit him at his headquarters at City Point, on the James River near Richmond: "Can you not visit City Point for a day or two? I would like very much to see you and I think the rest would do you good."[1]

Lincoln accepted this opportunity to relax while acquainting himself firsthand with the progress of the war. On March 24 he reached City Point on the *River Queen*. Sherman, according to his *Memoirs*, decided coincidentally to pay a visit to Grant at just this time, arriving on the evening of the 27th: "After I had been with him an hour or so, [Grant] remarked that the President [was on the *River Queen*] . . . and he proposed that we should call and see him."[2]

Since Porter, in charge of the Union fleet on the James River, was also in City Point, he joined the others. On March 27 and again on the 28th, the four gathered aboard the steamer. The first meeting was, according to Sherman, "a good, long, social visit."[3] During the second meeting their conversation, although wide-ranging, turned often to the conclusion of the peace. Only Sherman and Porter left written

accounts, and some have suggested that they exaggerated Lincoln's desire for peace, as Porter put it, "on almost any terms" in order to justify Sherman's later, controversial liberal surrender terms to Gen. Joseph Johnston.[4] But Lincoln's generous intentions had been memorably formulated in his Second Inaugural Address, just three weeks before: "With malice toward none; with charity for all."

According to Porter the discussion was almost entirely between Sherman and Lincoln. Indeed, in Healy's re-creation of the scene, Porter seems withdrawn while Grant looks attentively at Sherman, whose emphatic attitude echoes Porter's account: "Sherman energetically insisted that he could command his own terms, and that Johnston would have to yield to his demands."[5] The President leans forward, listening and thoughtful.

George P. A. Healy was already a famous international portraitist and the painter of many leading Americans—political, military, and social—of the day. But, like many other American artists, he often felt the desire to justify his profession by painting scenes from American history. *The Peacemakers* was his third history painting.

Healy had previously painted a portrait of Sherman, and they had become friends, so it was to the general that he telegraphed in early January 1868 for a physical and substantive description of the meeting. Sherman answered, in part: "We did not sit at a table, nor do I recall having any maps or papers. We merely sat at ease on such chairs as happened to be there. I think I can get a diagram of that cabin. . . ."[6]

Sherman relayed Healy's request for a portrait sitting to Grant, who replied, "I had determined not to sit again. The object Mr. Healy has is such, however, that I may change my mind. . . . " Grant did, although there were only a few brief sessions. Sherman also sent Porter's account of the meeting and a diagram of the cabin to Healy. Porter may not have posed for

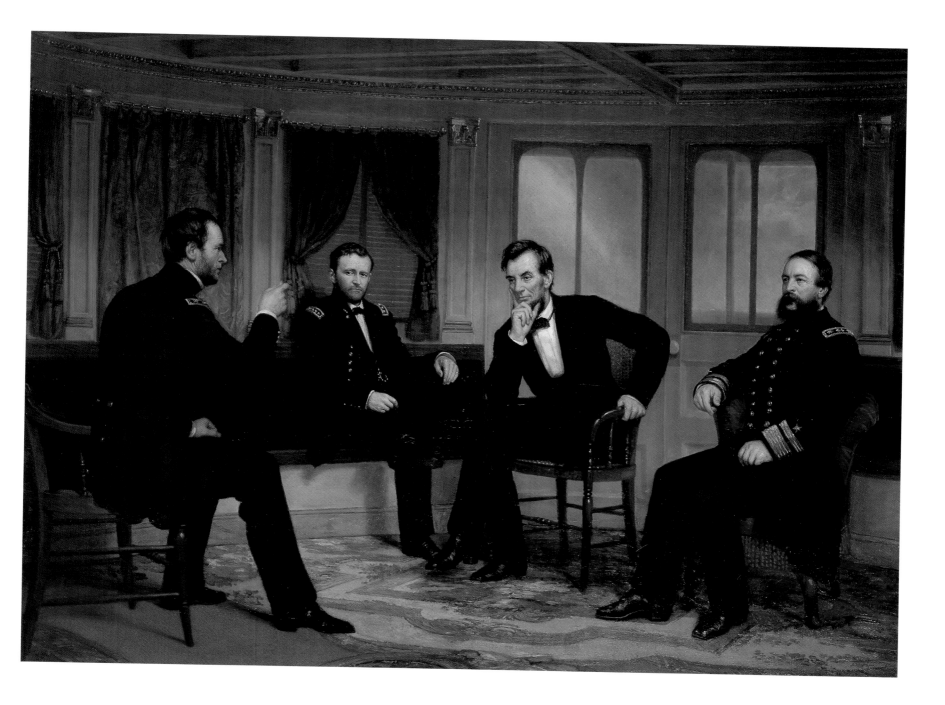

Healy; perhaps the artist adapted the image from an 1865 photograph taken by Alexander Gardner.[7]

Healy had painted Lincoln shortly before his Presidency, in Springfield, Illinois (the *Chicago Tribune* of November 17, 1860, announced the finished portrait). He sketched and painted Lincoln several more times at the White House. Most important were the sketches made during Cabinet meetings, which Healy was permitted to attend. From these came the image of the President concentrating, elbow on knee, chin in hand, that he would use for *The Peacemakers*.

The figures in *The Peacemakers* seem strangely isolated, consistent with the static figures of American history paintings generally. They *stand for* the democratic ideal. Meaning is embodied in their persons rather than displayed in their actions. Here, the separateness of each man is reinforced by the paneling and windows behind him. All heads are on the vertical, save Lincoln's. His inturned pose and brooding expression serve to differentiate him further. Behind him glows a rainbow, emblematic of the approaching peace. Its profounder meaning derives from the biblical description of God's covenant with man after the flood (Genesis 8–9):

> I will not again curse the ground any more
> for man's sake; . . . neither will I again smite
> any more every thing living, as I have
> done. . . . This is the token of the covenant
> which I make between me and you and every
> living creature that is with you, for perpetual
> generations: I do set my [rain]bow in the
> cloud, and it shall be for a token of a
> covenant between me and the earth. . . .
> And I will remember my covenant, which
> is between me and you and every living
> creature of all flesh; and the waters shall no
> more become a flood to destroy all flesh.

Grant's head is framed by curtains that suggest just-parted theater curtains. Since we know that Healy was still painting the background in October 1868, the curtains may allude to Grant's nomination on May 20, 1868, as the Republican candidate for President.[8]

Following the meeting shown in *The Peacemakers* and preceding the end of the war by one week, Petersburg fell on the night of April 2 after the long siege. Grant and Lincoln entered the city the next day. On his return to the Union base at City Point, Lincoln told Porter: "Thank God I have lived to see this. It seems to me that I have been dreaming a horrid dream for four years, and now the nightmare is gone. I want to see Richmond."[9] Together they sailed upriver to the defenseless capital of the Confederacy. There Lincoln, less than a fortnight before his assassination, walked the streets amid a swelling throng of emancipated black people.

The Peacemakers documents in measured accents this turning point of American history. Its somber figures—less actors than audience—await the denouement, the Confederate surrender at Appomattox Court House, Virginia.[10]

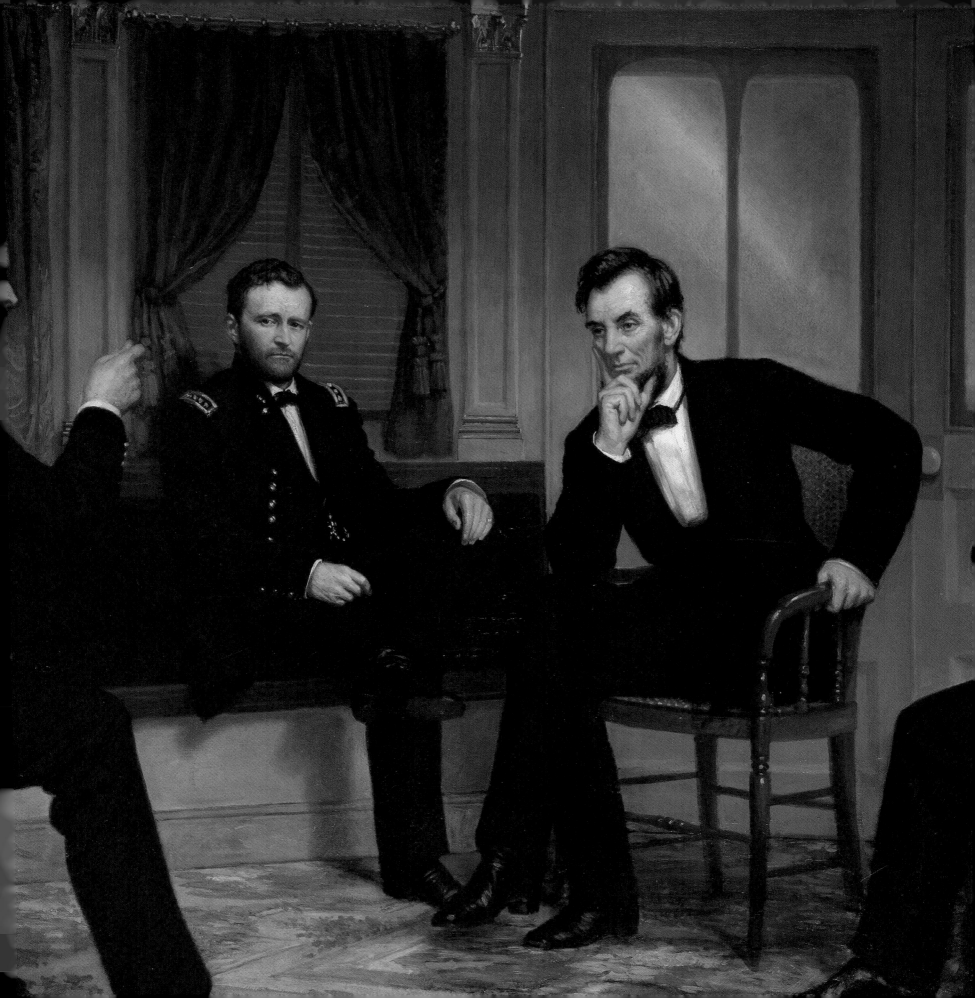

George P. A. Healy (1813–1894)

Abraham Lincoln 1869

Signed and dated lower left: G.P.A. Healy / 1869
Oil on canvas, 73¾ x 55⅝ inches (187.3 x 141.3 cm)
Bequest of Mrs. Robert Todd Lincoln, 1939

*L*incoln's last public address was delivered on April 11, 1865, from a window above the north door of the White House, two days after the Confederate surrender at Appomattox Court House. His subject was national reconciliation and the reconstruction of the South, and he concluded: "I am considering, and shall not fail to act, when satisfied that action will be proper." With his death just days later all action was ended, but in this portrait he is still considering, and he seems to attend to other voices.

Healy had begun work on a portrait of Abraham Lincoln for which the President had sat in August 1864. The assassination, however, turned the artist's thoughts in another direction, and he conceived *The Peacemakers* (page 156), the small version of which was completed late in 1868. In *The Peacemakers* Lincoln leans forward, listening attentively to General Sherman's urgings, as he habitually did to the advice of his counselors before offering his own pondered decisions. In the 1869 portrait Healy had the artistic inspiration of his career. He made the decision, no less pondered, to remove the President from all human assembly while preserving the listening, absorbed pose.

Having seized the essence of his image, the artist did not belabor it. Broad and simplified in handling, the figure is pulled forward from the murky olive-gray background by the sculptural modeling, the concentration of light upon hands and face, the lack of competing accessories. Though the chair is stately in contrast to the simple chair in *The Peacemakers*, Healy molds it to the President's body and turns the gilt wood and red brocade into the perfect foil for the strongly projected figure. Slight adjustments were made in the pose when the artist adapted it from the smaller group painting to the monumental single figure, all of them intended to solemnize the man and to move him from the temporal to the eternal. Healy has given us a face remarkable for its serenity and concentration, its poise and self-possession.

The portrait was painted in Paris and sent to Washington in response to an act of Congress (March 3, 1869) authorizing a Lincoln portrait for the White House.[1] When President Grant chose another likeness by William Cogswell, Lincoln's son Robert Todd Lincoln purchased the Healy, later declaring that "I have never seen a portrait of my father which is to be compared with it in any way."[2]

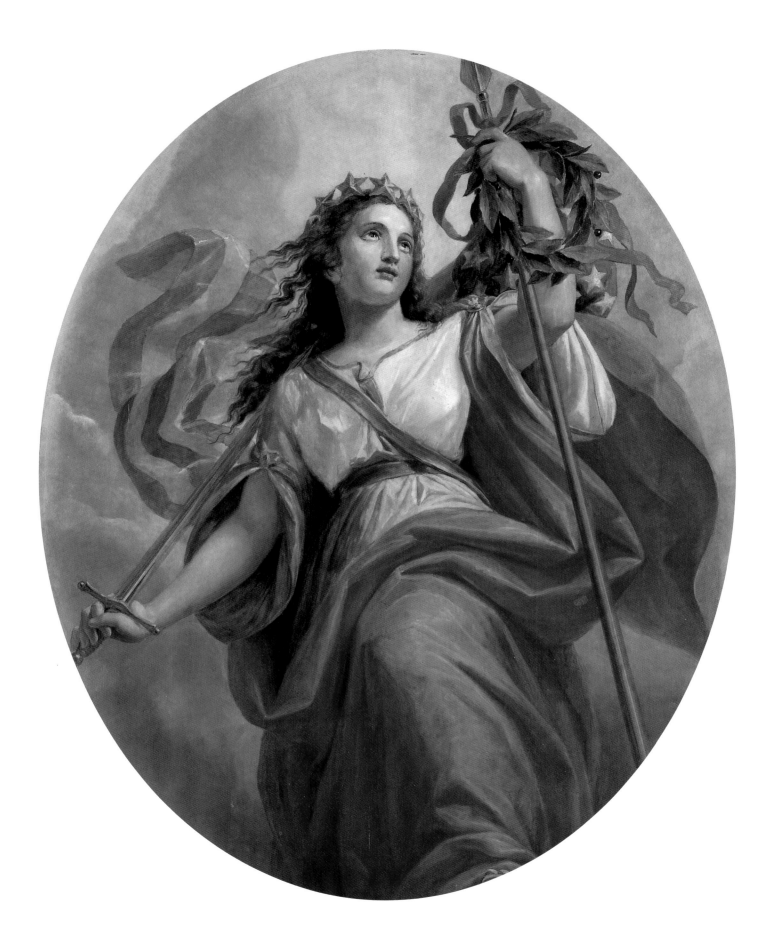

Constantino Brumidi (1805–1880)
Liberty 1869

Oil on canvas (oval), 62^{15}/$_{16}$ x 50^{7}/$_{8}$ inches (159.9 x 129.2 cm)
Gift of the Shaklee Corporation, 1981

Though the name of Constantino Brumidi will be forever linked with the U. S. Capitol Building, which he embellished with a multitude of admirable frescoes, he is also linked with the White House for his allegorical paintings there. The Italian-born Brumidi trained as an artist in Rome, where he also saw military service. While in the Papal Guard, he was assigned by Pope Pius IX to restore the frescoes designed by Raphael in the Loggia of the Vatican, a decorative ensemble that would greatly influence his work in the U. S. Capitol. Later, as a captain in the national guard during the French occupation of Rome, he refused to order his troops to fire upon the populace and was imprisoned for 14 months. After his release he emigrated to America in 1852.

Three years later Brumidi was commissioned by Montgomery C. Meigs, an admirer of Italian art and superintendent of the Capitol extension, to decorate the House of Representatives Agriculture Committee Room. Thus began a 25-year career as principal painter in the Capitol, ending only with his death. In 1866, with the Civil War at an end, he completed his monumental allegory in the Rotunda dome, *The Apotheosis of Washington*.

Soon thereafter he was asked by the Grant Administration to bring his talents to the White House. It may have been President Grant himself who decided to redo the Entrance Hall of the mansion, which had just been redecorated under Andrew Johnson with a fashionable Pompeiian motif. The new image was unabashedly American, and was probably intended to "epitomize the Republican Party as savior of the nation. . . . Flags, Union shields, eagles, and the initials 'U. S.' [and] a riot of Fourth of July red, white, and blue" turned the Entrance Hall into a visual fanfare to the Union, one nation once more indivisible.[1]

Brumidi had nothing to do with the decorative framework just described, an effort of the firm of Schutter & Rakeman. But the two allegorical paintings he created were central to the scheme. Mounted in the ceiling, *Liberty* and *Union* (following) were painted in a modified illusionistic style found especially in Venetian ceiling paintings of the 16th century, in which the figures are foreshortened as though seen from a viewpoint beneath their feet.

The personification of *Liberty*, crowned with golden stars symbolizing the original states, is sturdily poised and dynamically draped as she defends the flag with her body and her weapons. Her attitude and expression are at once vigilant and serene, commanding and devout. Her weapons, whose triangular placement stabilizes the composition, are nonetheless held in abeyance, the sword's point behind her shoulder and the spear entwined with red ribbon and the laurel wreath of victory. Brumidi, steeped in traditional symbolism, would have known that the laurel, like the olive branch, was also a sign of truce. In ancient Rome it was placed on the emperor's gateposts, "faithfully guarding his doors" (Ovid). All of these symbolic attributes of the laurel were pertinent to the postwar moment and to the White House Entrance Hall location of *Liberty*, a figure that embodies the famous admonition of Demosthenes: "Eternal vigilance is the price of liberty."

Constantino Brumidi (1805–1880)

Union 1869

Oil on canvas (oval), 62⅞ x 50½ inches (159.7 x 128.3 cm)
Gift of the Shaklee Corporation, 1981

*B*rumidi's allegory of *Union*, the companion piece to *Liberty* (preceding), floats free of earth, and her spiraling, unconstrained figure seems to dance in the clouds. Lightly garbed in a pure white tunic and wrapped in a cloak pale blue on one side and pale red on the other, she is the flag personified. She wears the Phrygian, or liberty, cap—a symbol of freedom through revolution—and lightly holds the Union shield (with 13 stripes for the original states), while she looks upward at the radiant constellation of 13 stars. The American bald eagle grasps arrows and an olive branch in its talons and stares fixedly up at Union, while it extends its wing behind her as though assuring her ascent. All of these attributes are components of the Great Seal of the United States, redistributed around the soaring allegorical figure.

Brumidi's two paintings were installed on the ceiling of the White House Entrance Hall, near two "cameos" or "medallions." These were actually monochrome imitations of relief sculptures, painted by Hubert Schutter, with the likenesses of George Washington and Abraham Lincoln. On the east wall over the marble mantel was the cameo of Washington with the allegory of *Union* above it on the ceiling; on the west wall was the Lincoln cameo below *Liberty*. A contemporary journalist wrote, possibly on Brumidi's authority, that the theme was "that memorable passage from Webster's speech, 'Liberty and Union, now and forever, one and inseparable.'"[1]

In the midst of yet another redecoration of the White House in 1891, during the Benjamin Harrison Administration, Edgar S. Yergason, a partner in the Hartford, Connecticut, firm that did the work, acquired the paintings after their removal from the ceiling in July of that year. He died in 1920, and in 1978 the forgotten canvases were rediscovered at his former summer residence in Windham, Connecticut. The works, crated in the barn loft, were found by the new owners, from whom they were acquired and restored to their first home, the White House.

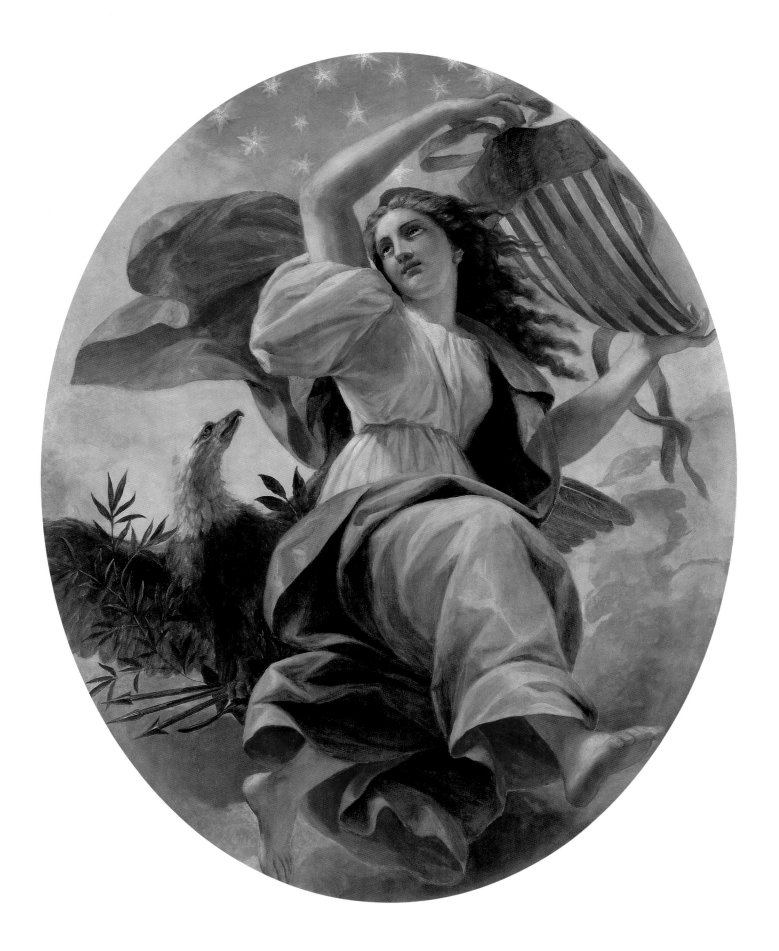

Worthington Whittredge (1820–1910)
Crossing the River Platte *c.* 1871

Signed lower right: W. Whittredge
Oil on canvas, 40⁵⁄₁₆ x 60⁵⁄₁₆ inches (102.4 x 153.2 cm)
Gift of C. R. Smith, 1967

*I*t was not until 1866, after years of travel and study in Europe and the commencement of a successful career in New York, that Whittredge first saw the American West. Invited to join Gen. John Pope's expedition to Colorado and New Mexico in 1866, he covered more than 2,000 miles on horseback, absorbing and sketching the still unfettered landscape with rapt attention. Of the journey he wrote:

> I had never seen the plains or anything like them. They impressed me deeply. I cared more for them than for the mountains. . . . Whoever crossed the plains at that period . . . could hardly fail to be impressed with its vastness and silence and the appearance everywhere of an innocent, primitive existence.[1]

In 1870 he traveled west again, this time in the company of fellow painters John F. Kensett and Sanford Gifford. A third trip followed in 1871. Some 40 sketches and paintings survive to document these three excursions. The paintings were produced in his Manhattan studio, many between 1870 and 1876. Among those was *Crossing the River Platte*, painted from sketches made at Denver, Colorado. It evidently is a mirror-image variant of *Crossing the Ford, Platte River, Colorado* (The Century Association, New York City), a painting exhibited in 1868 but reworked after the 1870 trip from some sketches of a group of trees that he found more suitable. Therefore, a date of circa 1871 for the picture in the White House is likely.[2]

The placid appearance of the scene is set by the river, which lies across the bottom of the picture with scarcely noticeable recession. Beyond it the Indian encampment is planted snugly among the cluster of trees. The flat sweep of prairie is measured by the sure placement of trees and smaller elements as Whittredge carefully paces out the space.

The masterly gradations of the haze-veiled mountains, among which Longs Peak is prominent, round out the distance but leave the foreground dominant. In a sense the painting is *about* the foreground with its substantial drawing and the few bright color notes in an otherwise muted palette of greens, sandalwood, and mauve.

Whittredge painted with the tones of a lyric poet, not an epic one. Through mood rather than narrative the domestic serenity of the encampment suffuses the painting. Whittredge often acknowledged that William Cullen Bryant's poetry touched him deeply. The "pensive quietness" of the landscape evoked in Bryant's "Thanatopsis" is matched by the tranquillity of this painting. The painting also partakes of the somber mood and the general disenchantment with the nation's course after the Civil War.

Setting out just a year after the end of the cataclysm, Whittredge must have been especially conscious of the yet unspoiled vastness and, even more, of the blessed silence of the prairies. Moreover, General Pope's mission was to report on the condition of the Indians. The elegiac mood of the painting may be interpreted as an ironic meditation upon the ideal harmony between the Indian and the land, and upon the continuing displacement and restriction of the Native Americans. As Bryant wrote in "The Prairies": "The red man, too, / Has left the blooming wilds he ranged so long, / And, nearer to the Rocky Mountains, sought / A wilder hunting-ground. . . ."

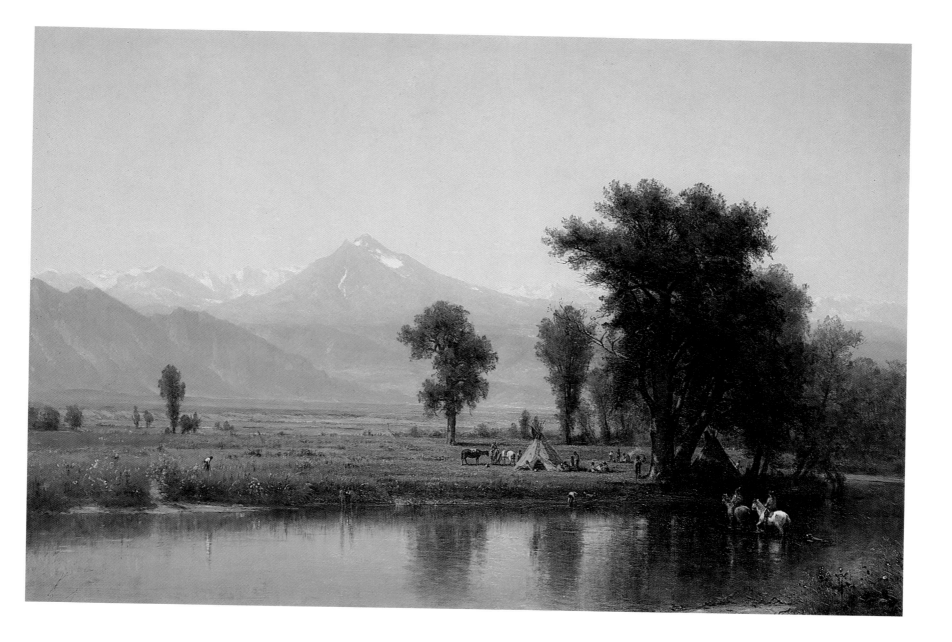

Martin Johnson Heade (1819–1904)
Sailing off the Coast 1869

Signed and dated lower left: HEADE / 1869[1]
Oil on canvas, 15⅛ x 29⅛ inches (38.4 x 74 cm)
Gift of the White House Historical Association, 1980

*T*his painting should be lived with. Accompanying the profound mood of peace and contemplation in Heade's coastal reverie is an aura less readily perceptible, a disconsolate sense of time passing irrevocably. It is established by the measured recession of the silent sails toward the sunset horizon, by the numberless pink and blue-gray bands of light and shadow that form the surface of the ocean, and by the pale pink-bellied clouds that hover almost regretfully above the horizon while the day holds its breath before expiring.

Beyond viewing *Sailing off the Coast* as a record of an unidentified shoreline (perhaps Newport), one should recognize that the mood of the painting is allied to the mood of the country after the Civil War. But in Heade's late Romanticism, American-style, the mood is conveyed in a language more private than the self-conscious symbolism of his European counterparts. Circumlocution may well be an American trait: "Tell all the truth but tell it slant, / Success in circuit lies," wrote Emily Dickinson, Heade's contemporary. Meaning must be sought in nuance and indirection.

Heade's extraordinarily long career began when he was apprenticed as a coach painter to Edward Hicks (famous today for his *Peaceable Kingdom* paintings). Two years in Europe (1838–40) did little to alter the naive style that characterizes the portraits and genre paintings that dominated his work until the late 1850s. In 1859 Heade took a studio in the Tenth Street Building in New York City, which put him in daily contact with Frederic Church and Albert Bierstadt, specialists in landscapes. His increasing attention to landscape painting dates from this time, as does his growing artistic sophistication.

At 50, when he painted *Sailing off the Coast*, Heade was in full command of his art, and his achievement is memorable and subtle. He excelled not only in the transcription of sublime light effects but also in the precision of compositional accents. Heade's shoreline is devoid of human observers; we alone witness the suspended moment. While the great boulders firmly anchor the picture, the pair of terns perched atop it draw our gaze. They fine-focus our attention, as though through a telescope, on the vast sea drift and the shroudlike sails.

George Inness (1825–1894)

The Rainbow in the Berkshire Hills 1869

Signed and dated lower right: G. Inness 1869
Oil on canvas, 20 x 30 inches (50.8 x 76.2 cm)
Gift of The Rita and Taft Schreiber Foundation, 1972

Violent storm clouds have passed over this gentle landscape amid the Berkshire Hills in western Massachusetts. The scraggly tree behind the shed at the left is still electric with the storm's golden afterglow. Into the newly peaceful countryside comes an ox-drawn hay wagon, with a farm boy enthroned upon an abundant and securely gathered harvest of green-gold hay. Above him arcs the rainbow that has superseded the departing storm. In the center of the picture a stand of old oaks anchors the scene and mediates between light and dark. The canvas is painted with a palette suffused with gray and with a blended, blotted brushstroke, resulting in a muted, soft-focus surface suggestive of reverie and contemplation.

From the outset of the Civil War Inness had more than once used landscape allegorically to express his emotions. A contemporary wrote of Inness that he was "never more excited than when the news of the firing upon Sumter reached the village, for he was not only a fervent American but an Abolitionist from his youth up."[1] Two of his paintings are acknowledged to be allegories of the war years: *The Sign of Promise* (1863; lost) and *Peace and Plenty* (1865; Metropolitan Museum of Art, New York). A writer for the *New York Evening Post* in 1863 had declared that *The Sign of Promise* "has a moral in its subject and a moral in its treatment. It expresses hopefulness, the promise of good; it implies a divine purpose, in the fertilizing shower, the genial sunshine, the beautiful and fruitful valley, and in the combination of these in a grand union that is surely not unmeaning."[2]

Some other paintings by Inness, including *The Rainbow in the Berkshire Hills,* are open to the same interpretation, for the war remained an explicit and implicit subject in art and literature to the end of the century. Given Inness's patriotic ardor in the 1860s, along with a deepening religious conviction on his part, it seems certain that this painting is a clear and uncomplicated postwar prayer of thanksgiving.

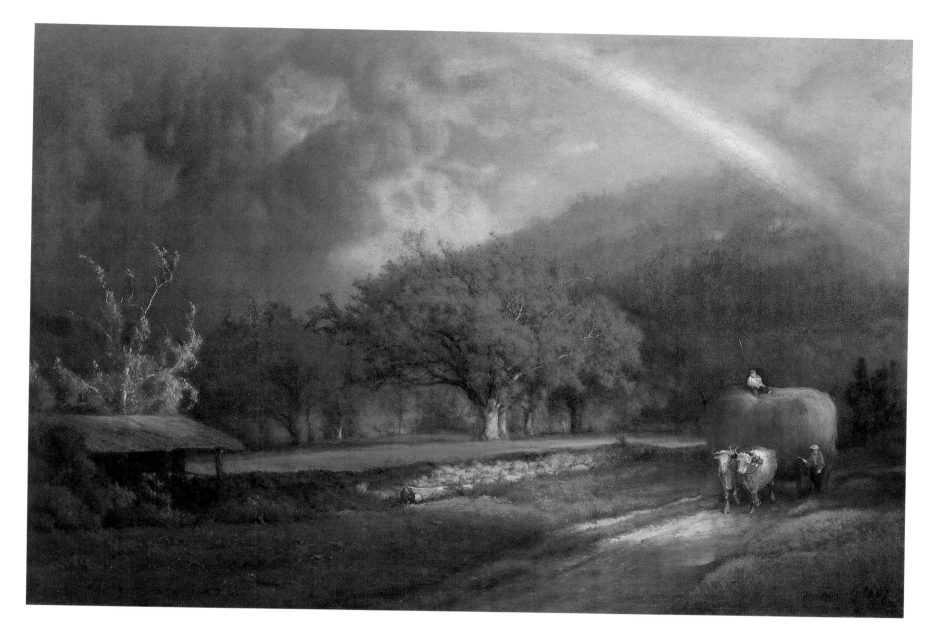

James McNeill Whistler (1834–1903)
Nocturne c. 1870–77

Oil on canvas, 19¹⁵⁄₁₆ x 30³⁄₁₆ inches (50.6 x 76.7 cm)
Gift of Mr. and Mrs. W. Averell Harriman, 1962

"A world of nocturnes . . . would be as tedious as an eternal souffle," wrote a critic of an 1892 Whistler exhibition.[1] It was a criticism raised about the artist's nightscapes from their first appearance in 1866. From the beginning Whistler was censured for the indistinctness of the works. The painter Edward Burne-Jones found one of the *Nocturnes* "bewildering in form . . . it has no composition and detail."[2]

Whistler's response to such criticism was at once direct and poetic:

> The desire to see, for the sake of seeing, is, with the mass, alone the one [desire] to be gratified, hence the delight in detail.
>
> And when the evening mist clothes the riverside with poetry, as with a veil, and the poor buildings lose themselves in the dim sky, and the tall chimneys become campanili, and the warehouses are palaces in the night, and the whole city hangs in the heavens, and fairy-land is before us—then the wayfarer hastens home; [people] cease to understand, as they have ceased to see, and Nature, who, for once, has sung in tune, sings her exquisite song to the artist alone. . . .[3]

Whistler's public posture as dandy and aesthete helped obscure the true radicalism of these paintings. In their near abstraction they posed challenging questions of objective and subjective reality. The term "nocturne" was borrowed from music and reflected the avant-garde interest in breaching the boundaries between the arts. "As music is the poetry of sound," wrote Whistler, "so is painting the poetry of sight. . . . Why should not I call my works 'symphonies,' 'arrangements,' 'harmonies,' and 'nocturnes'?"[4]

Like most of the series, this *Nocturne* was inspired by the artist's experience of the Thames River and its shoreline, especially near his home in Chelsea.

Whistler took long nocturnal walks during which he absorbed the shifting, insubstantial scenes—a silent river, its farther shore accented with a few, flickering lights, all wrapped in legendary London fogs. One of Whistler's students reported that the artist "never tried to use colour at night . . . , but made notes on brown paper in black and white chalk."[5] From such slight sketches he improvised his mysteries.

The site interpreted here is probably Battersea, across the Thames from Chelsea. One scholar has suggested that the "peculiar tower is probably 'Morgan's Folly,' a 100-foot clock tower built in 1862 near Morgan's Patent Plumbago Crucible Company's Works, importers of graphite."[6] By night, as Whistler knew, the tower sheds its prosaic identity and becomes a campanile in a nameless, timeless "fairy-land." The color in this mystery of blue and black shifts as we watch. Whistler was asked of another of his *Nocturnes:* "The prevailing colour is blue?" "Perhaps," he replied.[7] This color abstraction, with its organic pulsation, astonishes the viewer with an illusion of moonglow-fog gliding over the water. The only fixed point is the exclamation mark of the tower and its tangible reflection.

Creating such paintings, the skeptics charged, must be easy work. During the proceedings of the 1877 libel suit that Whistler brought against the critic John Ruskin (who had attacked a *Nocturne* in print), one of the attorneys asked sardonically:

> "Now, Mr. Whistler. Can you tell me how long it took you to knock off that nocturne?" . . .
>
> "I was two days at work on it."
>
> "Oh, two days! The labour of two days, then, is that for which you ask two hundred guineas!"
>
> "No;—I ask it for the knowledge of a lifetime."[8]

Albert Bierstadt (1830–1902)
Rocky Mountain Landscape 1870

Signed and dated lower right: ABierstadt / 70 [AB in monogram]
Oil on canvas, 36 5/8 x 54 3/4 inches (93 x 139.1 cm)
Gift of The Barra Foundation, Inc., 1981

When Albert Bierstadt painted *Rocky Mountain Landscape* in 1870, he had not seen the Rockies for seven years. He worked from studies made in 1863, during his second trip to the West. He had recently returned from a triumphal two-year tour of Europe; the following year he would go west again.

It is difficult to escape the conclusion that this painting is a combination of elements drawn from different sketches and diverse landscapes. An idealist, Bierstadt usually manipulated reality in the creation of his large, theatrical vistas, and in this case comparison with other canvases suggests that he rearranged nature with more than customary thoroughness. Elements familiar in other paintings, such as cascades and sheer cliffs, have been modified or shifted into new relationships. In addition, the mountains uppermost in the painting are really cloud-capped Alpine peaks, reflecting the powerful impression left by Bierstadt's re-encounter with that landscape a year earlier.[1]

Bierstadt's dramatic sense was keen, and he was a master at the creative transformation of a few basic compositions. He adopted devices associated with the theater: The contrast of the darkened proscenium and wings with the light-struck sky and water enhances the scene. The eye moves into the space by diagonal steps, from the family of deer (the only animate objects in the painting) just right of center, to the stand of trees, to the right distance, and to the soaring cathedral rock across the water. Finally, the most distant snow-covered peaks are seen at top left center. Against this Bierstadt develops a curvilinear play in the cuplike curves of rocks and lake shore. With the clarity and spatial penetration of a stereographic view (his use of photography is well documented), he rivets our gaze.[2] The innumerable oil sketches from which he composed his large canvases are typified by the

Storm Clouds *c.* 1880

Signed lower right: ABierstadt [AB in monogram]
Oil on fiberboard, 14 1/2 x 19 1/2 inches (36.8 x 49.5 cm)
Gift of Mr. and Mrs. Vincent Price, 1962

brisk cloud study reproduced above. It is alive with the exhilaration of on-the-spot observation.

In *Rocky Mountain Landscape* the shopworn adjectives "spellbinding" and "breathtaking" regain their identity, conveying the awestruck wonder the artist induces in the viewer. Both words imply the suspension of time. The cascades suggest neither sound nor motion; the great cloud banks are stopped in their ascent; the still water of the lake mirrors the rocks and locks them to the foreground shore through the complex and beautiful pattern of reflections.

We dare not move lest we lose the waking dream. No humans are present except ourselves; we have stumbled upon a hidden valley. The disposition of light and shadow furthers this illusion. Around a core of light the artist has wrapped a dark cloak, sealing off this extraordinary place from the civilized world.

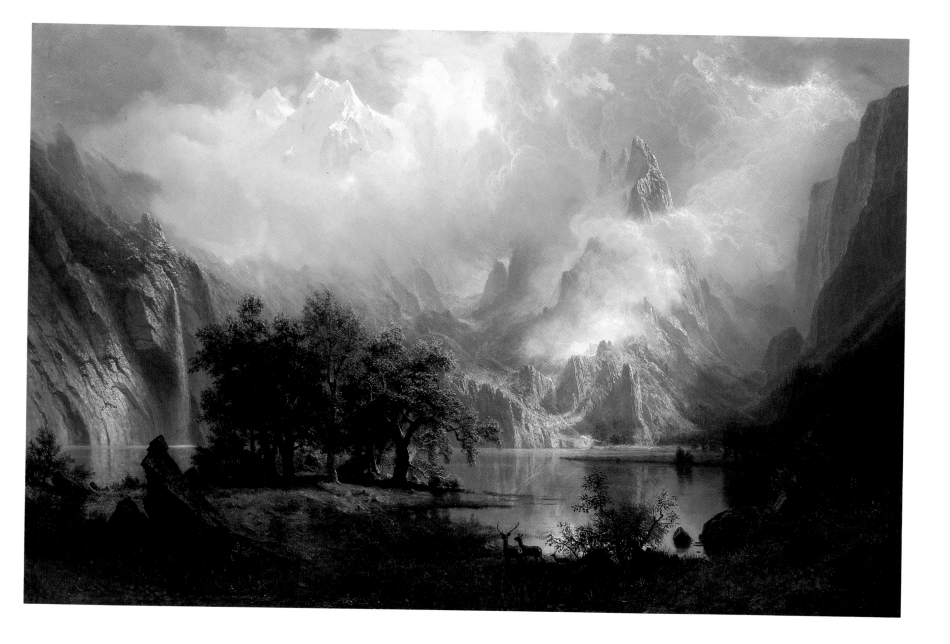

William Louis Sonntag (1822–1900)
In the White Mountains, New Hampshire 1876

Signed and dated lower right: W. Sonntag. / 1876
Oil on canvas mounted on panel, 23⁵⁄₁₆ x 37³⁄₈ inches (59.2 x 94.9 cm)
Gift of the White House Historical Association, 1976

Raised in art-conscious Cincinnati, Sonntag first exhibited a painting when he was only 19. Apparently self-taught, he formed his mature style during sojourns in Italy in 1853 and 1855–56. From 1870 until the end of his life he spent most of his summers at Shelburne, New Hampshire, in the White Mountains. There he made sketches from which to paint during the winter in his East 22nd Street studio in New York. His style shifted during those years from the use of bright colors to an increasingly tonal palette. The crisp impasto brushwork of his earlier work remained, but he used it more selectively, contrasting it with blended strokes that better conveyed atmosphere.

This landscape—whose location has not been firmly established despite the painting's title—is rendered by a sequence of receding planes.[1] Crisply painted trees frame the bright foreground, where two men stand in conversation beside a rocky outcrop. The bright area gives way to a dark strip of woods farther down the slope. Beyond the woods a cleared field is just seen, then a stand of lighter green forest, then a river flowing toward a lake at the left. Finally, the dark gray foothills are played against the dark gray mountains beneath the bright cloud-filled sky. Sonntag handles these pictorial devices with skill, and his habitual oily pigment lends an idealized sheen to the painting.

Comfortable paintings like Sonntag's appealed to the increasingly affluent society of the Reconstruction era. By 1876 the great American outdoors, popular as a subject for landscape paintings for half a century, had become more domesticated. Wilderness areas were now accessible to tourists; resort hotels had sprung up to accommodate them. Increasingly the symbolic landscapes of earlier generations were superseded by lovely, reassuring scenes, perfect decorations for the parlor.

Jasper F. Cropsey (1823–1900)
Autumn Landscape on the Hudson River 1876

Signed and dated on rock, lower left: J·F Cropsey / 1876
Oil on canvas, 24$\frac{1}{8}$ x 44$\frac{3}{16}$ inches (61.3 x 112.2 cm)
Gift of Mr. and Mrs. John C. Newington, 1972

This scene is somnolent with the warmth of late afternoons in late autumn. Human presence is restricted to two fishermen returning from a day on the water. That they are the intended focal point is clear. Branches of the overarching trees point to them as they debark in the lower center of the painting. Situated securely in a quiet inlet of the Hudson, they are caressed by the pink-yellow-mauve glow of the sky whose reflections in the estuary bind near and far distances together. The calm, unruffled aura of the scene is reinforced by the long, low format of the painting and its illusion of spatial sweep.

The poetic contrast of the copper red foliage of the foreground tree against the foil of yellow leaves behind it is typical of Cropsey's technique in this painting. Everywhere, he applies paint with a loaded brush, creating an unctuous surface texture.

To appreciate fully the nostalgic, retrospective character of Jasper Cropsey's paintings, one must consider the age in which they were made. A second-generation Hudson River School painter, Cropsey reached his full maturity during the decade following the Civil War, the period of Reconstruction that embittered much of the South, severely inhibiting the healing process.

The explosive growth of the great cities (Cropsey lived in New York City from 1863 to 1885), labor violence, the unchecked and often unscrupulous amassing of vast private fortunes, the scandals of the Grant Administration—all contributed to a national malaise the more distressing because it chilled the patriotic fervor animated by the preservation of the Union. Witness Longfellow's lament in 1872:

Ah, woe is me!
I hoped to see my country rise to heights
Of happiness and freedom yet unreached
By other nations, but the climbing wave
Pauses, lets go its hold, and slides again
Back to the common level. . . . [1]

In 1876, the centennial year and the year of this painting, the nation was treated to the spectacle of a fraudulent election in which Rutherford B. Hayes, himself a man of integrity, assumed the Presidency by means of a deal struck between Republican and Southern Democratic party leaders. In the face of these melancholy realities, many Americans—Cropsey among them—looked backward to an age less sour and to the solace of untroubled nature. His daydream seduces and convinces us as it must have comforted his contemporaries.

178

Alfred T. Bricher (1837–1908)

Castle Rock, Nahant, Massachusetts 1877

Signed and dated lower left: ATBRICHER. [ATB in monogram] / 1877
Oil on canvas, 26⅛ x 50 inches (66.4 x 127 cm)
White House Acquisition Fund, 1972

Taking the coastal sweep as his cue, Bricher emphasizes the spacious scene by choosing a canvas nearly twice as wide as high. Further, he chooses a low viewpoint so that one feels the tug of the tide and the weight of the water, calm though the surface is. From this groundswell of surf and sliver of beach rises the gray-brown mass of Castle Rock at Nahant. It is near the point of a long peninsula off the coast near Lynn. The lighthouse on the right stands on the small island of Egg Rock.[1]

Late afternoon shadow veils the eastern face of the rock, and a mood of pensive tranquillity pervades the scene, underscored by the tonal palette: gray, gray-white, gray-blue, gray-brown. It is typical of Bricher to invest the clouds with a drama denied the placid ocean. In an especially beautiful passage just above the tip of Castle Rock, the artist applies the whites dryly, with a palette knife or stiff brush, and with great variety. They dance like whitecaps in the sky.

Bricher was a native of Portsmouth, New Hampshire, and studied briefly at the Lowell Institute in Boston, where he set up his studio in 1860. He moved to Manhattan in 1868 and spent the rest of his life there and on Staten Island. Perhaps the most important influences on his painting were artists Martin Johnson Heade (pages 169, 203) and John F. Kensett (page 108). Although Bricher had clearly studied Kensett's coastal paintings, his own are more reserved. For example, Bricher is uninterested in using watery reflections of his promontories to produce monumental designs on the picture plane. Rather he preserves a more traditional perspective from the beach on which we stand or sit to the mid-ground rock to the far horizon marked by sails. The presence of an elegantly dressed young woman, rowboats drawn up on the shore, and the pleasure yachts correctly suggest that Nahant was richly, if not densely, inhabited.

The shore is deserted, not desolate; the rock rugged, not harsh; the ocean timeless, not perilous. The artist's delight in nature is obvious, but it is nature domesticated. In his mature art Bricher contemplates the cyclical nature of the world. He stands eternally at the water's edge and asks for nothing more than daily demonstration that the tides will continue as before.

John Rogers (1829–1904)
Neighboring Pews 1883 (patented 1884)

Signed and dated left side: JOHN ROGERS / NEW YORK / 1883
Inscribed on front of base: NEIGHBORING PEWS
Plaster, 18¾ x 16 x 11½ inches (47.6 x 40.6 x 29.2 cm)
Gift of Miss Stella Matthews, Miss Elsie Matthews,
 and Mrs. Bertha Matthews Harrison, 1961

This delightful tabletop sculpture group is like a vignette from a play in which costumes, props, staging, and direction are all managed with great skill and, especially, with attention to detail. It is as if we have entered the theater in mid-act, ignorant of the relationships of the characters and of details of the plot. Yet as we look on, much becomes clear.

It is time for a hymn in church, and the lovely young woman and the dapper young man have risen to sing. She is uncertain of the page, so he obligingly leans over, pointing out the place in his hymnal as he looks at her engagingly. The old lady (perhaps the young woman's grandmother?) glances up disapprovingly. The lad lounging on the front pew has put on the man's top hat and pulled on his too-large gloves. Are the two brothers? Or might we suspect that the youth is the girl's brother to whom the loan of the hat and gloves is another stratagem in this game of the heart?

When we have satisfied ourselves of the plot, we may delight in the details of costume and accessories, lovingly rendered, down to the quilted pew cushions, the old lady's footstool, and the hymnal racks on the pew backs (not visible here), in one of which is an open fan and another hymnal. The composition is remarkably compact, and the structural problem of fragility is cleverly solved in two spots in particular: The man's hymnal is joined to the belle's arm, and her hymnal to the top hat.

"Rogers Groups," as his works were known, were the most popular pieces of sculpture in America between 1860 and 1895. Rogers was, in fact, probably the most popular sculptor the country has ever known. He made about 80 groups in bronze, and from molds of them he produced about 80,000 plaster casts. The casts, originally painted soft tan, were sold by mail order for an average price of $15 (see the advertisement on page 184). "They have been compared to chromos [chromolithographs], but this is manifestly unjust," wrote Lorado Taft, a sculptor of quite different stylistic temperament, in 1903. "They are spontaneous and they are expressive in their straightforward way, . . . and these are very good things to find in any art." Taft concluded that "work as distinctive and widely welcome as that of Mr. Rogers has been is not to be summarily suppressed nor ignored."[1]

Rogers patented and mass-produced his works on the principle of large sales and small profits. His net return on sales of well over a million dollars must have been more than satisfactory for a man who came to his art indirectly and with almost no training. He was a machinist and a master railroad mechanic until the panic of 1857 cost him his job. Having begun to model in clay as a hobby, he took the opportunity to go to Rome and Paris to study sculpture. He spent less than a year in Europe, decided that the classicizing sculpture everywhere in vogue meant nothing to him, and returned to Chicago, where the successful exhibition of his *Checker Players* encouraged him to establish a studio in New York in 1860.

During and after the Civil War Rogers made his reputation for storytelling sculptures about slavery and emancipation, camp life or campaign episodes of the ordinary soldier, and Reconstruction. By the mid-seventies he had turned to scenes of everyday life. These genre subjects were long established in painting but rare in sculpture. Such work was widely popular, but as Lorado Taft noted, there was also "a smaller group of thoughtful men and women who . . . find within its homely oddities a hint at an indigenous art, an art inspired by the life of our own time."

NEIGHBORING PEWS

GENERAL RESEARCH DIVISION, THE NEW YORK PUBLIC LIBRARY, ASTOR, LENOX AND TILDEN FOUNDATION

NEIGHBORING PEWS. Price, $15.00.

These groups are packed, without extra charge, to go with safety to any part of the world. If intended for Wedding Presents, they will be forwarded promptly as directed. An Illustrated Catalogue of all the groups, varying in price from $10 to $25, and pedestals (in mahogany and ebony finish), can be had on application, or will be mailed by inclosing 10 cents to

JOHN ROGERS,

860 Broadway, corner of 17th St. New-York.

Take the Elevator.

The Century Magazine, April 1886

Mostly, however, that art was inspired by life in small town or rural America. Though Rogers was working in New York, he looked back to his New England (Salem, Massachusetts) childhood. Such nostalgia was common to post-Civil War art, especially in genre subjects that lent themselves so easily to a longing for a simpler, less troubled America. Although some have criticized Rogers for sentimentality, his sentiment was restrained for his era, and his humor warm. Among his contemporaries in the world of painting he should be compared not with the patently insincere John George Brown, but with Enoch Wood Perry or even with Eastman Johnson. It is worth noting that two of his most admired Civil War groups, *One More Shot* and *Taking the Oath*, were exhibited in the American section of the 1867 Universal Exposition in Paris, together with Winslow Homer's profound Civil War summation *Prisoners From the Front*.

Andrew Melrose (1836–1901)
New York Harbor and the Battery c. 1887

Signed lower left: Andrew Melrose
Oil on canvas, 22$\frac{1}{16}$ x 36$\frac{1}{16}$ inches (56 x 91.6 cm)
Gift of Mr. and Mrs. Joseph M. Segel, 1973

Replete with figures and anecdotal detail, this pleasant, light-filled picture charms and pacifies us. Showing a corner of Battery Park and New York Harbor at the mouth of the Hudson River, Melrose suggests a summery Sunday afternoon with families strolling or relaxing on benches, children playing, and working men idling on their day off. The small figures are adeptly characterized and grouped, and the groups are cogently placed within the picture space. A nice touch is the outdoor "still-life" composition anchoring the lower left corner, including a suitcase, a large water can, and an enormous watermelon, whimsically abutting the artist's signature.

Although the busy commercial harbor is indicated by the tugs, barges, side-wheelers, and sailing vessels, they are kept secondary to the scene of civilized ease they have made possible. This harmony is supported by the strong, simple composition with its skillful rhythmic order of the vertical elements and effective disposition of light and shade.

Still, this restful painting may have more significance than first appears. In the left distance stands the Statue of Liberty, unveiled only recently on October 28, 1886, the gift to America from the French to commemorate the shared ideal of liberty born of revolution. It is cleverly mimicked by the tall mast and sail closer in. At the far right, partially visible behind the trees, stands an older New York landmark, Castle Garden. This circular structure was built as a fort in the early 19th century, some 200 feet offshore and connected to the mainland by a causeway. An artillery emplacement, or battery, gave this area of New York its name.

When its military importance waned, the fort was used for various civic purposes and then transformed into a concert hall in the mid-1840s. In his diary for 1845 Philip Hone recorded his attendance at the performance of an Italian opera company (admission: 50 cents): "Lo and behold! when I entered I found myself on the floor of the most splendid and largest theater I ever saw—a place capable of seating comfortably six or eight thousand persons."[1]

Ten years later a long-projected landfill brought Castle Garden ashore, and it was transformed into a U.S. immigration station, the uncomfortable anteroom to America for more than seven and a half million of the Europeans who entered the country between 1855 and 1890. Among those millions, in all probability, was Andrew Melrose, who is thought to have arrived from his native Scotland in 1856. If this supposition is correct, then Melrose's picture of prosperous leisure, framed by the building through which he entered America and the new monument to immigration and opportunity, was an appropriate celebration of his 30 years in the New World.[2]

William M. Harnett (1848–1892)
The Cincinnati Enquirer 1888

Signed and dated lower left: WMHARNETT. [WMH in monogram] / 1888.
Stenciled on reverse: 9 / 88 [his ninth painting of 1888]
Oil on canvas, 30 x 25 inches (76.2 x 63.5 cm)
Gift of the Armand Hammer Foundation, 1978

A powerfully constructed painting, *The Cincinnati Enquirer* projects an aura of statuesque serenity. Against the nearly impenetrable gloom of the brown background, a table is placed, cropped so that only one leg is visible. That leg, the corner of the table it supports, and a book serve as a kind of pedestal for the pewter-capped glazed earthenware jug that presides over the remaining objects, gathered together in contrived disarray. The table and the jug provide the only horizontals and verticals in the painting, a scaffolding sufficient to stabilize the elaborate overlay of diagonals and curves. The life-size objects in the spotlit foreground, so naturalistic in detail, impress the viewer with their visual and tactile illusionism.

In his short career Harnett became one of America's most accomplished still life painters. Although he worked mostly in Philadelphia, during six years in Europe he observed and emulated old master techniques and styles. His tabletop still lifes, for example, were based on 17th-century Dutch prototypes, personally reinterpreted. Thus Harnett's homely objects, austerely depicted, are similar to those in works by Pieter Claesz or Willem Claesz Heda, but his tall format and tenebrous background derive instead from the noble still life paintings of Willem Kalf.

While Dutch artists sometimes included in their compositions half-eaten foods and overturned goblets to achieve immediacy, Harnett conveys an even more palpable sense of human contact. Harnett's objects bear, it seems, the fingerprints of recent handling. Hard biscuits lie about, the remnants of an unfinished snack. The candle has been snuffed out, its wax drippings now hardened on the candlestick. The chipped jug has lately been used to replenish the glass that stands behind it, still three-quarters full. The books, recently browsed, have been casually set down by the reader, perhaps while he lit his meerschaum pipe. Possibly he was called away abruptly, for he has carelessly laid his inverted pipe on the creased and torn newspaper, now scorched by hot ashes.

These objects were Harnett's familiars. The pipe and jug reappear in his paintings, though not identically rendered. In *Old Models* (Museum of Fine Arts, Boston), for instance, Harnett placed the jug in exactly the same position, but he altered the painted scene on its pot belly. As he once told an interviewer: "In painting from still life I do not closely imitate nature. Many points I leave out and many I add."[1]

Although he included newspapers in numerous paintings, only in this work did he make legible any type below the subheads. We can read "VOL. XLVI. NO. 130." above the two columns at left and "WEDNESDAY MORNI . . ." at the center. The issue was that of May 9, 1888. We can make out some other phrases, usually with difficulty. (The lettering may have been lost through abrasion, but it is more likely that Harnett intentionally obscured the words.) Several inches down the third column from the left is a heading: "EDITOR MEDHILL." Above the second column appears "YET A MYSTERY." Most prominent by far is the left column head "GATH." Its subheads may also be read, with progressive difficulty: "Criticising New York Newspapers. / Making the Claim That the Publishers Lack Sense. / Comparing the Conditions of the Leading Journals."

"GATH" was a regular political feature in the daily *Enquirer.* By long-established journalistic custom and from prudence, political views appeared under classical or biblical noms de plume such as "Caesar," "Cato," or "Gath." If the name "Gath" falls strangely upon modern ears, it was instantly comprehensible to its readers. It comes from the second verse of David's noble lamentation over Saul and Jonathan: "Tell it not

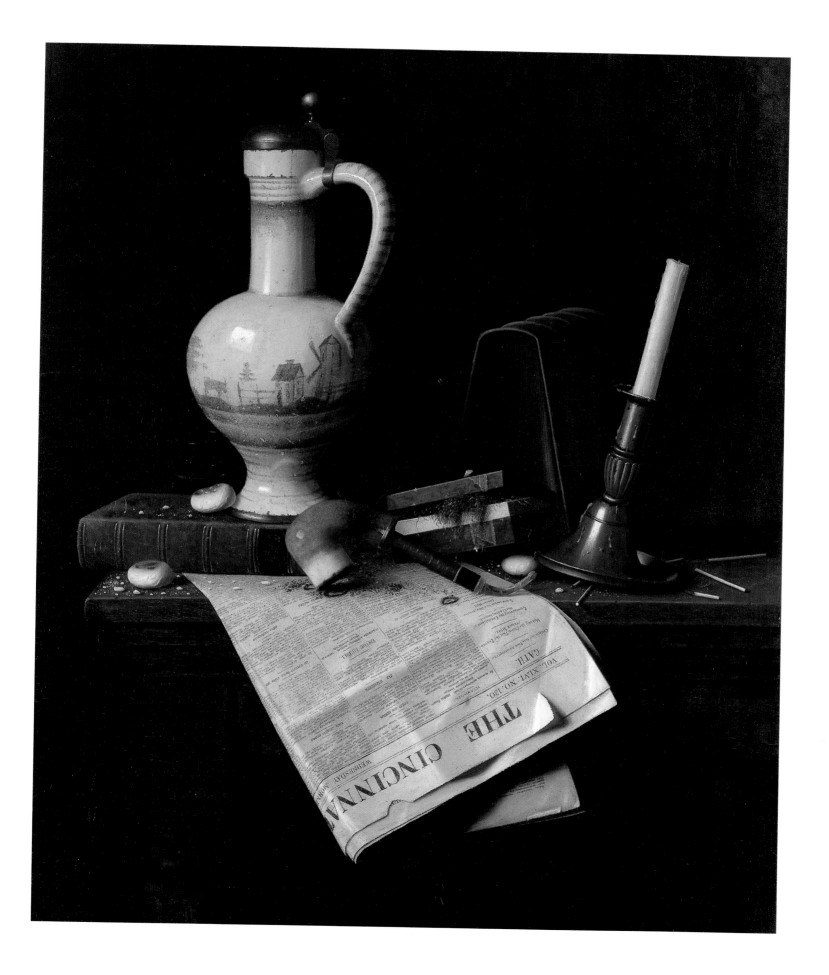

in Gath, / publish it not in the streets of Askelon; / lest the daughters of the Philistines rejoice" (II Samuel 1:20). For the pseudonymous writer, "Gath" was pointedly ironic—*do* publish it.[2]

But for Harnett the essential point was that Gath, as the home of the Philistines, was instantly equated with the Philistines by his contemporaries, steeped as they were in the King James translation of the Bible. "Philistine" had long since acquired the cultural meaning still common: "the enemy" (for example, a critic) into whose hands one might fall, or—from the supposed superiority of the Hebrews over the Philistines—a culturally deficient person. In September 1886 Harnett's *The Old Violin,* just acquired by Edwin L. Mehner of Cincinnati, had been exhibited in the city's annual Industrial Exposition, where it was very popular for its trompe l'oeil illusionism. However, the critic for the *Enquirer* condescendingly observed that Harnett

> thus far has confined his efforts to studies of this questionable character—questionable, because aside from the technical excellence manifest, there is nothing in them to attract. His may be one of those queerly constituted natures that run to fiddles and rusty hinges, just as Ruben's [sic] before him doted on babies. If it is not so, then he ought to give wider scope to abilities so genuine and play upon living, breathing subjects.[3]

Harnett considered himself to be more an inventor than an imitator. He tried, in his own words, "to make the composition tell a story." In *The Cincinnati Enquirer* he was quietly but lastingly defending himself (*and* Rubens—this is surely the only time their names have been linked!) against the Philistines of the *Enquirer.*

Harnett has purposefully rearranged the layout of the newspaper page. "GATH" in actuality appeared sometimes on the left side and sometimes on the right side of the page; in this day's paper it was on the right. But Harnett, having chosen to fold the newspaper and place it as he did, had to move the column so that "GATH" would be visible along with "Cincinnati." It was a move made with malice aforethought. That the Philistines would probably never see this riposte would not lessen the artist's satisfaction at his private revenge.[4]

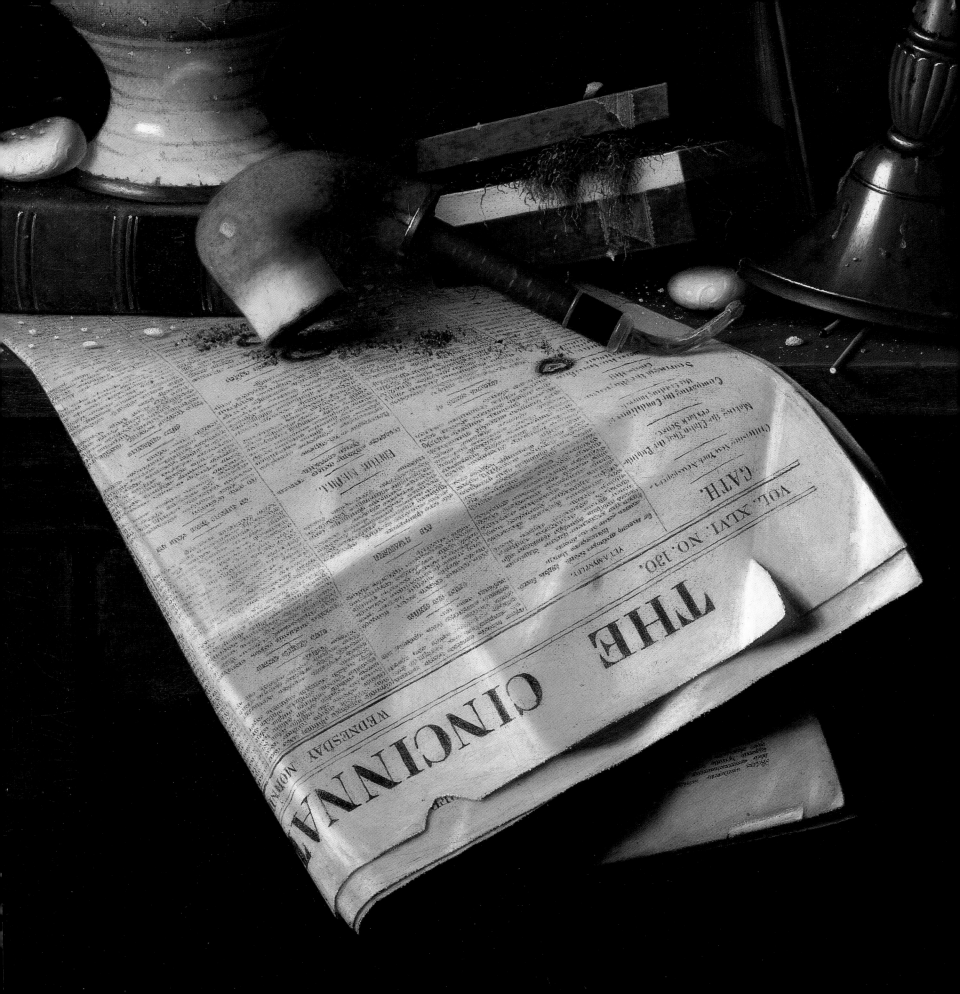

Thomas Hill (1829–1908)
Vernal Falls, Yosemite 1889

Signed lower right: T. Hill.
Oil on canvas, 30 x 20$\frac{1}{16}$ inches (76.2 x 51 cm)
Gift of the White House Historical Association, 1973

With Albert Bierstadt and Thomas Moran, Hill was of the first generation of artists who specialized in painting the landscape of the Far West, and like them he was born abroad. Brought as a child from Birmingham, England, to Massachusetts about 1841, he apprenticed as coach painter and decorator, then studied at the Pennsylvania Academy of the Fine Arts in 1853. He was a portrait painter when he first visited the West in 1861 (three years after Bierstadt did so), but his experience of Yosemite in 1862 focused his attention on that phenomenal landscape. After a year of study in Paris (1866–67) and several years in Boston, he moved permanently to San Francisco in 1871.

From his San Francisco base, Hill explored Yosemite, part of the great canyon of the Merced River 150 miles due east. The very existence of Yosemite had been unknown to all but the Indians and a few white men until 1851. The excitement that attended its discovery then by a volunteer militia led Congress, as early as 1864, to grant the valley to California to be held for "public use, resort, and recreation . . . inalienable for all time." Thomas Hill subsequently became *the* painter of Yosemite, even building a studio there in 1883 to minimize the still arduous approach to the valley.

More often than not, Hill focused on the waterfalls of Yosemite, remarkable for their variety and beauty. They were also suited to his technique. He worked in an appealingly spontaneous, plein air manner. His broad strokes of thinly applied paint offer little variety and less structure, though he gives the falling water a certain weight as well as brilliance.

Vernal Falls exhibits this loose handling; the canyon itself supplies the structure. By wrapping the white, watery core of the picture with dark cliffs and trees extending to the upper corners of the painting, Hill imposes form from without, rather than building it from within.

Not surprisingly, Hill painted rapidly. According to the landscape painter Benjamin Champney, he could "complete more pictures in a given time than anyone I ever met."[1] He favored a high-toned, mauve-dominated palette, and often started into his picture space from an untraditional light foreground. For such a light-filled painting, *Vernal Falls* has surprisingly little aerial perspective. The sky is not really atmospheric, only painterly in a summary way. Space is not felt beyond the falls, with the result that the great peak rising above it is not clearly situated.

It might be said, not unfairly, that Hill had not the temperament of a landscape painter but rather that of an accomplished decorator. The attraction of his paintings lies not in the projection of scenic grandeur, but in his ability to give to his canvases what art historian James Thomas Flexner has called "a peculiar artiness, flaking on large brushstrokes . . . and coloring everything dogmatically according to a formula of matched studio hues."[2] Nonetheless, the numerous replicas of his canvases brought America's "newest" natural wonder into many parlors, sometimes in matched pairs. As Flexner said, "They sold majestically."[3]

Charles M. Russell (1864–1926)

Fording the Horse Herd 1900

Signed and dated lower left: CM Russell 1900
 [with buffalo skull emblem before the date]
Oil on canvas, 24 x 36 inches (61 x 91.4 cm)
Gift of Dr. and Mrs. Armand Hammer, Dr. and Mrs. Ray Irani,
 Mr. and Mrs. John Kluge, Mr. and Mrs. Carl Lindner,
 the Armand Hammer Foundation, and the Milken
 Family Foundation, 1987

*I*n the quiet radiance of morning light, beneath the sliver of a waning moon, Blackfoot Indians urge a horse herd across a wide, placid river in Montana. The restrained image captures the effort of the crossing without theatrics through the compact grouping of the horses. Russell had a compelling sense of the unity of the Indians, the animals, and the land.

Although the palette is dominated by warm browns and grays, it is quickened by vibrant highlights in green, blue, mauve, and violet. The river is laid out in three bands of sky-reflected color: blue, yellow, and violet. The highest ranking Blackfoot leads the herd proudly, wearing a wolfskin headpiece surmounted by two eagle feathers, and riding a splendid pinto. Russell's quick, painterly touch is apparent in the coloration of the pinto, in the reflected glow of light on the rider's face, and especially in the water streaming off the horse into the emerald-and-pink ferment of water at its feet.

The massed horses and the spasm of agitation at the center, the smooth water and the Indians at the flanks, the simple X-shaped composition and the solid cap of the distant butte, a palette that captures the characteristics of the place without exaggeration— these are the open secrets of this finely crafted painting. Equally central to Russell's achievement in *Fording the Horse Herd* is his strong sense of identification with the Indians—what critic Peter Hassrick has called "equating their life with his."[1]

The year it was painted, 1900, was a good one for Charlie Russell, onetime cowboy. An inheritance from his mother gave him the means to build a home in Great Falls, Montana, for himself and his wife, Nancy. His reputation as a painter was increasing, as was his artistic mastery. In St. Louis the next year his first one-man exhibition would achieve critical success, and from this time forward his rise to national prominence would be unimpeded.

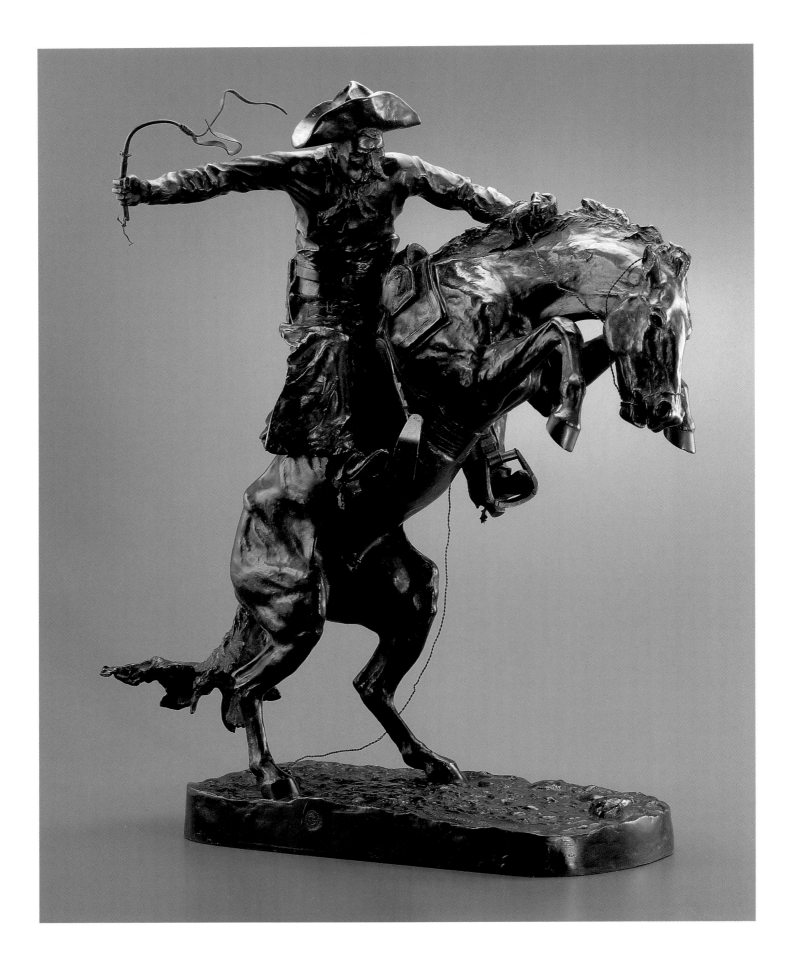

Frederic Remington (1861–1909)
The Bronco Buster modeled 1895, cast *c.* 1903

Inscribed on base, right: Frederic Remington.; rear: COPYRIGHTED BY / Frederic Remington 1895.; front: ROMAN BRONZE WORKS / N. Y. / CIREPERDUECAST; numbered: 23.
Bronze, $23\frac{3}{8}$ x $19\frac{7}{8}$ x $12\frac{1}{4}$ inches (59.4 x 50.5 x 31.1 cm)
Gift of Miss Virginia Hatfield and Mrs. Louise Hatfield Stickney in memory of James T. Hatfield, 1973.

"A first-class flash rider or bronco-buster receives high wages and deserves them, for he follows a most dangerous trade, at which no man can hope to grow old. . . ." The writer was Theodore Roosevelt in *Century Magazine* in 1888, describing the ranch life he knew well. The bitter winter of 1886–87 in the Dakota Territory had cost him his cattle ranch and tens of thousands of dollars. Roosevelt's articles for *Century* were illustrated by Frederic Remington (who had failed at sheep raising in Kansas), and the collaboration began a lifelong friendship.[1]

One of the illustrations was of a bronco buster, but it was a later drawing by the artist—*A Pitching Broncho*, in *Harper's Weekly* (April 30, 1892)—that became the inspiration for Remington's first attempt at sculpture. (Remington's variant spelling "broncho" is on his copyright document for the sculpture as well.) *The Bronco Buster* took him nearly a year to model. He copyrighted the model on his birthday, October 1, 1895. It was an instant success, destined to become "the most popular . . . small American bronze sculpture of the nineteenth century."[2]

No wonder. It is an inspired composition. Gripping both mane and rein with his left hand, the "flash rider" wields the quirt with his right. As in Roosevelt's description, he stands nearly erect in the stirrups, "and he grips with the thighs and not with the knees, throwing his feet well out." The moment of greatest tension is caught, the horse at its full rearing height before plunging its forelegs downward in an attempt to dislodge the rider. Ferocious animal energy—of horse and man—is captured in broadly modeled planes that echo through the figures: the hat brim and the rawhide chaps, the stallion's cheek and his hind flank. The combined energies of the towering rider and the tautly arching horse are anchored by the splayed tail and eased by the snapping whip.

Some 300 casts of *The Bronco Buster* exist, but they vary in detail. Remington's first foundry was the Henry-Bonnard Bronze Company, which made some 70 identical sand casts. In 1900 Remington transferred the model to the Roman Bronze Works, whose proprietor, Riccardo Bertelli, he had apparently met a year earlier and whose foundry was the first in America dedicated exclusively to lost-wax casting. This method made possible the casting of complex and detailed sculptures in a single piece. Moreover, the artist could alter the surfaces of the wax model before each casting, creating variations from one cast to the next.

Approximately 93 lost-wax casts of *The Bronco Buster* were produced by Bertelli's foundry during Remington's lifetime. The subtle contour of the horse's mane, flowing like water, suggests the fluency of the new process. The White House cast was probably made about 1903, just before the artist decided to turn the cowboy's whip hand 45 degrees so that the whip more closely echoed the arc of the horse.[3]

Remington soon recognized his true medium. He wrote to the author Owen Wister, his friend and the grandson of Fanny Kemble (page 98):

I am modeling—I find I do well—I am doing a cowboy on a bucking bronco and I am going to rattle down through all the ages. . . . I have simply been fooling my time away [as a painter]—I can't tell a red blanket from a grey overcoat for color but when you get right down to facts—and that's what you have got to sure establish when you monkey with the plastic clay, I am there—there in double leaded type.[4]

Frederic Remington (1861–1909)
Coming Through the Rye modeled 1902, cast 1918[1]

Inscribed on base, right: Copyrigh [*sic*] by. / Frederic Remington;
 on base, rear: ROMAN BRONZE WORKS N.Y.; under the base: № 13.
Bronze, 20 x 28 x 27 inches (50.8 x 71.1 x 68.6 cm)
Gift of Amon Carter, Jr., and Mrs. J. Lee Johnson III, 1962

*L*ike the *Bronco Buster* (preceding pages), Remington's *Coming Through the Rye* is derived from a drawing made for an illustration. Or rather, it is related to *two* such drawings. The first was made to illustrate Theodore Roosevelt's article "Frontier Types" for *Century Magazine* in October 1888.[2] The drawing, *Dissolute Cow-Punchers,* is not precisely illustrative of Roosevelt's text but is close in spirit to his description of cowboys who are willing to "exchange the wages of six months' grinding toil and lonely peril for three days' whooping carousal," and who have "come into town for a spree."[3]

In this drawing the cowboys ride rather slowly into town, firing their guns in the air while looking in several directions. The grouping of the figures is casual. But in a second Remington drawing, reproduced as a wood engraving for *Harper's Weekly* in December 1889, his cowboys are on the gallop. Entitled *Cow-boys Coming to Town for Christmas* (page 200), it has the unbridled power that Remington would later adopt for his famous bronze group. Now the riders storm into town as an explosive unit, most of the horses' hooves not touching the ground. For his later sculpture the artist combined aspects of both drawings. From the 1888 drawing he took the raucous firing of pistols that announces the cowboys' arrival. From the 1889 one he took the surging, soaring horses.[4]

When he reworked these ideas for his bronze group, Remington was in full command of his medium and his compositional powers. The four horsemen present a unified front, rushing across the prairie toward the town. Remington's theatricality and the cowboys' high spirits, in what has become the artist's most popular sculpture, are infectious, persuading us (in Roosevelt's words) that "this is mere horse-play," and that the cowboys "are in the main good men; and the disturbance that they cause in a

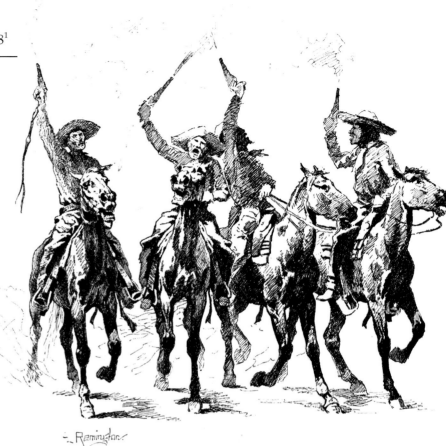

Dissolute Cow-Punchers
The Century Magazine, October 1888

town is done from sheer rough light-heartedness."[5] The title of the work likely alludes both to the abundant rye prairie grass—and to the whiskey distilled from it!

Form and expression are indivisible in this group. It is a technical tour de force. The two central horses do not touch; they are not joined. But with five of their hooves in contact with the base they form the support for the outer two horses. The outer right horse has just one hind hoof touching the ground, while the outer left horse flies free of it altogether, supported only by his neighbor at the saddle and through his rider's arm.

With seven of eight outer legs above the earth, the sculpture suggests an airplane as it is about to become airborne. The simile is justifiable. About 1906 Remington sent a Christmas card to his indispensable

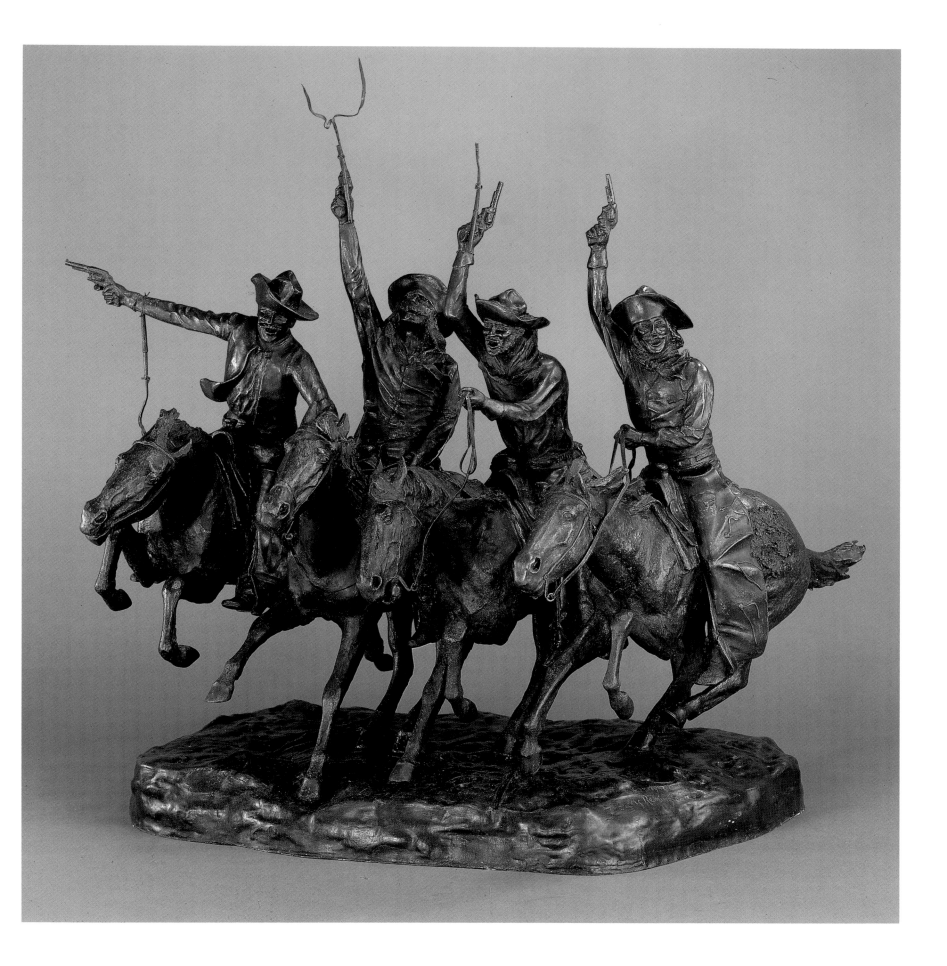

BUFFALO BILL HISTORICAL CENTER, CODY, WYOMING—THOMAS J. WATSON LIBRARY, METROPOLITAN MUSEUM OF ART

Cow-boys Coming to Town for Christmas

Harper's Weekly, December 21, 1889

bronze founder, Riccardo Bertelli. It was a caricature of the two friends with a Remington model of a horse balanced almost vertically on one foreleg. "Can you cast him?" asks the sculptor. "Do you think I am one of the Wright brothers?" responds Bertelli. The brilliant flying wedge of *Coming Through the Rye* was the product of intense concentration and much reworking. Describing a full day's effort on the "four horse bronze," Remington concluded, "Day after day I am to do this until I die or complete this bronze."[6]

In 1895, when Remington had just begun to work as a sculptor, he wrote to Owen Wister (who had already created the character that would make him famous in his 1902 novel *The Virginian*):

I have got a receipt for being *Great*. . . . your Virginian will be eaten up by time— all paper is pulp now. My oils will all get old mastery—that is, they will look like *pale molases* [sic] in time—my watercolors will fade—but I am to endure in bronze— even rust does not touch.[7]

His boast seems less idle than once it may have. Indeed, the critical reputation of Frederic Remington as sculptor has never been higher than at present, while his popular reputation has never waned.

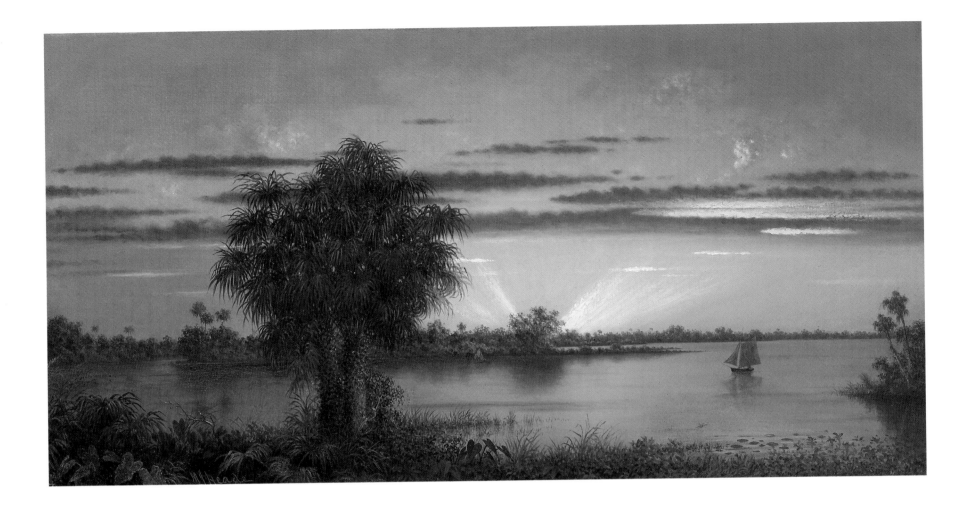

Martin Johnson Heade (1819–1904)
Florida Sunrise c. 1890–1900

Signed lower left: M J Heade
Oil on canvas, 28 x 54⅛ inches (71.1 x 137.5 cm)
Gift of Mrs. Jean Flagler Matthews, 1978

Heade was a restless soul. As an artist-naturalist—a recurring figure in the American art tradition—he roamed the Atlantic coast, recording the salt marshes with canvas and paints. Farther afield he journeyed to South America, where he focused on hummingbirds and orchids, seldom staying long. Frederic E. Church, himself a globe-trotter, once advised Heade to remain at home (then New York City) lest his public forget him.

By the time Heade painted *Florida Sunrise* he was in his 70s and "settled" in St. Augustine with his wife (he had married at age 64 for the first time in 1883), although he continued to visit the Northeast. His marriage and the patronage of Henry Morrison Flagler provided stability and credibility, social as well as financial, for the first time in his professional life. Flagler, a partner of John D. Rockefeller, had recently built the splendid Ponce de Leon Hotel in St. Augustine, and behind it he now built a studio for Heade. He is said to have paid Heade $2,000 each for two very large canvases, *The Great Florida Marsh* and *The Great Florida Sunset*.

Florida Sunrise is only about half the size of those ambitious paintings, although it shares with them the long, low format that Heade often favored. The canvas is nearly twice as wide as high, which emphasizes the uninterrupted flatness of water and land that Heade liked to paint. His technical steadiness had lessened with age, so that in this picture he generalizes the foliage. Even the clouds are drawn with less finesse than those in works of two decades earlier (compare *Sailing off the Coast*, 1869, page 168). Yet Heade could still conjure a radiant palette to express the miracle of a dawning day. The undersides of the clouds at the right glow with intense yellow-orange, their vibrancy enhanced by the brownish gray and mauve of clouds elsewhere in the painting.

The simple, economical composition is typical of Heade, yet here it has a special flavor. He seems to have felt the primeval quality of the lush Florida tidewater. He plays the dark tree clump in the left foreground directly against the sunrise at the horizon—a blunt contrast of dark and light, the finite and the infinite, the material and the ethereal. These antitheses combine with the mostly very thin, homogeneous paint layer to suggest a world in abeyance. With the calm and the silence comes a sense that this is a significant dawning.

It is both fitting and satisfying that the funds to purchase this painting of Florida for the White House were made available by Jean Flagler Matthews, a generous descendant of Heade's Florida patron, Henry Flagler.

Albert Bierstadt (1830–1902)

Butterfly 1893

Signed and dated lower right: Albert Bierstadt / Jan 20 / 93
Oil and pencil on paper mounted on pasteboard,
 $4^{15}/_{16}$ x $8^{1}/_{16}$ inches (12.5 x 20.5 cm; paper size)
Gift of Mr. and Mrs. James R. Graham, 1962

*T*his handsome lepidopteran belongs to the genus *Artisticus*, species *bierstadt*. It has a taxonomy of its own, deriving from the artist's pleasant habit of giving small tokens of his art to acquaintances, usually female. In May 1892 a journalist from *The Detroit Free Press* was among a "very small and select" group of visitors to the artist's studio on one of his carefully stage-managed "afternoons." She reported:

> We women were so glad we *were* women that afternoon, for Mr. Bierstadt presented each lady with a souvenir. This is how he made them. We all clustered about the table and he took out a palette, a knife and some large slips of cartridge paper. Two or three daubs of pigment on the paper, a quick fold, and holding it still folded against a pane of glass, he made two or three strokes of that wizard-like palette knife on the outside, and hey presto! a wonderful Brazilian butterfly or moth, even the veining on the wings complete! A pencil touch added the antennae, the artist's autograph was added to the corner, and now we each of us own a painting by Bierstadt.[1]

This is an invaluable description of the method by which, early in 1893, the artist created the *Butterfly* now in the White House collection. It was once thought, probably mistakenly, that this butterfly was actually made at the White House. The artist had been in correspondence with President Benjamin Harrison to urge the purchase of some of his paintings that had been on loan there since 1884, but there seems to be no evidence that Bierstadt visited the President in January 1893.

In February 1878, however, Bierstadt had been a guest in the White House. There he had demonstrated his cleverness for President Rutherford B. Hayes and his wife, Lucy Webb Hayes, during a week-long stay. The Hayes Presidential Center in Fremont, Ohio, owns a Bierstadt butterfly thought to have been executed at that time and given to the President. The center has, in addition, a butterfly painted in the same manner by Lucy Hayes in emulation of Bierstadt.[2]

Bierstadt's butterflies are not unrelated to the small studies of wildflowers, rocks, dead birds, and similar subjects by John Ruskin and other contemporary English and American artists. Bierstadt, who returned from study in Europe at the end of August 1857, must surely have seen the large exhibition of contemporary English art that was shown successively in New York, Philadelphia, and Boston in 1857–58. (In New York it was held at the National Academy of Design, where Bierstadt would exhibit his large *Lake Lucerne* in April 1858.)[3]

The exhibition was dominated by the Pre-Raphaelites, with their precise naturalistic technique. But Bierstadt avoided both the lavish detail and the watercolor medium preferred by many of them. He chose instead a spontaneous, evocative approach, and he used oil paint. His butterflies are expressive bursts of color, tiny affirmations of the glory of nature's small creations.

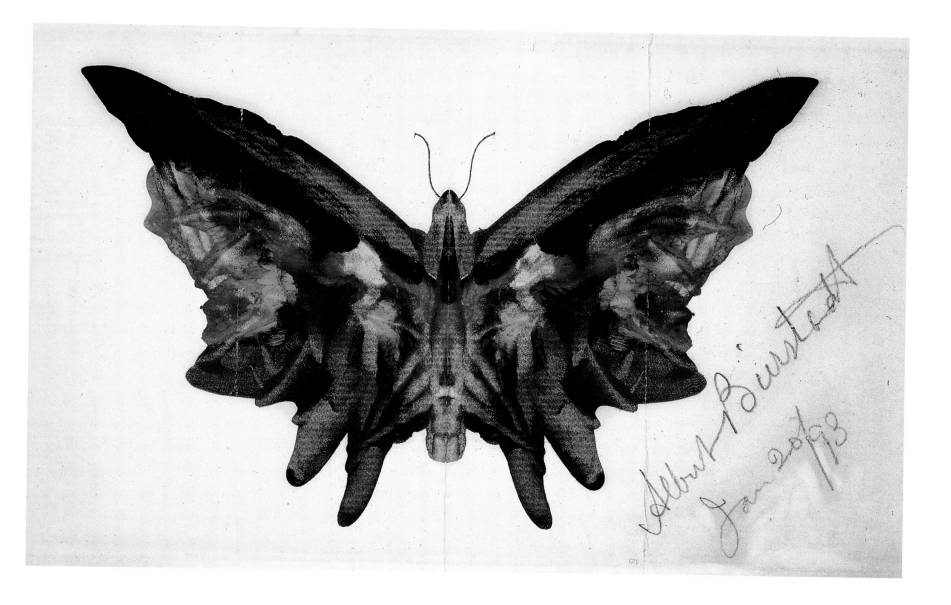

Albert Bierstadt
Jan 20/93

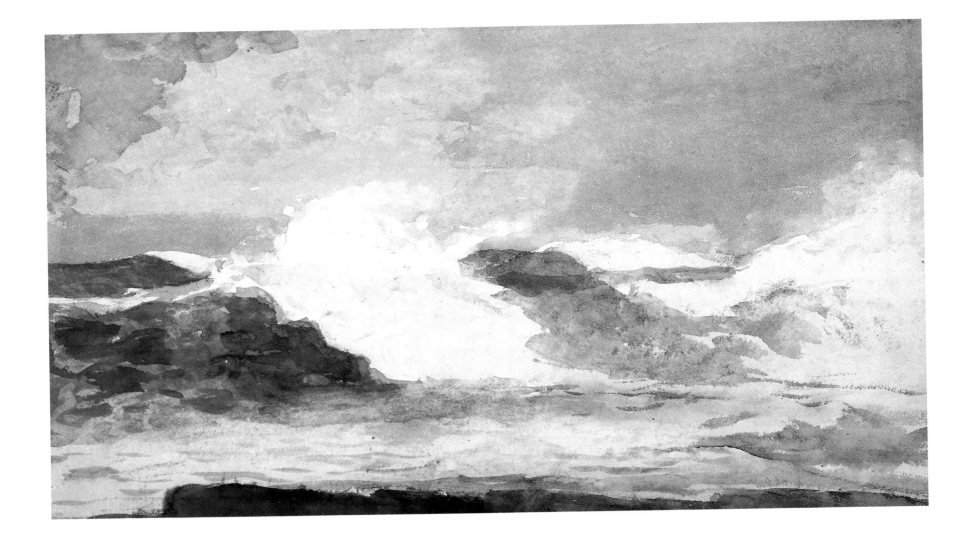

Winslow Homer (1836–1910)
Surf at Prout's Neck c. 1895

Estate seal with impress, lower left: WINSLOW / HOMER
 Illegible seal with impress, lower right
Watercolor on paper, 12¼ x 21½ inches (31.1 x 54.6 cm)
Gift of Mr. and Mrs. George Brown, 1964

Homer's watercolors are among the glories of American art. *Surf at Prout's Neck* is not a highly finished work and has no figures, yet its bleak interpretation of the elemental power of the ocean justifies the artist's prediction that "in the future I will live by my watercolors."[1] Prout's Neck is a rocky promontory on the Maine coast where Homer's family had property and a summer home. When not on painting trips, Winslow Homer lived and worked here for the last 27 years of his life.

A dramatic high sea is viewed from the rocky ledge of the coastline. These foreground rocks are brushed in solidly in an opaque brown. Between a film of weathery sky and a relatively quiet ebb tide of water near at hand lie dark, dense surging waves that at several points burst over rocks into white spray. The white water seems to be expressed entirely by the untouched paper. Elsewhere, Homer confines himself to grays, thin light strokes toward the bottom, heavier overlays in the dark cresting waves, and in the sky a prodigious, virtuosic washing together of grays— wet into wet—to conjure the rapidly shifting weather of the palpably wet sky.

The painting is extremely free, with no apparent underdrawing, and it exhibits a variety of brushstrokes. Although it is undated, the late Homer scholar Lloyd Goodrich assigned to it a date of circa 1895, by comparison with a number of similar watercolors of surf breaking on rocks or shore, some of which bear that date.[2]

Jasper F. Cropsey (1823–1900)
Under the Palisades, in October 1895

Signed and dated lower right: J. F. Cropsey 1895
Signed, dated, and inscribed on a label on the stretcher:
 Under the Palisades, in October / (opposite Hastings) /
 By J. F. Cropsey N.A. 1895 / Hastings-upon-Hudson / N.Y.
Oil on canvas, 60 x 48 inches (152.4 x 121.9 cm)
Gift of Mr. and Mrs. John C. Newington, 1973

*I*n his old age Cropsey pursued two contrasting yet complementary paths. Increasingly he painted in watercolor, brilliant small works that sparkle with the freshness of youth even while their meticulous, almost ethereal, delicacy suggests the meditations of age. He produced as well a small number of large vertical oils, formal and self-consciously grand. These he must have intended to stand as lasting memorials to his career.

The close relationship of the two sides of his late work is demonstrated by *Under the Palisades, in October*, which is closely based on a watercolor of 1893 known as *Fishing in the Cove*.[1] The massive cliff and its shadow, painted in more muted and mellow tones than much of his earlier work, occupies perhaps 40 percent of the picture plane and projects the monumental permanence of nature. This great calm form, wrapped by the sky, is very carefully designed, but its decorative aspect is secondary to its expressive one. The painting is "composed" in both senses of the word.

Much of the work's success lies in Cropsey's ability to keep the dark mass and the light sky-water in scrupulous balance. The brightness of the sky is tempered by the pink tones of late afternoon and their reflections on the quiet Hudson. Many other details display the artist's technical control and expressive skill. He assures nature's dominance by suppressing the human figure. In the boat lying silently in the cove at the foot of the escarpment a man, barely noticeable, sits motionless. In the sailboat at the left a sailor is even less apparent, but the irregular patch of the partially furled sail has its own liveliness, serving as an effective echo of the bare rocky outcrop at the upper right of the palisades. There is a masterly economy of means. Cropsey partly forgoes his innate love of texture; paint is applied sparingly, and as a result the basic, bold shapes on his canvas speak with a single voice.

It is a voice of serenity and equanimity, of moral harmony. Thirty years earlier Cropsey had known John Ruskin in England, and he must have agreed with the evangelical art critic and author that "the duty of the painter is the same as that of a preacher. . . . Both are commentators on infinity, and the duty of both is to take for each discourse one essential truth . . . and to impress that, and that alone, upon those whom they address. . . ."[2]

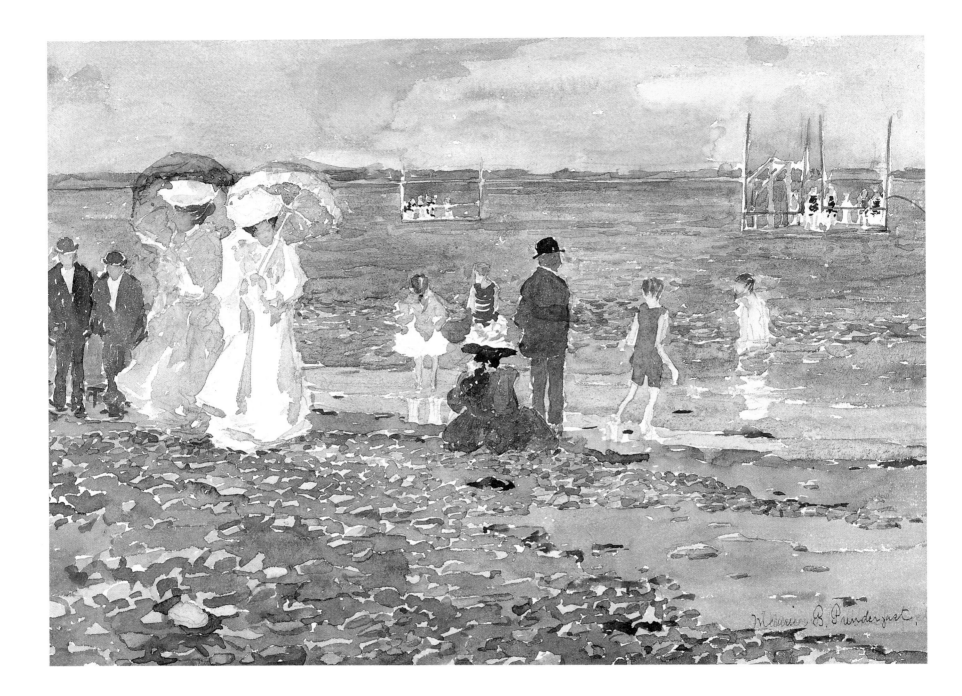

Maurice B. Prendergast (1858–1924)
Revere Beach c. 1896–97

Signed lower right: Maurice B. Prendergast.
Watercolor and pencil on paper, 9½ x 12 inches (24.1 x 30.5 cm)
Gift of Arthur G. Altschul, in memory of
 Stephanie Wagner Altschul, 1962

*I*n early 1895, fresh from some four years of travel, study, and work in France, Prendergast settled in Boston and almost immediately began to exhibit his striking watercolors. In the next three years, before returning to Europe in 1898, he made some paintings of Revere Beach, this one among them.[1] In contrast to the modernist stylization he developed after 1900, the watercolors of the mid-nineties are traditional in their brushwork, but highly accomplished.

The scene deftly captured in *Revere Beach* charms us with its cool, refreshing, delicious atmosphere. It is a New England summer day of fitful weather, sunny but not hot, with intermittent clouds suggesting an imminent change. As he usually did, Prendergast prepared the paper with much underdrawing including, interestingly, indications of facial features that are not developed in watercolor. (Even his signature, in the full form he used during these years, was first penciled in.) The artist lays on color with a varied touch. For instance, he attends to the intrinsic shapes and textures of the small irregular patches of stony beach and the larger, less broken areas at the water's edge. In places the water has an appropriately stained or soaked look: for example, just to the right of the two women.

The high horizon, a feature of much recent art that had already been assimilated by the academies, is usual in Prendergast's paintings. Strand, sea, and sky become flat bands against which the figures are silhouetted. The women and their parasols help to unite these bands, as do the vertical posts of swimming rafts. The artist's groupings of figures are imaginative, creating a visual music with vivid rhythms and harmonies.

Although dominated by blues and aquas and warmed by a scattering of pinks and browns, the color scheme is distinguished by the liberal use of gray tones. This was the palette that Prendergast so admired in the works of French artists such as Vuillard (in whose paintings he noted "the most delightful greys") and Cézanne (whose palette included "the most wonderful color, a dusky kind of grey").[2] To some extent Prendergast has succeeded in transposing the beach scenes of Monet and especially Eugène Boudin from Normandy to New England. He achieves an effect of vibrant light similar to theirs, for example, in the white dress and hat of one of the parasoled women, where he brushes in a pale blue to indicate shadows, leaving the whiteness of the paper to dazzle the eye.

William Merritt Chase (1849–1916)

Shinnecock Hills, Long Island 1900

Signed lower left: W^m M. Chase.
Oil on panel, 14½ x 18⅝ inches (36.8 x 47.3 cm)
Gift of Dr. and Mrs. Irving Frederick Burton, 1962

*T*he urbane Chase loved Europe (he once exclaimed, "My God, I'd rather go to Europe than to heaven"), and his famous Tenth Street Studio in Manhattan was tastefully crammed with art and mementos from around the world. Nevertheless, he turned down an opportunity to teach in Munich after studying there. He wanted to paint and teach in New York because, as he later recalled: "I was young; American art was young; I had faith in it."[1]

Chase's name was to become inseparable from Shinnecock, at the eastern end of Long Island. There this brilliant teacher opened a summer art school in 1891 with the financial backing of a socialite of nearby Southampton and her friends. To this site at the edge of the Atlantic came hundreds of aspiring art students every summer until 1902.

Painting at Shinnecock was done out of doors. Such plein air painting, long resisted by conservative artists everywhere, was now as acceptable to the academy as to the avant-garde, and Chase was one of the most accomplished of the plein air painters.

The dunes of Shinnecock were, if not featureless, certainly not picturesque. With no trees to unite land and sky, few houses, relatively little contrast in the high-toned dune grass and pale blue sky, this landscape had neither the variety nor the sentimental overtones of the French Barbizon School paintings that were still immensely popular in America. Despite the simple setting, the relatively flat coast, marsh, and dune scenes appealed to painters other than Chase, including Worthington Whittredge, Homer Dodge Martin, and Martin Johnson Heade.

Shinnecock Hills is painted on a small panel of the type often carried by landscape artists in their search for motifs. Pre-primed with a very light tone, such panels were used by artists to record their chosen segments of the landscape, to capture a transient cloud or a change of light. "When I have found the spot I like," said Chase, "I set up my easel and paint the picture on the spot. I think that is the only way rightly to interpret nature."[2]

So simple does the subject seem that the artist's subtlety is easily overlooked. Chase edited the extensive view that confronted him on the dunes. He cropped the gentle hills to stress the dale between them, where the dusty purple and green scrub bushes cluster at the center. These undulations and troughs mimic ocean swells, while the blue-gray ocean itself, barely glimpsed, lies motionless at the horizon.

Chase creates the sensation of extensive space, a feat all the more impressive because he did not use strong contrasts of light and shade. The flowering shrubs in the foreground, whitecap-like, are sharply focused and step diagonally into the picture space. The diagonal line of the hill and the purple-green stand of bushes further point the way to the sea. The few superbly painted clouds, diminishing in crispness and intensity as they approach the horizon, complete the conquest of pictorial space.

The breeze that blows across the dunes is first stated in the striated sky. There Chase used a stiff brush to apply broadly a bright, lightened cobalt blue, leaving clear strokes and channels through which the white ground is seen. Blended, flexible brushstrokes in the foreground suggest the effect of wind in the dune grass.

All this is accomplished directly, with no aesthetic posturing. Indeed, it is this apparent simplicity, this matter-of-factness, that marks Chase's best work and distinguishes it from the contemporary European art he knew so well. A discerning critic, writing at the height of Chase's fame, observed: "In a certain sense, Mr. Chase is a typical American artist . . . he is sane, unsentimental, truthful and unpretentious. All these are typical American qualities so far as our painters are concerned."[3]

Ernest Lawson (1873–1939)
The Red Mill c. 1904

Signed lower left: E. LAWSON
Oil on canvas, mounted on
 panel, 18 x 24 inches (45.7 x 61 cm)
Gift of Richard Manoogian, 1978

Born in Nova Scotia and widely traveled throughout his life, Lawson began to study painting when he was 15. Three years later he enrolled at the Art Students League in New York City, where he studied with John Twachtman, who was to exert the greatest influence on his development. He shared Twachtman's lyrical, intimate interpretation of landscape and, to some extent, his deft, feathery brushwork. It was probably during the winter of 1904 that Lawson painted *The Red Mill*, which gives convincing evidence of his innate skill as well as his debt to Twachtman.

Lawson's landscape subjects were usually quite specific. Although this scene has not been precisely identified, it was probably a textile mill in the Connecticut Valley. The mill and the river angle diagonally into the landscape, suggesting the depth of the view. The dense brushwork and thick impasto, however, counter this perspective and, together with the network of trees and bushes, pull the eye back to the surface of the canvas. So does the pale red ocher of the mill, a color that Lawson weaves through the dark, wintry blues of the river and sky, unifying the surface. Ultimately the painting is memorable because of the keenly felt contrast between the bright upper third glinting with the chill of a winter day, and the dark lower part, wrapped in the penumbral shadows of the advancing afternoon.

In 1904—the presumed year of this painting— Lawson won a first prize for painting and a silver medal at the Universal Exposition in St. Louis, Missouri. One of the best painters of his generation, he was among those American artists who united to protest academic conservatism and to promote some of the principles of European modernism. He exhibited with The Eight (1908), an anti-establishment group, and helped to organize the Armory Show (1913), which introduced modern art, European and American, to a wide public. His own painting was increasingly influenced by the paintings of Cézanne and the later work of Monet.

Thomas Eakins (1844–1916)

Ruth 1903

Inscribed, signed, and dated on canvas back:
 LAURA K. HARDING / FROM / THOMAS EAKINS / 1903
Oil on canvas, 24³/₁₆ x 20¹/₄ inches (61.4 x 51.4 cm)
Gift of Joseph H. Hirshhorn, 1967

While most other portraits in the White House are of persons connected with the mansion, this one has entered the collection because it is a fine example of Eakins's penetrating art. Ruth Warner Harding (1893–1944), who was no relation to President Harding, seems confined by the large, velvet-covered, carved mahogany chair in which she is ensconced. Her barely glimpsed arms are contained by the chair's arms, and she is firmly lodged between the chair's back and the picture plane. By severely cropping the chair, Eakins has pulled her close for his scrutiny. There is a striking contrast between the physical proximity of this young girl and her emotionally unresponsive face.

It is a long face, more rectangular than oval, homely yet striking in the full cheeks and angular chin. The high forehead is emphasized by the pulled-back hair, which falls in long, soft, tresses framing her face. Blond accents touch the light brown hair, especially in the shining, pale yellow brushstrokes near her right cheek.

Her white dress is painted with brio, the many strokes of light and dark gray suggesting volume as well as transparency. Those grays are repeated in her eyes, to somber effect. The hat-size, light pink hair ribbon is a tour de force, broadly painted and enlivened with white highlights and touches of carmine—a color scheme echoed in her face, notably in the strong pink of the right cheek. The warm, scumbled, nondescriptive background is characteristic of many of Eakins's portraits. Though compositionally restrained, this is a virtuosic painting.

The sitter was the niece of Jennie Dean Kershaw, then fiancée of Samuel Murray, Eakins's favorite pupil and closest friend. Eakins painted several portraits of relatives of Murray and Kershaw as gifts. He gave this portrait to Ruth's mother, Laura K. Harding, from whom it passed to Samuel and Jennie.[1] Forty years afterward Ruth told her husband that the sullen expression recorded by Eakins was that of a ten-year-old who "wanted to be playing with the kids instead of sitting for the painting."[2] Even so, it is in accord with the generally introverted expressions of the sitters in most of Eakins's portraits—including Ruth's aunt Jennie and her great-aunt Anna Kershaw, to both of whom she bears marked resemblance despite her youth—and it is difficult not to see them as projections of the artist's own guarded and melancholy temperament. Eakins's widow, the painter Susan Macdowell, recalled her husband as "a silent man, not sad exactly, but disappointed—he had had blows. . . . There was sadness underneath."[3]

216

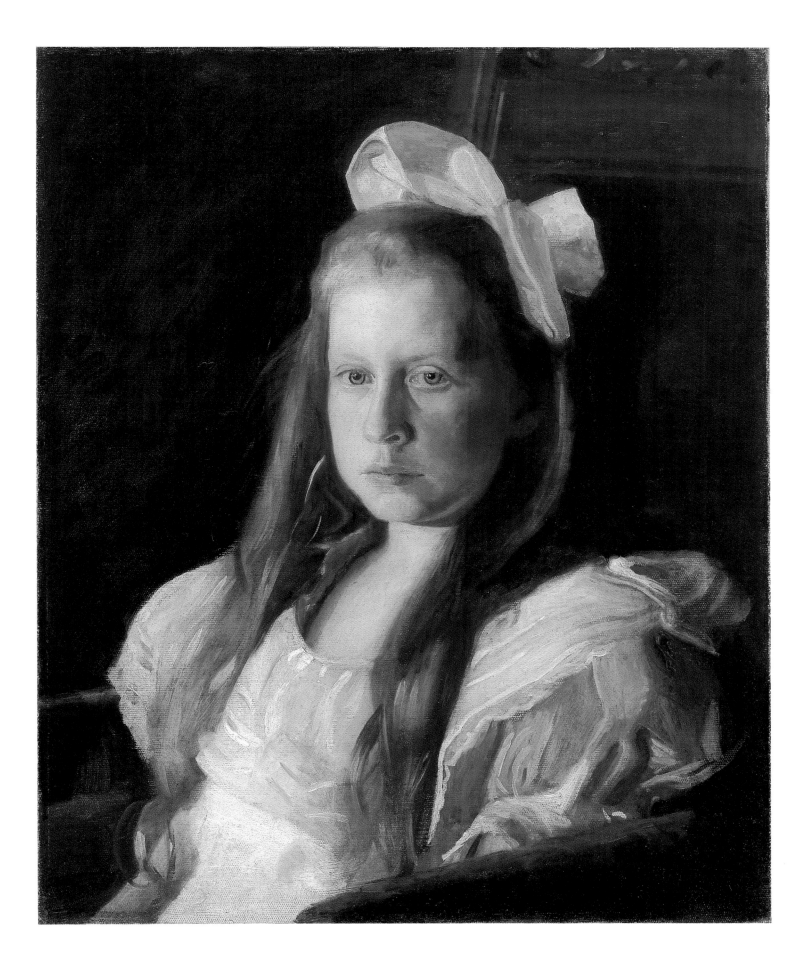

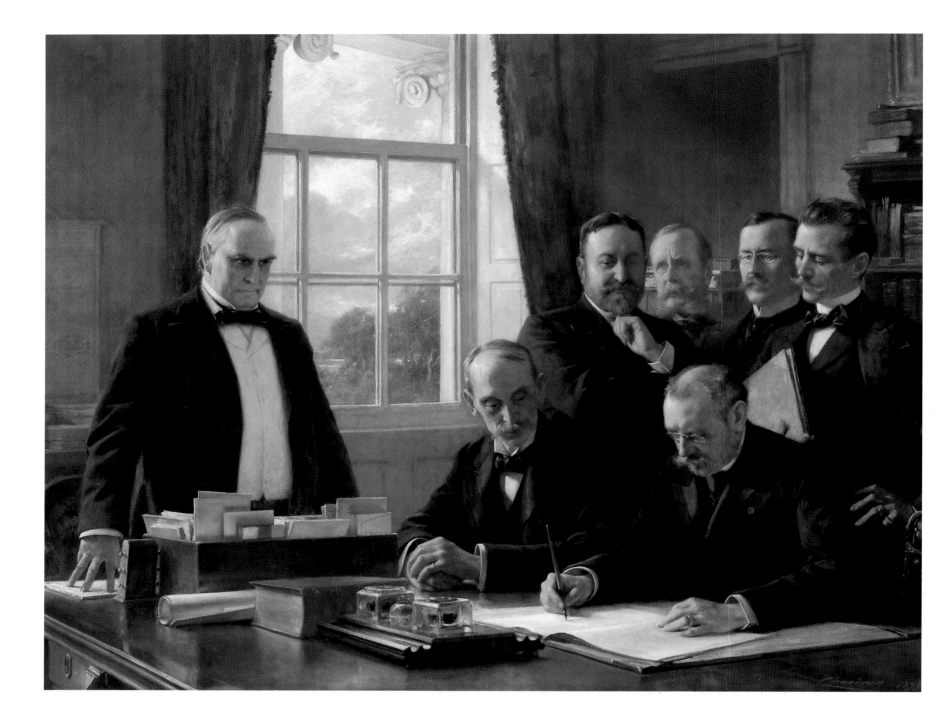

Théobald Chartran (1849–1907)

Signing of the Peace Protocol Between Spain and the United States, August 12, 1898 1899

Signed and dated lower right: Chartran 1899.
Oil on canvas, 62⅛ x 82¹/₁₆ inches (157.8 x 208.4 cm)
Gift of Henry Clay Frick, 1902

The "splendid little war," as John Hay called the Spanish-American War, was not one of the nation's prouder conflicts, although it was one of the most popular. Following the explosion and sinking of the U.S.S. *Maine* in Havana's harbor on February 15, 1898 (responsibility for which was never determined), Congress—ignoring a clear opportunity for a peaceful solution to the Cuban crisis—declared war on April 20. The superiority of the United States Navy in the Pacific as well as in the Caribbean was decisive, and by July 15 the war was over.

The armistice terms gave independence to Cuba, ceded Puerto Rico to the United States, and permitted American occupation of Manila in the Philippines, where an anti-Spanish uprising had already begun. In accepting the terms of the preliminary protocol on August 12, the Spanish lamented that "This demand strips us of the very last memory of a glorious past, and expels us . . . from the Western Hemisphere, which became peopled and civilized through the proud deeds of our ancestors."[1]

The French government acted on behalf of the Spanish; therefore French Ambassador to the United States Jules Cambon is signing the preliminary peace document in Chartran's painting of the event. Immediately behind him stands Eugène Thiébaut, first secretary of the French Embassy. Although the two men were merely surrogates, in the artist's interpretation they seem to take on the added burden of accepting the defeat for the Spanish. Relegated to the right edge of the canvas, they are painted with downcast eyes. The five American officials, in contrast, are presented more or less full face.

His stout figure alone in half the picture, President William McKinley dominates the proceedings. He stands at the end of the Cabinet table that he used habitually as his desk. A letter or file box rests in front of him, a calendar beside it. The room, which served as the Cabinet Room between 1867 and 1902, is on the south, or garden, side of the White House, thus the bucolic landscape seen through the window. The upper sash of the window has been lowered to alleviate the swelter of an August day in Washington before air-conditioning. The columns of the South Portico frame the view.

Photographs of the event confirm many of the details of the room and the participants, but Chartran has moved the signing to the window wall for purposes of illumination. The light enters not only through the visible window but also through the unseen east window, falling upon the side of the President's massive head and on the foreheads of the seated signatories.

The principal U. S. representative is Secretary of State William R. Day, seated. Day had only become secretary after the war had begun on April 26. He would resign a month after the signing of the protocol to enter the federal judiciary. He later was to become an associate justice of the Supreme Court (1903–22). Behind him, from left to right, stand John Bassett Moore, first assistant secretary of state, Alvey A. Adee, second assistant secretary, and Thomas W. Cridler, third assistant secretary. Moore, who was to have a long and distinguished judicial and diplomatic career, had also been appointed at the outbreak of the war and would serve as secretary and counsel in the final treaty negotiations in Paris that October.

The photographs reveal that there were as many as 12 persons present, but Chartran has edited them for maximum concentration.[2] The photographs show Secretary Day signing the protocol, but the artist has chosen instead to emphasize the Spanish

capitulation by depicting their representative signing under the stern gaze of the President.

It is not known if Henry Clay Frick commissioned Chartran to paint *Signing of the Peace Protocol.* Although the painting is recorded as a gift from Frick to the White House, two letters of thanks from President Theodore Roosevelt at his home in Oyster Bay, New York, to Frick make it appear that the work was intended rather as a personal gift to the President. Roosevelt wrote:

> The picture has just arrived. Permit me
> to thank you for it most heartily. I admire it
> greatly for itself and I value it still more
> because of the donor and because it will recall
> to me the delightful day I spent with you.
> All I regret is that Mrs. Roosevelt could not
> be present and that I could not meet your
> family. (July 12, 1902)

Its imminent transfer to Washington is announced in the second letter:

> That picture is a beauty. My house is so small
> that I shall probably take it to the White
> House, where incidentally it will do immense
> good, for the pictures of the White House
> are not all that fancy. . . . (July 30, 1902)[3]

In that Roosevelt owed his national ascendancy in part to the heroes' laurels bestowed on him and the Rough Riders for their actions during the war, and that he succeeded to the Presidency after McKinley's assassination, it was an appropriate gift.

Chartran's considerable skill is apparent in the bold, simple, architectonic composition that invests the scene with appropriate gravity and strength. The palette is reserved, although fairly high in tonality.

Chartran enlivens the scene through the manipulation of light, the President's lowered face placed in shadow, Day's intelligent head vividly modeled and warm with his auburn mustache and pale red-blond hair. Sunlight streams in and gives rise to a softly veiled halo above the assistant secretaries' heads. Chartran further mitigates any suggestion of condescension by adding the freely painted, poetic head of Alvey Adee, behind the others. He alone seems inattentive to the signing, lost in an uncertain introspection. The Cabinet table pushes out of the picture space to where we are seated, face-to-face with history in the making.

An artist of the Second Empire in France, Chartran was a student of Alexandre Cabanel, then in his meteoric rise to prominence under the patronage of Napoleon III. A history painter when the genre was in decline, Cabanel passed the tradition on to Chartran, who in many respects was a superior talent. In 1877 Chartran won the Grand Prix de Rome. His many historical pictures included scenes from ancient and medieval French history, which enjoyed a particular vogue in the wake of the debacle of the Franco-Prussian War. Soon, however, he became a portrait specialist. Just as George P. A. Healy had done in *The Peacemakers* (page 156), Chartran embraced the opportunity to combine portraits and contemporary history in *Signing of the Peace Protocol.*

Théobald Chartran (1849–1907)

Edith Carow Roosevelt 1902

Signed and dated lower left: Chartran / Washington D.C. / 1902
Oil on canvas, 58¼ x 50¼ inches (148 x 127.6 cm)
Gift of the French Republic, 1902

While his early reputation was made as a creator of history paintings—religious, mythological, or political—Chartran in the mid-1880s turned his attention to portraits and became one of the most fashionable international portraitists. In the last decade of his life the French artist spent some months of each year in New York, which brought him important American commissions.

This handsome painting of the handsome Edith Carow Roosevelt is testimony to his skill and his combination of tradition and modernity. Mrs. Roosevelt, wife of President Theodore Roosevelt, posed for this formal-informal portrait in the colonial garden. (The South Portico in the background has been repositioned by the artist for pictorial effect.) She reminds us of 18th-century English ladies at their country homes, as painted by Gainsborough and others. At the same time Chartran's extensive use of the cream-to-tan underpaint as a prominent part of the surface speaks to his knowledge of modern French painters, his contemporaries. This primer is most apparent in the lace overlay of the black coat, but it is also evident in the coat itself and in the skirt.

Despite the black coat and splendid black feathered hat, the painting is filled with light, due not only to the extensive areas of white and the light underpaint but also to the sea green found in much of the picture—in the background, in the subject's eyes, and as a tint in the white of the bench. Edith Roosevelt's elegant pose, with such torsion in the body, may seem contrived to us, but her biographer felt that "the pose characteristically combined informality with regality and the calm that was always Edith's most noted attribute."[1]

Details of the commission are sketchy; it seems that Attorney General Philander C. Knox asked Chartran to paint Theodore Roosevelt, who had succeeded to the Presidency upon the assassination of William McKinley in 1901. As painter of the 1899 *Signing of the Peace Protocol Between Spain and the United States* (page 219; it had been presented to the White House by Henry Clay Frick in 1902), Chartran was a likely choice to paint the portrait of the President. Delayed in traveling to Washington and, upon his arrival, finding Roosevelt too busy to pose, Chartran persuaded Mrs. Roosevelt to sit for her portrait. Her diary for 1902 records two sessions, on March 24 and April 17.[2]

The completed portrait of Edith Roosevelt never left the White House. She alludes to it in a letter of August 21, 1902, in which she asks architect Charles F. McKim, then engaged in a major renovation of the house, to "put all the ladies of the White House, including myself, in the down-stairs corridor. . . . It could then be called the picture gallery, and you know a name goes a long way."[3] That the portrait was officially recorded as a gift of France suggests that someone, possibly the artist or one of the Roosevelts, interceded with the French ambassador in Washington to arrange the commission retroactively.

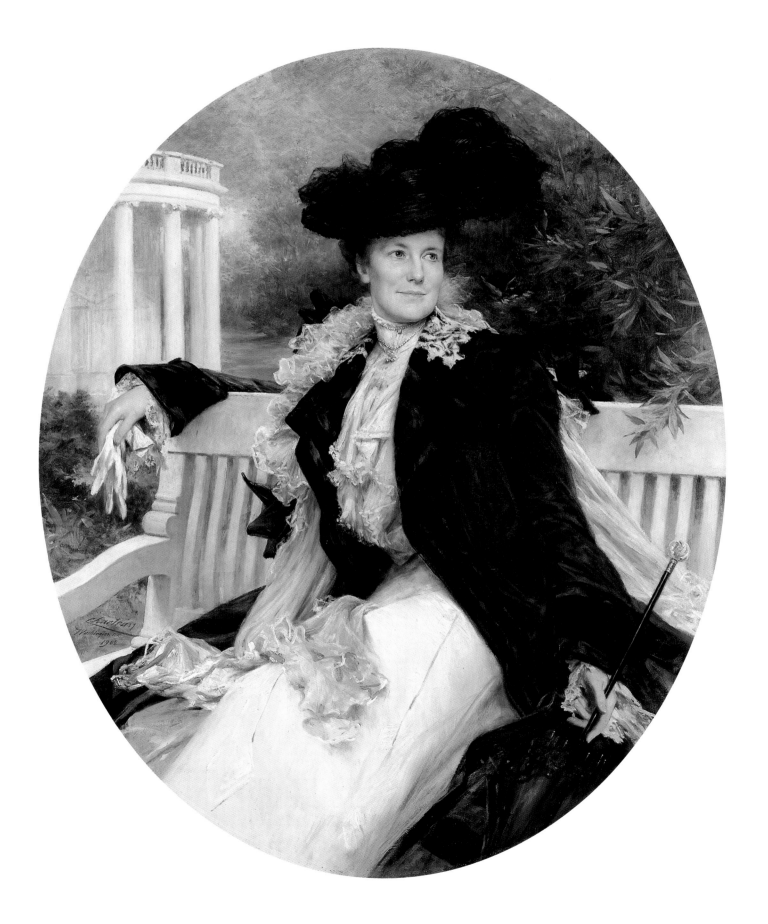

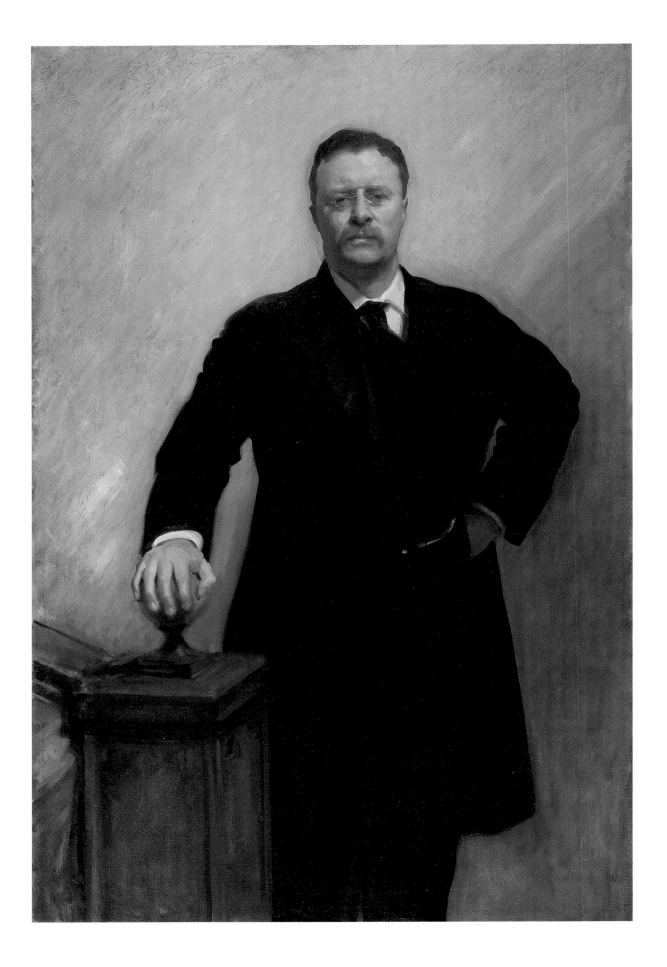

John Singer Sargent (1856–1925)
Theodore Roosevelt 1903

Signed and dated upper right: John S. Sargent 1903
Oil on canvas, 58⅛ x 40 inches (147.6 x 101.6 cm)
United States government purchase, 1903

*V*ice President Theodore Roosevelt (1858–1919) acceded to the Presidency upon the death of William McKinley on September 14, 1901. In Roosevelt's official presidential portrait Sargent seized upon two of the President's most salient characteristics, physical vitality and a self-assurance bordering on arrogance, and he painted a tour de force of nuanced blacks, grays, browns, and creams.

The commission no doubt owed much to the urging of architect Charles McKim, whose renovation of the White House was just getting under way in April 1902, and who was expecting Sargent to come from London to Boston soon to continue his decorations (1890–1916) for McKim's Boston Public Library.

In any event the commission was settled by mid-May 1902, and the President's letter to Sargent was sent through the American Embassy in London: "Disregarding entirely my personal feelings, it seems to me eminently fitting that an American President should have *you* paint his picture. I cordially thank you" (May 13).[1]

The famous expatriate artist arrived in America in January 1903 and soon received a letter from Roosevelt inviting him to live in the White House during February to work on the portrait. The artist's pleasure was quickly mitigated when, shortly after his arrival on February 10, he experienced the impatient manner typical of the President.

Together they toured the White House while Sargent looked for proper light and a good pose. Sargent was dissatisfied with the rooms first suggested. As Roosevelt led the way upstairs, so the story goes, he said, "The trouble with you, Sargent, is that you don't know what you want." "No," replied the artist, "the trouble, Mr. President, is that you don't know what a pose means." Roosevelt turned sharply back, grasped the newel-post and snapped, "Don't I!" "Don't move an inch. You've got it now," responded Sargent.[2]

While Sargent later complained about the brevity of the sittings, the President himself was enthusiastic. To his son Kermit, he wrote:

> Mr. Sargent is staying with us and is painting my picture. I think it is going to be great. I wish you were here to see it. He is painting it on the landing of the big stairs where everything has been rigged up for it, because he said the light was best there. He has some shades hung up to change the lights. . . . [3]

Sargent formalized the pose as an official portrait demands, but the highly colored face and hand bring the painting to vivid life. There is rare skill in Sargent's handling of the black suit and in the strong relief provided by the light-swept background. The expression—a near scowl with narrowed eyes focused on the viewer—and the vigorously modeled head compel attention and respect.

The writer Henry Adams, the President's neighbor (but not admirer) across Lafayette Park, got a look at the President's likeness soon after it was completed. On March 8 he reported, with characteristic acerbity:

> The portrait is good Sargent and not very bad Roosevelt. It is not Theodore, but a young intellectual idealist with a taste for athletics, which I take to be Theodore's idea of himself. It is for once less brutal than its subject. . . . Of course we all approve it.[4]

The subject certainly approved it. On the day the portrait was finished (February 19) he wrote to Kermit: "This afternoon I had my last sitting with Mr. Sargent. I like his picture enormously."[5]

John Singer Sargent (1856–1925)
The Mosquito Net 1912

Oil on canvas, 22⅝ x 28½ inches (57.5 x 72.4 cm)
Gift of Whitney Warren, in memory of President John F. Kennedy, 1964

*E*nveloped in voluminous satin skirts, cushioned by white pillows, the youngish woman has abandoned her reading. The book lies neglected in her hand. Her pensive features are glimpsed through the black enclosure of the mosquito net, whose wire ribs describe a series of strong arcs. The white dress and pillows are actually a miraculous mixture of grays, whites, browns, and greens, with brilliant pools of white setting off her face and marking the angles of her legs beneath the satin.

The curtain or wall covering behind her, with its suggestion of a floral pattern, is brushed in quick, unfocused touches in sandalwood and brown, blue, green, and red. It owes much to Édouard Manet's portrait of *Stéphane Mallarmé* (1876; Musée d'Orsay, Paris), a work that had demonstrable impact upon Sargent.[1] His perfumed palette is at once heady and subtle, his handling combines unctuousness with delicacy. The contrast between the flashing brushwork in the satin skirt and the motionless brushwork in the silent face is one measure of his imagination and skill.

Reclining attitudes are common in Sargent's art, both in portraits and in small genre pictures, and they are evocative of a pervasive fin de siècle indolence. In fact, one such painting by Sargent is titled *Nonchaloir* (1911; National Gallery of Art, Washington, D. C.), which may be translated as "nonchalance, laziness, or heedlessness."[2]

Neither signed nor dated, *The Mosquito Net* was retained by Sargent until the end of his life and has long been ranked among his best "private" works— small paintings done for his own delectation rather than for a patron. The woman who posed for this poem in paint was Marion Alice (Polly) Barnard, whose father, Frederick, was a painter and friend of Sargent's.[3] As children, Polly Barnard and her sister, Dorothy, had posed for *Carnation, Lily, Lily, Rose* (1885–86; Tate Gallery, London), Sargent's first great success in England.

In 1905, following the death of his mother, Sargent began to take annual trips in the autumn, to Italy and Switzerland, usually in the company of his sister Emily and friends of hers, including the Barnard sisters. On these trips the women often posed for Sargent's watercolors and oil paintings, and in preparation he brought with him elaborate costumes and accessories. One such accessory was the remarkable mosquito net, designed by Emily (and called by Sargent *garde-mangers*, or "protection from the eaters.")[4]

Although the painting is not dated, Sargent scholar David McKibbin, who knew the Barnard sisters, specified that it was painted in 1912 at Abries, in the French Alps, a few kilometers from the Italian border.[5] By 1912 Sargent had almost abandoned portraiture, devoting his immense skill instead to large mural decorations, dazzling landscapes, and exquisite, intimate interludes like *The Mosquito Net*.

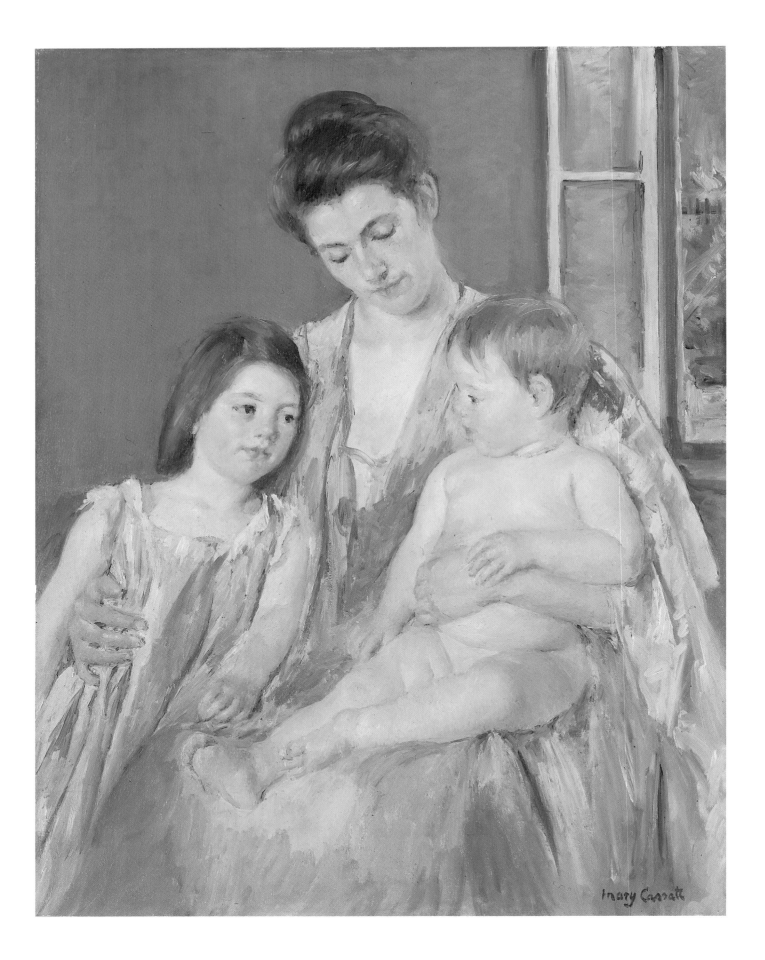

Mary Cassatt (1844–1926)

Young Mother and Two Children 1908

Signed lower right: Mary Cassatt
Oil on canvas, 36⅜ x 29 inches (92.4 x 73.7 cm)
Gift of an anonymous donor, 1965

While some of Cassatt's late work is mannered, with an aura of artifice, *Young Mother and Two Children* is distinguished by directness and simplicity. The sturdy frontal composition is reinforced by the unadorned setting and palette. A neutral gray wall, a glimpse out an open casement at a vague, blended blue and green park, and the still more blended reflection of the park in the two panes of glass provide the foil for the strong, cohesive group of woman, girl, and baby. The baby's legs and the mother's strong embracing hands form the base of a pyramid that rises through continuous, unbroken contours to the mother's solemn, downturned head. The foreshortening is secure (as in the mother's right hand), and the shallow space is controlled.

The gentle oil palette is similar to the pastel medium that Cassatt loved and used with skill. Subtle, modulated blues and blue-greens dominate. For example, the girl's "brown" eyes are actually rendered with purple pupils and pale blue irises, and the lilac tone of the ribbon in the woman's hair is quietly echoed in her ear.

Much of the painting is homogenous: the merged contours of the girl and the woman, the parallel arms of the children, the open flow of the central axis from the mother's head through her décolletage to the baby's foot. Vital and varied brushwork invigorates this unity, from the blended background to the long strokes in the dresses, to a scrubby buildup of strokes in the baby and in the girl's left arm.

Cassatt, who grew up mainly in Philadelphia, spent nearly all her adult life in France. There in 1877 she met Edgar Degas. From Degas, as well as from Édouard Manet, came the strong drawing and bold shapes of her best known paintings. The apparent ease of the subjects in her early portraits, however, owed much to members of her own family. Cassatt's parents and her older sister, Lydia, had joined her in Paris, also in 1877. They served as her frequent models, along with her brother's four children, who often spent summers with her. Family and France thus collaborated to produce Cassatt's characteristic paintings, which, paradoxically, are both frank and reticent.

After 1900, in later works such as this, Cassatt turned to hired models. The young mother of this 1908 painting was a woman known to us simply as Jeanne. Despite the title of this work, *Young Mother and Two Children*, the woman was mother to only the girl; she and the baby boy were unrelated. (The nude children in Cassatt's paintings are surely boys, but the artist concealed or suppressed their sex, an odd bow to Victorian propriety that may owe more to Philadelphia than to France.)

A quiet joy resides in this painting, a familial feeling that is comparatively rare in Cassatt's late works and that surmounts the use of professional models. Though the country girls she employed to pose lacked (to her) expressive personalities, they had perhaps a deeper reservoir of maternal feeling than women of the *haut bourgeois*: Cassatt once shrewdly observed that women who employed nannies knew little about holding children.

Anders L. Zorn (1860–1920)

William Howard Taft 1911

Signed and dated upper right: Zorn / 1911 / Zorn
Oil on canvas, 46⅜ x 35⅛ inches (117.8 x 89.2 cm)
United States government purchase, 1912

When Alice Roosevelt Longworth complained to President Taft that Zorn's portrait made him look pudgy, Taft replied, "But I am." The genial Taft, who accepted the portrait without complaint, may have recognized that Zorn had actually treated his 300-pound bulk with some tact.[1]

By placing the figure in a three-quarter seated pose and cutting it off just below the knees, the artist lessened the breadth of the torso and eliminated the widely spread lower legs that would call attention to the presidential poundage. This finesse extends to the finely modeled hands and head. The powerful, intelligent head is buttressed by the gilt crest rail of the armchair and by the gold Greek key band on the blue silk wall covering. Lit by patches of sun, the hands are arranged in a slightly transitory position that avoids stodginess. Zorn painted the chair and slice of wall with the same broad gusto that he brought to the President. The portrait was painted in the Blue Room as it appeared after the 1902 renovation of the White House for Theodore Roosevelt.[2]

Zorn's international reputation as a portraitist gave him the income to live lavishly and to travel widely. Born in Sweden, he returned there often, and he died there. But his clients were of many nationalities. Between 1882 and 1885 he maintained his studio in London, becoming friends with many Americans abroad who encouraged him to visit their country and who helped him gain commissions. On his seventh and last trip to the United States he painted Taft.

When Taft sat for this likeness, he was in his third year of office. Many of his presidential proposals had been diluted or rejected; his wife had only recently recovered sufficiently from a stroke to appear in public; and his estrangement from Roosevelt threatened his hopes for reelection and Republican hopes of retaining the White House. By nature

William Howard Taft 1911

Etching, 15³⁄₁₆ x 11¹³⁄₁₆ inches (38.6 x 28 cm)
Gift of the White House Historical Association, 1989

gregarious, the President here seems withdrawn and preoccupied. The artist appealed to Secretary of Commerce and Labor Charles Nagel (who may have arranged the commission): "The President is so weary that it shows in his face. Can't you come over and talk to him so I can paint him as he really is?"[3]

Zorn was famous in his day for his etchings, and his reputation has rested upon them. Among them is the 1911 etching of his Taft portrait, acquired by the White House in 1989 and reproduced above.

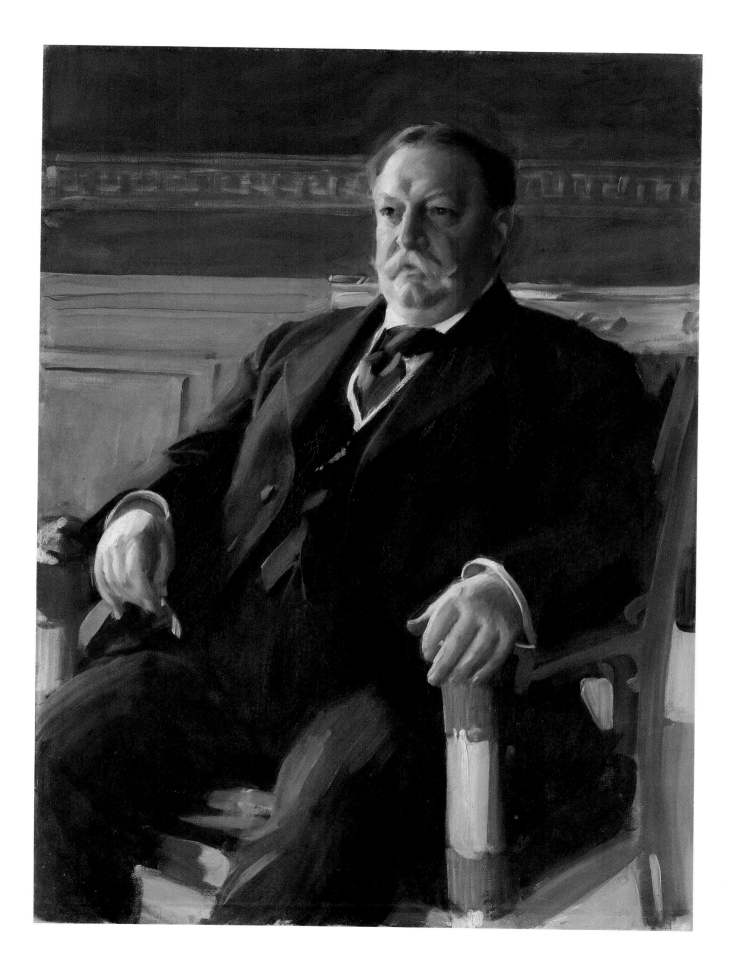

Thomas Moran (1837–1926)
Point Lobos, Monterey, California 1912

Signed and dated lower left: TYMORAN. [TYM in monogram, abraded] 1912.;
 lower right: the artist's thumbprint
Oil on canvas, 30³/₁₆ x 40¹/₄ inches (76.7 x 102.2 cm)
Gift of the White House Historical Association, 1977

Moran had been re-creating the American West for 40 years by the time he painted *Point Lobos* (located on the south side of Carmel Bay just south of Pebble Beach). Soon, in 1916, he would settle in Santa Barbara, California, for the last years of his long life.

Although Moran was brought to America as a child, he was English by birth. The work of the great English landscape painter J. M. W. Turner had an impact upon him. At first the influence was indirect, through the painter James Hamilton, known as "the American Turner" (a sobriquet Moran was to inherit). Later it came through Moran's exposure to Turner's own works during a trip to England in 1861–62. Naturalistic detail and poetic sweep combined to instill a spiritual fervor in Moran's work as in Turner's. The precise nature studies of John Ruskin and his American and English followers also influenced Moran. In 1882 Ruskin favorably reviewed the London exhibition of Moran's work, and the two subsequently became friends.

This striking painting typifies Moran's late work. Its calculated aesthetic effects are exaggerated, but they produce a vivid—almost visionary—sensation. Instead of emphasizing the vast horizon of the Pacific Ocean at land's end, Moran makes his true subject the dramatic interaction of the elements of earth, water, and air. The structure of the picture is rigorous. Strong parallel diagonals of trees, storm cloud, and inlet are the dynamic spur to the scene, but they are modified and controlled by an implicit diagonal from the upper left to the lower right. There is, to some extent, a traditional theater proscenium structure, with darker foreground and wings framing a scenic backdrop. But the heightened colors and suave brushwork mostly disguise that formula.

Everything in the painting contributes to cohesion. The brushwork, though economical, is never vague. The agitated waves, the cusps of blue water and whitecap, are strongly tactile. The deep blue and turquoise of ocean and inlet stun the eyes, in contrast to the nuanced chiaroscuro of the precisely drawn rocks and trees. These dappled passages of light and shade, supremely elegant, lend the painting depth and surface order.

Forty years earlier an anonymous critic for *Scribner's Monthly* had described Moran's highly finished watercolors in words that apply equally to this late canvas:

> [The watercolors] show a strong man rejoicing to run a race; and with all his senses alive for rich and strange and tender shimmering color, rainbow, and mist, with fleeting cloud, and more hues than Iris with her purple scarf can show. His love of form is strong as his love of color, and his lines betray the same innate grace of spirit, the same delicately moving mind.[1]

Shortly after 1910 Moran's popularity led to a number of forgeries. To protect his reputation, he began to include his thumbprint with his signature, a safeguard he took here.[2]

233

Adolph A. Weinman (1870–1952)

Rising Day (opposite) and *Descending Night* (following)

Both modeled *c*. 1914, cast *c*. 1915–23

Rising Day signed and inscribed on rear of base: © / A A WEINMAN FECIT;
 edge of base: ROMAN BRONZE WORKS N.Y.; under base: № 38
Bronze, moss green patina, 26¾ x 24⅞ x 9¼ inches (68 x 63.2 x 23.5 cm)
Descending Night signed and inscribed on rear of base: © / .A. A. WEINMAN. FECIT.;
 edge of base: ROMAN BRONZE WORKS N.Y.; under base: № 5
Bronze, moss green patina, 25½ x 21¾ x 10 inches (64.8 x 55.2 x 25.4 cm)
Gifts of Adolph Alexander Weinman, 1923

*I*n her personal and loving history of the White House furnishings, Lou Henry Hoover, the President's wife, remarked on the "small gift pieces of sculpture [that] were presented to the White House by their artists during the chatelainage of Mrs. Coolidge." She wrote especially of "the lyric pair of winged figures called Ascending Morn and Descending Night . . . [that] were given by their sculptor, A. A. Weinman, a member of the Fine Arts Commission at Washington." Mrs. Hoover continued:

> They were first placed in the Green Room. . . . But when the West End Sitting room on the second floor was turned into an indoor garden-room for Mrs. Hoover, these green-bronze figures were the exact notes needed for completing its living green charm. Now, on a table in that palmy court their glorious lines lift and droop against the great west window, a delight to all who pass on their way.[1]

Weinman's pair of allegorical sculptures are proud reminders of a notable era in our cultural history. Between 1876 and 1917 the United States experienced a remarkable alliance of artistic talent and capitalist wealth that made possible the cultural phenomenon called the American Renaissance. The hallmark of this movement was the amalgamation of all the arts and crafts in grandiose public projects, including permanent buildings—the Library of Congress is a prime example—and ideal cities, mostly constructed of unsubstantial materials for national and international exhibitions.

Beginning with the Centennial Exposition in Philadelphia (1876) and the World's Columbian Exposition in Chicago (1893), and including fairs in Nashville (1897), Omaha (1898), Buffalo (1901), St. Louis (1904), and Seattle (1910), these were huge undertakings covering acres of urban land with exhibition halls for everything from agriculture to art. The decorative component of the structures was equally significant. In what they believed to be a parallel to and a continuance of the Italian Renaissance, planners gathered large teams of architects, painters, sculptors, and designers to create monuments to civic pride and democratic achievement.

The last of the major American expositions before the U. S. entry into World War I was the Panama-Pacific International Exposition of 1915, held in San Francisco to celebrate the completion of the Panama Canal and the link between the Atlantic and the Pacific, between Europe and the Orient, with the Americas at the center. The architectural firm of McKim, Mead & White designed perhaps the most imposing complex, the Court of the Universe, which featured an immense Arch of the Rising Sun and a courtyard—the "meeting place of the hemispheres" —700 by 900 feet. Here were two fountains with Weinman's three-quarter life-size figures (alternatively called, among other variations, *Rising Sun* and *Setting Sun*) atop enormous columns. Made of staff (i.e., plaster reinforced with burlap fiber or hay), they have not survived.

Weinman had four known bronze pairs cast from his working models (57½ and 55¾ inches high, respectively). An undetermined number of reductions the size of the White House pair were cast at the Roman Bronze Works, the major art foundry of the era.[2] *Rising Day* (the model was Weinman's son) is all extension and youthful aspiration expressed in perfect symmetry and open stance. The youth's head rises strongly above wings that grow convincingly from the body, while his hands, spread-fingered beneath the wingtips, retain a subtle independence. His feet are poised within the circle of a sun with flaring rays on the base.

The pensive female figure of *Descending Night* stands within a crescent moon and a field of stars, her languid body curving inward. Both the long tresses of her hair and the proportions and pose of her body suggest that Weinman looked long at Botticelli's *Birth of Venus* (Uffizi, Florence). Her wings, completely separate from her expressive arms, enclose her head and overshadow the lithe asymmetrical body. Her legs are arranged in an extraordinary overlapping fashion, perfect for a figure alighting from flight but not practicable for the earthbound (try it).

There is an ironic personal footnote to the optimistic "universal" theme of the exposition that gave rise to the commission. That these poetic, noble sculptures are signed "A. A." rather than "Adolph" Weinman is no accident. Weinman, born in Karlsruhe but taken to America at age ten, substituted his initials for his too-German first name in the wake of the government-sponsored propaganda campaign of 1917–18, designed to counter isolationism, that followed American entry into World War I. A distinguished American historian has written that "German-Americans, who did as much to support the war as any group, suffered the most. Stay-at-home patriots indulged in an orgy of hate, which even extended to passing state laws forbidding the teaching of German in schools or colleges. . . . "[3]

To the nation's shame, the artist who gave us these figures that symbolize not merely the times of day but also the union of the Orient and the Occident, who had collaborated in the embellishment of the Library of Congress, and who also in 1916 designed our Winged Liberty-head dime (commonly called the "Mercury" dime) suffered from the general calumny. To the nation's credit, in the postwar era he was commissioned to create the equally idealistic sculptural programs for the Post Office Department Building and for the Court Chamber of the Supreme Court Building.

Childe Hassam (1859–1935)
The Avenue in the Rain 1917

Signed and dated lower left: Childe Hassam / February 1917
Inscribed on reverse, lower center: C. H. [circled] / February 1917
Oil on canvas, 42 x 22¼ inches (106.7 x 56.5 cm)
Gift of T. M. Evans, 1963

*H*assam was the most prominent of the "Ten American Painters," a group founded in 1898 and influenced by recent French art. In his native Boston he had worked as a wood engraver of book illustrations before beginning to paint. Study in France in the late 1880s had introduced him to the Impressionists, whose broken brushwork and high-toned palette he emulated. Regarded as the leading American Impressionist, Hassam actually disliked the term and was stylistically conservative, with a tendency toward the chic in figure type and costume. Sociable and generous, he led a charmed professional life, achieving both fame and financial success.

The Avenue in the Rain was painted at the height of Hassam's powers, and is one of some 30 related paintings of flag-decorated streets that the artist produced between 1916 and 1919, during and immediately after the First World War.[1] That they are intensely patriotic works is patent, while aesthetically they bear witness to the example of Claude Monet, both in the subject (Monet created two paintings of flag-bedecked avenues on a single day in 1878) and in the concept (a series of paintings of a motif, such as haystacks or Rouen Cathedral).

Hassam had long painted city views, and the ones in the flag series represent the climax of his career. The avenue is Fifth Avenue, frequently decorated with flags as American sentiment moved inexorably from isolationism toward intervention. The artist's most striking device here is the projection of flags into the picture from unseen points of anchor beyond the frame, covering a quarter of the surface of the painting. In one sense the flags *become* the surface of the painting, an identity seconded by the tall "hanging" format, which echoes a flag's shape.

Observing shadows to be bluish rather than black, the Impressionists often became mannered in their use of blue, making it the dominant hue in many of their paintings. Hassam also loved blues and blue-greens, and here the rain and the rain-slicked streets give him an excuse for a literal wash of blue and blue-gray, enhanced by a profusion of reflections. The surface pulsates, electric in the rain.

Painted in February 1917, this work may have had a specific impetus: On January 22 President Wilson had delivered his "Peace Without Victory" address, holding out the ideal of a compromise peace that would leave no residue of bitterness. But sentiment to enter the war had been building since the May 1915 sinking of the British liner *Lusitania* by a German submarine. When the German government announced on January 31, 1917, that unrestricted submarine warfare would resume, the President broke off diplomatic relations. Three weeks later a German diplomatic note to Mexico proposing an alliance against the United States was intercepted, and Wilson sought congressional approval to arm American merchant ships. Although a declaration of war was still five weeks away, the turning point had been reached. Patriotic fervor peaked. It is reflected in *The Avenue in the Rain*, which ultimately is not a street scene, not a painting of flags, but in essence a vibrant flag unto itself.

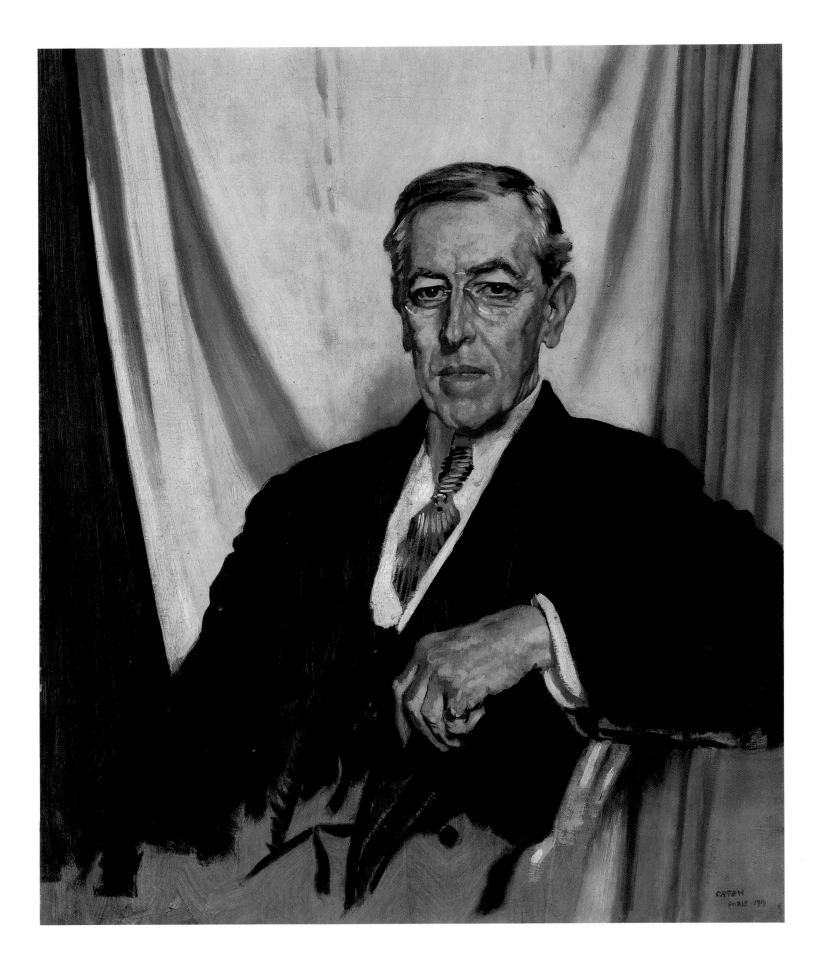

Sir William Orpen (1878–1931)
Woodrow Wilson 1919

Signed and dated lower right:
ORPEN / PARIS 1919
Oil on canvas, 36 x 30⅛ inches (91.4 x 76.5 cm)
Gift of Bernard M. Baruch, Jr., in honor of
 Bernard M. Baruch, 1962

*T*his penetrating, somber likeness of President Woodrow Wilson (1856–1924) was painted in 1919 at the Paris Peace Conference during the protracted negotiations that followed the end of the First World War. In December 1918, the month after the November 11 armistice, Wilson had arrived in France. Despite his party's losses in the November congressional elections—interpreted by some as a repudiation of his wartime policies—the President was determined to lead the United States delegation. At the conference, which opened in January 1919, he pushed his idealistic proposals for a just settlement and a lasting peace under a new League of Nations, the focus of his aspirations.

The Dublin-born Orpen, a noted portraitist who had done many wartime sketches and paintings at the battlefront and had been knighted in consequence, was official painter at the conference. Orpen painted portraits of the prime ministers of Italy, France, and Britain: Vittorio Orlando, Georges Clemenceau, and David Lloyd George. These paintings, as well as the one of Wilson, he used in composing a large historical work commemorating the June 28, 1919 *Signing of the Peace in the Hall of Mirrors* (Imperial War Museum, London).

The Versailles Treaty was to have been the culmination of Wilson's quest for a new global order under international law. But a renewed mood of isolationism prevailed in America, and the President, stubbornly refusing to compromise with the political opposition, embarked on a nationwide speaking tour to rally support for the treaty's ratification. In September in Colorado he collapsed; the exact nature of his severe illness was withheld from the public.

His health impaired, the invalid President was unable to rally the necessary support, and Congress repudiated a compromise version of the treaty the following March.

Because Orpen undertook the painting as a study for the large historical picture, he did not finish some areas, but his signature attests his satisfaction with the portrait. The painting may have belonged to President and Mrs. Wilson before it passed to Wilson's close friend and adviser, Bernard M. Baruch (1870–1965), the financier and statesman who had been the most influential member of the War Industries Board.

Philip de László (1869–1937)
Florence Kling Harding 1921

Signed and dated lower right: de László / . The White House. / 1921. July 8.
Oil on canvas, 32 x 22 inches (81.3 x 55.9 cm)
Gift of The Harding Memorial Association, 1971

One of the most prolific portrait painters of his or of any other generation (he completed more than 3,000 works), de László was born in Budapest, Hungary, and christened Philip Alexius de László de Lombos. He married an Englishwoman and settled in England in 1907, where he adopted the shortened form of his name. Much younger than Giovanni Boldini or John Singer Sargent, fashionable international portraitists with whom he is most often compared, he gained a particular reputation for his portraits of royalty and heads of state.

He visited the United States in 1921 to paint portraits of the delegates to the Washington Conference on arms limitation. An exhibition of his portraits at the Corcoran Gallery of Art preceded him and attracted numerous commissions. While in America he had the opportunity to paint some 14 portraits. The first was of the statesman and Nobel Peace laureate Elihu Root, whose recommendation brought him an invitation to paint President Harding.

The portrait of Mrs. Harding came about somewhat by chance. The artist had begun to paint the President at the White House on July 8. Mrs. Harding, however, was "compelled to interrupt the sitting," according to a chatty account in the Boston *Sunday Post* on Christmas Day. Continued the writer, a family friend:

> As she was, in a simple little organdy morning dress of a soft and lovely shade of yellow, she entered the "Pink Room" where the President was posing. During their conversation de Laszlo, unknown to her, hastily sketched her as she conversed and listened to her husband. From this sketch he painted her portrait. This picture [referring to an accompanying newspaper illustration] is a photograph of that painting.

> I have seen her in this yellow dress. Her hair is always dressed in this manner. Note its wonderful abundance. Note, too, the keen intellect shining from those blue-gray eyes. Note the sweetness of expression. This is "HERSELF." This is the real Mrs. Harding. Here is our "FIRST LADY," the cynosure of all eyes, but herself, unconscious of observation—at home, conversing with her husband.[1]

Of Mrs. Harding's hair, the voluble author said:

> Her hair is luxuriant, beautiful even gray. It has been said of Queen Mother Alexandra of England that she had the most beautifully coiffed head in Europe. Mrs. Harding surely has that distinction in the United States. Waving hair, looking always as if just from the hands of a coiffure [sic], but lacking even a suggestion of studied effect. Neither does she have to lay it away in the dressing table on retiring.

Altogether de László's portrait is as flattering as the word portrait. The contours of the face are kindly handled. What might have been unlovely sag in a realist's hands is suave melody in de László's. The unusually dark gray ground throws the light-toned head into strong relief, while the abstract thin plumes of white paint at the left echo the curvilinear brushwork in the head and effectively balance the off-center placement of the unsuspecting sitter. So fond of this portrait was Mrs. Harding that she had prints made of it and distributed them to the White House staff. She took the portrait with her when she left the White House, and later the Harding Memorial Association of Marion, Ohio, presented it to the collection.

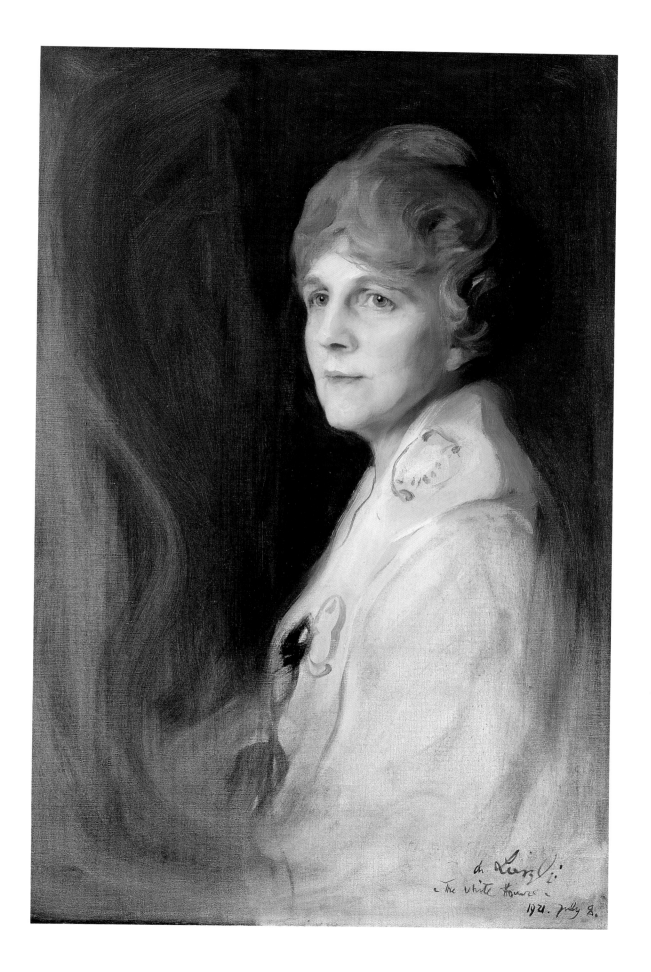

Willard Leroy Metcalf (1858–1925)
Spring in the Valley c. 1924

Signed lower right: W.L.METCALF
Oil on canvas, 26⅛ x 29⅛ inches (66.4 x 74 cm)
Gift of the White House Historical Association, 1979

An academically trained artist who specialized in figure painting and illustration, Metcalf made an abrupt change in middle age. He turned to landscapes, becoming a committed Impressionist in the style practiced by his close friends among "The Ten American Painters," especially John Twachtman and William Merritt Chase (see page 212). This shift occurred during 1903–04, when the artist spent a year in Maine painting 21 canvases.[1]

The peaceful mood evoked in most of his landscapes was in contrast to Metcalf's unstable life. He was a problem drinker, twice divorced, prone to depression, and, like his parents, a believer in the occult and a habitué of séances. We may suppose that the New England countryside of his birth provided the security and serenity that seem to have eluded him elsewhere. He himself spoke of the change in his art as a "new birth" or "Renaissance."

Spring in the Valley, probably painted near Chester, Vermont, though the site has not been identified, exudes an aura of contentment.[2] From a sloping meadow we look down and across a tranquil valley, a view selected with great care, framed with farm buildings and rising hills and backed with the benevolent shape of the humpback mountain. It is a leisurely ramble for the eye, following the country lanes or skipping from one group of houses and barns to another or drifting with the evanescent light and cloud-shadow that glides over the greening valley, fresh and glad.

Above the valley the robin's-egg blue sky and windblown clouds amplify the mood of quiet elation. It is the visual equivalent of Amy Lowell's poetic description of May in New England: "May is a green as no other" ("Lilacs"). The range of delicious greens in Metcalf's palette perfectly captures spring at a time when most of the trees are in leaf. The still unfolding season is seen with a tree in pink and white blossom in the left foreground (the white is the exposed white primer), balanced by an undefined burst of white at the right edge. Metcalf was fond of a particular salmon pink tone, found here especially in a broad patch in the center of the canvas. But with all his joy in color and the easy vitality of his brushstroke, the pictorial structure is firm, the nearly square format enhancing the physical and psychological cohesion of the scene. With a seemingly intuitive grasp of geology, Metcalf unfolds a landscape that is at once an organic entity and an enduring bedrock beneath the transitory season.

William Glackens (1870–1938)
Carl Schurz Park, New York c. 1922

Signed lower right: W. G.
Oil on canvas, 18 x 24$\frac{1}{16}$ inches (45.7 x 61.1 cm)
Gift of Ira Glackens, 1968

A small snippet of life in Manhattan in the upbeat 1920s after the Armistice and before the Crash, this charming painting has the casual grace of a many-hued butterfly caught on the wing by the artist's affectionate brush. Glackens's lifelong admiration for the paintings of Auguste Renoir—especially the later paintings with their blended brushwork and bright palette—is apparent in every stroke and in the choice of subject. For here we have the closest American equivalent to a Renoir scene: people, mostly women and children, enjoying their leisure on a blissful and unhurried day. They are active, but their activity is in harmony with the trees and the breeze, the river and the sky. The two girls walking away from us, for example, are gently embraced by two slender trees.

Glackens was a founding member of "The Eight," a group of anti-establishment painters who portrayed scenes of urban life. They exhibited together just once, in New York in 1908, but their influence was far-reaching. Although many of the group relished the seamier, sootier side of Manhattan and were affected by both the ideals of social reform and the visceral realism of Walt Whitman's poetry, Glackens preferred to paint the carefree upper middle class.

Carl Schurz Park is located between 84th and 89th Street on the East River adjoining Gracie Mansion, the home of the mayor of New York. Earlier called East End Park, it was renamed in honor of Schurz (1829–1906),[1] a distinguished member of the German immigrant community that had settled in the area. By the time Glackens painted this scene, the park was no longer the center of an ethnic community but an urban oasis for a homogenized population. The view from the small park looks northeast over the broad expanse of the East River near its junction with the Harlem River. The confluence, called Hell Gate because of the dangerous currents, is traversed in this picture by a ferry seen at the left and by the Hell Gate bridge

(properly called the New York Connecting Railroad Bridge) just completed in 1917. In Glackens's rendering the great bridge is an insubstantial thing indeed, daintily sketched in pale blue with yellow ocher towers, scarcely more assertive than the pink, yellow, and blue sky or the candy-colored trees. Well-mannered and agreeable, this lovely image asks only to be liked. In this respect it is the genuine reflection of the pleasant artist who, as his son has written, "never quarreled and would have been at a loss to know how."[2]

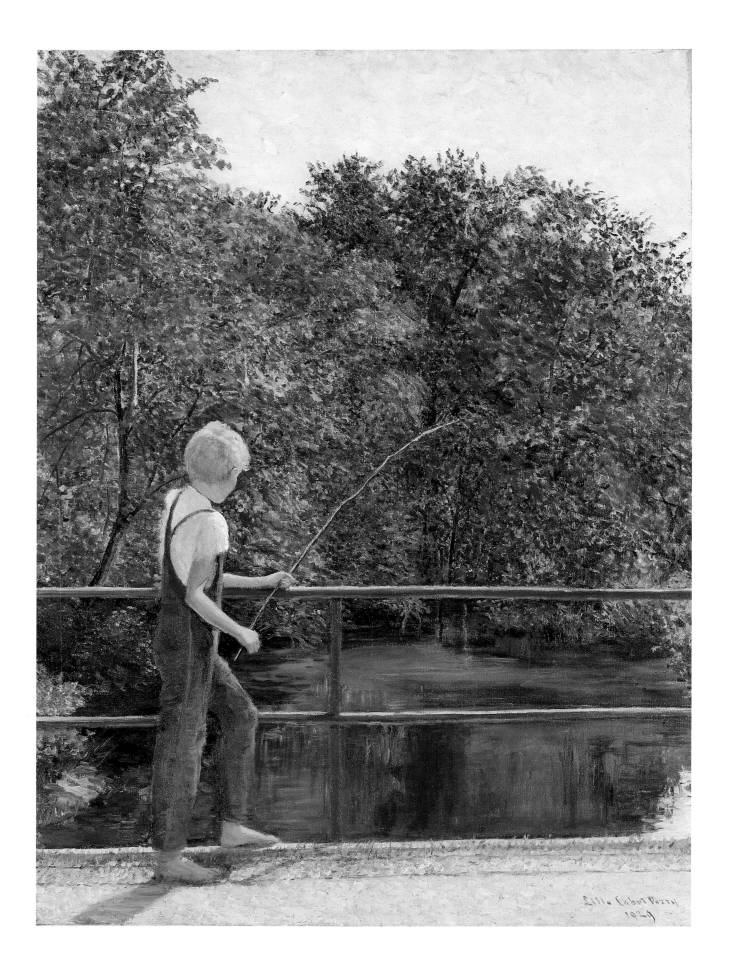

Lilla Cabot Perry
1929

Lilla Cabot Perry (1848–1933)

Boy Fishing 1929

Signed and dated lower right: Lilla Cabot Perry / 1929
Oil on canvas, 40⅛ x 30¹/₁₆ inches (101.9 x 76.4 cm)
Gift of Mrs. Cecil B. Lyon, Mrs. Albert Levitt,
 and Mrs. Anita English, 1979

A reverie from the last years of Perry's long life and career, *Boy Fishing* is an unselfconscious poem of adolescence. Simple in conception, direct in execution, it breathes the New England of her childhood and her old age, and the spirit of Henry David Thoreau, whose *Walden* appeared when Lilla Cabot was six years old. Perry at 81 echoed Thoreau's words in this painting evoking youthful "days when idleness was the most attractive and productive industry. . . . For I was rich, if not in money, in sunny hours and summer days, and spent them lavishly."

Born in Boston, into the Lowell–Cabot clan, she studied art there at the Cowles School with Robert Vonnoh and Dennis Bunker. Traces of Vonnoh's influence can be seen intermittently throughout her career, especially in her paintings of women in interiors. She joined the steady stream of American artists who went to Paris and enrolled in classes at the recently founded Académie Julian, an anti-establishment school with a remarkably cosmopolitan atmosphere. "Now and then," John Russell has written, "there was a young woman member of American high society who lived a life of tranquil discretion, side by side with the Turks, the Syrians, the Peruvians, the Chileans and the many, many Japanese who gave the school its ethnic richness."[1] Such a young woman was Lilla Cabot Perry.

While in Paris, she studied with the fine Belgian painter Alfred Stevens. But her introduction to Claude Monet at Giverny in the summer of 1889 was to have the greatest impact on her art. It was Monet who told her that her forte was plein air, figures out of doors, and urged her to paint more boldly:

Remember that every leaf on the tree is as important as the features of your model. . . . When you go out to paint, try to forget what objects you have before you, a tree, a house, a field or whatever. Merely think, here is a little square of blue, here an oblong of pink, here a streak of yellow, and paint it just as it looks to you, the exact color and shape, until it gives your own naive impression of the scene before you.[2]

Perry's account of Monet's comments are often quoted, for they are among his most revealing remarks about his own art. In the fall of 1889 Perry brought home the first painting by Monet to be seen in Boston.

Never would one mistake a Perry for a Monet in brushwork, and seldom in conception or composition —yet Monet's remarks about the equal importance of tree leaves and facial features, and achieving "your own naive impression," are relevant to Perry's mature style. The boy in *Boy Fishing* is nearly schematic. His features are almost completely suppressed, reduced to a triangular patch of face and a circle of hair; the body is equally simplified. Seemingly "artless" (one of the meanings of "naive"), this approach succeeds in projecting an aura of adolescence. The bridge railing together with the boy form the armature of the painting and forever encapsulate the timeless, motionless silence of the hot summer afternoon.

Robert Richardson, Perry's 14-year-old model that afternoon in 1929, has said that he was paid 15 cents for five hours of posing.[3] He lived in Hancock, New Hampshire, where Lilla and her husband, Thomas Sergeant Perry (a noted scholar of American literature), had their summer home from 1903 on. There *Boy Fishing* was painted, and there Lilla Cabot Perry died four years later at the age of 85.[4]

John Marin (1870–1953)

The Circus No. 1 1952

Signed and dated lower right: marin 52
Oil on canvas, 22 x 28 inches (55.9 x 71.1 cm)
Gift of Mr. and Mrs. Leigh B. Block, 1962

This vivacious circus painting from the mid-20th century is somewhat conspicuous among the works reproduced here.[1] But it is the work of a quintessentially American artist, and it comfortably takes its place among its ancestors.

Although Marin did not devote himself completely to painting until he was almost 30, he has been called the most significant of the first generation of American painters in this century.[2] These were the artists who introduced European modernism into America, and of them all it was Marin who absorbed the stylistic and expressive innovations of Cubism and Futurism most effortlessly and unselfconsciously. The language of color and form that he found in these "isms" he adapted almost intuitively to his favorite subjects, the city of New York and the rugged Maine landscapes and seascapes. But it is the elemental quality of his style—large, lucid forms, charged lines, and luminous color—as much as his subjects that marks his art as specifically American.

Like other artists, Marin may have been drawn to the circus as a metaphor for his profession. The arena may be seen as a theater of creation. The artist is variously a performer who entertains or the ringmaster who presides over a fantastic realm where reality is defied and the world magically transformed. In The Circus No. 1 the world radiates from the ringmaster at center. The "force lines" that overlay the pink and blue color washes seem to emanate from him, or to be under his control.

The relative symmetry of the picture, wittily bracketed at the bottom by elephants' heads, like bookends, emphasizes his controlling position in the kaleidoscopic image. Besides this master of ceremonies only the performers, animal and human, are brought to life. The spectators are barely suggested in vague shapes in the foreground (bottom) and in figures resembling thumb smudges on the other side of the ring.

The energy unleashed by Marin through his floating scaffold of lines was not by chance. In 1913 he wrote about "the life of a great city":

> . . . the whole city is alive; buildings, people, all are alive; and the more they move me, the more I feel them to be alive. It is this "moving of me" that I try to express. . . . I see great forces at work. . . . And so I try to express graphically what a great city is doing. Within these frames there must be balance, a controlling of these warring, pushing, pulling forces.[3]

Nearly 40 years later, at the end of his life, Marin was still pursuing this aim in The Circus No. 1.

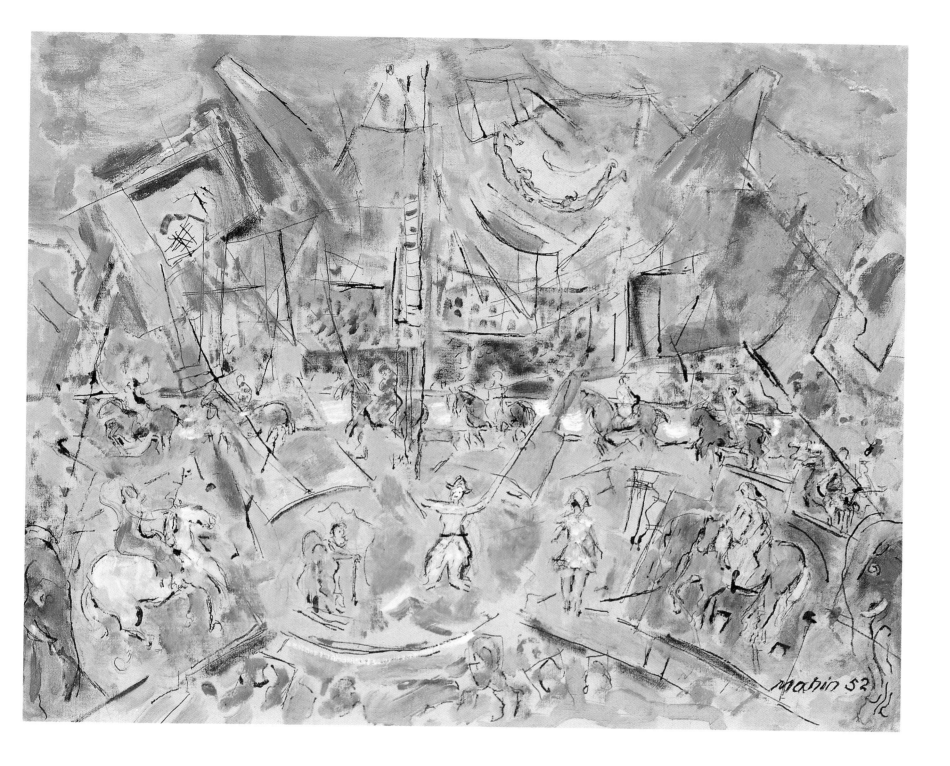

Henriette Wyeth (1907–)
Patricia Ryan Nixon 1978

Signed lower right: Henriette Wyeth
Oil on canvas, 45⅞ x 36 inches (116.5 x 91.4 cm)
Gift of the White House Historical Association, 1981

*Y*our mother . . . loves beauty and the care of things and caring for others. The care of their lives means a tremendous amount to her. . . . While she posed for me, there were times I could tell she wanted to be outside picking off the dead things. Things in the garden were going to hell without her.[1]

Thus wrote Henriette Wyeth to Julie Nixon Eisenhower, and therefore, perhaps, she placed the vivid white hibiscus ("plucked from a bush outside Mother's bedroom window") in this portrait of Patricia Ryan Nixon. The brilliant bloom serves as foil to the composed, opalescent countenance of the former First Lady.

At once a decorative tour de force and a moving likeness, the portrait projects a spirit of enchantment in its shimmering surface. The iridescent palette was suggested by Patricia Nixon's aquamarine brocade dress, touched with violet and white. Placed against a thinly brushed veil of pale grays, sparing pinks, aqua, and turquoise, the figure emerges gently from an indefinite space, a creation of light from light. But the head is given volume and presence by the darker ground behind it and the shadow that passes over the proper left side of her face.

Henriette Wyeth, daughter of N. C. Wyeth, sister of Andrew, and wife of Peter Hurd—artists all—seems, from the evidence of the portrait, to have been the ideal choice to paint Mrs. Richard Nixon four years after the family left the White House. The artist was, as always, intent on "pursuit of the truth" of character, and there was a further kinship of age and health. Patricia Nixon was recovering from illness; Henriette Wyeth was painting her first portrait since cataract surgery. (To prepare for the commission, she asked her friend Helen Hayes to pose for her so she might test her vision.)[2] The sympathetic bond between artist and subject is palpable.

Henriette Wyeth's art, in portraiture as in still life, has always combined a deceptive simplicity of presentation with a firm grasp of physical and spiritual realities. Julie Eisenhower wrote that her mother thought the expression "too sad." But to most who view the portrait, the inwardness of Mrs. Nixon's countenance is rather that of an innately private person. The writer Jessamyn West said that Mrs. Nixon's "is a private face by structure, by its owner's temperament, by her punishing and cruel experience as a girl, by reason of thirty years of political exposure."[3] And Henriette Wyeth felt deeply, so she wrote to Julie, that

> your mother has eyes that are like no one else's. The eyes reveal an unusual spirit. They are the eyes of a sixteen-year-old girl— an expression of great sweetness. And, in that expression, occasionally the doors close and the lights go out. For there is a wistfulness in your mother's beauty. . . . She has maintained a kind of fragile beauty about her life. When she looked out the window at the hummingbirds, I liked the expression then in her eyes best. She still believes despite injustices.[4]

Certainly, the complex expression set down here is not the whole personality of Patricia Ryan Nixon. Just as certainly the artist has penetrated, feelingly, to the intensely human, resilient core. We may say, as Louisa Adams did of her equally inward portrait by Gilbert Stuart (page 90), that "'tis but a speaking tell tale which may in time of need . . . give a lesson of feeling and wisdom."[5]

Selected Works From the Collection by Modern European Masters

William Kloss

Paul Cézanne (1839–1906)

Still Life With Quince, Apples, and Pears c. 1885–87

Oil on canvas, 11⅛ x 12⅛ inches (28.3 x 30.8 cm)
Bequest of Charles A. Loeser, 1952

A capsule biography of Cézanne tells us little that would seem to explain his stature. Born in Aix-en-Provence, in France, to a prosperous family, he studied law, attended some art classes, and in 1861 went to Paris, where he studied art at the Académie Suisse. For 20 years he was active in Paris and in the Île-de-France, with frequent trips south. He exhibited paintings in the first three Impressionist group exhibitions—and was even more ridiculed by the critics than were the other artists. After 1882 he made Aix his base while often visiting Paris. Until 1895 his work was little seen by the public. Three years before Cézanne died, a French critic remarked that he was "unknown to the public," and at the time of his death a sympathetic obituary ironically noted: "As for the 'art world,' the death of Cézanne, the life and work of Cézanne, hardly touches it."[1]

Yet Cézanne towers over French painting of the second half of the 19th century. Without subjective assertions about "greatness" or "beauty," one can still affirm that the intellectual penetration of his art and its power to stimulate the senses were unequaled. His transforming effect on artists who followed him— Picasso, Matisse, and others—is uncontested, but the admiration felt by his contemporaries, whose own painting styles were quite different, is often overlooked. In 1895, after visiting the exhibition of Cézanne at Ambrose Vollard's gallery, Camille Pissarro wrote to his son Lucien:

> I also thought of Cézanne's show in which there were exquisite things, still lifes of irreproachable perfection, others much worked on and yet unfinished, of even greater beauty, landscapes, nudes and heads that are unfinished but yet grandiose, and so painted, so supple. . . . Why? Sensation is there! . . . But my enthusiasm was nothing compared to Renoir's. Degas himself is

seduced by the charm of this refined savage, Monet, all of us. . . . Are we mistaken? I don't think so.[2]

That the White House owns a group of Cézannes comes as a surprise to most people. One of them is this imposing little still life. Strangely, perhaps, it is often difficult to identify the fruits in Cézanne's still lifes. In this picture they have been variously denominated, but it is probably a quince that rests upon two apples and a barely glimpsed green fruit that may be a pear—by analogy with the green pear to the left.[3] Their actual identity matters little, for Cézanne was not a botanical illustrator but an artist intent on transmuting the perishable, inanimate fruits into permanent, eternally growing presences. As the poet Rainer Maria Rilke wrote of Cézanne in 1907, "It has never before been so demonstrated to what extent painting takes place among the colours themselves. . . . [His fruits] cease altogether to be edible" but are "indestructible in their stubborn presence."[4]

Still Life With Quince, Apples, and Pears was one of more than a dozen Cézannes, eight of them now in the White House collection, owned by Charles A. Loeser, an American expatriate who lived in Florence. Most of Loeser's Cézannes were seen in public for the first time in an exhibition of French paintings in Florentine collections organized in 1945, after the liberation of Italy. The celebrated art historian Bernard Berenson, who wrote the catalogue introduction, characterized this painting as "less exquisite, less delicate than [a still life by] Chardin, but more delectable, more sensuous."[5]

Perhaps the shade of Berenson will not be discomfited if the last word is given to John Updike, who apropos of the apple counseled:

> My child, take heart: the fruit that undid Man
> Brought out as well the best in Paul Cézanne.[6]

OPPOSITE: PHOTOGRAPH COURTESY OF THE NATIONAL GALLERY OF ART

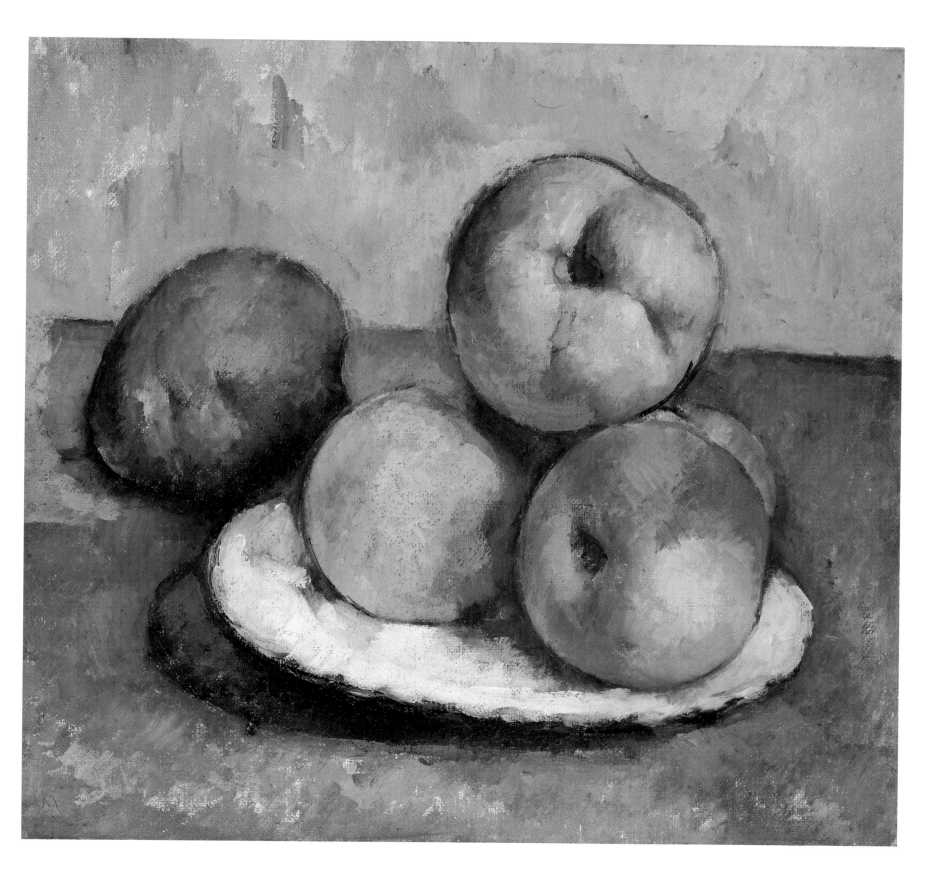

Paul Cézanne (1839–1906)
The Forest 1890–92

Oil on canvas, 28³⁄₄ x 36¹⁄₄ inches (73 x 92.1 cm)
Bequest of Charles A. Loeser, 1952

*I*t is a very French "forest" that Cézanne spreads before us, parklike and inviting. The soft play of light and the fresh palette recall, not altogether by chance, the pleasant parks of 18th-century French painters like Watteau in which fancifully costumed demoiselles and their beaus gather in amorous elegance, with music and dalliance in mind.

Cézanne's glade, by contrast, is unpeopled. The trees themselves become the actors and dancers, their limbs undulating with a sensuous pictorial music. The rolling ground is counterbalanced by the vertical thrust of the dominant tree, whose strikingly sinuous branches perform ornamental variations on the groundswell. Their bold calligraphy flows over and among the carefully controlled structure of short brushstrokes.

The eight paintings by Cézanne so unexpectedly found in the White House collection were the gift of Charles A. Loeser (1864–1928) who bequeathed them, with his daughter retaining life interest, "to the President of the United States of America and his successors in office for the adornment of the White House at Washington." These European subjects, however, are not in keeping with the period rooms of the White House. Therefore one or two at a time are hung elsewhere in the White House; some are on loan to the National Gallery of Art.

Charles Loeser was born in Brooklyn, the son of department store owner Frederick Loeser. He graduated from Harvard College in 1886. After further study there and in Berlin he settled in Florence in 1890. Harvard people formed the nucleus of his circle, which included William James, George Santayana, and the great print and drawing connoisseur Paul Sachs. In addition to the Cézannes, Loeser collected Italian sculptures and paintings, which he left to the City of Florence, and 262 old master drawings, which he gave to the Fogg Art Museum at Harvard. His great print collection remained with his widow and daughter until it was sold at auction in 1974.[1]

Cézanne scholar John Rewald has suggested that *The Forest* is the painting that Loeser referred to in his pocket diary (Paris; March 31, 1911): "At Vollard—Many Cézannes—liked particularly one landscape—wood with fine light—asking 30,000 Frcs."[2]

OPPOSITE: PHOTOGRAPH COURTESY OF THE NATIONAL GALLERY OF ART

Paul Cézanne (1839–1906)

House on the Marne 1888–90

Oil on canvas, 28¾ x 35⅞ inches (73 x 91.1 cm)
Bequest of Charles A. Loeser, 1952

*T*he artist used the motif of this house on the Marne
at least three times, most likely in 1888. During that
year, while living in Paris, he painted along the Marne
between Paris and Rheims on a number of occasions.[1]
Of the three compositions this is the most insistently
symmetrical, with the house and even the river
presented nearly frontally, parallel to the picture
plane, framed by the inward-arching trees. The cone-
capped turret of the house is carefully linked with
the vertical trees behind. These verticals are strongly
reflected in the river, creating a central axis that
intersects the riverbank to control the picture surface.

It is an easy, not a rigid, control that sustains
a scene that is very satisfying and restful to
contemplate. In this painting (and in this period)
Cézanne's palette is sumptuous and varied. A rich
blue-green with touches of violet dominates, but
in and around the house Cézanne introduces white,
slate blue, alizarin crimson, burnt sienna, and yellow,
while the light gleaming through the trees at the
far right is effected by laying in a pinkish, slightly
fleshlike tone. Together with the light cream primer
that, when left uncovered, creates flickering lights
across the painting, this "true painter's palette"
(as artist Émile Bernard called it) delights the eyes.

Some secrets of Cézanne's magic may be
discovered in the painting of the river. The
suppression of the near bank distances us from
the motif, so that the house seems unreachable across
the water. Cézanne has contrasted the water on either
side of the painting. On the left the river is rendered
with lighter tones and an open touch; on the right
it is painted more darkly, with blended brushwork.
The contrast is analogous to a shift in mood, and is
indicative of Cézanne's intuitive desire to present
nature as process, not as a record of the past, and not
to subject it to academic rules of composition,
drawing, or color.

OPPOSITE: PHOTOGRAPH COURTESY OF THE NATIONAL GALLERY OF ART

Paul Cézanne (1839–1906)

Mont Sainte-Victoire and Hamlet Near Gardanne 1886–90

Oil on canvas, 24⅝ x 35⅞ inches (62.6 x 91.1 cm)
Bequest of Charles A. Loeser, 1952

A s a young man in Europe in the late 1880s, Charles Loeser met and became a disciple of Giovanni Morelli (1816–1891), an Italian art critic whose "scientific" approach to connoisseurship, whatever its shortcomings, demanded looking closely at pictures. Perhaps it was this habit that allowed Loeser, whose student interest had centered on Italian art, to look at Cézanne's paintings with open eyes and mind at a time when the master was by no means universally recognized as such.

Most of Loeser's Cézannes were acquired early. The depth of his response to them is suggested by the fact that he hung the works in his bedroom and dressing room rather than spreading them among the diverse paintings and drawings in his collection. By keeping them apart, he allowed the paintings to unite in contemporary chorus, their distinctive modern harmony undisputed by the older Italian voices in the house.[1]

In this superlative painting Cézanne proves himself at once a master of place, able to apprehend and convey its essence, and a maker of unshakable pictorial structures. If one is first drawn to *Mont Sainte-Victoire and Hamlet* by the harsh splendor of the landscape, one stays with the painting because of the compelling geometry of the buildings that are of, not on, the earth. This bold group, drawn together like a single structure, a sort of Provençal manor house that seems to have risen from a geological fold, presents a united face against the baking sun.

The greatest heat of the day has passed, and shadows have begun to lengthen on the houses, but their glowing walls (as Cézanne once said of the rocks of Provence) "were of fire . . . and fire is in them still." Their angular roof lines are modulated by the swelling arcs of this "tableland that Nature didn't quite succeed in planing"; then a lone house bridges the rest of the distance to the mountain whose pulsing surface distantly echoes the buildings.[2]

Gardanne is about eight kilometers south of Aix-en-Provence, where Cézanne had his studio. The "hamlet" of the title is in fact Meyreuil, situated on a plateau about four kilometers northeast of Gardanne with Mont Sainte-Victoire about seven kilometers beyond.[3] It is not the view of the mountain with which we are most familiar from Cézanne's paintings, yet the site held a deep fascination for him. He first spent extended time there in 1885–86, when he wrote (May 11, 1886) to the collector Victor Chocquet: "There will be treasures to carry from this region, which has not yet found an interpreter equal to the riches which it unfolds."[4]

During his lifetime and since, critics have confused Cézanne's preoccupation with certain motifs as an indication that he had a limited imagination. An attentive look at the four paintings shown here should dispel that notion. Though the four were created within a brief span, each is distinct. The very different subjects, the diverse compositions, the substantial contrasts in paint handling, and the variety of emotional response in these works must astonish us with the range as well as the depth of Cézanne's imagination.

Claude Monet (1840–1926)
Morning on the Seine, Good Weather 1897

Signed and dated lower left: Claude Monet 97
Inscribed on the original stretcher: beau temps
Oil on canvas, 35 x 36⅛ inches (88.9 x 91.8 cm)
Gift of the family of John Fitzgerald Kennedy
 in memory of President Kennedy, 1963

"Just before dawn, in August, three-thirty." On
this morning in 1897 Monet, accompanied by an
assistant and an invited observer, walks from
his home in Giverny to the river. "Here," writes the
observer, Maurice Guillemot, "he unties his skiff
moored among the reeds at the bank and, with a few
strokes of the oars, reaches the large boat at anchor
that is his studio." His assistant

> undoes the parcels—so they designate the
> stretched canvases tied in pairs and
> numbered—and the artist sets to work. There
> are fourteen paintings begun at the same
> time, virtually a series of studies, interpreting
> one and the same motif the effect of which is
> modified by the hour, the sun, the clouds.[1]

This invaluable and evocative account of the great
painter at work continues:

> It is at the spot where the Epte enters
> the Seine, among little islands shaded by tall
> trees, where some branches of the stream
> beneath the leaves seem to form solitary and
> peaceful lakes, mirrors of water that reflect
> the green foliage, it is here that Claude Monet
> has worked since last summer.[2]

Morning on the Seine, Good Weather is one of
twenty-one extant paintings of this motif and one of
fifteen shown at the Galerie Georges Petit in Paris
in 1898, in an exhibition of sixty-one Monets. All in
the series were painted in late 1896 (when wretched
weather limited work) and in 1897. The *Mornings on
the Seine* were the last of Monet's great serial paintings
of French sites (from the poplars to the grain stacks to

the facade of Rouen Cathedral). The splendid White
House painting—an exemplary representative of the
series—was chosen and donated by members of
the Kennedy family to commemorate the assassinated
President. His widow, Jacqueline Kennedy, noted
that President Kennedy "liked French paintings" and
"loved paintings of water and sky."[3]

In this painting Monet seems to have
concentrated more than ever before on the minute
shifts in color produced by the growing light of
morning, and on the veiled evanescence of the misty
atmosphere. The eyewitness Guillemot said the
canvases were numbered, and certainly the series
documents "the progress of the sun over the river
with the kind of meticulousness that permits a
chronological ordering of most of the paintings in the
group."[4] Monet, working on each canvas in ordered
succession for as long as the light held his intended
effect, would return to the series on the following
morning, weather permitting.

The *Mornings* paintings are more decorative than
works from the earlier series; that is, the suavely
elegant shapes and the homogeneous brushwork
produce a surface of such unity that pictorial recession
nearly gives way to abstract pattern. (Nevertheless,
when one steps well back from this canvas, the
perspective depth of the scene is suddenly and
strikingly apparent.)

These paintings were—contrary to the widespread
belief probably encouraged by the artist—almost
always finished in the studio where they could be
adjusted to a predetermined aesthetic, and where "the
imagination proved more subtle than the eye."[5] The
nearly square format of *Morning on the Seine, Good
Weather* is itself aesthetically self-conscious in the
sense that it avoids the natural horizontal presentation

Claude Monet 97

of the landscape and provides instead an artfully balanced, motionless field.

These stylistic qualities produced as well the ethereal aura, the nuanced mood, that sets the painting apart from Monet's earlier work, with its fresh, youthful zest. The mood, due in part, perhaps, to the artist's advancing age, also reflects the spirit of the century's waning years. The fin de siècle, as art historian Joel Isaacson has suggested, gave rise not only to "the dawning veils of Monet," but also to such artistic phenomena as Proust's preoccupation with memory and the shifting hues of a Tiffany vase.[6]

The wondrous undulating curve of hazy bright sky and its reflection in the water is the core, physical and emotional, of this painting. Its dancing glow is lovingly enfolded by the deep blue-green and purple masses of foliage on the left, and the soft violet, pink, and yellow trees of the island on the right. Far from being an objective record of the river, the painting is a lyrical evocation of the meaning of the place for Monet, rendered in insubstantial masses and colors of infinite refinement.

While many of his contemporaries were obsessed with recording exotic lands, Claude Monet, in *Morning on the Seine, Good Weather*, draws back the curtain on a home scene of natural beauty, so familiar, but in this unfamiliar light so spellbinding, that it seems a memory of childhood or a vision of paradise.

Notes

The notes and provenances for works of art discussed in Part Two of *Art in the White House: A Nation's Pride* appear below. The page numbers in the left margin of the notes direct you to the page on which the text for each painting begins.

Special appreciation goes to William Seale, whose invaluable two-volume work, *The President's House: A History* (Washington, D. C.: White House Historical Association, 1986), is frequently referred to and hereafter cited as Seale, *President's House.*

Page 53 *Landing of the Pilgrims*
Michele Felice Cornè

NOTES
1. Carl L. Crossman and Charles R. Strickland, "Early depictions of the landing of the Pilgrims," *Antiques*, Nov. 1970, 777–80. See also Nina Fletcher Little, *Michele Felice Cornè, 1752–1845* (Salem, Mass.: Peabody Museum, 1972).

2. In 1989 the painting at the Peabody Museum was consigned to Vose Galleries, Boston.

PROVENANCE
Hirschl & Adler, Inc., 1979; Mr. and Mrs. John P. Humes, New York. 984.1548.1

54 *Benjamin Franklin*
Benjamin Wilson

NOTES
1. Quoted by Charles Coleman Sellers, *Benjamin Franklin in Portraiture* (New Haven: Yale Univ. Press, 1962), 409–10.

2. Ibid., 273. Letter of Oct. 23, 1788.

PROVENANCE
Mr. and Mrs. Benjamin Franklin, 1759; removed from the Franklin Philadelphia house during British occupation by Maj. John André, 1778; gift to Maj.-Gen. Sir Charles Grey, Northumberland, England; descended in his family to Albert Henry George, Fourth Earl Grey, 1894; donated in honor of the bicentennial of Franklin's birth, 1906. 906.3501.1

57 *Benjamin Franklin*
David Martin

NOTES
1. Martin returned to Edinburgh in 1775, becoming Painter to the Prince of Wales for Scotland. Upon marrying a wealthy Englishwoman he went to London, remained there until her death, then returned to Scotland to stay. He also made mezzotint engravings of portraits, including this portrait of Franklin.

2. The bust apparently imitates one in marble or terra-cotta by Louis François Roubiliac, "bronzed" by Martin to echo the gilt chair crest with an American eagle. Of several known replicas of the portrait, the most important (1767) was ordered by Franklin himself and now belongs to the Pennsylvania Academy of the Fine Arts, from which it is on extended loan to the Diplomatic Reception Rooms of the U. S. Department of State. See Charles Coleman Sellers, *Benjamin Franklin in Portraiture* (New Haven: Yale Univ. Press, 1962), 74–80 and 328–33.

3. Benjamin Franklin, "Information to Those Who Would Remove to America," in *Works*, ed. Jared Sparks (Boston, 1836), 2: 472.

PROVENANCE
Commissioned by Robert Alexander, 1767; descended in his family; M. Knoedler & Co., Inc., New York. 962.187.1

58 *George Washington*
Charles Willson Peale

NOTES
1. Quoted in Charles Coleman Sellers, "Portraits and Miniatures by Charles Willson Peale," *Transactions of The American Philosophical Society* (Philadelphia: American Philosophical Society, June 1952), new ser., vol. 42, pt. 1, 220.

2. See Gervase Jackson-Stops, ed., *The Treasure Houses of Britain* (Washington, D. C.: National Gallery of Art, 1985), 545, cat. 483. Peale displayed *Portrait of a Girl* in the same exhibition.

3. Sellers, "Portraits and Miniatures," 221. For the rediscovery of the portrait, see M-L. D'Otrange Mastai, "The American Connoisseur. An Important Discovery," *Connoisseur*, Nov. 1965, 192–93. The identity of the Frenchman for whom the replica was destined has never been confirmed. The painting was discovered in Ireland; its appearance there has not been explained.

PROVENANCE
Painted for "a French gentleman"; discovered in Ireland; sold at Christie's, London, July 16, 1965, #91, to Lansdell K. Christie; on loan from the Estate of Lansdell K. Christie to the White House, 1971–79. 979.1405.1

61 *To the Genius of Franklin*
Jean-Honoré Fragonard

NOTES
1. Roger Portalis, *Honoré Fragonard, sa vie et son oeuvre* (Paris, 1889), 142.

2. *Journal de Paris,* Nov. 15, 1778. Quoted in Charles Coleman Sellers, *Benjamin Franklin in Portraiture* (New Haven: Yale Univ. Press, 1962), 287. The White House acquired one of the prints in 1992.

3. When owned by Wildenstein & Co., the drawing was sometimes exhibited as *Apotheosis of Franklin* or *Allegory of Franklin.*

4. Quoted in Hugh Honour, *The European Vision of America* (Cleveland: Cleveland Museum of Art, 1975), cat. 206 (unpag.). See also the helpful commentary by Helen O. Borowitz in "The European Vision of America: Notes on the Exhibition" (Cleveland: Cleveland Museum of Art, 1975), 28. For the original French text announcing the print (*Journal de Paris,* Nov. 15, 1778), see Sellers, *Benjamin Franklin,* 287–88.

PROVENANCE
Hippolyte Walfredin—collection sale in Paris, Apr. 3, 1880, #60; Eugene Feral—collection sale in Paris, Apr. 22–24, 1901, #198; Wildenstein Galleries, Paris, by 1926; acquired as *The Apotheosis of Benjamin Franklin.* 961.2.1

62 *Thomas Jefferson*
John Trumbull

NOTES
1. Maria Cosway to Jefferson, Aug. 19, 1788, *Papers of Thomas Jefferson,* ed. Julian P. Boyd (Princeton: Princeton Univ. Press, 1950–), 12: 525. Quoted in Helen A. Cooper, *John Trumbull: The Hand and Spirit of a Painter* (New Haven: Yale Art Gallery, 1982), 117.

2. Jefferson to Maria Cosway, Oct. 12, 1786, *The Life and Selected Writings of Thomas Jefferson,* ed. Adrienne Koch and William Peden (New York: Random House, 1944), 396–97.

3. Ibid., 406.

4. Trumbull to Jefferson, Mar. 6, 1788, Boyd, *Papers of Jefferson,* 647; Maria Cosway to Jefferson, Mar. 6, 1788, Boyd, 645; see also Elizabeth Cometti, "Maria Cosway's Rediscovered

Miniature of Jefferson," *William and Mary Quarterly,* 3rd ser., 9 (1952): 153.

5. Maria Cosway to Jefferson, Apr. 29, 1788, Boyd, *Papers of Jefferson,* 115–16; Angelica Church to Jefferson, July 21, 1788, quoted in Cometti, "Maria Cosway's Miniature," 153.

6. Cometti, "Maria Cosway's Miniature," 150.

PROVENANCE
Commissioned by Maria Cosway, England, 1788; bequest to Instituto Maria SS. Bambina, Lodi, Italy, 1838; purchased by the Italian Republic for donation to the White House, 1976. 976.1262.1

65 *John Adams*
John Trumbull

NOTES
1. Quoted in Margaret C. S. Christman, *The First Federal Congress, 1789–1791* (Washington, D. C.: Smithsonian, 1989), 217–18.

2. A second version of this portrait, of the same dimensions, is in the Fogg Art Museum at Harvard University, and a third, smaller replica descended in the Adams family until it entered the National Portrait Gallery. In the former the head is only slightly higher on the canvas, while in the latter it is in the upper half with the chin at the midline. The Alexander Hamilton portrait commissioned by Jay is very similar in pose and costume to the John Adams portrait that he commissioned. The Hamilton portrait passed to the National Gallery of Art in 1952.

PROVENANCE
Commissioned by John Jay (Chief Justice of the United States Supreme Court), c. 1792–93; descended in his family; Christie's, New York, 6074, Jan. 25, 1986, #235. 986.1582.1

66 *George Washington*
Gilbert Stuart

NOTES
1. Seale, *President's House,* 1:132–36.

2. An excellent example of a conversation piece, among dozens, is *Arthur Holdsworth, Thomas Taylor and Captain Stancombe Conversing by the River Dart,* 1757, by Arthur Devis (National Gallery of Art).

3. Garry Wills, *Cincinnatus: George Washington and the Enlightenment* (Garden City, N. Y.: Doubleday, 1984), 171.

4. The source is an 18th-century engraving by Pierre Imbert Drevet of a late 17th-century portrait of Bishop Jacques Benigne Bossuet (1627–1704), orator and theologian, by Hyacinthe Rigaud (1659–1743). It is reproduced by Charles Merrill Mount, *Gilbert Stuart: A Biography* (New York: Norton, 1964), between pages 128 and 129.

5. Quoted both in James Thomas Flexner, *Gilbert Stuart: A Great Life in Brief* (New York: Knopf, 1955), 127, and in Richard McLanathan, *Gilbert Stuart* (New York: Abrams, 1986), 81–82. Washington had been fitted with a new set of false teeth shortly before the sitting from which this head derives, and they altered the shape of his mouth, but that is not an adequate explanation of his demeanor.

6. Stuart first painted a bust-length portrait showing the right side of Washington's face (the Vaughan portrait, after its first owner) in 1795. Then, through the intervention of Mrs. William Bingham, wife of the Philadelphia financier and United States senator, he painted another portrait. This time he showed the left side of the face (the Athenaeum portrait, since it was purchased by the Boston Athenaeum after Stuart's death). The second head was probably in preparation for a half-length portrait commissioned by Senator Bingham. The senator, however, decided to order a full-length portrait instead. This is the version, signed and dated 1796, that was willed by Bingham to the Pennsylvania Academy of the Fine Arts, where it

Page 66
(Continued) remains. Pleased with the portrait, Bingham ordered a replica for his acquaintance Lord Lansdowne, who admired Washington. This painting, now owned by Lord Rosebery, has been on extended loan to the National Portrait Gallery since 1968. At about the same time William Kerin Constable, a New York merchant in the China trade, saw the original Bingham commission in progress in Stuart's studio and ordered a copy to be painted simultaneously so that it would be equally an "original." This version is now in the Brooklyn Museum. The two Bingham commissions are clearly superior to the Constable replica. A lengthy conservation report on the White House replica prepared by Marion B. Mecklenburg and Justine S. Wimsatt declares forcefully: "With respect to all four paintings, we feel that their palettes and techniques are identical, but that the major variations arise from their execution, specifically the degree to which the artist completed the paintings. These variations do not suggest the work of different artists, but define one artist's degrees of effort. We feel that all four versions were painted in their entirety by a single hand." See Marion B. Mecklenburg and Justine S. Wimsatt, "The Full Length Portrait of George Washington by Gilbert Stuart—Conservation Treatment Report and Commentary," 1978, Office of the Curator, the White House.

7. Secretary of State Timothy Pickering confirmed this in a letter to Pinckney (July 22, 1797), adding that "the picture remains with [Stuart] . . . subject to your orders." In Mount, *Gilbert Stuart*, 216.

8. One infamous proof is the 16-year "delay" in the delivery of a portrait of Thomas Jefferson, already paid for, while Stuart made replicas from it. Fiske Kimball, "The Life Portraits of Jefferson and Their Replicas," *Proceedings of The American Philosophical Society* 88 (Philadelphia, 1944), 512–23.

9. Gardner Baker died suddenly in Boston at the end of Sept. 1798. According to William Dunlap, "Mr. Baker in the course of business became the debtor of Mr. Wm. Laing [the Thos. Lang of the

purchase order], who, in the process of time, received the . . . picture in payment. Mr. Laing being in the metropolis [Washington, D. C.] when the president's house was being furnished, suggested the appropriateness of such a picture as he possessed, for such a place, and eventually sold the portrait to the committee who directed the business." (See William Dunlap, *A History of the Rise and Progress of the Arts of Design in the United States* [1834; reprint, New York: Dover, 1965], 202.)

10. The 1878 hand copy in the Office of the Curator, the White House, reads "Long," but the original in the Treasury Department (now unlocated) was read as "Lang" and cited in Elizabeth B. Johnston, *Original Portraits of Washington* (Boston: James R. Osgood and Co., 1882), 88. "Lang" for "Laing" is not surprising given the vagaries of 19th-century spelling. "William" for "Thomas" is probably due to the fact that Dunlap was writing decades afterward.

11. Dunlap, *A History*, 202. Winstanley had already made a number of copies of Stuart's portraits of Washington and had sold several landscapes to the President in 1793–94. Dunlap recounts the tale as told to him by Stuart.

12. "Diary of Mrs. William Thornton" [1800], *Records of the Columbia Historical Society* 10 (Washington, D. C., 1907): 160–63, 191.

13. Seale, *President's House*, 1: 80.

14. Quoted both in Mount, *Gilbert Stuart*, 263, and in Lawrence Park, *Gilbert Stuart: An Illustrated Descriptive List of His Works*, 4 vols. (New York: W. E. Rudge, 1926), 2: 880.

15. Original letter in the Library of the University of Virginia, Manuscript Division; quoted in Ethel Stephens Arnett, *Mrs. James Madison, The Incomparable Dolley* (Greensboro, N. C.: Piedmont Press, 1972), 473 n. 47.

16. Dunlap, *A History*, 199–202. "This cheat was not discovered until after Stuart removed to the

city of Washington, when he at a glance, saw that the picture was not from his pencil and disclaimed it" (202).

PROVENANCE
Probably commissioned by Charles Cotesworth Pinckney for the official American residence, Paris, 1796 (paid for in 1797, but never received); possibly Gardner Baker, New York, by Feb. 1798; Thomas Long (Lang). 800.1290.1

70 *Amerigo Vespucci*
Giuseppe Ceracchi

NOTES
1. Quoted in Daniel J. Boorstin, *The Discoverers* (New York: Random House, 1983), 249.

2. See, for example, an Italian engraving of 1761 by Francesco Allegrini "derived from an old painting from the time of the illustrious gentleman Amerigo Vespucci." Reproduced on the frontispiece in *Raccolta di carte e documenti esposti alla mostra tenuta in Palazzo Vecchio nel V centenario della nascita di Amerigo Vespucci* (Florence, 1955). An image of Vespucci painted by Constantino Brumidi about 1860 in the President's Room of the U. S. Capitol Building attests the persistence of the traditional representation. See *Compilations of Works of Art and Other Objects in the United States Capitol* (Washington, D. C.: U. S. Government Printing Office, 1965), 314.

3. *Giuseppe Ceracchi (1751–1801): Scultore Giacobino* (Rome: Artemide [for the] Palazzo dei Conservatori, 1989), 63; *Philadelphia: Three Centuries of American Art* (Philadelphia: Philadelphia Museum of Art, 1976), 169, cat. 139.

4. *Giuseppe Ceracchi*, 63.

5. The confusion may have begun with a replica of the bust of Columbus that was given to the New-York Historical Society in 1928 by James Gore King, who identified it from family tradition as Ceracchi's *Amerigo Vespucci*; as far as is known the family did not own the companion piece

(*Catalogue of American Portraits in The New-York Historical Society* [New Haven: Yale Univ. Press, 1974], 2: 843–44m no. 2140). The identities of the White House busts have been transposed for at least 30 years; this may well be the result of reliance on the NYHS's misidentification. Ulysse Desportes has also confused the two busts ("Giuseppe Ceracchi in America and his Busts of George Washington," *The Art Quarterly* 26 [1963]: 141–79). Unfortunately, the 1989 exhibition catalogue *Giuseppe Ceracchi* (see 64, cat. 13 n. 3) borrowed the NYHS bust *and* its identification as Vespucci without question and without comparison, since the companion bust was not reproduced or discussed.

None of the numerous supposed portraits of Columbus resembles the bust or the engraving. Instead many of them show a younger man with a narrower mouth, a full head of hair, and sometimes a full beard, though with little similarity in other particulars. See Nestor Ponce de Leon, *The Columbus Gallery* (New York: N. Ponce de Leon, 1893).

6. His terra-cotta sculptures were still in the Pisani studio in 1802. The marble replicas of Vespucci and Columbus were carved by the Pisani brothers or other sculptors with access to the models. For an incomplete inventory of the sculpture left in Florence, see the letter of Arsenio Thibaud to Giovanni Fabbroni (Sept. 14, 1802), in *Giuseppe Ceracchi*, 64, cat. 13.

7. *Giuseppe Ceracchi*, 18–20, 46.

8. B. L. Lear's signed receipt is in the National Archives, Record Group 217, Miscellaneous Treasury Accounts, Account 43754, 85–no. 7 (Nov. 11, 1817). Monroe's friendship with Ceracchi probably dated to 1795 when he was American minister to France and Ceracchi was in Paris planning a monument to the French Revolution. See *Giuseppe Ceracchi*, 11.

9. *Dictionary of American Biography*, s.v. "Lear, Tobias."

10. For the transactions between Tobias Lear and Thomas Appleton, see Philipp Fehl, "The Account Book of Thomas Appleton of Livorno," *Winterthur Portfolio* 9 (Charlottesville: Univ. Press of Virginia, 1974), 138–40.

PROVENANCE
Benjamin Lincoln Lear 817.3753.1

73 *Thomas Jefferson*
Rembrandt Peale

NOTES
1. The painting itself was destined for the Peale Museum in Baltimore. After the holdings of the museum were finally dispersed in 1854, the painting was bought by Charles J. M. Eaton, whose daughters presented it to the Peabody Institute in 1893. Only in 1959 was it again recognized as the original life portrait of Thomas Jefferson.

2. Reprinted in Henry Steele Commager, *Documents of American History*, 9th ed., 2 vols. (Englewood Cliffs, N. J.: Prentice Hall, 1973), 1:187.

PROVENANCE
Peale Museum, Baltimore, 1800; Charles J. M. Eaton, Baltimore, 1854; his daughters, 1893, to Peabody Institute, Baltimore. 962.395.1

74 *Joel Barlow*
Jean-Antoine Houdon

NOTES
1. Quoted in Hugh Honour, *The European Vision of America* (Cleveland: Cleveland Museum of Art, 1975), cat. 194. About the bust see H. H. Arnason, *The Sculptures of Houdon* (New York: Oxford Univ. Press, 1975), 100–101, and 119 n. 246; idem, *Sculpture by Houdon* (Worcester, Mass.: Worcester Art Museum, 1964), 120–22.

2. The plasters are signed and dated "Houdon f. an. XII" (the French Republican Calendar year equivalent to Sept. 1803–Sept. 1804) and

inscribed "J. Barlow 50 ans," whereas the marble has no inscriptions. However, this "has no significance since Houdon frequently signed a plaster and did not sign a commissioned marble." (Letter from H. H. Arnason, Office of the Curator, the White House.) Though the Salon catalogue did not give the material, it has been observed that only one Houdon in the list was specified as a plaster and that it might be inferred that the rest were marbles.

3. Quoted in Charles E. Fairman, *Art and Artists of the Capitol of the United States of America* (Washington, D. C.: U. S. Government Printing Office, 1927), 32. Latrobe added that "Mrs. Barlow's bust cost in Paris 600 dollars, including the Material."

4. The quotation is from Barlow's poem, "Advice to a Raven in Russia/ December, 1812," written in diplomatic code shortly before his death.

PROVENANCE
Joel Barlow, District of Columbia, c. 1804; descended in his family; purchased by Judge Peter Townsend Barlow (collateral descendant), New York; Samuel L. M. Barlow (son), New York; Maury A. Bromsen Associates, Boston. 963.466.1

77 *Benjamin Henry Latrobe*
Charles Willson Peale

NOTES
1. William Howard Adams, ed., *The Eye of Thomas Jefferson*. Exhibition catalogue. (Washington, D. C.: National Gallery of Art, 1976), 254–55.

2. Charles Coleman Sellers, "Portraits and Miniatures by Charles Willson Peale," *Transactions of The American Philosophical Society*, (Philadelphia, American Philosophical Society, June 1952), new ser., 42, pt. 1, 122 n. 461, fig. 289. The portrait of Latrobe was first listed in the 1813 museum catalogue. At the liquidation of Peale's Museum in 1854 it was sold to Joseph

Page 77
(Continued) Harrison of Philadelphia. In the absence of a known replica, it can be assumed that the painting passed eventually to Ferdinand C. Latrobe of Baltimore, the subject's grandson, and thence to his widow, the known provenance of the White House painting. The portraits in Peale's Museum were usually presented in rectangular frames with oval apertures, as is this one. When the frame is removed, one finds that Peale had completed painting the bust of Latrobe to the bottom of the canvas (catalogue, page 336). Nonetheless, it is presumed that it was always framed in an oval format.

3. The phrase is Peale's. Quoted by Charles Coleman Sellers in Adams, *The Eye of Thomas Jefferson*, 268, cat. 457.

PROVENANCE
Probably painted for the artist's Peale Museum, Philadelphia; museum collection sale at Thomas & Sons, Philadelphia, Oct. 6, 1854, #146; Ferdinand C. Latrobe (grandson), Baltimore; descended in his family; Kennedy Galleries, Inc., New York. 973.1032.1

78 *James Madison*
John Vanderlyn

NOTES
1. Jefferson to Madison, Nov. 18, 1788, *The Life and Selected Writings of Thomas Jefferson*, ed. Adrienne Koch and William Peden (New York: Random House, 1944), 452.

2. Quoted in Elisabeth McClellan, *Historic Dress in America, 1607–1870* (1904–10; reprint, 2 vols. in 1, New York: Benjamin Blom, 1969), 2: 368.

PROVENANCE
Commissioned by Secretary of State James Monroe, 1816; descended in his family to Laurence Gouverneur Hoes (great-grandson), Washington, D. C., c. 1933. 968.627.1

81 *Colonel William Drayton*
Samuel F. B. Morse

NOTES
1. For a similar elevation see Sebastiano Serlio, *The Book of Architecture* (1611; reprint, New York: Benjamin Blom, 1970), 3rd bk., 4th chap., fol. 66.

2. Quoted by Frank Milling Reach, "Old Philadelphia Families," *The North American* (Philadelphia), Sunday, Dec. 15, 1912, p. 9 of a typed transcript, Office of the Curator, the White House.

PROVENANCE
Commissioned by the sitter, South Carolina, 1818; descended in his family; Miss Eunice Chambers, Hartsville, S. C.
962.278.1

82 *James Monroe*
Samuel F. B. Morse

NOTES
1. Quoted in Edward Lind Morse, ed., *Samuel F. B. Morse: His Letters and Journals*, 2 vols. (Boston: Houghton Mifflin, 1914), 1: 222. (The Charleston portrait still hangs in City Hall.)

2. Ibid., 226.

3. Ibid.

4. Ibid., 227.

5. Seale, *President's House*, 1: 152–56.

PROVENANCE
Commissioned by President James Monroe, c. 1819; descended in his family; sold at Stan V. Henckels auction, Philadelphia, 1917, to donor's father; purchased from sale of mother's property, Old Westbury, N. Y., c. 1953. 965.587.1

85 *Monchousia (White Plume), Kansa*
Charles Bird King

NOTES
1. Herman J. Viola, *The Indian Legacy of Charles Bird King* (Washington, D. C., and New York: Smithsonian and Doubleday, 1976), 22.

2. George Catlin, *Letters and Notes on the Manners, Customs, and Conditions of North American Indians*, 2 vols. (1841; reprint, New York: Dover, 1973), 2: 23.

3. Viola, *Indian Legacy*, 118–19. Some of the surviving paintings may be originals—paintings done from the live model—for King may have followed the practice of such artists as Charles Willson Peale and Gilbert Stuart, who retained the life portrait to make replicas, often supplying the original patron with a replica instead of the life portrait. If King himself retained some of the life portraits, they would have been among the approximately 215 paintings he gave to the Redwood Library, Newport, Rhode Island, over a period of years and in his final bequest in 1862. The 21 Indian paintings in the group were all sold by the Redwood Library through Parke Bernet (auction, May 21, 1970); 14 have remained together in the collection of Gulf States Paper Corp., Tuscaloosa, Ala.

4. Viola, *Indian Legacy*, 119.

PROVENANCE
Patrick Macaulay, Baltimore; sent to Christopher Hughes, U. S. Chargé d'Affaires, the Netherlands, 1826; George Rimington; G. L. Rimington, Ontario, Canada; Kennedy Galleries, Inc., New York. 962.394.5

86 *Petalesharro (Generous Chief), Pawnee*
Charles Bird King

NOTES
1. In the breathtakingly racist remark of a 19th-century writer, this showed "that the most refined and Christian sentiments are

sometimes concealed beneath a red skin." In "Petalesharoo," *United States Magazine,* new ser., no. 6 (Dec. 1856): 547.

2. With relish Morse concluded that "such was [Petalesharro's] popularity, no inquiry was made into his conduct, no censure was passed on it." Jedidiah Morse, "Report to the Secretary of War . . . on the State of Indians" (New Haven, 1822), 248.

3. Ibid.

4. Congressman Thomas P. Moore's objections are quoted. McKenney soon published an open letter in which he responded: "Indians are like other people in many respects—and are not less sensible than we are to marks of respect and attention." Viola, *Indian Legacy,* 56.

5. Frances Trollope, *Domestic Manners of the Americans* (1832; reprint of 5th ed.[1839]; New York: Dodd, Mead & Co., 1927), 185–86.

PROVENANCE
Patrick Macaulay, Baltimore; sent to Christopher Hughes, U. S. Chargé d'Affaires, the Netherlands, 1826; George Rimington; G. L. Rimington, Ontario, Canada; Kennedy Galleries, Inc., New York. 962.394.3

89 *Grapes and Apples*
James Peale

NOTES
1. James Peale frequently replicated his still lifes. One replica is in the Butler Institute of American Art, Youngstown, Ohio, as a James Peale. A second replica is at the Sheldon Memorial Art Gallery, the University of Nebraska, Lincoln, where it has been reattributed to Mary Jane Peale (1827–1902), daughter of Rubens Peale (Norman A. Geske and Karen O. Janovy, *The Sheldon Memorial Art Gallery: The American Painting Collection* [Lincoln: Univ. of Nebraska Press, 1988], 319). No stylistic reasons are given for the new attribution, which I find improbable. Mary Jane Peale was a prosaic painter, even in her copies (primarily of her father's work).

2. William J. Gerdts and Russell Burke, *American Still-Life Painting* (New York: Praeger, 1971), 36. The authors long ago noted that "the paintings from James's hand often have withered leaves, bruises, and soft spots reflecting a concern with the passage of time." By contrast, "Raphaelle's fruit is perfect in condition."

3. Thomas Jefferson, *Notes on Virginia* (first published, 1784), in *The Life and Selected Writings of Thomas Jefferson,* ed. Adrienne Koch and William Peden (New York: Random House, 1944), 280.

4. *Writings of Thomas Jefferson,* ed. H. A. Washington, 7 vols. (Washington, D. C.: Taylor & Maury, 1854), 6: 6. Letter to Mr. Peale, Aug. 20, 1811. For further observations on Jefferson, the Peales, and their immersion in "natural history," see John Wilmerding, "America's Young Masters: Raphaelle, Rembrandt, and Rubens," in Nicolai Cikovsky, Jr., *Raphaelle Peale Still Lifes* (Washington, D. C.: National Gallery of Art, 1988), 73–93.

PROVENANCE
William David and Sarah Claypoole Lewis (niece of Mrs. James Peale), Philadelphia; descended in their family to Mrs. Sarah C. Madeira, Haverford, Pa.; Hirschl & Adler Galleries, Inc., New York. 962.189.1

90 *Louisa Catherine Johnson Adams*
Gilbert Stuart

NOTES
1. Quoted in Andrew Oliver, *Portraits of John Quincy Adams and His Wife* (Cambridge: Harvard Univ. Press, 1970), 81. Stuart's portrait is the only one to which this can refer.

2. Ibid., 81–82: Ward Nicholas Boylston to John Quincy Adams, Oct. 27 and Dec. 22, 1825; poem enclosed in a letter to her son George, both dated Dec. 18, 1825.

3. Ibid., 84–85. Although Oliver recounts all these documents, he dates the picture 1821 in the photograph caption, and in the text (p. 87) says it "reflects her appearance as it must have been sometime between 1821 and 1825." We have no record of a final sitting in late 1825 or early 1826, but I believe we may assume from Louisa's appearance that it took place.

4. Henry Adams, *The Education of Henry Adams* (1918; reprint, Boston: Houghton Mifflin, 1961), 18.

5. Louisa Adams to Mary Hellen, July 13, 1827, Oliver, *Portraits,* 85. That her hair is not white may suggest poetic license or her memory of the white cap; "half Corps," is a nice pun on "corpse" in this *half-length* portrait.

6. Ibid.

7. Adams, *Education,* 18–19.

PROVENANCE
Commissioned by Secretary of State and Mrs. John Quincy (Louisa Catherine) Adams, 1821, received (as President) c. 1827; given to Charles Francis Adams (son), Boston, 1829; descended in his family to John Quincy Adams V, Dover, Mass. 971.676.1

93 *John James Audubon*
John Syme

NOTES
1. Two of Audubon's engravings, *Iceland Falcon* and *Brown Pelican,* are in the White House collection.

2. See Francina Irwin, "The Man in the Wolfskin Coat," *Country Life,* Apr. 1977, 1104–06. Audubon was elected to memberships in the Wernerian Natural History Society, the Scottish Academy, the Society of Antiquaries, and the Royal Society of Edinburgh.

3. Havell is represented in the White House by the 1850 painting *West Point Near Garrisons.*

Page 93 **4.** Maria R. Audubon, *Audubon and his Journals,*
(Continued) 2 vols. (New York: C. Scribner's Sons, 1897),
1: 157, 165, 167, 168, 169, 171, and 172.

5. Carlotta J. Owens, *John James Audubon: The
Birds of America* (Washington, D. C.: National
Gallery of Art, 1984), unpag., "Introduction"; the
Self-Portrait is reproduced on the facing page.

PROVENANCE
Marianne Wilson Russell, Edinburgh, Scotland;
descended in her family; M. Knoedler & Co.,
Inc., New York. 962.385.1

94 *Mouth of the Delaware*
Thomas Birch

NOTE
1. An account of Thomas Birch's career is in John
Wilmerding, *American Marine Painting*, 2nd ed.
(New York: Abrams, 1987), 74–86 and *passim*.

PROVENANCE
Kennedy Galleries, Inc., New York. 962.181.1

97 *City of Washington From
Beyond the Navy Yard*
George Cooke

NOTE
1. The White House owns an impression of the
Bennett aquatint.

PROVENANCE
Kennedy Galleries, Inc., New York; Robert Lee
Gill, New York. 972.883.1

98 *Fanny Kemble*
Thomas Sully

NOTES
1. In Charleston three of the boys, including
Thomas, were enlisted in the family enterprise. A
handbill announced two plays, to be followed by
"Master C. Sully, T. Sully and Mr. M. Sully,

being their first appearance on this stage; whose
mixed exertions [an acrobatic exhibition] will
afford an entertainment highly pleasing." In
Monroe H. Fabian, *Mr. Sully, Portrait Painter*
(Washington, D. C.: Smithsonian, 1983), 10.

2. In all, including later replicas and paintings
from recollection, he completed at least thirteen
portraits of her. Most significant were four in
costume and two formal portraits.

3. Quoted in J. C. Furnas, *Fanny Kemble* (New
York: Dial, 1982), 119.

4. Quoted in Dorothy Marshall, *Fanny Kemble*
(New York: St. Martin, 1977), 91.

5. Edward Biddle and Mantle Fielding, *The Life
and Work of Thomas Sully* (Philadelphia: privately
printed, 1921), 196, nos. 957 and 958.

6. Frances Anne Kemble, *Records of Later Life*
(New York: Henry Holt, 1882), 81.

7. "Sonnet. On Mrs. Kemble's Readings from
Shakespeare." *The Poems of Longfellow* (London:
Oxford Univ. Press, n.d.).

PROVENANCE
Frances Anne Kemble; the Honorable Mrs. James
Wentworth Leigh (Frances Kemble Butler, the
sitter's daughter); Richard Taylour, London;
M. Knoedler & Co., Inc., New York. 965.566.1

101 *Martin Van Buren*
Hiram Powers

NOTES
1. For this chronology, see Richard P. Wunder,
Hiram Powers: Vermont Sculptor, 1805–1873, 2 vols.
(Newark: Univ. of Delaware Press, 1991), 2: 99.

2. Dec. 4, 1841. Inman's letter is in the Library of
Congress; see *Calendar of the Papers of Martin Van
Buren* (Washington, D. C.: Library of Congress,
1910), 436. At some time, probably after it
entered the White House, the bust was severely
damaged, the head broken off. The restored area,
not especially subtle, has become discolored.

3. See Herbert P. Collins and David B. Weaver,
Wills of the U. S. Presidents (New York:
Communication Channels, 1976), 74. The two
later replicas were ordered in 1862 through
Timothy Bigelow Lawrence, U. S. Consul
General at Florence (Wunder, *Hiram Powers,* 2:
99). John's role is confirmed by his letter to
Samuel J. Tilden, Sept. 4, 1863: "I have ordered
two copies or as they are to be executed by
Powers, they will in effect be originals" (New
York Public Library, Tilden Papers). He
obviously was unaware of Ambuchi, who is
recorded as the carver (Wunder), or that Powers
rarely made the marbles that emerged from his
studio. These late replicas descended in the
family. One is now at the New-York Historical
Society, the other at the Martin Van Buren
National Historic Site, Kinderhook, N. Y.

PROVENANCE
Former President Martin Van Buren,
Kinderhook, N. Y., received 1841–42; Martin Van
Buren (grandson), 1862; Travis C. Van Buren
(brother), 1885. 890.3751.1

102 *Angelica Singleton Van Buren*
Henry Inman

NOTES
1. See Seale, *President's House,* 1: 213.

2. Ibid., and 2: 1092 n. 5.

PROVENANCE
Commissioned by Mr. and Mrs. Abraham
(Angelica) Van Buren, Kinderhook, N. Y.,
received 1842; Travis C. Van Buren (son),
c. 1873–78. 890.2061.1

105 *Lighter Relieving a Steamboat Aground*
George Caleb Bingham

NOTES
1. The dominance of steamboats on the rivers
has been debated. Nancy Rash, in an article on

the present painting ("George Caleb Bingham's *Lighter Relieving a Steamboat Aground," Smithsonian Studies in American Art* 2, no. 2 [Spring 1988]: 17–31), claims that the view that the flatboats were fast disappearing "is belied by Thomas Allen's report of 1847, recording four thousand keel and flatboats on the Missouri and Mississippi in that year" (31 n. 31). But that fact did not alter the perception of contemporaries, especially *imaginative* contemporaries like Bingham and like Washington Irving, who in 1836 (*Astoria*) asserted of the flatboatmen: "their consequence and characteristics are rapidly vanishing before the all pervading intrusion of steamboats."

2. George Catlin, *Letters and Notes on the Manners, Customs, and Conditions of the North American Indians* (1844; reprint, New York: Dover, 1973), 2: 157.

3. See Ron Tyler, "George Caleb Bingham, The Native Talent," in Peter H. Hassrick et al., *American Frontier Life: Early Western Paintings and Prints* (New York: Abbeville, 1987), 34–35.

4. Rash, "Lighter Relieving Steamboat," 31.

5. Ibid., 19.

PROVENANCE
Purchased from artist by James E. Yeatman, St. Louis, 1847; descended in his family to anonymous donor. 978.1392.1

108 *Niagara Falls*
John Frederick Kensett

NOTES
1. The transaction, for $500, is listed in Kensett's "Record of Sales" for 1854. It was the second highest price yet realized by the artist. See John Paul Driscoll and John K. Howat, *John Frederick Kensett, An American Master* (New York: Worcester Art Museum in association with Norton, 1985), 189 n. 56.

2. John Paul Driscoll, *John F. Kensett Drawings* (University Park: Pennsylvania State Univ., 1978), 67–69 and pl. 52. Also reproduced in Driscoll and Howat, *John Frederick Kensett,* 87, fig. 49.

3. Driscoll and Howat, *John Frederick Kensett,* 89, pl. 14.

PROVENANCE
The Earl of Ellesmere, 1854; Wildenstein and Co., New York. 961.158.1

111 *Rutland Falls, Vermont*
Frederic E. Church

NOTES
1. In 1981 Merl Moore first correctly identified the site depicted. The falls, at Center Rutland on Otter Creek, were known as Mead's Falls from about 1770 and as Gookin's Falls by 1810. But the painting is presumed to be the one exhibited at the American Art-Union in 1848, no. 360, as *Rutland Falls, Vermont.* Church's first known sketching trip to Vermont was in Aug. and Sept. 1848, so the painting must have been executed in the late autumn.

2. See Franklin Kelly, *Frederic Edwin Church and the National Landscape* (Washington, D. C.: Smithsonian, 1988), 19, fig. 19. The recently located painting (Des Moines Women's Club, Des Moines, Iowa) was painted in Apr. 1848 and exhibited at the American Art-Union in May, certainly to coincide with the obsequies held at the National Academy of Design in New York City on May 4, at which William Cullen Bryant delivered his impassioned *A Funeral Oration Occasioned by the Death of Thomas Cole Delivered Before The National Academy of Design, New York* (New York: D. Appleton, 1848), 41. See J. Gray Sweeney, "To The Memory Of Cole: A Recently Rediscovered Memorial Painting by Frederic Edwin Church, October 20, 1983," manuscript, Office of the Curator, the White House.

3. Bryant, *Funeral Oration,* 41.

4. *Thomas Cole's Poetry,* ed. Marshall B. Tymn (York, Pa.: Liberty Cap Books, 1972), 167; and "Bulletin of the American Art-Union . . . Catalogue of Paintings" (New York, 1848), entry no. 30, 12.

5. Kelly, *Church and the National Landscape,* 16.

PROVENANCE
Possibly American Art-Union, New York, 1848, exhibited as *Rutland Falls, Vermont;* C. W. Sanford, New York; Cynthia Fehr Antiques, New Market, Md.; acquired as *Schoharie Creek, Adirondacks, New York.* 976.1296.1

112 *The Indian's Vespers*
Asher B. Durand

NOTES
1. David B. Lawall, *Asher B. Durand: A Documentary Catalogue of the Narrative and Landscape Paintings* (New York: Garland, 1978), 62–64, cat. 113. Quoted on 64. A family tradition of interim owners led to its publication as *Last of the Mohicans* in *The White House: An Historic Guide,* 5th ed. (Washington, D. C.: White House Historical Assn., 1964), a romantic but clearly inaccurate title. The date of 1857 reported by a conservator in 1964 is no longer visible, and cannot be accepted in light of the documentary evidence.

2. *Literary World* 2, no. 38 (Oct. 23, 1847): 277, and *American Literary Gazette and New York Weekly Mirror,* new ser., 6, no. 2 (May 29, 1847): 29. Quoted in Lawall, *Asher Durand,* 63. From these contemporary descriptions there can be no doubt that this is the painting exhibited at the American Art-Union in 1847, then given by lottery to Chauncey Shaffer.

3. Asher B. Durand, "Letters on Landscape Painting," *The Crayon* 1 (1855): 34–35; reprinted by John W. McCoubrey, *American Art 1700–1960,* in *Sources & Documents in the History of Art Series* (Englewood Cliffs, N. J.: Prentice Hall, 1965), 112.

Page 112 4. Durand, "Letters on Landscape Painting," 98.
(Continued)

PROVENANCE
Commissioned by the American Art-Union, 1847; Chauncey Schaffer, New York; J. L. Phillips, Thomasville, Ga., 1925; Mrs. Margaret P. Cooper, Mrs. Frances P. Mitchell, and Mrs. Eleanor P. Drake (daughters), Thomasville, Ga.; acquired as *Last of the Mohicans.* 963.506.1

117 *Pastoral Landscape*
Alvan Fisher

NOTE
1. When acquired for the White House collection in 1973, this painting was called *Tending Cows and Sheep.* It has not been identified with any exhibited work by the artist.

PROVENANCE
Kennedy Galleries, Inc., New York. 973.974.1

119 *Floral Still Life With Nest of Eggs*
Severin Roesen

NOTE
1. Roesen's American career began in New York City about 1848. His earliest dated painting is a similar floral piece of 1848 (Corcoran Gallery of Art). The White House painting has not been relined and retains its original stretcher. The stencil mark on the back identifies the supplier as "WILLIAMS STEVENS & WILLIAMS/Looking Glass Ware Rooms / & ART REPOSITORY Engravings Art Materials &c / 353 BROADWAY NEW YORK." From this we can date the painting more precisely, since the firm was called Williams & Stevens Co. until 1851. It remained at the same address until 1859 (see Alexander W. Katlan, *American Artists' Materials Suppliers Directory* [Park Ridge, N. J.: Noyes, 1988], 27–29 and ill. 89, 437). Judith H. O'Toole's *Severin Roesen* (Lewisburg, Pa.: Bucknell Univ. Press, 1992) is the first monograph on the artist.

PROVENANCE
David Stockwell, Inc., Wilmington, Del. 976.1234.1

120 *Still Life With Fruit, Goblet, and Canary (Nature's Bounty)*
Severin Roesen

NOTE
1. Maurice A. Mook, "Severin Roesen: Also the Huntingdon Painter," *Lycoming College Magazine,* June 1973, 13, 16.

PROVENANCE
Berry-Hill Galleries, New York; acquired as *Nature's Bounty.* 962.188.1

122 *Boston Harbor*
Fitz Hugh Lane

NOTE
1. Erik A. R. Ronnberg, Jr., "Imagery and Types of Vessels," in John Wilmerding, *Paintings by Fitz Hugh Lane* (New York: Abrams, 1988), 100–101.

PROVENANCE
Kennedy Galleries, Inc., New York. 963.507.1

125 *Boys Crabbing*
William Ranney

NOTES
1. Anonymous writer in "The Ranney Fund," *New York Times,* Dec. 10, 1858; quoted by Linda Ayres in Peter H. Hassrick et al., *American Frontier Life: Early Western Painting and Prints* (New York: Abbeville, 1987), 82.

2. Born in Middletown, Conn., but raised from age 13 by an uncle in Fayetteville, N. C., Ranney moved to New York City when he was about 20. While working in an architect's office he studied drawing and painting, but left in 1836 to enlist in the Texas war for independence from Mexico. He served nine months and was probably back in New York by the spring of 1837. See Ayres in Hassrick, *American Frontier Life,* 79–80.

3. Ibid., 101.

4. Quoted in William H. Gerdts, *The Art of Henry Inman* (Washington, D. C.: National Portrait Gallery, Smithsonian, 1987), 73.

PROVENANCE
Charles H. Rogers, Ravenswood, N. Y.; Henry N. Corwith (nephew), Bridgehampton, N. Y.; Mrs. Henry N. Corwith, Barre, Vt.; Hirschl & Adler Galleries, Inc., New York. 972.940.1

126 *Andrew Jackson*
Clark Mills

NOTES
1. White metal: "Any one of the various white alloys, such as pewter, Babbitt metal, Britannia, etc., used for making ornaments, small castings, etc." (*Funk & Wagnalls Standard College Dictionary*). Although analyzed in 1982 as *either* zinc or lead, the metal is most probably an alloy.

2. "Petition to the Commissioner of Patents," copy, Office of the Curator, the White House. Perhaps the best and most reliable account of the life-size bronze is by James Goode, *The Outdoor Sculpture of Washington, D. C.* (Washington, D. C.: Smithsonian, 1974), 377–78. See also Wayne Craven, *Sculpture in America* (New York: Thomas Y. Crowell, 1968), 166–74, much of whose material is drawn from Lorado Taft, *The History of American Sculpture* (1903; rev. ed., New York: MacMillan, 1930), 123–28, and from Henry T. Tuckerman, *Book of the Artists* (1867; reprint, New York: James F. Carr, 1967), on whom Taft also relies.

PROVENANCE
A. G. Southall. 859.1451.1

129 View of the City of Washington From the Virginia Shore
William MacLeod

NOTE

1. A second apparently identical *View of the City of Washington*, also signed and dated 1856, has been discovered. It is in a private collection.

PROVENANCE

H. Curley Boswell, Washington, D. C.; acquired as *View of the City of Washington from the Anacostia Shore*. 971.689.1

130 View of Lake George
Andrew Andrews, attributed to

NOTE

1. Doreen Bolger, in the course of research on Ambrose Andrews, discovered the confusion between Ambrose Andrews and A. Andrews the landscape specialist. In "Ambrose Andrews and his Masterpiece, The Children of Nathan Starr" (*The American Art Journal* 22, no. 1 [1990]: 4–19), she presented a summary of the information on Andrew Andrews of Buffalo (p. 14 and nn. 38–40). While much of the circumstantial evidence connecting the Buffalo artist with the artist who exhibited in New York City is persuasive, a difficulty (acknowledged by Bolger) arises in the 1860 Census where A. Andrews is listed as a 23-year-old artist, therefore born about 1837 and certainly not exhibiting in New York in 1847. This may have been a simple error. He may have been 33 in 1860. Still, the possibility of a third A. Andrews cannot be discounted.

PROVENANCE

Kennedy Galleries, Inc., New York.
975.1169.1

133 Lake Among the Hills (Lake Mohonk)
William M. Hart

NOTES

1. The identification was made by Nash Castro, formerly general manager of the Palisades Interstate Parkway, in correspondence and conversation, with the support of photographs of Lake Mohonk. In 1858 the lake was not yet dominated by the famous resort hotel, Mohonk Mountain House, which opened in 1870.

2. Bartlett Cowdrey, *National Academy of Design Exhibition Record, 1826–1860*, 2 vols. (New York: New-York Historical Society, 1943), 1: 213.

3. For a summary of Hart's career see Mark Sullivan, *James M. and William Hart: American Landscape Painters* (Philadelphia: John F. Warren, 1983), 3–8, and notes and bibliography.

PROVENANCE

Sotheby Parke Bernet, New York, 3865, Apr. 29, 1976, #13. 976.1225.1

134 Farmyard in Winter
George Henry Durrie

PROVENANCE

Purchased at auction by Albert Scholding, New York, c. 1918–23; descended to a daughter; Hirschl & Adler Galleries, New York.
971.804.1

137 View on the Mississippi Fifty-Seven Miles Below St. Anthony Falls, Minneapolis
Ferdinand Richardt

NOTES

1. *The Art-Journal* (London) 2 (Dec. 1, 1863): 241.

2. George Catlin, *Letters and Notes on the Manners, Customs, and Conditions of North American Indians*, 2 vols. (reprint, New York: Dover, 1973), 2: 129–30.

3. James D. Thueson, Chief Librarian, Minnesota Historical Society, letter of Aug. 17, 1976, Office of the Curator, the White House.

4. Nina M. Archabal, "A White House Connection," *Minnesota History* (Summer 1981): 249–50; the MHS painting is reproduced on the cover.

PROVENANCE

The Old Print Shop, New York. 970.655.1

138 Independence Hall in Philadelphia
Ferdinand Richardt

NOTES

1. The Danish-born artist, whose surname was originally spelled "Reichardt," usually spelled it "Richardt" on paintings made in America. Compare with the painting on page 137.

2. The studies for Richardt's painting probably date from 1858. Records in the Philadelphia City Archives reveal that in that year no fewer than 13 independent "passenger railway" companies were granted charters by the Assembly to lay streetcar lines in Philadelphia. Most of these were granted in April and May; additional lines were chartered during the next three years. Although horse-drawn, the rails offered a smoother ride over the unpaved or uneven streets of the city. Thanks are due to Jefferson Moak for the archival information.

3. *Catalogue of Ferdinand Richardt's Gallery of Paintings of American Scenery, and Collection of Danish Paintings*, exhibited at the National Academy of Design, New York, commencing Jan. 10, 1859 (16 pages, 100 items); and *Catalogue of Ferdinand Richardt's Gallery of Superb Paintings of American Scenery, and Collection of Danish Paintings*, to be sold by Henry H. Leeds & Co., Mar. 10, 1859, at the National Academy of Design, New York (6 pages, 84 items).

4. *The Art-Journal* (London) 2 (Dec. 1, 1863): 241.

PROVENANCE

Estate of Saler Jung, Hyderabad, India; Albert Nesle, New York, 1962; Kennedy Galleries, Inc., New York, 1963; acquired as *Philadelphia in 1858*.
963.508.1

Page 141 *John Tyler*
George P. A. Healy

NOTES

1. *Dictionary of American Biography*, s.v. "Tyler, John." See also Lowell Harrison, "The President Without a Party," *American History Illustrated*, Apr. 1981, 13–21; Harrison relates Tyler's quip at his last White House reception: "Yes, they cannot say now that I am a President without a party" (p. 17).

2. Charles Dickens, *American Notes* and *Pictures from Italy* (New York: MacMillan, 1893), 109.

3. Marie De Mare, *G. P. A. Healy, American Artist* (New York: McKay, 1954), 103.

4. A photocopy of Tyler's letter is in the Office of the Curator, the White House.

5. The portrait now in the National Portrait Gallery was transferred from the National Institute to the Smithsonian Institution in 1859, but it cannot have been the 1842 likeness since it clearly shows Tyler in old age (compare the 1841 lithographic portrait of Tyler by Charles Fenderich also in the National Portrait Gallery; NPG.66.92) and is in fact inscribed on the reverse, "PAINTED BY HEALY / SHERWOOD FOREST / FEB. 25, 1859." Healy's receipt for the White House portrait is in the National Archives, G. A. O. account No. 135.802, miscellaneous treasury account, Statement of the Account of M. Nourse, agent for a Series of the Presidents of the United States for the Executive Mansion.

6. Quoted in William E. Ames, *A History of the "National Intelligencer"* (Chapel Hill: Univ. of North Carolina Press, 1972), 263.

PROVENANCE
Commissioned by the U. S. government. 859.1403.1

144 *Daniel Webster* and *Henry Clay*
Thomas Ball

NOTES

1. Thomas Ball, *My Threescore Years and Ten* (1891; 2nd ed., 1892; reprint, New York: Garland, 1977), 136 ff. The only mention of the painted portrait known to me is by Henry T. Tuckerman, *Book of the Artists, American Artist Life* (1867; reprint, New York: James F. Carr, 1967), 578.

2. Ball sold the rights to G. W. Nichols. Although he did not profit from the popularity of this small bronze, Ball reworked and enlarged the figure in 1876 for a monumental bronze (17 feet high) commissioned by Gordon W. Burnham, cast in Munich, and installed in New York's Central Park near Central Park West and 72nd Street, where it still stands.

3. The bronze foundry of J. T. Ames in Chicopee, Mass., had begun casting statues about 1850, the first such foundry in America. It was to Ames that the purchaser of the reproduction rights turned for casts of Ball's figures. The *Daniel Webster* statuette is probably the earliest sculpture to be patented and mass-produced in America.

PROVENANCE
Victor D. Spark, New York. 961.158.1,2

147 *Hungry Office Seekers*
Thomas Nast

NOTES

1. *Concise Dictionary of American Biography*, s.v., "Greeley, Horace."

2. Margaret Leech, *Reveille in Washington* (New York: Harper & Row, 1941), 39.

3. William Howard Russell, *My Diary North and South* (New York, 1863), 51; quoted in Hermann Warner Williams, Jr., *The Civil War: The Artists' Record* (Boston: Beacon, 1961), 223.

4. Leech, *Reveille*, 42.

5. Albert Bigelow Paine, *Thomas Nast: His Period and His Pictures* (facsimile of 1904 ed., Princeton: Pyne), 18, 76.

6. Williams, *Civil War*, cat. 202; reproduced p. 223. A notation on the reverse of the drawing, "for Mr. Waud," must refer to Alfred R. Waud (1828–1891), another artist/illustrator employed by the *Illustrated News*.

7. Paine, *Thomas Nast*, 69–76.

PROVENANCE
Probably Davis Galleries, New York; purchased for donation by Mr. and Mrs. Walter Fillin, Rockville Centre, N. Y. 964.537.1

148 *Cannonading on the Potomac, October, 1861*
Wordsworth Thompson

NOTES

1. Two inscriptions are on the back of the relined canvas. The first gives the title and the artist. The second reads: "Near Edwards Ferry and / Ball's Bluff, Virginia. 21 Oct 1861 / Battery B, Rhode Island Artillery / Col. E. D. Baker, Commanding, / was killed in this action." Baker was a U. S. senator from Oregon, an intimate of President Lincoln's who named his second son for him, and an inexperienced soldier. Before leaving to join his brigade across from Leesburg, he had visited at the White House. When Mrs. Lincoln gave him a bouquet of late autumn flowers he remarked ominously, "These flowers and my memory will wither together." News of his death moved Lincoln to tears. Baker's command, though composed mainly of Philadelphians, was called the "1st California Regiment" because Baker had lived in that state.

2. A complete account of the Ball's Bluff debacle appears in Ronald H. Bailey et al., *Forward to Richmond: McClellan's Peninsular Campaign* (Alexandria, Va.: Time-Life Books, c. 1983), 38–53. An authoritative summary is in James M.

McPherson, *Battle Cry of Freedom* (New York: Oxford Univ. Press, 1988), 362. See also Byron Farwell, *Ball's Bluff: A Small Battle and Its Long Shadow* (McLean, Va.: EPM Publications, 1990).

3. Maria Naylor, ed., *The National Academy of Design Exhibition Record 1861–1900* (New York: Kennedy Galleries, 1973), 2: 924, as no. 350.

PROVENANCE
Phineas C. Launsbury, Ridgefield, Conn., by 1925; descended in his family; Kennedy Galleries, Inc., New York, 1961. 962.182.1

151 *The Republican Court in the Days of Lincoln*
Peter F. Rothermel

NOTES
1. The painting has hitherto been called *Reception at the White House* and attributed to Francis B. Carpenter (page 155), who lived for a time in the White House during the Civil War to paint Lincoln and his Cabinet. Although the painting is unsigned and its early history unknown, the attribution to Rothermel, first suggested by Mark Thistlethwaite in correspondence (July 23, 1984) with the Office of the Curator, the White House, seems amply supported by the evidence presented in the text. I am indebted to Professor Thistlethwaite, Texas Christian University, for discussing this painting with me and for sharing his unpublished research with me. See also his *The Image of George Washington: Studies in Mid-Nineteenth Century American History Painting* (New York: Garland, 1979), 169–71 and 180–82 nn. 46, 47, 55, 56.

2. Broadside Collection, Library of Congress. A photocopy is in the Office of the Curator, the White House.

3. Sadly, while on exhibition at the Derby Athenaeum, in New York City (Jan. 13, 1869), "Rothermel's picture of the *Court of Lincoln* was totally destroyed." (Robert Weir, Jr., to John Ferguson Weir, Jan. 15, 1869, Yale Univ., Manuscripts and Archives, John Ferguson Weir Papers, ser. I, Box 5, folder 135.) Yet in the *New*

York Evening Post, May 23, 1870, it was reported that Rothermel's *Republican Court, Time of President Lincoln* had been sold at the Leeds Gallery for $450. This was probably the small painting now in the White House. Huntington's painting was exhibited in Paris at the Universal Exposition in 1867 (U.S. section, no. 37). I am indebted to Professor Betsy Fahlman, Arizona State University, for the reference to the Weir correspondence.

4. Mark Thistlethwaite, "Peter F. Rothermel: a forgotten history painter," *Antiques,* Nov. 1983, 1,016–22; Abigail Schade, in *Philadelphia: Three Centuries of American Art* (Philadelphia: Philadelphia Museum of Art, 1976), 371–72.

PROVENANCE
Maj. William James Carlton (original owner); descended in his family; acquired as *Reception in the White House* by Francis B. Carpenter. 962.294.1

152 *Watch Meeting—Dec. 31st 1862—Waiting for the Hour*
William Tolman Carlton

NOTES
1. William T. Carlton was born in Boston and by 1836 had already exhibited at the Athenaeum. He studied in Florence, from 1837 until 1840, and then set up his studio in Boston, where he specialized in portraits and genre pictures. In 1851 he and George Hollingsworth founded the Lowell Institute in Boston, where they taught drawing until the school was disbanded in 1879. A number of his works are preserved in Cooperstown at the New York State Historical Association, and a self-portrait of about 1839 is owned by the Society for the Preservation of New England Antiquities. The SPNEA was given the *Self-Portrait* by Carlton's daughter in 1931 accompanied by a letter in which she briefly outlined her father's career. I am indebted to Richard C. Nylander, Curator of Collections, for this information.

2. William Lloyd Garrison to Abraham Lincoln, Jan. 21, 1865, John G. Nicolay Papers (microfilm edition), Library of Congress. Garrison added, intriguingly, in the letter, that "many photographic copies were made of it, and it was by my advice that it was presented to you as the most fitting person in the world to receive it." I have not seen any such photographs.

3. The Garrison–Lincoln painting, of the same size but more highly finished, signed and dated 1863, was sold at auction in 1979 (location unknown). In Christie's, *American Paintings, Drawings, and Sculpture of the 18th, 19th & 20th Centuries,* New York, Oct. 24, 1979. The only provenance given for this version was Hirschl & Adler Galleries, New York, through whom the White House painting also came from the artist's descendants.

PROVENANCE
Descended in the artist's family; Hirschl & Adler Galleries, Inc., New York, 1969. 972.842.1

155 *Lincoln and Tad*
Francis Bicknell Carpenter

NOTES
1. Harold Holzer, Gabor S. Boritt, and Mark E. Neely, Jr., "Francis Bicknell Carpenter (1830–1900): Painter of Abraham Lincoln and His Circle," *The American Art Journal* (Spring 1984): 66–80.

2. James D. Horan, *Mathew Brady, Historian with a Camera* (New York: Bonanza Books, 1955), 54–55 and fig. 153.

3. It had previously been assumed that the miniature was painted during Carpenter's residence in the White House (Feb. to July 1864), but the presence of the fountain on the north lawn would seem to disallow it, for a bronze statue of Thomas Jefferson by David d'Angers stood there in Lincoln's day. The statue was removed in late 1873 or early 1874 and replaced by a fountain.

Page 155 **4.** James M. McPherson, *Battle Cry of Freedom*
(Continued) (New York: Oxford Univ. Press, 1988), 732.

5. Francis B. Carpenter, *Six Months at the White House with Abraham Lincoln: The Story of a Picture* (New York: Hurd & Houghton, 1866), 30–31.

PROVENANCE
Charles L. Carter, Andover, Mass.; Hiram Burlingham, New York, 1934; Erskine Hewitt, 1938; A. Jay Fink, Baltimore. 963.500.1

156 *The Peacemakers*
George P. A. Healy

NOTES
1. Quoted in William S. McFeely, *Grant: A Biography* (New York: Norton, 1981), 21.

2. William T. Sherman, *Memoirs of General William T. Sherman* (New York: D. Appleton and Co., 1889), 2: 324.

3. Ibid., 325.

4. Porter quoted in Sherman, *Memoirs*, 329–31.

5. Ibid., 330.

6. Quoted in Marie De Mare, *G.P.A. Healy, American Artist* (New York: McKay, 1954), 240.

7. Reproduced in Andrew J. Cosentino and Henry H. Glassie, *The Capital Image: Painters in Washington, 1800–1915* (Washington, D. C.: Smithsonian, 1983), 119, fig. 66.

8. Healy's progress on the painting was recorded in the diary of Edith Healy, the artist's daughter. This reference is under "Rome, October 9, 1868." Typescript copy, Office of the Curator, the White House.

9. Quoted in James M. McPherson, *Battle Cry of Freedom* (New York: Oxford Univ. Press, 1988), 846.

10. Healy took the unfinished painting to Rome with him in the summer of 1868, where he used it to produce a life-size version. That monumental canvas was not purchased by the government, as hoped, but by Ezra B. McCagg of Chicago, who lent it to the Calumet Club, where fire destroyed it in 1892.

PROVENANCE
Edward N. Dickerson, England; descended in his family; M. Knoedler & Co., Inc., New York. 947.2558.1

161 *Abraham Lincoln*
George P. A. Healy

NOTES
1. In addition to the White House portrait, there exist at least four replicas or variants, in the Chicago Historical Society; the Newberry Library, Chicago; the Minnesota State House, Minneapolis; and the National Portrait Gallery, Washington, D. C. (dated 1887; transferred from the National Gallery of Art).

2. Quoted in a letter to Franklin D. Roosevelt by Frederic N. Towers, an executor of and trustee under the will of Mrs. Robert Todd Lincoln. Towers was quoting from a much earlier letter by Robert Lincoln. White House press release (1939), Office of the Curator, the White House.

PROVENANCE
Rejected submission in the 1869 competition for an official White House portrait; purchased by Robert Todd Lincoln, Chicago; Mrs. Robert Todd Lincoln, Manchester, Vt., 1925; bequest to the White House with life interest to Mrs. Mary Lincoln Isham (daughter), Chicago, 1937. 939.1388.1

163 *Liberty*
Constantino Brumidi

NOTE
1. Seale, *President's House*, 1:469.

PROVENANCE
Commissioned for the White House, 1869; removed by Edgar S. Yergason, Hartford, Conn., during 1891 redecoration of the White House; discovered in the Yergason summer home, Windham, Conn., 1978. 978.1390.1

164 *Union*
Constantino Brumidi

NOTE
1. *The Critic*, Washington, D. C., Dec. 14, 1869, 3. The pairings described by the journalist are confirmed by a surviving photograph of the Entrance Hall.

PROVENANCE
Commissioned for the White House, 1869; removed by Edgar S. Yergason, Hartford, Conn., during 1891 redecoration of the White House; discovered in the Yergason summer home, Windham, Conn., 1978. 978.1390.2

166 *Crossing the River Platte*
Worthington Whittredge

NOTES
1. Quoted in John I. H. Baur, ed., *The Autobiography of Worthington Whittredge, 1820–1910* (*Brooklyn Museum Journal* 1, 1942; reprint, New York: Arno, 1969), 45–46.

2. Ibid., 64. See also Cheryl A. Cibulka, *Quiet Places: The American Landscapes of Worthington Whittredge* (Washington, D. C.: Adams Davidson Galleries, 1982), 24 and plates 17–18; and Anthony F. Janson, "The Western Landscapes of Worthington Whittredge," *American Art Review* 3, no. 6 (Nov.–Dec. 1976): 58.

PROVENANCE
C. R. Smith, New York. 967.602.1

169 *Sailing off the Coast*
Martin Johnson Heade

NOTE

1. Prior to relining, the painting was inscribed more precisely on the reverse: "Feb. 1869."

PROVENANCE

Sotheby Parke Bernet, New York, 4365, Apr. 25, 1980, #13; Kennedy Galleries, Inc., New York. 980.1426.1

170 *The Rainbow in the Berkshire Hills*
George Inness

NOTES

1. Montgomery Schuyler, "George Inness: The Man and His Work," *Forum* 18 (Nov. 1894): 307; quoted in Nicolai Cikovsky, Jr., and Michael Quick, *George Inness* (New York: Harper & Row, 1985), 21.

2. *New York Evening Post*, Mar. 3, 1863; quoted in Cikovsky and Quick, *George Inness*, 23.

PROVENANCE

Mr. and Mrs. Lawrence A. Fleischman, Detroit; Kennedy Galleries, Inc., New York; Sotheby Parke Bernet, New York, Apr. 19–20, 1972, #47; purchased for donation by The Rita and Taft Schreiber Foundation, Universal City, Calif. 972.866.1

173 *Nocturne*
James McNeill Whistler

NOTES

1. *The Saturday Review*, Mar. 26, 1892, 357.

2. Quoted in J. A. M. Whistler, *The Gentle Art of Making Enemies* (1892; reprint, New York: Dover, 1967), 15.

3. Ibid., 144.

4. Ibid., 126–27.

5. Elizabeth R. Pennell, *The Whistler Journal* (Philadelphia: J. B. Lippincott Co., 1921), 117.

6. John Siewert, Smithsonian Fellow at the Freer Gallery of Art, Smithsonian Institution, in a letter of Sept. 12, 1988, Office of the Curator, the White House.

7. Whistler, *Gentle Art*, 8.

8. Ibid., 4–5. Whistler won his suit, but was awarded only one farthing in damages. He declared bankruptcy and left England.

PROVENANCE

Purchased from the artist by Otto Goldschmidt, c. 1891; M. Knoedler & Co., Inc., New York; Mrs. E. H. Harriman, 1913; Mr. and Mrs. W. Averell Harriman. 962.303.1

174 *Rocky Mountain Landscape*
Albert Bierstadt

NOTES

1. The most recent monograph on the artist is Nancy K. Anderson and Linda S. Ferber, *Albert Bierstadt: Art & Enterprise* (New York: Brooklyn Museum in association with Hudson Hills, 1990). See also Gordon Hendricks, *Albert Bierstadt: Painter of the American West* (New York: Harrison House, 1974).

2. Elizabeth Lindquist-Cock, "Stereoscopic Photography and the Western Paintings of Albert Bierstadt," *Art Quarterly* 33 (Winter 1970): 360–78.

PROVENANCE

John Jacob Astor, New York; M. Knoedler & Co., Inc., New York; Julia Riker Harman; Graham Galleries, New York; loan from The Barra Foundation, Inc., to the White House, 1977–81; converted to gift, 1981; acquired as *View of the Rocky Mountains*. 981.1468.1

177 *In the White Mountains, New Hampshire*
William Louis Sonntag

NOTE

1. The title under which the painting was acquired has been retained. The view, however, has not yet been identified with certainty, and the title may have been assigned by an art dealer, based on Sonntag's long association with the White Mountains. The painting does not appear in Nancy Dustin Wall Moure's *William Louis Sonntag: Artist of the Ideal 1822–1900* (Los Angeles: Goldfield Galleries, 1980). Among the unlocated paintings in Moure's catalogue, only no. 326 corresponds closely to the measurements of the White House painting; it is called *Summer Day, Catskills*.

PROVENANCE

Richard Green, London. 976.1222.1

178 *Autumn Landscape on the Hudson River*
Jasper F. Cropsey

NOTE

1. Quoted and dated in Samuel Eliot Morison, *The Oxford History of the American People* (New York: Oxford Univ. Press: 1965), 732–33.

PROVENANCE

Mr. and Mrs. John C. Newington, Greenwich, Conn. (Mrs. Newington is the great-granddaughter of the artist.) 972.880.1

181 *Castle Rock, Nahant, Massachusetts*
Alfred T. Bricher

NOTE

1. When the painting was acquired and first published, the site was misidentified as Marblehead, Mass. Samuel Hammond, a former resident of Nahant whose family had lived there since 1825, kindly supplied the correct information (letter, July 9, 1979, Office of the Curator, the White House).

Page 181 PROVENANCE
(Continued) John S. Radway, New York; T. Scudda Winslow, New York; Graham Gallery, New York; acquired as *Castle Rock, Marblehead*. 972.878.1

182 *Neighboring Pews*
John Rogers

NOTE
1. Lorado Taft, *The History of American Sculpture* (1903; rev. ed. New York: MacMillan, 1930), 181–82.

PROVENANCE
Maryland estate auction, c. 1959; Misses Stella and Elsie Matthews and Mrs. Bertha Matthews Harrison, Ridgely, Md. 961.58.1

187 *New York Harbor and the Battery*
Andrew Melrose

NOTES
1. Allan Nevins, ed., *The Diary of Philip Hone* (New York: Dodd, Mead & Co., 1927), 2: 731. Jenny Lind, the Swedish Nightingale, sang the first concert of her legendary American tour at Castle Garden in 1850.

2. The date of c. 1887 is based upon a chromolithograph, after the painting, which has been tentatively dated to that year. An example is in the New York Public Library. See *American Paintings & Historical Prints from the Middendorf Collection,* exhibition catalogue (New York: Metropolitan Museum of Art, 1967), 50, cat. 36.

PROVENANCE
Mr. and Mrs. Paul E. Lopschire, Indianapolis; Parke-Bernet Galleries, New York, May 13, 1966, #44 as *Castle Garden, New York, Showing Bartholdi's Statue of Liberty*; J. N. Bartfield Gallery, New York; Kennedy Galleries, Inc., New York, 1966; J. William Middendorf II, McLean, Va.; Sotheby Parke Bernet Galleries, New York, Oct. 27, 1973, #27. 973.1033.1

188 *The Cincinnati Enquirer*
William M. Harnett

NOTES
1. Interview in the "rather obscure" New York *News*, 1889 or 1890, quoted in Alfred Frankenstein, *After the Hunt,* rev. ed. (Berkeley: Univ. of California Press, 1975), 55.

2. For the newspaper's history, see Francis L. Dale, *The Cincinnati Enquirer—The Extended Shadows of its Publishers* (New York: Newcomen Society, 1966), 20–21; and Osman Castle Hooper, *History of Ohio Journalism, 1793–1933* (Columbus: Spahr & Glenn, 1933), 95–97. Although the publisher, John R. McLean, was a power in Ohio Democratic politics, a writer in *Harper's Weekly* reported that the paper "aims to give the news uncrippled by party prejudice. It is read by politicians of both parties for its political news." Such scrupulousness did not necessarily apply to political views, however. During the month of May 1888 "GATH" wrote most frequently about James G. Blaine, who was withdrawing from presidential consideration.

3. Quoted in Frankenstein, *After the Hunt,* 76.

4. The newspaper was still among Harnett's studio effects at the time of his death in 1892. The catalogue of the sale of his effects, including "models" (i.e., the objects in his still lifes), issued by Thomas Birch's Sons (Philadelphia, Feb. 23–24, 1893), listed it as no. 302: "*Cincinnati Enquirer.* This was painted in a picture ordered by Joseph P. [actually James T.] Abbe of Holyoke, Mass., for which he gave $5000. and is as represented. Burnt." (Ibid., 84.)

PROVENANCE
Mrs. Nina Mathews, Tulsa, Okla.; Hirschl & Adler Galleries, Inc., New York, 1971; J. William Middendorf II, Washington, D. C.—lent to White House, 1977; Armand Hammer Foundation, Los Angeles, 1977—lent to White House until donation, 1978. 978.1382.1

193 *Vernal Falls, Yosemite*
Thomas Hill

NOTES
1. Benjamin Champney, *Sixty Years' Memories of Art and Artists* (Woburn, Mass.: Wallace and Andrews, 1900), 145–46.

2. James Thomas Flexner, *That Wilder Image* (New York: Bonanza Books, 1962), 299.

3. Ibid.

PROVENANCE
Graham Gallery, New York. 973.1027.2

194 *Fording the Horse Herd*
Charles M. Russell

NOTE
1. Peter H. Hassrick, *Charles M. Russell* (New York: Abrams, 1989), 35, 70.

PROVENANCE
Purchased from the artist by Mrs. Ernestine Wallenstein, New York; the estate of Mrs. Wallenstein—lent to the White House, 1981–86. 987.1595.1

197 *The Bronco Buster*
Frederic Remington

NOTES
1. Theodore Roosevelt, *Ranch Life in the Far West* (1888; reprint, Flagstaff, Ariz.: Northland, 1968), 21.

2. Michael Edward Shapiro et al., *Frederic Remington* (New York: Abrams, 1988), 186. *A Pitching Broncho* is reproduced in Michael Edward Shapiro, *Cast and Recast: The Sculpture of Frederic Remington* (Washington, D. C.: Smithsonian, 1981), 39, fig. 19.

3. Shapiro, *Cast and Recast,* 63–64.

4. Remington to Wister, undated [1895], Owen Wister Papers, Manuscript Division, Library of Congress, Washington, D. C. See also Ben Merchant Vorpahl, *My dear Wister! The Frederic Remington–Owen Wister Letters* (Palo Alto, Calif.: American West Publishing Co., 1972), 160; and James K. Ballinger, *Frederic Remington* (New York: Abrams, 1989), 76–77.

PROVENANCE
Purchased at Tiffany & Co., New York, by James T. Hatfield, Covington, Ky., 1925; Virginia Hatfield and Louise Hatfield Stickney (daughters), Covington, Ky., 1938. 973.1019.1

198 *Coming Through the Rye*
Frederic Remington

NOTES
1. *Coming Through the Rye* was copyrighted Oct. 8, 1902. It was cast by Roman Bronze Works, New York, supervised by founder Riccardo Bertelli. The White House cast (#13) was produced Mar. 23, 1918. It was apparently consigned by Eva A. Remington, the artist's widow (or by her estate—she died Nov. 3, 1918), to Tiffany's from which it was purchased by Mrs. A. H. Wiggin. From her estate it passed through James Graham and Sons to the Amon G. Carter Foundation, 1951. It is one of 20 casts that either bear numbers, have documentary support, or have early provenances, listed by Michael Edward Shapiro, *Cast and Recast: The Sculpture of Frederic Remington* (Washington, D. C.: Smithsonian, 1981), 88, 103.

2. *Century*, Oct. 1888, 836. Roosevelt's articles for *Century* were published in book form as *Ranch Life in the Far West* (1888; reprint, Flagstaff, Ariz.: Northland, 1968), 82 (illus.).

3. Ibid., 84.

4. *Cow-boys Coming to Town for Christmas* appeared in *Harper's Weekly* 33, Dec. 21, 1889, 1016–17. See Michael Edward Shapiro, Peter H.

Hassrick, et al., *Frederic Remington: The Masterworks*, exhibition catalogue (New York: Abrams, 1988), 85 (illus.) and 262 n. 12.

5. Roosevelt, *Ranch Life in the Far West,* 84.

6. Shapiro, *Frederic Remington,* 55, fig. 37, and 50–51.

7. Remington to Wister, undated [1895], Owen Wister Papers, Manuscript Division, Library of Congress, Washington, D. C.; quoted in James K. Ballinger, *Frederic Remington* (New York: Abrams, 1989), 76–77.

PROVENANCE
Purchased at Tiffany & Co., New York, by Mrs. A. H. Wiggin, 1920s; James Graham & Sons, New York; Amon G. Carter Foundation, Fort Worth, Tex., 1951. 962.270.1

203 *Florida Sunrise*
Martin Johnson Heade

PROVENANCE
Phillip Baker, Jr., Wellesley Hills, Mass.; Parke-Bernet Galleries, New York, May 21, 1970, #38; William Postar and William Young, Boston, 1971; Hirschl & Adler Galleries, New York, 1972–73; Sotheby Parke Bernet, New York, #35, Apr. 21, 1977. 977.1318.1

204 *Butterfly*
Albert Bierstadt

NOTES
1. May 15; quoted in Gordon Hendricks, *Albert Bierstadt: Painter of the American West* (New York: Harrison House, 1988), 302–03.

2. The Bierstadt butterfly (Hayes Presidential Center reg./cat. 1934-603-1) is signed with the initials "AB" and again "Bierstadt." Mrs. Hayes's effort (cat. 1914-603-5) is signed "LWH 1 Mch 1878." The Hayes Presidential Center owns three other butterflies attributed to Bierstadt, though unsigned (cat. nos. 1914-603-2,3,4).

3. Linda S. Ferber and William H. Gerdts, *The New Path* (Brooklyn, N. Y.: Brooklyn Museum, 1985); especially the essay by Susan P. Casteras, "The 1857–58 Exhibition of English Art in America and Critical Responses to Pre-Raphaelitism," 109–33. Rediscovered in 1990, *Lake Lucerne* has belonged to the National Gallery of Art since 1991.

PROVENANCE
Mr. and Mrs. James R. Graham, Bayside, N. Y. 962.268.1

207 *Surf at Prout's Neck*
Winslow Homer

NOTES
1. Quoted in Lloyd Goodrich, *Winslow Homer* (New York: MacMillan, 1945), 159.

2. Manuscript catalogue raisonné of the works of Winslow Homer by Lloyd Goodrich, courtesy of the City University of New York, Lloyd and Edith Havens Goodrich, Whitney Museum of American Art, record of the works of Winslow Homer. I am grateful to Abigail Booth Gerdts for this information. See also *Winslow Homer in the 1890s: Prout's Neck Observed*, ed. Paul Anbinder (New York: Hudson Hills, in association with the Memorial Art Gallery of the Univ. of Rochester, 1990).

PROVENANCE
Artist's estate; Charles S. Homer (brother), Prout's Neck, Maine; Mrs. Charles S. Homer, New York; Charles L. Homer (nephew), Prout's Neck, Maine; private collection, New York; Long and Company, Houston. 964.525.1

208 *Under the Palisades, in October*
Jasper F. Cropsey

NOTES
1. Auctioned at Christie's, Sept. 30, 1982, no. 34C (illustrated).

Page 208 **2.** John Ruskin, *Modern Painters* (1843; reprint,
(Continued) 4th ed., Philadelphia: John Wanamaker, 1873),
1: 147.

PROVENANCE
M. Knoedler & Co., Inc., New York, by 1956;
Sotheby Parke Bernet, New York, Oct. 19, 1972,
#15; Hirschl & Adler Galleries, Inc., New York;
purchased for donation by Mr. and Mrs. John C.
Newington, Greenwich, Conn. (Mrs. Newington
is the great-granddaughter of the artist.)
973.985.1

211 *Revere Beach*
Maurice B. Prendergast

NOTES
1. Carol Clark, Nancy Mowll Mathews, and
Gwendolyn Owens, *Maurice Brazil Prendergast,
Charles Prendergast: A Catalogue Raisonné*
(Williamstown, Mass.: Williams College Museum
of Art, 1990), 357, cat. 621, illus.

2. Quoted in Eleanor Green, *Maurice Prendergast*
(College Park: Univ. of Maryland, 1976), 23.

PROVENANCE
Mr. and Mrs. MacKinley Helm, Santa Barbara,
Calif.; E. A. Milch Gallery, New York, 1953; Mr.
and Mrs. Arthur G. Altschul, New York, 1953.
962.280.1

212 *Shinnecock Hills, Long Island*
William Merritt Chase

NOTES
1. Quoted in Anonymous, "Chase's
Americanism," *Literary Digest*, Nov. 11, 1916,
1250–51.

2. Quoted in A. R. Ives, "Suburban Sketching
Grounds: Talk with Mr. William M. Chase, Mr.
Edward Moran, Mr. Leonard Ochtman," *Art
Amateur*, Sept. 1891, 80.

3. William H. Downes, "William Merritt Chase,
A Typical American Artist," *The International
Studio*, Dec. 1909, xxix.

PROVENANCE
Dr. and Mrs. Irving Frederick Burton,
Huntington Woods, Mich. 962.191.1

215 *The Red Mill*
Ernest Lawson

PROVENANCE
Charles Downing Lay; Gen. and Mrs. A. Bruce
Matthews, Willowdale, Ontario; Kraushaar
Galleries, New York; private collection, Long
Island, N. Y. 978.1371.1

216 *Ruth*
Thomas Eakins

NOTES
1. Lloyd Goodrich, *Thomas Eakins* (Cambridge:
Harvard Univ. Press, 1982), 2: 103, 109. Goodrich
was not aware of the gift inscription on the
reverse from Eakins to Laura K. Harding
and assumed it had been given directly to
the Murrays.

2. John B. Thomson to M. Knoedler & Co., New
York City, Dec. 12, 1964; photocopy, Office of the
Curator, the White House.

3. Quoted in Goodrich, *Thomas Eakins*, 2: 259–60.

PROVENANCE
Mrs. Edward H. (Laura K.) Harding (the sitter's
mother), Philadelphia; Samuel Murray (the
sitter's uncle), Philadelphia; Mrs. Samuel
Murray; Mrs. John B. Thomson (the sitter's
married name), Malvern, Pa.; John B. Thomson;
M. Knoedler & Co., Inc., New York; Joseph H.
Hirshhorn, New York, 1965. 967.595.1

219 *Signing of the Peace Protocol
Between Spain and the United States,
August 12, 1898*
Théobald Chartran

NOTES
1. Quoted in Samuel Eliot Morison, *The Oxford
History of the American People* (New York: Oxford
Univ. Press, 1965), 799–810.

2. Photographs are reproduced in: Frank Freidel,
The Splendid Little War (Boston: Little, Brown,
1958), 294; and Charles S. Olcott, *The Life of
William McKinley* (Boston: Houghton Mifflin,
1916), 2: opp. 74.

3. Quoted in Katharine McCook Knox,
"Paintings in the White House, 1931,"
unpublished manuscript, Office of the Curator,
the White House.

PROVENANCE
Henry Clay Frick, Pittsburgh. 902.1537.1

222 *Edith Carow Roosevelt*
Théobald Chartran

NOTES
1. Sylvia Jukes Morris, *Edith Kermit Roosevelt:
Portrait of a First Lady* (New York: Coward,
McCann & Geoghegan, 1980), 260. Ethel
Roosevelt Derby, upon seeing the portrait again
in 1977, said that while her mother was sitting for
the portrait, Madame Jusserand, wife of French
Ambassador Jules Jusserand, suggested that she
wear a hat and proceeded to place her own hat
on Edith Roosevelt's head. Thus Mrs. Roosevelt
was painted with it. The Jusserands and the
Roosevelts were close friends. Memo, Office of
the Curator, the White House.

2. A. Richard Boera, ed., "The Edith Kermit
Roosevelt Diaries," *Theodore Roosevelt Association
Journal* 12, no. 2 (Spring–Summer, 1986): 7. The
President subsequently sat for his portrait.
Chartran may have made a replica of it that he
exhibited in the Paris Salon of 1903 (Thieme-
Becker, *Kunstlerlexikon*). The original remained in

the White House, disliked by the family, until Mrs. Roosevelt ordered it destroyed in 1909 (Archibald Butt, *The Letters of Archie Butt*, ed. Lawrence F. Abbott [Garden City, N. Y.: Doubleday, Page & Co., 1924], 328–29, 340–41).

3. Edith K. Roosevelt (Oyster Bay, N. Y.) to Charles F. McKim (New York City), Aug. 21, 1902; copy, Office of the Curator, the White House.

PROVENANCE
Commissioned by the French Republic for presentation to the White House. 902.1477.1

225 *Theodore Roosevelt*
John Singer Sargent

NOTES
1. *The Letters of Theodore Roosevelt*, ed. Elting E. Morison, 8 vols. (Cambridge: Harvard Univ. Press, 1951), 3: 264; Charles Merrill Mount, *John Singer Sargent, A Biography* (New York: Norton, 1955), 238.

2. Mount, *John Singer Sargent*, 245–56. Interestingly, the newel-post as painted by Sargent is not an accurate depiction of that part of McKim's 1902 staircase, nor of the newel-posts of two earlier sets of stairs removed during the Roosevelt renovation.

3. Morison, *Letters of Theodore Roosevelt*, 428.

4. Henry Adams, *Letters*, ed. Worthington Chauncey Ford (New York: Houghton Mifflin, 1938), 398.

5. Mount, *John Singer Sargent*, 248. There are four copies of the portrait: 1) by Margaret F. Browne, for New York State Roosevelt Memorial; 2) by Fred W. Wright, for U. S. Naval Academy Museum, Annapolis; 3) by Alex James, for New York Harvard Club; 4) also by Alex James, for Roosevelt's birthplace, Manhattan. See David McKibben, *Sargent's Boston* (Boston: Museum of

Fine Arts, 1956), 120. Odile Duff, Research Director, *John Singer Sargent Catalogue Raisonné*, has informed me (Oct. 21, 1991) that copies of Sargent's portraits were "done at the demand of the sitter, but the artists painting them were always chosen by Sargent himself."

PROVENANCE
Commissioned by the U. S. government.
903.1328.1

226 *The Mosquito Net*
John Singer Sargent

NOTES
1. Manet's influence upon Sargent was decisive. If Sargent had not already known Manet's *Stéphane Mallarmé*, he would have seen it at the Manet retrospective at the École nationale des Beaux-Arts in Jan. 1884. There he would also have seen a remarkable portrait of a reclining woman, *La dame aux éventails: Portrait of Nina de Callias* (1873–74; Musée d'Orsay, Paris), to which his *Mosquito Net* could almost be a pendant, a late response. See *Manet, 1832–1883*, exhibition catalogue (Paris: Éditions de la Réunion des musées nationaux, 1983), 377, cat. 149, and 347, cat. 137.

2. The painting is often published under the English title *Repose*. See John Wilmerding, *American Masterpieces from the National Gallery of Art* (New York: Hudson Hills, 1988), 138–39.

3. Frederick Barnard (1846–1896) was a London-born artist who studied with Léon Bonnat in Paris. An illustrator, he was especially known for his drawings of characters from the novels of Charles Dickens.

4. The designing of the mosquito net was described by the Sargents' friend Eliza Wedgwood in a letter quoted in James Lomax and Richard Ormond, *John Singer Sargent and the Edwardian age* (London: exhibition organized by the Leeds Art Galleries, the National Portrait Gallery, London, and the Detroit Institute of Arts, 1979), 102, cat. 92.

5. The painting has long been dated circa 1908, because one of a similar subject, *Mosquito Nets*, was painted in that year at Majorca, Spain. On the other hand, a summary catalogue of paintings appended to the biography of Sargent by his friend Evan Charteris lists *The Mosquito Net (Lady in White)* in 1905 (*John Sargent* [New York: Charles Scribner's Sons, 1927], 287). David McKibbin's dating of the painting was kindly supplied by Odile Duff, Research Director, *John Singer Sargent Catalogue Raisonné*, who accepts it on stylistic grounds as well as on McKibbon's authority (letter to the author, Jan. 27, 1992).

PROVENANCE
Artist's estate, sold at Christie's, London, 1925; Scott and Fowles, New York. 964.530.1

229 *Young Mother and Two Children*
Mary Cassatt

PROVENANCE
Durand-Ruel, Paris; Wildenstein & Co., New York. 965.586.1

230 *William Howard Taft*
Anders L. Zorn

NOTES
1. Quoted in Ishbel Ross, *An American Family: The Tafts—1678–1964* (Cleveland: World Publishing Co., 1964), 252.

2. Seale, *President's House*, 2: 676–77.

3. Quoted in Jane K. Bledsoe, ed., *Anders Zorn Rediscovered*, exhibition catalogue (Long Beach: Univ. Art Museum, California State Univ., 1984), 21.

PROVENANCE
Painted and hung in the White House, 1911; purchased by the U. S. government, 1912.
912.1415.1

Page 233 *Point Lobos, Monterey, California*
Thomas Moran

NOTES
1. "Thomas Moran's Water-Color Drawings," *Scribner's Monthly,* Jan. 1873, 394.

2. Thurman Wilkins, *Thomas Moran: Artist of the Mountains* (Norman: Univ. of Oklahoma Press, 1966), 231.

PROVENANCE
Vose Galleries, Boston; Sotheby Parke Bernet, New York, Apr. 21, 1977, #65. 977.1319.1

235 *Rising Day* and *Descending Night*
Adolph A. Weinman

NOTES
1. Lou Henry Hoover Papers, AG 42, Herbert Hoover Presidential Library (West Branch, Iowa), 149; this excerpt in the Office of the Curator, the White House.

2. The highest number known to me in the Roman Bronze Works edition is 52. In a recent auction catalogue (Sotheby Parke Bernet no. 6062, Sept. 26, 1990, no. 127) one of the pair was a numbered piece from Roman Bronze Works while the other (*Descending Night*) was inscribed "CELLINI BRONZE WORKS, N-Y." This is the only cast from another foundry known to me.

3. Samuel Eliot Morison, *The Oxford History of the American People* (New York: Oxford Univ. Press, 1965), 874.

PROVENANCE (*Rising Day*)
The artist. 923.1031

PROVENANCE (*Descending Night*)
The artist. 923.1169

238 *The Avenue in the Rain*
Childe Hassam

NOTE
1. Most of the series was published in Ilene Susan Fort, *The Flag Paintings of Childe Hassam* (Los Angeles: Los Angeles County Museum of Art, 1988).

PROVENANCE
T. M. Evans, New York; acquired as *Flag Day.* 963.422.1

241 *Woodrow Wilson*
Sir William Orpen

PROVENANCE
Bernard M. Baruch, Jr., New York, by 1951. 962.329.1

242 *Florence Kling Harding*
Philip de László

NOTE
1. Kate Marcia Forbes, *Boston Sunday Post,* Dec. 25, 1921.

PROVENANCE
President and Mrs. Warren G. Harding—hung in the White House; Louise Kling and Mrs. R. T. Lewis (nieces of Mrs. Harding), c. 1924; The Harding Memorial Assn., Marion, Ohio, 1948. 971.715.1

245 *Spring in the Valley*
Willard Leroy Metcalf

NOTES
1. The authoritative monograph on Metcalf is Elizabeth de Veer and Richard J. Boyle, *Sunlight and Shadow: The Life and Art of Willard L. Metcalf* (New York: Abbeville, 1988).

2. Although *Spring in the Valley* was previously assigned a date of 1921 based upon an old label

from the Milch Gallery 1925 exhibition of paintings from the Metcalf estate, Elizabeth de Veer believes that it should be dated "probably 1924 when he did a number of canvases of larger dimensions. Probably painted in Springfield, Vt., or at Gassetts in Chester's environs" (letter, Office of the Curator, the White House).

PROVENANCE
Artist's estate exhibition, The Milch Gallery, New York, 1925; Coe Kerr Gallery, Inc., New York, 1974; Thomas Colville, New Haven, Conn., 1977; Hirschl & Adler Galleries, Inc., New York, 1977. 979.1401.1

246 *Carl Schurz Park, New York*
William Glackens

NOTES
1. Schurz, who lived in the neighborhood in the 1880s and 1890s, was a German revolutionary who had come to America in 1852. Command service in the Civil War and a Republican political career that included a term as secretary of the interior were followed by 25 years in New York. There he achieved fame as editor of the *New York Evening Post* and *Harper's Weekly*, in the service of political and social reform.

2. Ira Glackens, *William Glackens and the Ashcan Group* (New York: Crown, 1957), 76.

PROVENANCE
The artist; Ira Glackens (son), c. 1938. 969.628.1

249 *Boy Fishing*
Lilla Cabot Perry

NOTES
1. John Russell, "An Art School That Also Taught Life," *New York Times*, Mar. 19, 1989, 33, 44.

2. Lilla Cabot Perry, "Reminiscences of Claude Monet from 1889 to 1909," *The American Magazine of Art* 18, Mar. 1927, 119–25. This passage is also quoted in Linda Nochlin, *Impressionism and Post-Impressionism, 1874–1904,* Sources & Documents in the History of Art Series, ed. H. W. Janson (Englewood Cliffs, N. J.: Prentice Hall, 1966), 35.

3. Cecil Lyon to the President, Dec. 9, 1988, Office of the Curator, the White House.

4. The catalogue of a comprehensive exhibition of the artist is Meredith Martindale, *Lilla Cabot Perry: An American Impressionist* (Washington, D. C.: National Museum of Women in the Arts, 1990).

PROVENANCE
The artist; Mrs. Cecil B. Lyon, Mrs. Albert Levitt, and Mrs. Anita English (granddaughters), Hancock, N. H. 979.1399.1

250 *The Circus No. 1*
John Marin

NOTES
1. Since it entered the White House collection, the painting has usually been called *Circus Scene.* The title now has been restored to the one apparently used by the artist and recorded by Sheldon Reich, *John Marin: A Stylistic Analysis and Catalogue Raisonné* (Tucson: Univ. of Arizona Press, 1970), Pt. 2, *Catalogue Raisonné,* 808, cat. 52.46. In the same year Marin painted *The Circus No. 2;* Reich, cat. 52.47.

2. Werner Haftmann, *Painting in the Twentieth Century,* 2 vols. (New York: Praeger, 1965), 2: 114.

3. Ibid., 1: 160.

PROVENANCE
Mr. and Mrs. Leigh B. Block, Chicago; acquired as *Circus Scene.* 962.197.1

253 *Patricia Ryan Nixon*
Henriette Wyeth

NOTES
1. Quoted in Julie Nixon Eisenhower, *Pat Nixon: The Untold Story* (New York: Simon & Schuster, 1986), 460.

2. Memorandum (Apr. 28, 1982) of a comment by Helen Hayes during a tour of the White House, Office of the Curator, the White House.

3. Quoted in Eisenhower, *Pat Nixon,* 300–301.

4. Ibid., 461.

5. Appropriately, this portrait of Louisa Adams was received into the White House collection in 1971 by Mrs. Nixon as First Lady, from the Adams family. Seventy-five members of the family were present.

PROVENANCE
Commissioned by the White House Historical Association, 1978; donated in 1981 upon completion of the portrait of President Nixon. 981.1472.1

256 *Still Life With Quince, Apples, and Pears*
Paul Cézanne

NOTES
1. Quoted in John Rewald, *Cézanne and America* (Princeton: Princeton Univ. Press, 1989), 100, 102.

2. John Rewald, ed., *Camille Pissarro: Letters to his son Lucien,* 4th ed. (London: Routledge & Kegan Paul, 1980), 275.

3. Rewald, *Cézanne and America,* 53 and 304, pl. XVI. This painting has previously been identified in the White House inventory as *Still Life With Apples.* Rewald, on the other hand, published it as *Still Life With Three Peaches,* and called the green fruit at the left a pear. I accept Rewald's identification of the pear, while disagreeing with

his multiple peaches. We are indebted to him for the precise identification of the landscape formerly called simply *Gardanne* (p. 55, fig. 31; our p. 263), and especially for the most authoritative dating of these four Cézannes.

4. Cézanne to his wife, Clara, Oct. 8, 1907, quoted in Ellen H. Johnson, *Cézanne* (London: Purnell & Sons, 1967), 8.

5. Quoted in Rewald, 344 and 345 n. 21.

6. "Apple," in Updike's "A Cheerful Alphabet of Pleasant Objects."

PROVENANCE
Charles A. Loeser, Florence, Italy; bequeathed to the White House, late 1920s, with life interest to daughter, Mrs. Matilda Calnan, Florence, which she renounced in 1950; acquired as *Still Life With Apples.* 952.3755.3

259 *The Forest*
Paul Cézanne

NOTES
1. See Konrad Oberhuber, "Charles Loeser as a Collector of Drawings," *Fogg Art Museum, Harvard University,* reprinted from *Apollo* 107, no. 195 (May 1978): 94–99. Also John Rewald, *Cézanne and America* (Princeton: Princeton Univ. Press, 1989), 53 and 105 n. 30.

2. Rewald, *Cézanne and America,* 82–83 n. 5. The painting is V. 645 in Lionello Venturi, *Cézanne, son art, son oeuvre* (Paris: Paul Rosenberg, 1936).

PROVENANCE
Charles A. Loeser, Florence, Italy; bequeathed to the White House, late 1920s, with life interest to daughter, Mrs. Matilda Calnan, Florence, which she renounced in 1950. 952.3755.4

Page 260 *House on the Marne*
Paul Cézanne

NOTE
1. The White House painting is not found in the standard catalogue by Lionello Venturi, *Cézanne, son art, son oeuvre* (Paris: Paul Rosenberg, 1936). The two other paintings (both smaller) of the scene are listed as V.629 (no location) and V.630 (Hermitage, Leningrad [now St. Petersburg]).

PROVENANCE
Charles A. Loeser, Florence, Italy; bequeathed to the White House, late 1920s, with life interest to daughter, Mrs. Matilda Calnan, Florence, which she renounced in 1950. 952.3755.5

263 *Mont Sainte-Victoire and Hamlet Near Gardanne*
Paul Cézanne

NOTES
1. John Rewald, *Cézanne and America* (Princeton: Princeton Univ. Press, 1989), 53.

2. Sandra Orienti, *The Complete Paintings of Cézanne* (New York: Abrams, 1972), 106; Jean Hureau, *Provence and the French Riviera Today* (Paris: Editions J. A., 1977), 9.

3. It is called the *Plan de Meyreuil; plan* is Provençal for "plateau" or "flatland." See Marianne R. Bourges, *Itineraires de Cézanne* (Aix-en-Provence, 1982), 26–27 (unpag.).

4. Ibid., 40 (unpag.).

PROVENANCE
Charles A. Loeser, Florence, Italy; bequeathed to White House, late 1920s, with life interest to daughter, Mrs. Matilda Calnan, Florence, which she renounced in 1950; acquired as *Gardanne*. 952.3755.7

264 *Morning on the Seine, Good Weather*
Claude Monet

NOTES
1. Maurice Guillemot, "Claude Monet," *La Revue illustree* 13 (Mar. 15, 1898); reprinted in full in *Claude Monet au temps de Giverny*, exhibition catalogue (Paris: Centre Culturel du Marais, 1983), 121.

2. Ibid.

3. Quoted in Mary Van Rensselaer Thayer, *Jacqueline Kennedy: The White House Years* (Boston: Little, Brown, 1971), 344.

4. Paul Hayes Tucker, *Monet in the '90s: The Series Paintings* (New Haven: Yale Univ. Press, 1990), 225.

5. Joel Isaacson, *Claude Monet: Observation and Reflection* (New York: Phaidon, 1978), 43.

6. Ibid.

PROVENANCE
Durand-Ruel, Paris; Mr. Ballantine; J. Duncan Pitney (grandson); M. Knoedler & Co., Inc., New York. 963.509.1

Catalogue of the White House Collection of Paintings, Sculpture, and Works on Paper

Introduction by Betty C. Monkman

The Catalogue

This catalogue of the nearly 450 works in the fine arts collection represents more than 190 years of collecting paintings, drawings, and sculpture for the White House. It is the culmination of the vision and contributions of many people: Presidents and First Ladies, members of White House advisory committees, generous donors, historians, and curators.

Prior to the 20th century there were no published materials on art in the White House. The first effort was a 1901 publication, *The White House Gallery of Official Portraits of the Presidents* (The Gravure Company), which contained handsome engravings of the portraits of Presidents from Washington to McKinley, along with biographies of each man. It was reprinted in later editions to include Theodore Roosevelt. The first articles on the art collection appeared in a 1901 issue of *Harper's Bazar* (later *Bazaar*) and a 1904 issue of *The Independent*.

Although inventories since 1801 have listed objects in the White House, no attempt to catalogue or systematically record the collection was begun until 1931, when First Lady Lou Henry Hoover initiated a study of the art and furnishings in the house. She also supported a project proposed by the Frick Art Reference Library in New York City to examine, photograph, and prepare descriptive and historical records of each painting. The Frick Library made the photographs available to scholars and publishers; information on the works, including biographies of the artists, was likewise available to the White House staff for answering inquiries. This important project was updated in 1953 to include paintings acquired since 1931.

At the request of the White House chief usher, the National Park Service instituted a comprehensive study of the collection in 1946. (Mrs. Hoover had taken her materials with her at the end of her husband's term; those records, largely forgotten for decades, were provided to the White House only in the 1960s.) Thus the National Park Service began what was described as "the first systematic and scholarly investigation on an extensive collection of historic objects which because of the nature and location of their assemblage, possess the utmost historical and cultural importance for the American people." Works were accessioned according to museum methods; catalogue cards were prepared; and an extensive search of original documents in the National Archives was made. The work was interrupted when President and Mrs. Harry S. Truman moved out of the White House in 1948 for an extensive renovation of the building. While it was closed, a selected group of portraits was shown outside the White House for the first time in an exhibition at the National Gallery of Art: "Makers of History in Washington 1800–1950."

Enormous growth in the collection began under Mrs. John F. Kennedy, and in 1961 a professional curatorial staff assumed responsibilities for the collection, its care, preservation, and interpretation. A preliminary catalogue, which included all works of art acquired since 1961, was published in 1964 by the Office of the Curator; and in that same year an advisory committee, the Committee for the Preservation of the White House, was established by Executive Order to advise the President on future acquisitions. By 1965 the growing art collection became the subject of a film, "Paintings in the White House," narrated by Mrs. Lyndon B. Johnson. Since 1962 selected works of art have been illustrated and discussed in publications of the White House Historical Association.

With the expansion of the collection and the increased interest in American art, further research has been conducted; inquiries about the collection have increased; and many works have been lent to major museum exhibitions. A conservation program has been ongoing. To assist the curatorial staff with these responsibilities a computerized system was put into operation in 1978.

William G. Allman and Lydia Tederick of the staff of the Office of the Curator and Richard Napoli of the National Park Service have devoted much effort to the preparation of the illustrated catalogue. It is a complete list of the works of art, except prints, in the collection. The listings are arranged alphabetically by artist, followed by works of unknown artists arranged alphabetically by title. Additional information is available from the Office of the Curator, the White House.

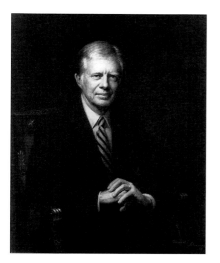

Abrams, Herbert (1921–　)
Jimmy Carter (1924–　)
1982, oil on canvas
38⅟₁₆ x32⅟₁₆ in (96.7 x 81.4 cm)
Signed and dated lower right:
Herbert E/Abrams./82
Gift of an anonymous donor
982.1517.1

Addy, Alfred (?–?)
The Presidential Yacht **Mayflower**
c. 1902–29, watercolor on paper
12½ x 19½ in (31.8 x 49.5 cm)
Signed lower left: ALFRED ADDY.
Gift of Dr. and Mrs. James A. Piccolo
977.1316.1

Alexander, Francis (1800–1880)
Martin Van Buren (1782–1862)
c. 1830–40, oil on panel
30⅟₁₆ x 24⅟₁₆ in (76.4 x 61.1 cm)
Stenciled on reverse: The Tayloe Collection
Gift of the Society of Mayflower Descendants
962.277.1

Andrews, Andrew (?–?), attributed to
View of Lake George
c. 1850–60, oil on canvas
25⅛ x 35⅟₁₆ in (63.8 x 89.1 cm)
Signed lower right: A Andrews
Gift of the White House Historical Association
975.1169.1

Andrews, Eliphalet Frazer (1835–1915)
James Abram Garfield (1831–1881)
1882, oil on canvas
96 x 60 in (243.8 x 152.4 cm)
Signed and dated lower right:
E.F. Andrews-/1882
U. S. government purchase
882.3752.1

Andrews, Eliphalet Frazer (1835–1915)
after **James Henry Beard** (1812–1893), 1840
William Henry Harrison (1773–1841)
1879, oil on canvas
30¼ x 25³⁄₁₆ in (76.8 x 64 cm)
Signed and dated lower right: E.F. Andrews/
1879/After JHBeard [JHB in monogram]/1840;
inscribed on reverse: Copied by E.F. Andrews
1879/From the portrait from life/by
James H. Beard 1840/Now in possession of/
Geo. K. Shoenberger/of Cincinnati, Ohio
U. S. government purchase
879.1134.1

Andrews, Eliphalet Frazer (1835–1915)
after **Thomas Sully** (1783–1872), 1845
Andrew Jackson (1767–1845)
1879, oil on canvas
60⅜ x 48¾₆ in (153.4 x 122.7 cm)
U. S. government purchase
879.1136.1

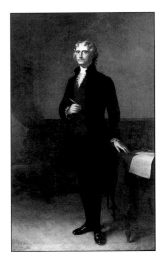

Andrews, Eliphalet Frazer (1835–1915)
Thomas Jefferson (1743–1826)
1884, oil on canvas
94⅜ x 60 in (240.4 x 152.4 cm)
Signed and dated lower left:
E.F. Andrews/1884.
U. S. government purchase
886.1337.1

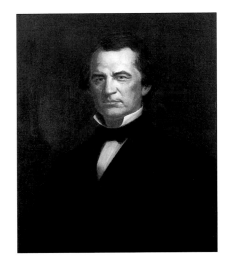

Andrews, Eliphalet Frazer (1835–1915)
Andrew Johnson (1808–1875)
1880, oil on canvas
30⅜ x 25⅛ in (77.2 x 63.8 cm)
U. S. government purchase
880.2489.1

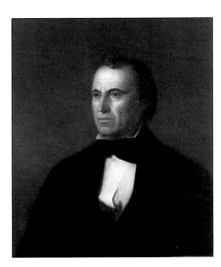

Andrews, Eliphalet Frazer (1835–1915)
after **John Vanderlyn** (1775–1852), c. 1850
Zachary Taylor (1784–1850)
1879, oil on canvas
29¹³⁄₁₆ x 24⅞ in (75.7 x 63.2 cm)
Signed and dated lower left:
E.F. Andrews/After Vanderlyn/1879
U. S. government purchase
879.1138.1

Andrews, Eliphalet Frazer (1835–1915)
Martha Dandridge Custis Washington
(1732–1802)
(Mrs. George Washington)
1878, oil on canvas
96⅞₆ x 59⅞ in (244.3 x 152.1 cm)
Signed and dated lower right:
E.F. Andrews./1878.
U. S. government purchase
878.1289.1

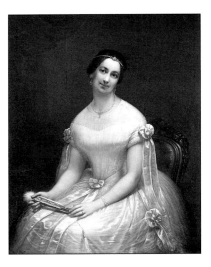

Anelli, Francesco (c. 1805–1883)
Julia Gardiner Tyler (1820–1889)
(Mrs. John Tyler)
1846–48, oil on canvas
50⅛ x 38⅞ in (127.3 x 98.7 cm)
Signed lower left: By F. Anelli;
inscribed on reverse: Mrs. Giulia Gardiner
Tyler/in her 26 year/By F. Anelli- 1848
Gift of Julia Gardiner Tyler
869.1533.1

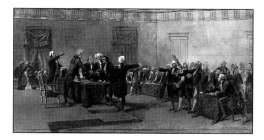

Armand-Dumaresq, Charles Edouard (1826–1895)
The Declaration of Independence of the
United States of America, July 4, 1776
c. 1873, oil on canvas
29½ x 47½ in (74.9 x 120.6 cm)
Signed lower right: ARMAND DUMARESQUE
Gift of Sam Salz
961.3.1

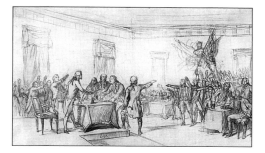

Armand-Dumaresq, Charles Edouard (1826–1895)
The Declaration of Independence of the
United States of America, July 4, 1776
c. 1873, pencil on paper
10¼ x 17¼ in (26 x 43.8 cm)
Signed lower center on step: A-D.q.;
inscribed on reverse: Proclamation de
l'Independance, 1776 - A.D. Esquisse de
tableau chez Mme Mérédith Read
White House Acquisition Fund
965.539.1

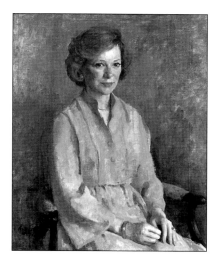

Augusta, George (1922–)
Rosalynn Smith Carter (1927–)
(Mrs. Jimmy Carter)
1984, oil on canvas
36 x 30 in (91.4 x 76.2 cm)
Signed lower left: Augusta/1984
Gift of the White House Historical Association
985.1573.1

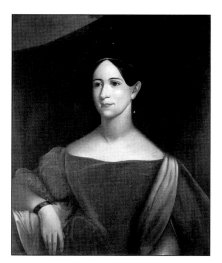

Avent, Mayna Treanor (1868–1958)
after **Ralph E. W. Earl** (c. 1785–1838), c. 1833
Sarah Yorke Jackson (1805–1887)
(Mrs. Andrew Jackson, Jr.)
c. 1921, oil on canvas
30 x 24½ in (76.2 x 62.2 cm)
Gift of the Ladies Hermitage Association
924.1501.1

Ball, Thomas (1819–1911)
Ames Company (foundry)
Henry Clay (1777–1852)
1858, bronze
31 x 12 x 10¾ in (78.7 x 30.5 x 27.3 cm)
Signed and dated on drapery rear:
T. BALL Sculpt Boston 1858;
inscribed on base rear: PATENT assigned to
G W Nichols/Ames Co. Founders/
Chicopee/Mass
Gift of Mr. and Mrs. James W. Fosburgh
961.158.2

Ball, Thomas (1819–1911)
J. T. Ames (founder)
Daniel Webster (1782–1852)
1853, bronze
30 x 13 x 11 in (76.2 x 33 x 27.9 cm)
Signed and dated on drapery rear:
T Ball Sculpt/Boston Mass/1853/
Patent assigned to/G W Nichols;
foundry stamp on base rear:
J T AMES/FOUNDER/CHICOPEE/MASS/17
Gift of Mr. and Mrs. James W. Fosburgh
961.158.1

Baur, Theodore (1835–?)
Meriden Britannia Company (foundry)
The Buffalo Hunt
1882–86, silver-and-gold-plated bronze
22¾ x 28 x 16¼ in (57.8 x 71.1 x 41.3 cm)
Gift of Jay P. Altmayer
980.1433.1

Bennett, William James (1787–1844),
attributed to
Three–Masted American Barque
c. 1830–40, oil on canvas
17⅞ x 25⅞ in (45.4 x 65.7 cm)
Gift of Mr. and Mrs. Joel Barlow
971.808.6

Bezerédi, Gyula Julius (1858–?)
Méngsik, Antal (founder)
Louis Kossuth (1802–1894)
1923, bronzed plaster
40 x 14¾ x 12½ in (101.6 x 37.5 x 31.8 cm)
Marked on base right side front: BEZEREDI;
marked on base right side rear:
ÖNTÖTTE/MÉNGSIK ANTAL/BUDAPEST.;
inscribed on base front: LOUIS KOSSUTH/
GOVERNOR OF HUNGARY/AS HE APPEARED
WHEN IN THE UNITED STATES IN
1851–52/PRESENTED/TO THE WHITE HOUSE BY
AMERIGANS [*sic*] OF HUNGARIAN
ORIGIN/SOJOURNING IN HUNGARY/1923
Gift of Americans of Hungarian Origin
923.2678.1

Bezerédi, Gyula Julius (1858–?)
Méngsik, Antal (founder)
George Washington (1732–1799)
1923, bronzed plaster
40 x 20 x 14½ in (101.6 x 50.8 x 36.8 cm)
Marked on base right side front: BEZEREDI;
marked on base right side rear:
ÖNTÖTTE/MENGSIK ANTAL/BUDAPEST;
inscribed on base front: GEORGE
WASHINGTON/A REDUCED REPLICA OF
THE STATUE IN BUDAPEST, HUNGARY/
PRESENTED/TO THE WHITE HOUSE
BY AMERICANS OF HUNGARIAN ORIGIN/
SOJOURNING IN HUNGARY/1923
Gift of Americans of Hungarian Origin
923.2679.1

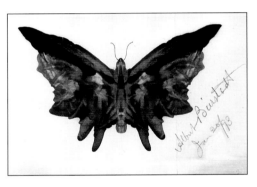

Bierstadt, Albert (1830–1902)
Butterfly
1893, oil and pencil on paper on pasteboard
4¹⁵⁄₁₆ x 8¹⁄₁₆ in (12.5 x 20.5 cm);
card: 5⅞ x 8¹³⁄₁₆ in (14.9 x 22.4 cm)
Signed and dated lower right:
Albert Bierstadt/Jan 20/93
Gift of Mr. and Mrs. James R. Graham
962.268.1

Bierstadt, Albert (1830–1902)
Niagara Falls
late 19th century, oil on paper on canvas
13⅜ x 19¼ in (34.6 x 48.9 cm)
Signed lower right: ABierstadt [AB in monogram]
Gift of the White House Historical Association
974.1104.1

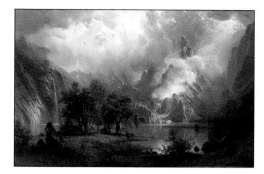

Bierstadt, Albert (1830–1902)
Rocky Mountain Landscape
1870, oil on canvas
36⅜ x 54¾ in (93 x 139.1 cm)
Signed and dated lower right:
ABierstadt [AB in monogram]/70
Gift of The Barra Foundation, Inc.
981.1468.1

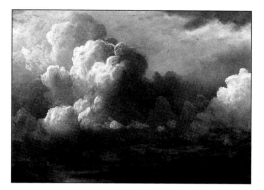

Bierstadt, Albert (1830–1902)
Storm Clouds
c. 1880, oil on fiberboard
14½ x 19½ in (36.8 x 49.5 cm)
Signed lower right: ABierstadt [AB in monogram]
Gift of Mr. and Mrs. Vincent Price
962.314.1

Bierstadt, Albert (1830–1902)
Washington, D. C.
c. 1863, oil on paper on canvas
10⅛ x 14⅞ in (25.7 x 37.8 cm)
Inscribed on reverse of paper:
Washington. D. C.
Gift of Mr. and Mrs. Maurice Glickman
981.1438.1

Bingham, George Caleb (1811–1879)
Lighter Relieving a Steamboat Aground
1847, oil on canvas
30⁵⁄₁₆ x 36³⁄₁₆ in (77 x 91.9 cm)
Gift of an anonymous donor and
Mr. and Mrs. Walter Shorenstein
978.1392.1

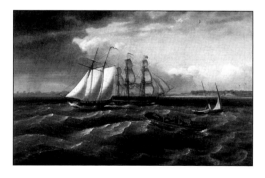

Birch, Thomas (1779–1851)
Mouth of the Delaware
1828, oil on canvas
20 x 30 in (50.8 x 76.2 cm)
Signed and dated on drift log, lower left:
T. Birch Esqr 1828
Gift of the White House Historical Association
962.181.1

Bittinger, Charles (1879–1970)
Blue Room, The White House
1903, oil on canvas
21⅜ x 25¾ in (54.9 x 65.4 cm)
Signed and dated lower right:
Charles Bittinger/1903
Gift of Francis G. Bittinger and
Charles Bittinger, Jr.
983.1528.1

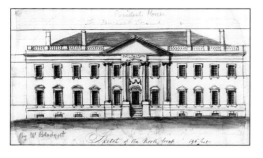

Blodget, Samuel, Jr. (1757–1814)
North Front of the President's House
c. 1800, ink and wash on paper
6⁵⁄₁₆ x 10⅞ in (16.7 x 27.6 cm)
Inscribed upper center: Presidents House,
The Presidents House [partially erased];
lower left: By Mr Blodgett,
architect of the Publik Buildings [partially erased];
lower center: Sketch of the North front 196 feet;
lower right: In the Presidency of Jefferson
& Madison [partially erased]
Gift of The Sack Foundation
971.752.1

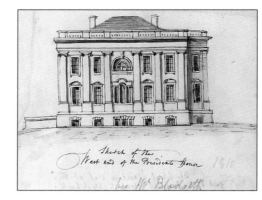

Blodget, Samuel, Jr. (1757–1814)·
West End of the President's House
c. 1800, ink and wash on paper
6¼ x 8⅛ in (15.9 x 20.6 cm)
Inscribed lower center: Sketch of the/West end
of the Presidents House, 1810/by Mr Blodgett;
reverse: The Chief Staircase was at this/
end of the President's House, lighted by
the/large window. — The two windows on the
right were/in the dining room which opened
into a drawing room/in which Mrs. Madison
received morning visitors & which opened
into the circular room on the other side
Gift of The Sack Foundation
971.752.2

Borglum, John Gutzon De La Mothe (1867–1941)
Gorham Company (foundry)
Abraham Lincoln (1809–1865)
1908, bronze
37½ x 28¼ x 22¼ in (95.2 x 71.8 x 56.5 cm)
Signed and dated on left rear:
GUTZON/BORGLVM/1908;
marked on right lower edge: GORHAM CO.
Gift of Eugene Meyer
954.3672.1

Bricher, Alfred Thompson (1837–1908)
Castle Rock, Nahant, Massachusetts
1877, oil on canvas
26⅛ x 50 in (66.4 x 127 cm)
Signed and dated lower left:
ATBRICHER. [ATB in monogram]/1877
White House Acquisition Fund
972.878.1

Brown, John Henry (1818–1891)
James Buchanan (1791–1868)
1851, watercolor on ivory
6¹⁄₁₆ x 4½ in (15.4 x 11.4 cm)
Signed and dated lower edge:
J. Henry Brown. Pinxit. March. 1851.
Gift of the White House Historical Association
989.1665.1

Brown, Richard Marsden (1919–1964)
after **Philip A. de László de Lombos**
(1869–1937), 1932
Lou Henry Hoover (1874–1944)
(Mrs. Herbert Hoover)
1950, oil on canvas
29½ x 19¾ in (74.9 x 50.2 cm)
Signed lower left: RICHARD M. BROWN/1950;
lower right: de László 1932.1
Gift of Herbert Hoover
951.3409.1

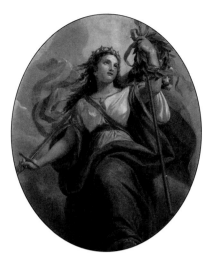

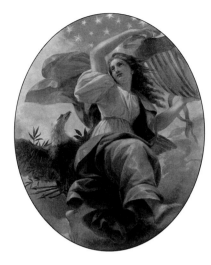

Brumidi, Constantino (1805–1880)
Liberty
1869, oil on canvas
62¹⁵⁄₁₆ x 50⅞ in (159.9 x 129.2 cm) oval
Gift of the Shaklee Corporation
978.1390.1

Brumidi, Constantino (1805–1880)
Union
1869, oil on canvas
62⅞ x 50½ in (159.7 x 128.3 cm) oval
Gift of the Shaklee Corporation
978.1390.2

Burnham, Anita Willets (1880–?)
Our White House, Washington, D. C.
1942, watercolor on paper
19¹⁵⁄₁₆ x 12¹⁵⁄₁₆ in (50.6 x 32.9 cm)
Signed lower right: Anita Willets Burnham/
Our White House - Washington DC.
Gift of the artist to Eleanor Roosevelt
(Mrs. Franklin D. Roosevelt)
942.2285.1

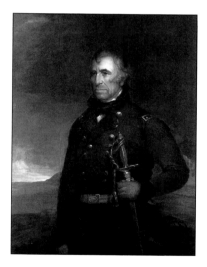

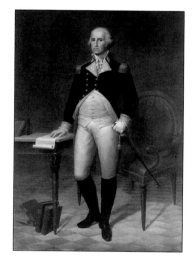

Bush, Joseph Henry (1794–1865)
Zachary Taylor (1784–1850)
c. 1848, oil on canvas
46⅛ x 36 in (117.2 x 91.4 cm)
Gift of Mrs. Betty Taylor Dandridge
960.1532.1

Cadena, Luis Leonardo (1830–1889)
George Washington (1732–1799)
1877, oil on canvas
82 x 57¹⁵⁄₁₆ in (208.3 x 147.2 cm)
Signed and dated lower left:
Luis Cadena/Quito 1877.
Gift of the Republic of Ecuador
879.1137.1

Calusd, Carl (or Charles) (c. 1860–1936)
Welcome
early 20th century, oil on canvas
22 x 39 in (55.9 x 99.1 cm)
Signed lower right: C. Calusd
Gift of H. H. Topakyan
907.3807.1

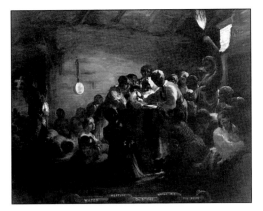

Calyo, Nicolino (1799–1884)
Fairmount Waterworks—Philadelphia
c. 1834, gouache on paper
25⁷⁄₁₆ x 32¾ in (64.6 x 83.2 cm)
Gift of Mr. and Mrs. Meyer P. Potamkin
979.1416.1

Calyo, Nicolino (1799–1884)
Merchant's Exchange—Philadelphia
c. 1834, gouache on paper
21⁹⁄₁₆ x 32¼ in (54.8 x 81.9 cm)
Signed lower left: Nicolino Calyo
Gift of Mr. and Mrs. Meyer P. Potamkin
979.1416.2

Carlton, William Tolman (1816–1888)
Watch Meeting—Dec. 31st 1862—
Waiting for the Hour
1863, oil on canvas
29⅜ x 36¼ in (74.6 x 92.1 cm)
Inscribed lower edge (in chain):
WATCH/MEETING/DEC. 31st. 1862/
WAITNG [*sic*] FOR/THE HOUR
Gift of the Republican National
Finance Committee
972.842.1

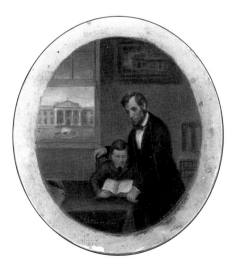

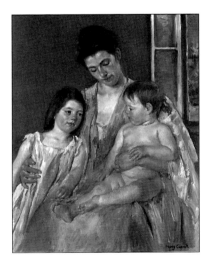

Carpenter, Francis Bicknell (1830–1900)
Lincoln and Tad
c. 1873–74, oil on paperboard
3¾ x 3³⁄₁₆ in (9.5 x 8.1 cm) oval
Signed lower left: F.B. Carpenter
Gift of The A. Jay Fink Foundation, Inc.
963.500.1

Casilear, John William (1811–1893), attributed to
Hudson River Highlands
c. 1850, pencil and chalk on paper
9½ x 13⅝ in (24.1 x 34.6 cm)
Gift of William MacLeod Ittman
962.237.3

Cassatt, Mary Stevenson (1844–1926)
Young Mother and Two Children
1908, oil on canvas
36⅜ x 29 in (92.4 x 73.7 cm)
Signed lower right: Mary Cassatt
Gift of an anonymous donor
965.586.1

Ceracchi, Giuseppe (1751–1801)
Christopher Columbus (1451–1506)
modeled c. 1790–94, carved c. 1815, marble
19½ x 11½ x 10 in (49.5 x 29.2 x 25.4 cm)
U. S. government purchase
817.1507.1

Ceracchi, Giuseppe (1751–1801)
Amerigo Vespucci (1454–1512)
modeled c. 1790–94, carved c. 1815, marble
21 x 12½ x 10 in (53.3 x 31.8 x 25.4 cm)
U. S. government purchase
817.3753.1

Ceracchi, Giuseppe (1751–1801)
George Washington (1732–1799)
modeled c. 1790–94, carved c. 1815, marble
22 x 10 x 8¾ in (55.9 x 25.4 x 22.2 cm)
U. S. government purchase
817.1434.1

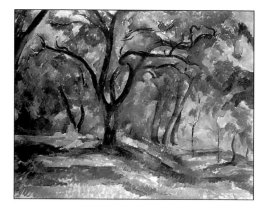

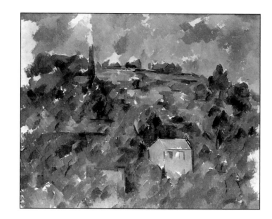

Cézanne, Paul (1839–1906)
Boathouse on a River
early 20th century, oil on canvas
22¾ x 28⅜ in (57.8 x 72.1 cm)
Bequest of Charles A. Loeser
952.3755.7

Cézanne, Paul (1839–1906)
The Forest
1890–92, oil on canvas
28¾ x 36¼ in (73 x 92.1 cm)
Bequest of Charles A. Loeser
952.3755.5

Cézanne, Paul (1839–1906)
House on a Hill
early 20th century, oil on canvas
25⅞ x 31⅞ in (65.7 x 81 cm)
Bequest of Charles A. Loeser
952.3755.6

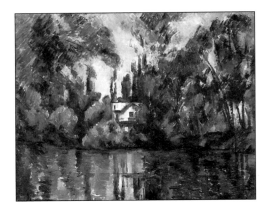

Cézanne, Paul (1839–1906)
House on the Marne
1888–90, oil on canvas
28¾ x 35⅞ in (73 x 91.1 cm)
Bequest of Charles A. Loeser
952.3755.4

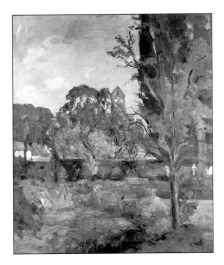

Cézanne, Paul (1839–1906)
Landscape With Tower
1885–90, oil on canvas
25¾ x 21¼ in (65.4 x 54 cm)
Bequest of Charles A. Loeser
952.3755.8

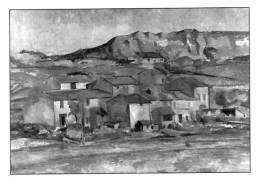

Cézanne, Paul (1839–1906)
Mont Sainte-Victoire and Hamlet Near Gardanne
1886–90, oil on canvas
24⅝ x 35⅞ in (62.6 x 91.1 cm)
Bequest of Charles A. Loeser
952.3755.3

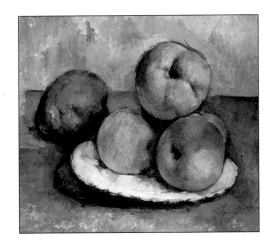

Cézanne, Paul (1839–1906)
Still Life With Quince, Apples, and Pears
c. 1885–87, oil on canvas
11⅛ x 12⅛ in (28.3 x 30.8 cm)
Bequest of Charles A. Loeser
952.3755.1

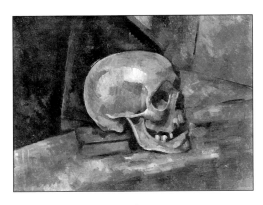

Cézanne, Paul (1839–1906)
Still Life With Skull
c. 1900, oil on canvas
13⅛ x 18 in (33.3 x 45.7 cm)
Bequest of Charles A. Loeser
952.3755.2

Chandor, Douglas Granville (1897–1953)
Anna Eleanor Roosevelt Roosevelt (1884–1962)
(Mrs. Franklin D. Roosevelt)
1949, oil on canvas
49⅛ x 38¼ in (124.8 x 97.2 cm)
Signed and dated upper left:
CHANDOR/1949/NEW YORK.;
inscribed by sitter upper right:
A trial made pleasant/by the painter./
Eleanor Roosevelt
Gift of the White House Historical Association
965.578.1

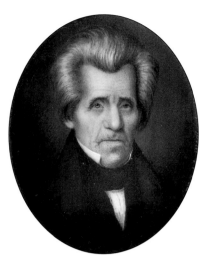

Charles, Samuel M. (c. 1815–?)
Andrew Jackson (1767–1845)
1835, watercolor on ivory
1¹⁵⁄₁₆ x 1⁹⁄₁₆ in (4.9 x 4 cm) oval
Signed and dated at right:
Painted by S M. Charles 1835
Gift of Mr. and Mrs. Ronald Tree
961.149.1

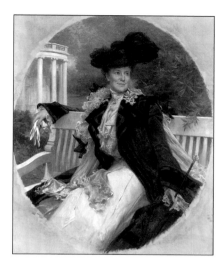

Chartran, Théobald (1849–1907)
Edith Carow Roosevelt (1861–1948)
(Mrs. Theodore Roosevelt)
1902, oil on canvas
58¼ x 50¼ in (148 x 127.6 cm)
Signed and dated lower left:
Chartran/Washington D. C./1902
Gift of the French Republic
902.1477.1

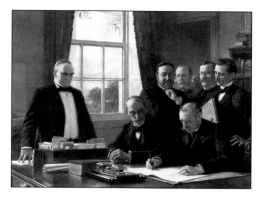

Chartran, Théobald (1849–1907)
*Signing of the Peace Protocol Between Spain
and the United States, August 12, 1898*
1899, oil on canvas
62⅛ x 82¹⁄₁₆ in (157.8 x 208.4 cm)
Signed and dated lower right: Chartran 1899.
Gift of Henry Clay Frick
902.1537.1

Chase, William Merritt (1849–1916)
James Buchanan (1791–1868)
1902, oil on canvas
60½ x 48⅝ in (153.7 x 123.5 cm)
Inscribed on reverse:
President James Bucanan [*sic*]/Painted by/
Wm. M. Chase after an/old Engraving-/
New York March 1902
Gift of Mrs. Harriet Lane Johnston
902.1135.1

Chase, William Merritt (1849–1916)
Lettuce and Tomatoes
late 19th century–early 20th century,
oil on panel
23⅜ x 28¾ in (59.4 x 73 cm)
Signed lower right: WM M Chase.
Gift of Mrs. Suzette Morton Zurcher
961.159.1

Chase, William Merritt (1849–1916)
Shinnecock Hills, Long Island
1900, oil on panel
14½ x 18⅝ in (36.8 x 47.3 cm)
Signed lower left: Wᵐ M. Chase.
Gift of Dr. and Mrs. Irving Frederick Burton
962.191.1

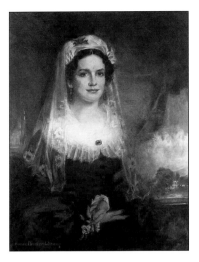

Christy, Howard Chandler (1873–1952)
Grace Goodhue Coolidge (1879–1957)
(Mrs. Calvin Coolidge)
1924, oil on canvas
90¾ x 42¼ in (230.5 x 107.3 cm)
Signed and dated lower right: Howard Chandler
Christy/The WHITE HOUSE/Feb. 1924.
Gift of Pi Beta Phi Fraternity
924.1564.1

Christy, Howard Chandler (1873–1952)
Grace Goodhue Coolidge (1879–1957)
(Mrs. Calvin Coolidge)
c. 1924, watercolor on paper
12½ x 10½ in (31.8 x 26.7 cm)
Signed lower right: Howard Chandler Christy
Gift of the White House Historical Association
987.1613.1

Christy, Howard Chandler (1873–1952)
after **Ralph Eleaser Whiteside Earl**
(c. 1788–1838), c. 1827
Rachel Donelson Robards Jackson (1767–1828)
(Mrs. Andrew Jackson)
1941, oil on canvas
41 x 31⅛ in (104.1 x 79.1 cm)
Signed lower left: Howard Chandler Christy
Gift of the State of Tennessee
942.1540.1

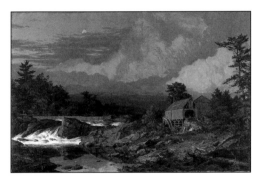

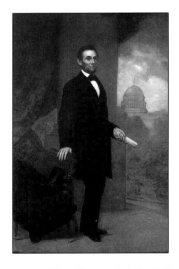

Church, Frederic Edwin (1826–1900)
Rutland Falls, Vermont
1848, oil on canvas
20 x 29¾ in (50.8 x 75.6 cm)
Signed and dated lower left: F. CHURCH/1848
Gift of the White House Historical Association
976.1296.1

Clayton, Alexander Benjamin (1906–)
Richard Milhous Nixon (1913–)
1981, oil on canvas
40 x 32 in (101.6 x 81.3 cm)
Signed and dated lower right:
Alexander Clayton '81, New York
Gift of the White House Historical Association
981.1471.1

Cogswell, William F. (1819–1903)
Abraham Lincoln (1809–1865)
1869, oil on canvas
102¼ x 65¾ in (259.7 x 167 cm)
Signed lower right: W. Cogswell
U. S. government purchase
869.1539.1

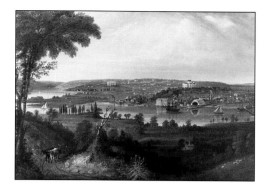

Coles, John, Jr. (c. 1780–1854)
James Freeman Curtis (1797–1839)
c. 1830, oil on panel
28⅛ x 21⁹⁄₁₆ in (71.4 x 54.8 cm)
Signed on reverse lower right: John Coles Jr.
Acquisition undocumented
960.2093.1

Comins, Eben Farrington (1875–1946)
after **John Vanderlyn** (1775–1852),
1816 or 1820
Elizabeth Kortright Monroe (1768–1830)
(Mrs. James Monroe)
1932, oil on canvas
30⁵⁄₁₆ x 24 in (76.7 x 61 cm)
Signed and dated on reverse upper center:
"Copy"/BY EBEN. F. COMINS/.1932.
Gift of the artist
933.1214.1

Cooke, George (1793–1849)
City of Washington From Beyond the Navy Yard
1833, oil on canvas
18 x 25 in (45.7 x 63.5 cm)
Gift of The Morris and Gwendolyn Cafritz
Foundation
972.883.1

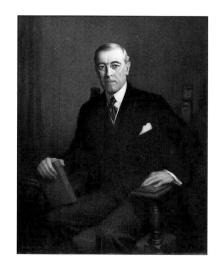

Cooper, Colin Campbell (1856–1937)
The Capitol at Night
1902, watercolor
8½ x 10⅝ in (21.6 x 27 cm)
Signed and dated lower left:
Colin Campbell Cooper/1902
Gift of Mr. and Mrs. Raymond J. Horowitz
965.563.1

Cooper, Colin Campbell (1856–1937)
Kimberly Crest, Redlands, California
c. 1929, oil on canvas
18⅛ x 21½ in (46 x 54.6 cm)
Signed lower right: Colin Campbell Cooper
Gift of the White House Historical Association
977.1313.1

Cootes, Frank Graham (1879–1960)
Woodrow Wilson (1856–1924)
1936, oil on canvas
50 x 40 in (127 x 101.6 cm)
Signed lower left: F. Graham Cootes
Gift of Edith Bolling Galt Wilson
(Mrs. Woodrow Wilson)
937.1414.1

Cornè, Michele Felice (1752–1845)
Landing of the Pilgrims
c. 1803–07, oil on canvas
36 x 52¼ in (91.4 x 132.7 cm)
Gift of Mr. and Mrs. John P. Humes
984.1548.1

Corsini, Raffaele (active 1830–60)
Bark Nonpareil
1860, watercolor on paper
19¹¹⁄₁₆ x 26⅝ in (50 x 67.6 cm)
Signed lower right: Raffaele Corsini;
inscribed lower edge: BARK "NONPAREIL"
W.W. FLINN, ENTERING SMYRNA 9 DECEMBER 1860.
Gift of Mr. and Mrs. Joel Barlow
971.808.3

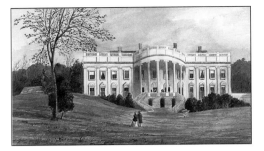

Cranstone, Lefevre J. (active 1845–67)
President's House, Washington
1860, watercolor on paper
7¹⁄₁₆ x 12⁷⁄₁₆ in (17.9 x 31.6 cm)
Inscribed lower left on mount:
The Presidents' House Washington
Gift of Wilmarth Lewis in memory of
Mrs. Annie Burr Lewis
961.28.2

Cranstone, Lefevre J. (active 1845–67)
Railway Station, Washington
1860, watercolor on paper
6⅛ x 13⅛ in (15.6 x 33.3 cm)
Inscribed lower left on mount:
Railway Station, Washington
Gift of Wilmarth Lewis in memory of
Mrs. Annie Burr Lewis
961.28.1

Cropsey, Jasper Francis (1823–1900)
Autumn Landscape on the Hudson River
1876, oil on canvas
24⅛ x 44³⁄₁₆ in (61.3 x 112.2 cm)
Signed and dated on rock, lower left:
J. F Cropsey/1876
Gift of Mr. and Mrs. John C. Newington
972.880.1

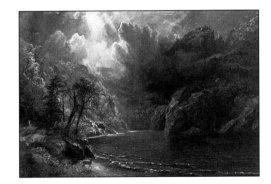

Cropsey, Jasper Francis (1823–1900)
Deer by a Lake
1870, oil on canvas
15⅞ x 22⁵⁄₁₆ in (40.3 x 56.7 cm)
Signed and dated lower left:
J.F. Cropsey/1870
Gift of M. R. Schweitzer
962.285.1

Cropsey, Jasper Francis (1823–1900)
The Mellow Autumn Time
1884–97, oil on canvas
42¹/₁₆ x 72⅛ in (106.8 x 183.2 cm)
Signed and dated lower right:
J. F Cropsey/1884–97
Gift of Mr. and Mrs. John C. Newington
972.879.1

Cropsey, Jasper Francis (1823–1900)
A Mountain Glimpse
1854, oil on canvas
25⅛ x 38⅛ in (63.8 x 96.8 cm)
Signed and dated lower right:
J.F Cropsey./1854
Gift of Mrs. A. S. Chisholm
962.180.1

Cropsey, Jasper Francis (1823–1900)
Under the Palisades, in October
1895, oil on canvas
60 x 48 in (152.4 x 121.9 cm)
Signed and dated lower right: J. F. Cropsey 1895;
signed, dated, and inscribed on a label on the
stretcher: Under the Palisades, in
October/(opposite Hastings)/By J.F. Cropsey
N.A. 1895/Hastings-upon-Hudson/N.Y.
Gift of Mr. and Mrs. John C. Newington
973.985.1

Curtis, Calvin (1822–1893)
James Abram Garfield (1831–1881)
1881, oil on canvas on fiberboard
38 x 30⅞ in (96.5 x 78.4 cm)
Signed and dated lower right:
C. Curtis, 1881.
Gift of James Rudolph Garfield
945.1499.1

Cutts, Mary Estelle Elizabeth (1814–1856),
attributed to
Dolley Payne Todd Madison (1768–1849)
(Mrs. James Madison)
c. 1840, watercolor on paper
5¼ x 4¾ in (13.3 x 12.1 cm)
Inscribed on reverse: This was given to
my grandmother Clifford as a token of
friendship by Dolley Madison.
Gift of Miss Julia B. Whiting
962.355.1

Dallin, Cyrus Edwin (1861–1944)
Gorham Company (foundry)
Appeal to the Great Spirit
c. 1916, bronze
21¼ x 21¾ x 14½ in (54 x 55.2 x 36.8 cm)
Signed and dated on base top front right:
C.E. Dallin 1913.; foundry stamps on base edge
right rear: GORHAM CO. FOUNDERS/G wolf C
[boxed]/QPN 2_[illegible].
Gift of The Barra Foundation, Inc.
991.1694.1

Davey, Randall (1887–1964)
Jerome, Arizona—Early Morning
c. 1954, oil on paper
21⅛ x 25¼ in (53.7 x 64.1 cm)
Signed lower left: Randall Davey
Gift of the Committee to Preserve
the Randall Davey Estate
978.1387.1

De Cossio, Felix (1913–)
Elizabeth (Betty) Bloomer Ford (1918–)
(Mrs. Gerald R. Ford)
1977, oil on canvas
36 x 30 in (91.4 x 76.2 cm)
Signed lower left: FELIX DE COSSIO
Gift of the White House Historical Association
978.1374.1

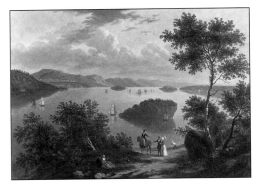

De Grailly, Victor (1804–1889), attributed to
after **William Henry Bartlett** (1809–1854),
c. 1836–37
Eastport and Passamaquoddy Bay
c. 1845, oil on canvas
16¹⁵⁄₁₆ x 23½ in (43 x 59.7 cm)
White House Acquisition Fund
973.979.1

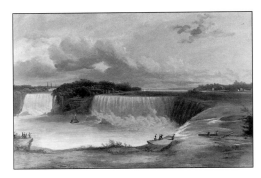

De Grailly, Victor (1804–1889), attributed to
Niagara Falls From the Canadian Side
c. 1845, oil on canvas
19¼ x 28⅞ in (48.9 x 73.3 cm)
Gift of the White House Historical Association
975.1168.1

Doctoroff, John (1894–1970)
Herbert Clark Hoover (1874–1964)
1931, oil on canvas
30⅜ x 25¼ in (77.2 x 64.1 cm)
Signed and dated lower left:
John Doctoroff/–1931–;
inscribed on reverse: John Doctoroff/
1515 PALMOLIVE/BLDG./CHICAGO
Gift of the artist to President Herbert Hoover
931.2686.1

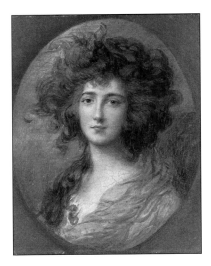

Dupont, Gainsborough (?–?), attributed to
after **Thomas Gainsborough** (1727–1788), c. 1785
Mrs. Richard Brinsley Sheridan (1754–1792)
c. 1785, oil on panel
5⅝ x 4 in (14.3 x 10.2 cm)
Gift of Mrs. Messmore Kendall
974.1122.1

Durand, Asher Brown (1796–1886)
The Indian's Vespers
1847, oil on canvas
46⅛ x 62¼ in (117.2 x 158.1 cm)
Signature, lower right, now virtually illegible;
the date has disappeared
Gift of the Alfred and Viola Hart Foundation
963.506.1

Durrie, George Henry (1820–1863)
Farmyard in Winter
1858, oil on canvas
26 x 36⅛ in (66 x 91.8 cm)
Signed and dated lower right:
G. HDurrie/1858
Gift of the Richard King Mellon Foundation
971.804.1

Durrie, George Henry (1820–1863)
Going to Church
1853, oil on canvas
22 x 30⅛ in (55.9 x 76.5 cm)
Signed and dated on reverse:
G. HDurrie [HD in monogram] Pinxt/1853
Gift of George Frelinghuysen
963.504.1

Durrie, George Henry (1820–1863)
Jones' Inn—Winter
1853, oil on canvas
18 x 24 in (45.7 x 61 cm)
Signed and dated on reverse:
G. HDurrie [HD in monogram] Pinxt,/Oct 1853
Gift of the White House Historical Association
977.1317.1

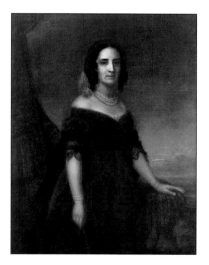

Dury, George (1817–1894)
after **George P. A. Healy** (1813–1894), 1846
Sarah Childress Polk (1803–1891)
(Mrs. James Knox Polk)
1883, oil on canvas
50⅜ x 40³⁄₁₆ in (128 x 102.1 cm)
Signed and dated on reverse lower right:
G. Dury/1883
Gift of the Ladies of Tennessee
883.1528.1

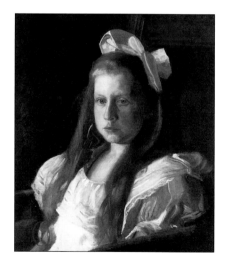

Eakins, Thomas Cowperthwaite (1844–1916)
Ruth
(Ruth W. Harding) (1893–1944)
1903, oil on canvas
24³⁄₁₆ x 20¼ in (61.4 x 51.4 cm)
Inscribed, signed, and dated on reverse:
LAURA K. HARDING/FROM/
THOMAS EAKINS/1903
Gift of Joseph H. Hirshhorn
967.595.1

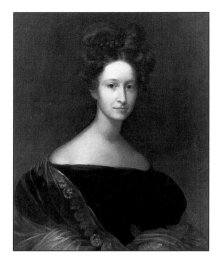

Earl, Ralph Eleaser Whiteside (c. 1788–1838),
attributed to
Emily Donelson (1807–1836)
(Mrs. Andrew Jackson Donelson)
1830, oil on canvas
30³⁄₁₆ x 25⅛ in (76.7 x 63.8 cm)
Gift of Pauline Wilcox Burke
946.1541.1

Earl, Ralph Eleaser Whiteside (c. 1788–1838)
Andrew Jackson (1767–1845)
c. 1835, oil on canvas
30 x 25 in (76.2 x 63.5 cm)
Gift of the White House Historical Association
977.1324.1

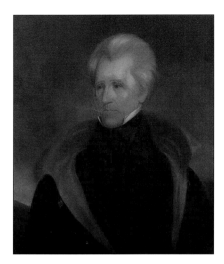

Edouart, Auguste (1789–1861)
Jobina Hallowell (?–?)
1841, cut paper silhouette on
watercolor on paper
9⅛ x 6 in (23.2 x 15.2 cm)
Signed and dated lower left:
Aug. Edouart fecit/1841
Gift of Mrs. Stanley M. Straus
967.598.7

Edouart, Auguste (1789–1861)
Commodore Uriah P. Levy (1792–1862)
1842, cut paper silhouette on
charcoal on paper
11¹⁄₁₆ x 7⁷⁄₁₆ in (28.1 x 18.9 cm)
Signed and dated lower right:
Aug. Edouart, fecit 1842./Saratoga Springs
Gift of Mrs. Stanley M. Straus
967.598.9

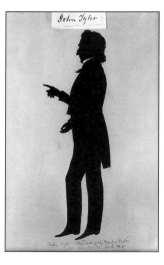

Edouart, Auguste (1789–1861)
John Tyler (1790–1862)
c. 1841, cut paper silhouette
10⅛ x 8¾ in (25.7 x 22.2 cm)
Gift of Mrs. Neville Jackson
911.3003.1

Edouart, Auguste (1789–1861)
Samuel Weston and Lige (?–?)
c. 1840, cut paper silhouette on
watercolor on paper
8¼ x 8¼ in (21 x 21 cm)
Signed lower right: Augt. Edouart - fecit
Gift of Mrs. Stanley M. Straus
967.598.6

Edouart, Auguste (1789–1861)
Master Samuel Wharton (?–?)
1842, cut paper silhouette on
watercolor on paper
6³⁄₁₆ x 5⅛ in (15.7 x 13 cm)
Signed and dated lower left:
Aug. Edouart/Boston/1842
Gift of Mrs. Stanley M. Straus
967.598.4

Edouart, Auguste (1789–1861)
Unknown Female Subject
1842, cut paper silhouette on lithograph
11¹⁄₁₆ x 7⁷⁄₁₆ in (28.1 x 18.2 cm)
Signed and dated lower left:
Aug. Edouart, fecit 1842./Boston V.O.[?]
Gift of Mrs. Stanley M. Straus
963.478.4

Ellis, Fremont F. (1897–1985)
Mountain Landscape—
El Rancho de San Sebastian—Santa Fe
c. 1930, oil on canvas
23⅞ x 29⅞ in (60.7 x 75.9 cm)
Signed lower right: FREMONT F ELLIS
Gift of Mr. and Mrs. John Dimick
981.1463.1

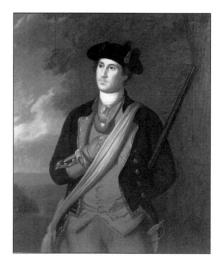

Epstein, Jacob (1880–1959)
Winston Spencer Churchill (1874–1965)
1946, bronze
11⅞ x 7 x 9 in (30.2 x 17.8 x 22.9 cm)
Gift of the Wartime Friends of
Winston Churchill
965.577.1

Field, Robert (c. 1769–1819)
William Thornton (1759–1828)
c. 1800, watercolor on ivory
2¹⁵⁄₁₆ x 2⅜ in (7.5 x 6 cm) oval
Gift of Mrs. Henry H. Flather
929.2992.1

Fischer, Ernst (1815–1874)
after **Charles Willson Peale** (1741–1827), 1772
George Washington (1732–1799)
c. 1850–52, oil on canvas
49 x 40½ in (124.5 x 102.9 cm)
Signed upper right: E. Fischer/
from the Original by/Chas. W. Peal [*sic*];
inscribed on reverse:
Col. Washington/[age?] 40
Gift of Robert E. Lee IV and
Mrs. A. Smith Bowman
976.1278.1

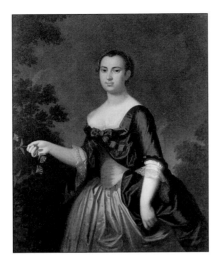

Fischer, Ernst (1815–1874)
after **John Wollaston** (c. 1710–c. 1767), 1757
Martha Dandridge Custis Washington
(1731–1802)
(Mrs. George Washington)
c. 1850–52, oil on canvas
49½ x 40½ in (125.7 x 102.9 cm)
Signed upper right: E. Fischer/
from the Original by/Wollaston;
inscribed on reverse: Martha Washington/
E Fischer
Gift of Robert E. Lee IV and
Mrs. A. Smith Bowman
976.1279.1

Fisher, Alvan (1792–1863)
Indian Guides
1849, oil on canvas
36 x 44³⁄₁₆ in (91.4 x 112.2 cm)
Signed and dated lower center:
AFisher [AF in monogram]/1849
Gift of the Nathaniel Saltonstall Arts Fund
962.186.1

Fisher, Alvan (1792–1863)
Pastoral Landscape
1854, oil on canvas
24¹⁄₁₆ x 20¹⁄₁₆ in (61.1 x 51 cm)
Signed and dated on rock, lower left:
AF [in monogram]/1854
White House Acquisition Fund
973.974.1

Folsom, E. (?–?)
House in New England
late 19th century–early 20th century,
oil on canvas
27⅛ x 24¼ in (68.9 x 61.6 cm)
Gift of Malcolm W. Vallance
974.1133.1

Folsom, E. (?–?)
Wild Flowers
late 19th century–early 20th century,
oil on canvas
27¹⁄₁₆ x 24¹⁄₁₆ in (68.7 x 61.1 cm)
Signed lower right: E. Folsom.
Gift of Malcolm W. Vallance
974.1132.1

Fragonard, Jean-Honoré (1732–1806)
To the Genius of Franklin
c. 1778, pencil and sepia wash on paper
21⅜ x 17⅛ in (54.9 x 43.5 cm)
Signed lower right: fragonard;
inscribed lower border: Eripuit Ceolo
Fulmen Siptrum Tyranis/Frankelin [*sic*]
Gift of Georges Wildenstein
961.2.1

Francklyn, Mary Brenda (1878–1971)
Lucretia Rudolph Garfield (1832–1918)
(Mrs. James A. Garfield)
c. 1913–18, watercolor on ivory
3⅜₁₆ x 3¹₁₆ in (8.1 x 7.8 cm) oval
Gift of the artist
971.751.1

Fraser, James Earle (1876–1953)
Theodore Roosevelt (1858–1919)
c. 1920, bronze
9¼ x 10½ x 8 in (23.5 x 26.7 x 20.3 cm)
Signed under left shoulder:
FRASER/©
Gift of Mr. and Mrs. Saul Lerner
971.708.1

Fraser, Laura Gardin (1889–1966)
Timmy (Tiny Tim) (c. 1926–?)
1929, bronze
8½ x 7¼ x 5¼ in (21.6 x 18.4 x 13.3 cm)
Signed and dated on base left rear:
© LAVRA GARDIN FRASER/1929/
TO CHARLES MOORE; inscribed on base front:
"TIMMY"/FOR/MRS. CALVIN COOLIDGE
Gift of Charles Moore
937.1174.1

Glackens, William James (1870–1938)
Bouquet With Ferns
1920–25, oil on canvas
24 x 20¹₁₆ in (61 x 51 cm)
Gift of Ira Glackens
968.628.3

Glackens, William James (1870–1938)
Carl Schurz Park, New York
c. 1922, oil on canvas
18 x 24¹₁₆ in (45.7 x 61.1 cm)
Signed lower right: W.G.
Gift of Ira Glackens
968.628.1

Glackens, William James (1870–1938)
Clove Pond
c. 1916, oil on canvas
18 x 24 in (45.7 x 61 cm)
Signed lower right: W.Glackens;
inscribed on stretcher in pencil:
CLOVE POND W. GLACKENS 10 W 9th ST N.Y. City
Gift of Ira Glackens
968.628.4

Glackens, William James (1870–1938)
Pavilion at Gloucester
1919, oil on canvas
12⅜ x 15½ in (31 x 39.4 cm)
Signed lower right: WG
Gift of Ira Glackens
968.628.2

Grant, Gordon Hope (1875–1962)
U. S. S. **Constitution**
1926, oil on canvas
34⅜ x 42⅛ in (87.1 x 106.8 cm)
Signed and dated lower left:
Gordon Grant/1926
Gift of the National Save
the Old Ironsides Committee
930.4103.1

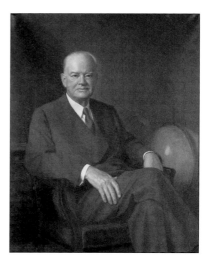

Greene, Elmer Wesley (1907–1964)
Herbert Clark Hoover (1874–1964)
1956, oil on canvas
50⅛ x 40⅛ in (127.3 x 101.9 cm)
Signed and dated lower left:
Elmer Wesley Greene 1956
Gift of Herbert Hoover
956.3412.1

Gros, Antoine Jean (1771–1835), attributed to
Jérôme Bonaparte (1784–1860)
1807, oil on canvas
18 x 14¾ in (45.7 x 37.5 cm)
Acquisition undocumented
960.3826.1

Guérin, Jules (1866–1946)
South Front of the White House
1903, pencil on canvas on board
20 x 29¼ in (50.8 x 74.3 cm)
Signed lower right: Jules Guerin
Gift of the White House Historical Association
in memory of T. Sutton Jett
990.1668.1

Hahn, Carl William (1829–1887)
A Day at the Seashore
c. 1872–78, oil on canvas
24⅞ x 39⅞ in (63.2 x 101.3 cm)
Signed lower right: Wm Hahn/San Francisco
Gift of the White House Historical Association
979.1400.1

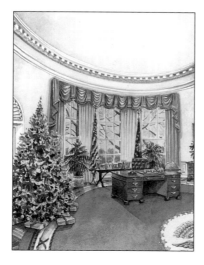

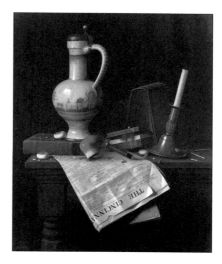

Hampton, Mark Iredell (1940–)
Green Room, The White House
1983, watercolor on paper
9¾ x 7⅛ in (24.8 x 18.1 cm)
Signed lower right: Mark Hampton
Gift of the artist
988.1639.1

Hampton, Mark Iredell (1940–)
The Oval Office, The White House
1990, watercolor on paper
9¼ x 8³⁄₁₆ in (23.5 x 20.8 cm)
Signed lower left: Mark Hampton
Gift of the artist
991.1690.1

Harnett, William Michael (1848–1892)
The Cincinnati Enquirer
1888, oil on canvas
30 x 25 in (76.2 x 63.5 cm)
Signed and dated lower left:
WMHARNETT. [WMH in monogram]/1888.;
stenciled on reverse: 9/88
Gift of the Armand Hammer Foundation
978.1382.1

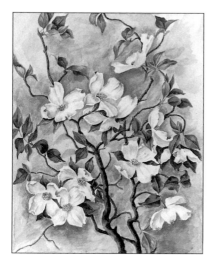

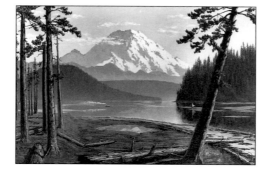

Harrison, Caroline Scott (1832–1892)
(Mrs. Benjamin Harrison)
Flowering Dogwood
c. 1889–92, watercolor on paper
12⅞ x 10⅜ in (32.7 x 26.4 cm)
Gift of the Arthur Jordan Foundation
965.541.1

Harrison, Thomas Alexander (1853–1930)
Mt. Rainier, State of Washington
late 19th century–early 20th century, oil on canvas
28¾ x 43¼ in (73 x 109.9 cm)
Signed lower right: T A Harrison
Gift of Mrs. Elizabeth L. Williams
977.1320.1

Hart, Joel Tanner (1810–1877)
Henry Clay (1777–1852)
c. 1850–60, Parian ware
15¾ x 7¾ x 4¾ in (40 x 19.7 x 12.1 cm)
Gift of Mrs. William S. Paley
962.213.3

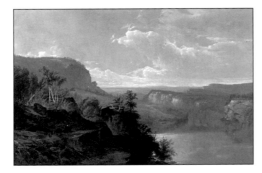

Hart, William M. (1823–1894)
Lake Among the Hills (Lake Mohonk)
1858, oil on canvas
40⅛ x 60¼ in (101.9 x 153 cm)
Signed and dated lower left: WM. HART 58
Gift of the White House Historical Association
976.1225.1

Hassam, Frederick Childe (1859–1935)
The Avenue in the Rain
1917, oil on canvas
42 x 22 ¼ in (106.7 x 56.5 cm)
Signed and dated lower left:
Childe Hassam/February 1917;
on reverse, lower center: C.H. [circled]/
February 1917
Gift of T. M. Evans
963.422.1

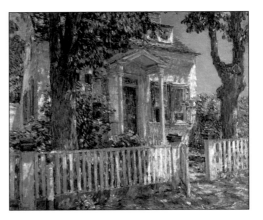

Hassam, Frederick Childe (1859–1935)
Colonial Cottage, Cos Cob
1902, oil on canvas
25 x 30 in (63.5 x 76.2 cm)
Signed and dated lower left:
Childe Hassam 1902
Gift of the White House Historical Association
975.1183.1

Hassam, Frederick Childe (1859–1935)
South Front of the White House
1916, pencil on paper
5¹⁄₁₆ x 7⅞ in (12.9 x 20 cm)
Signed and dated lower right:
CH/Washington/Dec 7th 1916
Gift of Charles E. Bennett
965.582.1

Hassam, Frederick Childe (1859–1935)
Telegraph Hill
1914, oil on canvas
24⅛ x 24⅛ in (61.3 x 61.3 cm)
Signed and dated lower right:
Childe Hassam 1914; inscribed
on reverse: C.H [circled] and 1914 [circled]
Gift of Mr. and Mrs. John Dimick
981.1464.1

Havell, Robert, Jr. (1793–1878)
West Point Near Garrisons
1850, oil on canvas
29⅞ x 40³⁄₁₆ in (75.9 x 102.1 cm)
Inscribed on reverse:
West Point near Garrisons by Robert Havell
Gift of Mrs. Lila Acheson Wallace
972.885.1

Heade, Martin Johnson (1819–1904)
Florida Sunrise
c. 1890–1900, oil on canvas
28 x 54⅛ in (71.1 x 137.5 cm)
Signed lower left: M J Heade
Gift of Mrs. Jean Flagler Matthews
977.1318.1

Heade, Martin Johnson (1819–1904)
Red Roses and Green Leaves
c. 1903, oil on canvas
10⅟₁₆ x 15⅟₁₆ in (25.6 x 38.3 cm)
Signed lower right: M J Heade
Gift of Ernest Rosenfeld
962.261.1

Heade, Martin Johnson (1819–1904)
Sailing off the Coast
1869, oil on canvas
15⅛ x 29⅛ in (38.4 x 74 cm)
Signed and dated lower left: HEADE/1869
Gift of the White House Historical Association
980.1426.1

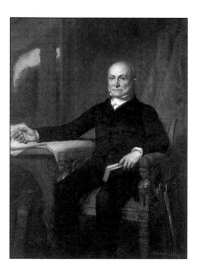

Healy, George Peter Alexander (1813–1894)
John Quincy Adams (1767–1848)
1858, oil on canvas
62 x 47 in (157.5 x 119.4 cm)
Signed and dated lower right:
G.P.A. Healy, 1864.;
inscribed on reverse: John Quincy Adams./
Painted in Chicago./July 21, 1858. -by-/
Geo. P.A. Healy.
U. S. government purchase
858.1354.1

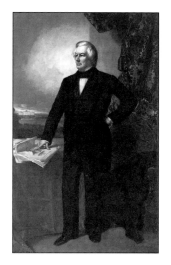

Healy, George Peter Alexander (1813–1894)
Millard Fillmore (1800–1874)
1857, oil on canvas
94⅛ x 58 in (239.1 x 147.3 cm)
Signed and dated lower right:
G.P.A. Healy, pinx/1857.;
inscribed on reverse: President Fillmore,
Aged 57/painted by G.P.A. Healy/
February 16, 1857
U. S. government purchase
858.1531.1

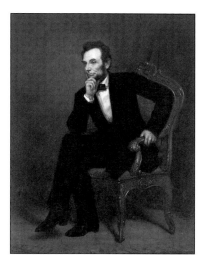

Healy, George Peter Alexander (1813–1894)
Abraham Lincoln (1809–1865)
1869, oil on canvas
73¾ x 55⅝ in (187.3 x 141.3 cm)
Signed and dated lower left:
G.P.A. Healy/1869
Bequest of Mrs. Robert Todd Lincoln
939.1388.1

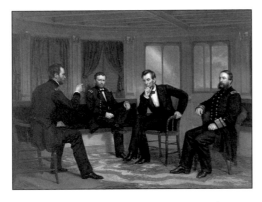

Healy, George Peter Alexander (1813–1894)
The Peacemakers
1868, oil on canvas
47⅛ x 62⅝ in (119.7 x 159.1 cm)
U. S. government purchase
947.2558.1

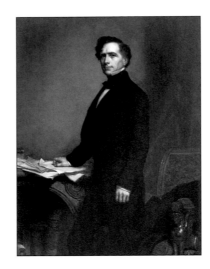

Healy, George Peter Alexander (1813–1894)
Franklin Pierce (1804–1869)
1858, oil on canvas
62³⁄₁₆ x 47⅛ in (158 x 119.7 cm)
Signed and dated lower left:
G.P.A. HEALY, PINXT./CHICAGO 1858.;
inscribed on reverse: Ex President/
Franklin Pierce./Painted in Chicago/
May 15, 1858/by-/Geo. P.A. Healy.
U. S. government purchase
858.1133.1

Healy, George Peter Alexander (1813–1894)
James Knox Polk (1795–1849)
1858, oil on canvas
62¹⁄₁₆ x 47⅛ in (157.6 x 119.7 cm)
Inscribed on reverse:
Ex–President James K. Polk painted by
G.P.A. Healy/October 7, 1858 at Chicago
U. S. government purchase
858.1335.1

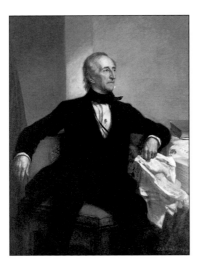

Healy, George Peter Alexander (1813–1894)
John Tyler (1790–1862)
1859, oil on canvas
62 x 47⅛ in (157.5 x 119.7 cm)
Signed and dated lower right:
G.P.A.Healy. 1864.
U. S. government purchase
859.1403.1

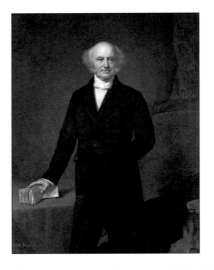

Healy, George Peter Alexander (1813–1894)
Martin Van Buren (1782–1862)
1858, oil on canvas
62½ x 47⅜ in (158.8 x 120.3 cm)
Signed and dated lower left: G.P.A. Healy./
1864; inscribed on reverse: President
Van Buren Age 75/painted at Lindenwald
April 12, 1858/by George P.A. Healy
U. S. government purchase
858.1336.1

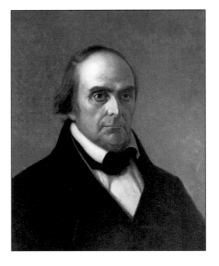

Healy, George Peter Alexander (1813–1894),
attributed to
Daniel Webster (1782–1852)
mid-19th century, oil on canvas
27⅛ x 22⅛ in (68.9 x 56.2 cm)
Gift of Louis Chandler and Vernon C. Stoneman
962.204.1

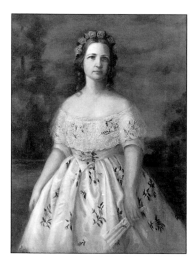

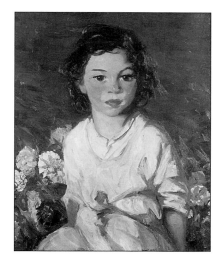

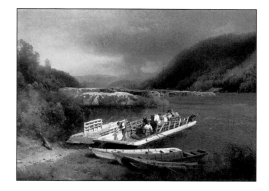

Helm, Katherine (1857–1937)
Mary Todd Lincoln (1818–1882)
(Mrs. Abraham Lincoln)
1925, oil on canvas
46 x 34⅛ in (116.8 x 86.7 cm)
Signed lower left: K Helm
Gift of Mr. and Mrs. Robert Todd Lincoln
926.1513.1

Henri, Robert (1865–1929)
Gypsy Girl With Flowers
early 20th century, oil on canvas
24 x 20 in (61 x 50.8 cm)
Signed lower right center: Robert Henri
Gift of Mr. and Mrs. William Benton
967.603.1

Herzog, Herman Ottomar (1831–1932)
Old Ferryboat at McCall's Ferry
c. 1875–80, oil on canvas
22⁷⁄₁₆ x 30⅛ in (56 x 76.5 cm)
Signed lower right: H Herzog
Gift of the White House Historical Association
975.1164.1

Hill, Thomas (1829–1908)
Yosemite, Bridal Veil Falls
1895, oil on canvas
35⁹⁄₁₆ x 54 in (90.3 x 137.2 cm)
Signed and dated lower right: T. Hill./1895.
Gift of the White House Historical Association
977.1331.1

Hill, Thomas (1829–1908)
Nevada Falls, Yosemite
1889, oil on canvas
30⅛ x 20⅛ in (76.5 x 51.1 cm)
Signed lower right: T. Hill
Gift of the White House Historical Association
973.1027.1

Hill, Thomas (1829–1908)
Vernal Falls, Yosemite
1889, oil on canvas
30 x 20ⁱ⁄₁₆ in (76.2 x 51 cm)
Signed lower right: T. Hill.
Gift of the White House Historical Association
973.1027.2

Homer, Winslow (1836–1910)
Surf at Prout's Neck
c. 1895, watercolor on paper
12¼ x 21½ in (31.1 x 54.6 cm)
Impressed estate seal lower left: WINSLOW/
HOMER; illegible impressed seal, lower right
Gift of Mr. and Mrs. George Brown
964.525.1

Hopkinson, Charles Sydney (1869–1962)
Calvin Coolidge (1872–1933)
1932, oil on canvas
55⅛ x 50⅜ in (140 x 128 cm)
Signed and dated lower left:
Charles Hopkinson 1932
U. S. government purchase
932.1417.1

Houdon, Jean-Antoine (1741–1828)
Joel Barlow (1754–1812)
c. 1804, marble
27½ x 19 x 12½ in (69.8 x 48.3 x 31.8 cm)
Gift of an anonymous donor
963.466.1

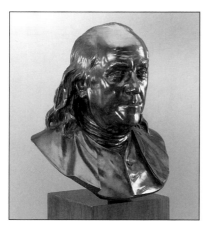

Houdon, Jean-Antoine (1741–1828)
Benjamin Franklin (1706–1790)
c. 1778–1828, bronze
15¾ x 13½ x 9 in (40 x 34.3 x 22.9 cm)
Signed on back center: houdon
Gift of J. William Middendorf II and
the White House Historical Association
980.1427.1

Huggins, William John (1781–1845)
The First Naval Action in the War of 1812
1816, oil on canvas
41¼ x 60¼ in (104.8 x 153 cm)
Signed and dated lower right:
W J Huggins. 1816
Gift of Mrs. Marshall Field
962.195.1

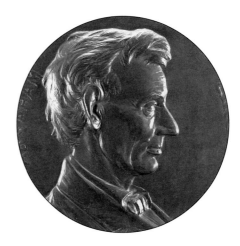

Humphriss, Charles Harry (1867–1934)
Roman Bronze Works (foundry)
Abraham Lincoln (1809–1865)
1912, bronze bas-relief
16⅜ (diam.) x 1¼ in (41.6 x 3.2 cm)
Signed and dated lower center:
ChS H. HumphriSS 1912;
marked lower edge: ROMAN BRONZE WORKS
N–Y–.; in relief on opposite sides:
ABRAHAM/LINCOLN
Gift of the White House Historical Association
975.1194.1

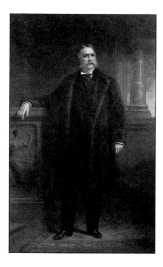

Huntington, Daniel (1816–1906)
Chester A. Arthur (1830–1886)
1885, oil on canvas
95¼ x 59¼ in (241.9 x 150.5 cm)
Signed and dated lower left:
D. Huntington/1885
U. S. government purchase
885.1530.1

Huntington, Daniel (1816–1906)
Caroline Scott Harrison (1832–1892)
(Mrs. Benjamin Harrison)
1894, oil on canvas
88½ x 54½ in (224.8 x 138.4 cm)
Signed and dated lower left:
D. Huntington/1894
Gift of the Daughters of the
American Revolution
894.1498.1

Huntington, Daniel (1816–1906)
Lucy Webb Hayes (1831–1889)
(Mrs. Rutherford B. Hayes)
1881, oil on canvas
87⅛ x 54¾ in (221.3 x 139.1 cm)
Signed and dated lower left:
D. Huntington 1881
Gift of the Woman's Christian
Temperance Union
881.1497.1

Huntington, Daniel (1816–1906)
Rutherford B. Hayes (1822–1893)
1884, oil on canvas
66³⁄₁₆ x 40⅜ in (168.1 x 102.6 cm)
Signed and dated lower left:
D. Huntington/1884
U. S. government purchase
884.1474.1

Inman, Henry (1801–1846)
Angelica Singleton Van Buren (1820–1878)
(Mrs. Abraham Van Buren)
1842, oil on canvas
42¼ x 33⅜ in (107.3 x 85.4 cm)
Signed and dated vertically on balustrade at
left: H. Inman./1842.;
inscribed on reverse: Painted by Henry Inman/
New York, 1842/Restored by H.E. Thompson/
Boston, Mass. 1932
Bequest of Travis C. Van Buren
890.2061.1

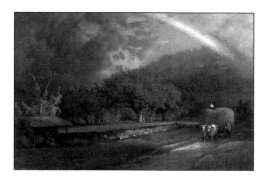

Inness, George (1825–1894)
The Rainbow in the Berkshire Hills
1869, oil on canvas
20 x 30 in (50.8 x 76.2 cm)
Signed and dated lower right: G. Inness 1869
Gift of The Rita and Taft Schreiber Foundation
972.866.1

Inness, George (1825–1894)
Woodland Pool
1891, oil on canvas
25¹⁄₁₆ x 30¹⁄₁₆ in (63.7 x 76.4 cm)
Signed and dated lower right: G. Inness 1891
Gift of the White House Historical Association
976.1226.1

Jacobsen, Antonio Nicolo Gaspara (1850–1921)
U. S. S. Galena
1909, oil on panel
22 x 35 ¾ in (55.9 x 90.8 cm)
Signed and dated lower right:
ANTONIO JACOBSEN. 1909
Gift of the Gordon Freesman family
991.1689.1

Jarvis, John Wesley (1780–1840)
after **Nathan W. Wheeler** (c. 1789–1849), 1815
Andrew Jackson (1767–1845)
c. 1817, oil on panel
25½ x 20⅞ in (64.8 x 53 cm)
Gift of Mr. and Mrs. Gerard B. Lambert
963.409.1

Jarvis, John Wesley (1780–1840)
John Marshall (1755–1835)
1825, oil on canvas
30⅜ x 25⅜ in (77.2 x 64.4 cm)
Gift of Mr. and Mrs. Samuel Newhouse
962.225.1

Jennewein, Carl Paul (1890–1978)
Paolo Romano (Jennewein)
1918, terra-cotta
10⅜ x 11 x 6¼ in (26.4 x 27.9 x 15.9 cm)
Signed and dated on base rear:
19. CPJ. 18 [CPJ in monogram];
inscribed on base front: PAOLO ROMANO
Gift of the artist to Lou Henry Hoover
(Mrs. Herbert Hoover)
929.1217.1

Johansen, John Christen (1876–1964)
Herbert Clark Hoover (1874–1964)
1941, oil on canvas
40⁹⁄₁₆ x 33⅜ in (103 x 84.8 cm)
Signed and dated lower left:
JOHN C. JOHANSEN, 1941.
U. S. government purchase
942.1416.1

Johnson, Adelaide (1846–1955)
Modern Art Foundry
Susan Brownell Anthony (1820–1906)
1972, bronze
23 x 16 x 10 in (58.4 x 40.6 x 25.4 cm)
Signed and dated on rear lower edge:
Adelaide Johnson. Washington. D. C. 1892.;
inscribed on pedestal front: SUSAN B. ANTHONY
Gift of the Citizens' Advisory Council on
the Status of Women and the Presidential Task
Force on Women's Rights and Responsibilities
973.1042.1

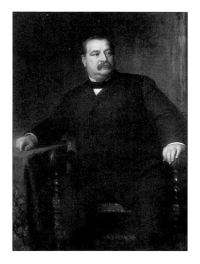

Johnson, Jonathan Eastman (1824–1906)
Grover Cleveland (1837–1908)
1891, oil on canvas
53¾ x 42⅜ in (136.5 x 107.6 cm)
Signed and dated lower left:
E. Johnson/April 1891
U. S. government purchase
891.1342.1

Johnson, Jonathan Eastman (1824–1906)
Benjamin Harrison (1833–1901)
1895, oil on canvas
60⅟₁₆ x 40 in (152.6 x 101.6 cm)
Signed and dated lower left:
E. Johnson/June 1895
U. S. government purchase
895.1476.1

Jones, Joseph John (1909–1963)
Prairie Harvest
c. 1930–50, oil on canvas
20⅛ x 25⅛ in (51.1 x 63.8 cm)
Gift of Adm. Neill Phillips
976.1257.1

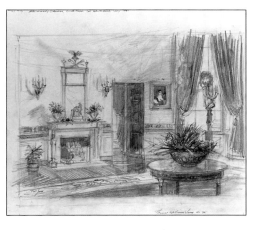

Jones, Thomas William (1942–)
Blue Room, The White House
1985, pencil on paper
14⅟₁₆ x 16⅟₁₆ in (35.7 x 42.4 cm)
Signed lower left: T.W. Jones;
inscribed and signed upper left margin:
5 [circled] 10¾ x 14¾ PRELIMINARY DRAWING,
"BLUE ROOM," THE WHITE HOUSE JULY 1985;
margin lower right: Thomas William Jones © 85
Gift of the artist
987.1612.1

Jones, Thomas William (1942–)
Blue Room, The White House
1985, pencil on paper
14⅛ x 16⅜ in (35.9 x 42.2 cm)
Signed lower left: T.W. Jones;
inscribed and signed lower left:
PRELIMINARY DRAWING, "BLUE ROOM" THE
WHITE HOUSE/Thomas William Jones JULY 1985;
margin upper right: 4 [circled] 12 x 12"
Gift of the artist
987.1612.2

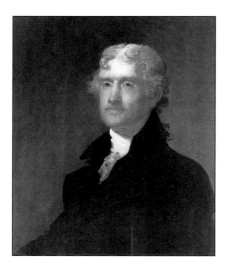

Jones, Thomas William (1942–)
Entry Hall, The White House
1987, watercolor on paper
8⅛ x 11 in (20.6 x 27.9 cm)
Signed lower left: Thomas William Jones;
signed lower margin: PRELIMINARY STUDY,
ENTRY HALL, THE WHITE HOUSE/
Thomas William Jones © 1988
Gift of the artist
988.1637.1

Jones, Thomas William (1942–)
Mirror Detail, East Room
1986, watercolor on paper
8⁵⁄₁₆ x 10¹⁄₁₆ in (21.1 x 25.6 cm)
Signed lower left: Thomas William Jones;
inscribed and signed upper margin:
"Mirror Detail" East Room Thomas William
Jones © 88
Gift of the artist
988.1630.1

Jones, Thomas William (1942–)
State Dining Room at Christmas
1987, watercolor on paper
8¹³⁄₁₆ x 9¾ in (22.4 x 24.8 cm)
Signed lower right: T.W. Jones; inscribed and
signed upper left margin: 2 [inverted and circled]
5½ x 7¼ /6¼ x 8" 10¼ x 12"/
Thomas William Jones © 1987;
backing, reverse upper right: PRELIMINARY
STUDY,/"STATE ROOM AT CHRISTMAS",
THE WHITE HOUSE./© 1987
Thomas William Jones
Gift of the artist
987.1612.3

Jouett, Matthew Harris (1788–1827)
after **Gilbert Stuart** (1755–1828), 1805
Thomas Jefferson (1743–1826)
c. 1817–27, oil on panel
26⅜ x 21⁷⁄₁₆ in (67 x 54.4 cm)
U. S. government purchase
874.2554.1

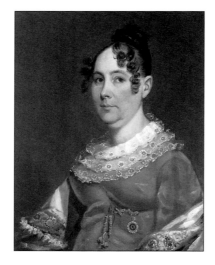

Jouett, Matthew Harris (1788–1827),
attributed to
Lucy Payne Washington Todd (1777–1846)
(Mrs. Thomas Todd)
c. 1817–20, oil on panel
26¾ x 21¾ in (68 x 55.2 cm)
Gift of Robert Haskins
974.1125.1

Judson, Sylvia Shaw (1897–1978)
Roman Bronze Works (foundry)
Gardener
1929, bronze
49½ x 15 x 12½ in (125.7 x 38.1 x 31.8 cm)
Gift of Mr. and Mrs. Paul Mellon
964.593.1

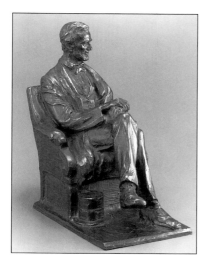

Juszko, Jeno (1880–1954)
American Art Foundry
Abraham Lincoln (1809–1865)
1925, bronze
15 x 6⅝ x 10¹¹⁄₁₆ in (38.1 x 16.8 x 27.2 cm)
Signed and dated at right on chair:
J Juszko/1925/©;
marked on rear right: AMER. ART FDRY. N.Y.
Gift of Bernard C. Heyn
955.3757.1

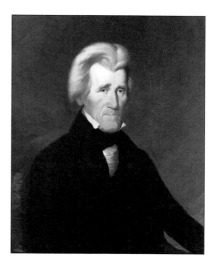

Keck, Charles (1875–1951)
Roman Bronze Works (foundry)
Harry S. Truman (1884–1972)
1947, bronze
15 x 10 x 6⅝ in (38.1 x 25.4 x 16.8 cm)
Signed on right shoulder: C. KECK;
marked on rear lower left:
ROMAN BRONZE WORKS INC.
Gift of the American Legion
947.4104.1

Kellogg, Miner Kilbourne (1814–1889),
attributed to
Andrew Jackson (1767–1845)
c. 1840, oil on canvas
29½ x 24⅝ in (74.9 x 62.6 cm)
Acquisition undocumented
960.1542.1

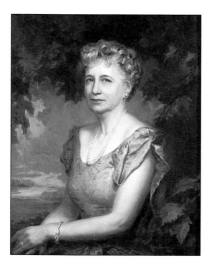

Kempton, Martha Greta (1903–1991)
Elizabeth (Bess) Wallace Truman (1885–1982)
(Mrs. Harry S. Truman)
1967, oil on canvas
32 x 26 in (81.3 x 66 cm)
Signed and dated on reverse:
Greta Kempton/1967;
lower right on front: Greta Kempton/1952.
Gift of the White House Historical Association
967.610.1

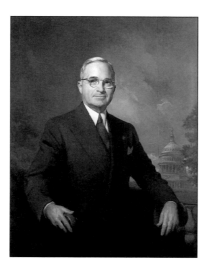

Kempton, Martha Greta (1903–1991)
Harry S. Truman (1884–1972)
1947, oil on canvas
50 x 40 ¼ in (127 x 102.2 cm)
Signed and dated lower left:
Greta Kempton/1947.
Gift of anonymous donors
953.3413.1

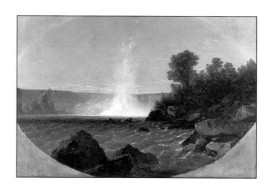

Kensett, John Frederick (1816–1872)
Niagara Falls
c. 1852–54, oil on canvas
32¾ x 48¹⁄₁₆ in (83.2 x 122.1 cm)
Gift of Mr. and Mrs. James W. Fosburgh
961.158.3

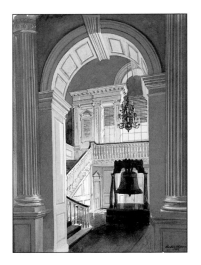

Ketterer, Gustav (1870–1953)
The Liberty Bell, Independence Hall
1932, watercolor on paper
28 x 21¹³⁄₁₆ in (71.1 x 55.4 cm)
Signed and dated lower right:
Gustav Ketterer/1932
Gift of the artist to Lou Henry Hoover
(Mrs. Herbert Hoover)
932.1443.1

King, Charles Bird (1785–1862)
Hayne Hudjihini (Eagle of Delight), Oto
c. 1822, oil on panel
17½ x 13⅞ in (44.4 x 35.2 cm)
Inscribed on upper reverse: No.4/Eagle
of Delight/Wife to the Ottoe Half Chief;
inscribed on reverse center: No 4/Ottoe
Half Chief/Wife of/Oto Warrior.
Gift of Sears, Roebuck & Company
962.394.4

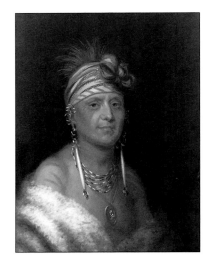

King, Charles Bird (1785–1862)
Monchousia (White Plume), Kansa
c. 1822, oil on panel
17½ x 13¹³⁄₁₆ in (44.4 x 35.1 cm)
Illegibly inscribed on upper reverse;
inscribed on lower reverse: No 5/
Woni–pa–wa–ra–/Great Chief of
The Kanzra's [*sic*].
Gift of Sears, Roebuck & Company
962.394.5

King, Charles Bird (1785–1862)
Petalesharro (Generous Chief), Pawnee
c. 1822, oil on panel
17½ x 13¹³⁄₁₆ in (44.4 x 35.1 cm)
Illegibly inscribed on upper reverse
Gift of Sears, Roebuck & Company
962.394.3

King, Charles Bird (1785–1862)
Sharitarish (Wicked Chief), Pawnee
c. 1822, oil on panel
17⁷⁄₁₆ x 13¹³⁄₁₆ in (44.6 x 35.1 cm)
Inscribed on upper reverse: No. 2/Wicked
Chief Great Pawnee; inscribed on reverse
center: No.2/Tarrare–ca–wako or Long Hair./
"Wicked Chief Great Pawnee."
Gift of Sears, Roebuck & Company
962.394.2

King, Charles Bird (1785–1862)
Shaumonekusse (Prairie Wolf), Oto
c. 1822, oil on panel
17½ x 13½ in (44.4 x 34.3 cm)
Inscribed on upper reverse: Ottoe Half Chief
Gift of Sears, Roebuck & Company
962.394.1

Kinsburger, Sylvain (1855–?)
Angler
late 19th century, bronzed metal
29½ x 9¾ x 10¼ in (74.9 x 24.8 x 26 cm)
Marked on base rear: S KINSBURGER;
front plaque: Pecheur a la Ligne
U. S. government purchase
960.1160.1

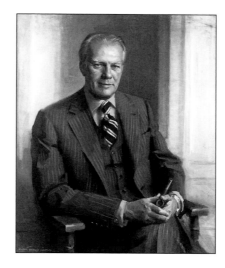

Kinstler, Everett Raymond (1926–)
Gerald Rudolph Ford (1913–)
1977, oil on canvas
40 x 34 in (101.6 x 86.4 cm)
Signed and dated lower left:
EVERETT RAYMOND KINSTLER./1977
Gift of the White House Historical Association
978.1373.1

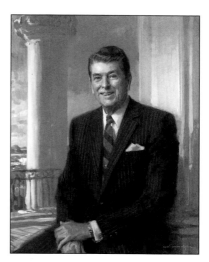

Kinstler, Everett Raymond (1926–)
Ronald Wilson Reagan (1911–)
1991, oil on canvas
50⅛ x 40⅛ in (127.3 x 101.9 cm)
Signed and dated lower right:
EVERETT RAYMOND KINSTLER. /1991
Gift of Mr. and Mrs. Joe L. Allbritton
991.1693.1

Köllner, Augustus (1813–1906)
Valley Forge
1884, watercolor on paper
21⅞ x 29¹³⁄₁₆ in (55.6 x 75.7 cm)
Signed and dated lower center:
A. Kollner fect/1844-/1884;
lower right: VALLEY FORGE./PA.
Gift of Mr. and Mrs. Robert W. Hompe
962.283.1

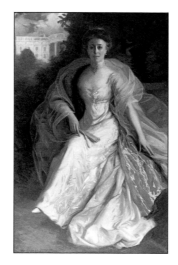

Kronstrand, Karl Bror Albert (1875–1950)
Helen Herron Taft (1861–1943)
(Mrs. William Howard Taft)
1910, oil on canvas
76¼ x 46¼ in (193.7 x 117.5 cm)
Signed and dated lower left:
B. Kronstrand/1910
Gift of Charles P. Taft
943.1475.1

Kuhn, Edward C. (1872–1948)
President's Flag 1882
c. 1920–31, watercolor on paper
14¹¹⁄₁₆ x 11⅜ in (37.3 x 29.5 cm)
Gift of Maj. Gen. M. C. Demler
971.783.1

Kuhn, Edward C. (1872–1948)
President's Flag 1902
c. 1920–31, watercolor on paper
14⁹⁄₁₆ x 11½ in (37 x 29.2 cm)
Gift of Maj. Gen. M. C. Demler
971.783.4

Kuhn, Edward C. (1872–1948)
President's Standard July 24th 1912
c. 1920–31, watercolor on paper
14⅝ x 11½ in (37.2 x 29.2 cm)
Gift of Maj. Gen. M. C. Demler
971.783.5

Kuhn, Edward C. (1872–1948)
President's Standard March 28th 1898
c. 1920–31, watercolor on paper
14⁹⁄₁₆ x 11¹¹⁄₁₆ in (37 x 29.7 cm)
Gift of Maj. Gen. M. C. Demler
971.783.2

Kuhn, Edward C. (1872–1948)
President's Standard May 29th 1916
c. 1920–31, watercolor on paper
14⅝ x 11⁹⁄₁₆ in (37.2 x 29.4 cm)
Gift of Maj. Gen. M. C. Demler
971.783.6

Kuhn, Edward C. (1872–1948)
President's Standard 1902
c. 1920–31, watercolor on paper
14⁹⁄₁₆ x 11¹¹⁄₁₆ in (37 x 29.7 cm)
Gift of Maj. Gen. M. C. Demler
971.783.3

Lamb, Adrian (1901–1989)
after **Gilbert Stuart** (1755–1828), c. 1818–20
James Monroe (1758–1831)
1975, oil on canvas
40¼ x 32⅞ in (102.2 x 82.4 cm)
Inscribed on reverse: -COPY by-/ADRIAN LAMB/
-1975-/FROM THE ORIGINAL by/GILBERT
STUART/IN THE METROPOLITAN. MUSEUM/
OF ART-NEW YORK-N.Y.
White House Acquisition Fund
975.1171.1

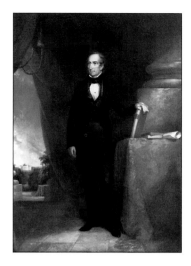

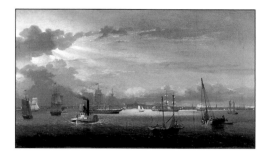

Lane, Fitz Hugh (1804–1865)
Boston Harbor
1854, oil on canvas
23¼ x 39¼ in (59.1 x 99.7 cm)
Signed and dated lower right: F H Lane/1854
Gift of Mr. and Mrs. Lew Wasserman
963.507.1

Lambdin, James Reid (1807–1889)
William Henry Harrison (1773–1841)
1835, oil on canvas
30 x 25 in (76.2 x 63.5 cm)
Inscribed on reverse: Original Portrait of/
Genl Wm Harrison/painted at Cincinnati, O./
Octr. 1835/by J R Lambdin.
Gift of the White House Historical Association
978.1383.1

Lambdin, James Reid (1807–1889)
John Tyler (1790–1862)
1841, oil on canvas
35⅝ x 25⅞ in (90.5 x 65.7 cm)
Signed and dated lower right:
JR LAMBDIN [JR in monogram] Pinxit/1841;
inscribed on reverse: Portrait of/
John Tyler/President of the U. S./
Painted by J R Lambdin/Philadelphia/1841./
The original head finished at Washington
City/June 22. 1841.
Gift of Mrs. Charles S. Payson
971.677.1

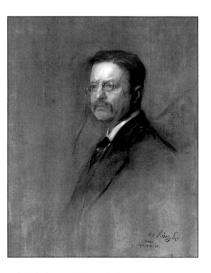

László de Lombos, Philip Alexius de
(1869–1937)
The Clock Room, Quai d'Orsay
1928, oil on canvas
55 x 38½ in (139.7 x 97.8 cm)
Signed and dated lower right:
de László/1928 PARIS
Gift of the artist
928.2517.1

László de Lombos, Philip Alexius de
(1869–1937)
Florence Kling Harding (1860–1924)
(Mrs. Warren Harding)
1921, oil on canvas
32 x 22 in (81.3 x 55.9 cm)
Signed and dated lower right:
de László/.The White House./1921. July 8.
Gift of The Harding Memorial Association
971.715.1

László de Lombos, Philip Alexius de
(1869–1937)
Theodore Roosevelt (1858–1919)
1910, oil on board
34 x 26¹¹⁄₁₆ in (86.4 x 67.8 cm)
Signed and dated lower right:
P. A. László/Paris/1910. April. 22.
Gift of Dr. and Mrs. W. Benjamin Bacon
971.772.1

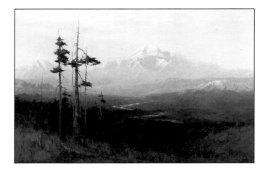

Laurence, Sydney Mortimer (1865–1940)
September Evening, Mount McKinley, Alaska
c. 1925, oil on canvas
26 x 40¼ in (66 x 101.9 cm)
Signed lower left: Sydney Laurence
Gift of the White House Historical Association
979.1412.1

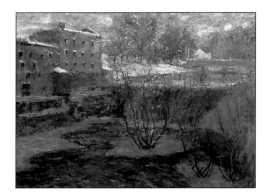

Lawson, Ernest (1873–1939)
The Red Mill
c. 1904, oil on canvas on panel
18 x 24 in (45.7 x 61 cm)
Signed lower left: E. LAWSON
Gift of Richard Manoogian
978.1371.1

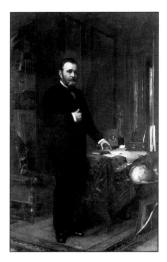

LeClear, Thomas (1818–1882)
Ulysses Simpson Grant (1822–1885)
1881, oil on canvas
96¾ x 60¾ in (245.8 x 154.3 cm)
U. S. government purchase
883.1538.1

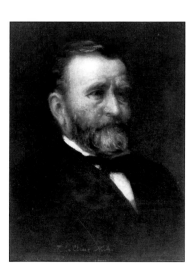

LeClear, Thomas (1818–1882)
Ulysses Simpson Grant (1822–1885)
c. 1881, oil on canvas
8 x 6 in (20.3 x 15.2 cm)
Signed lower center: T. LeClear N.A.
Gift of the White House Historical Association
988.1644.1

MacLeod, William (1811–1892)
*View of the City of Washington
From the Virginia Shore*
1856, oil on canvas
38¼ x 54¼ in (97.2 x 137.8 cm)
Signed and dated lower left: Wm MacLeod/1856
Gift of Mr. and Mrs. Richard M. Scaife
971.689.1

MacMonnies, Frederick William (1863–1937)
H. Rouard (founder)
Nathan Hale (1755–1776)
c. 1890, bronze
28⅜ x 9½ x 6 in (72.1 x 24.1 x 15.2 cm)
Signed and dated on base right side:
F. MacMonnies 1890;
inscribed on base left side rear:
H. ROUARD Fondeur Paris;
stamped on base above inscription:
MADE IN FRANCE
Gift of The Barra Foundation, Inc.
991.1695.1

Marin, John (1870–1953)
The Circus No. 1
1952, oil on canvas
22 x 28 in (55.9 x 71.1 cm)
Signed and dated lower right: marin 52
Gift of Mr. and Mrs. Leigh B. Block
962.197.1

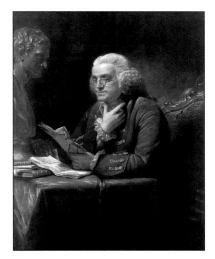

Martin, David (1737–1798)
Benjamin Franklin (1706–1790)
1767, oil on canvas on panel
50¹⁄₁₆ x 39¹⁵⁄₁₆ in (127.2 x 101.4 cm)
Gift of Mr. and Mrs. Walter H. Annenberg
962.187.1

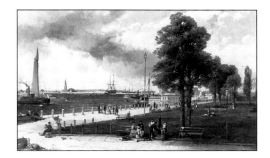

Melrose, Andrew (1836–1901)
New York Harbor and the Battery
c. 1887, oil on canvas
22¹⁄₁₆ x 36¹⁄₁₆ in (56 x 91.6 cm)
Signed lower left: Andrew Melrose
Gift of Mr. and Mrs. Joseph M. Segel
973.1033.1

Metcalf, Willard Leroy (1858–1925)
Spring in the Valley
c. 1924, oil on canvas
26⅛ x 29⅛ in (66.4 x 74 cm)
Signed lower right: W.L.METCALF
Gift of the White House Historical Association
979.1401.1

Mills, Clark (1815–1883)
Cornelius & Baker (foundry)
Andrew Jackson (1767–1845)
1855, white metal
23¾ x 19¾ x 7¾ in (60.3 x 50.2 x 19.7 cm)
Marked on base front: CORNELIUS & BAKER/
PHILADELPHIA; rear: PATENTED/MAY 15/1855;
inscribed under horse's tail: M
U. S. government purchase
859.1451.1

Monet, Claude (1840–1926)
Morning on the Seine, Good Weather
1897, oil on canvas
35 x 36⅛ in (88.9 x 91.8 cm)
Signed and dated lower left: Claude Monet 97;
inscribed on the original stretcher: beau temps
Gift of the family of John Fitzgerald Kennedy
in memory of President Kennedy
963.509.1

Mora, Francis Luis (1874–1940)
Warren Gamaliel Harding (1865–1923)
1930, oil on canvas
50⅛ x 40⁵⁄₁₆ in (127.3 x 102.1 cm)
Signed lower right: F. Luis Mora.;
inscribed on reverse: PORTRAIT OF PRESIDENT
OF THE/UNITED STATES/WARREN G.
HARDING/BY F. LUIS MORA. N.A./PAINTED APRIL
1930/FROM PHOTOGRAPHS/AND SCULPTURE
U. S. government purchase
931.1529.1

Moran, Thomas (1837–1926)
Cliffs of Green River, Wyoming
1909–10, oil on canvas
20¹⁄₁₆ x 30¹⁄₁₆ in (51 x 76.4 cm)
Signed and dated lower right:
TYMORAN.[TYM in monogram]/1910.;
inscribed on reverse lower right:
Cliffs of Green River./Wyoming./
TYMORAN.[TYM in monogram]/1909
White House Acquisition Fund
973.973.1

Moran, Thomas (1837–1926)
Point Lobos, Monterey, California
1912, oil on canvas
30³⁄₁₆ x 40¼ in (76.7 x 102.2 cm)
Signed and dated lower left: TYMORAN. [TYM
in monogram, abraded] 1912;
lower right: the artist's thumbprint
Gift of the White House Historical Association
977.1319.1

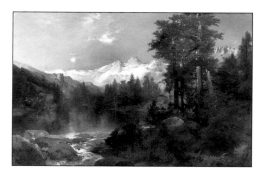

Moran, Thomas (1837–1926)
The Three Tetons
1895, oil on canvas
20⅝ x 30½ in (52.4 x 77.5 cm)
Signed and dated lower left:
TYMORAN [TYM in monogram] 1895
Gift of C. R. Smith
966.591.1

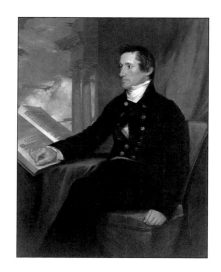

Morse, Samuel Finley Breese (1791–1872)
Colonel William Drayton (1776–1846)
1818, oil on canvas
48⅛ x 38⅜ in (122.2 x 97.5 cm)
Gift of an anonymous donor
962.278.1

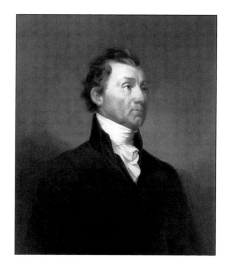

Morse, Samuel Finley Breese (1791–1872)
James Monroe (1758–1831)
c. 1819, oil on canvas
29⅝ x 24⅝ in (75.2 x 62.6 cm)
Gift of Michael Straight
965.587.1

Moser, James Henry (1854–1913)
A Summer Day at Saulsbury Beach
1889, watercolor on paper
20⅞ x 32¾ in (53 x 83.2 cm)
Signed and dated lower left:
-JAMES HENRY MOSER-/-1889-
U. S. government purchase
890.3809.1

Moses, Anna Mary Robertson (1860–1961)
(Grandma Moses)
July Fourth
1951, oil on Masonite
24 x 30 in (61 x 76.2 cm)
Signed lower left: MOSES.
Gift of Otto Kallir
952.3749.1

Moses, Henry (1782–1870)
Three-Masted British Barque
c. 1820–40, oil on canvas
23⅛ x 31⁷⁄₁₆ in (58.7 x 79.8 cm)
Signed lower left: H Moses.
Gift of Mr. and Mrs. Joel Barlow
971.808.1

Mount, Shepard Alonzo (1804–1868)
Hudson River Scene
1861, oil on canvas
26 x 36 in (66 x 91.4 cm)
Signed and dated on reverse:
By S.A. Mount/1861
Gift of Mr. and Mrs. Francis Sullivan
973.1046.1

Muller-Ury, Adolfo (1862–1947)
Edith Bolling Galt Wilson (1872–1961)
(Mrs. Woodrow Wilson)
1916, oil on canvas
39¾ x 29½ in (101 x 74.9 cm) oval
Signed and dated at right:
Muller Ury./-1916-
Bequest of Edith Bolling Galt Wilson
963.431.1

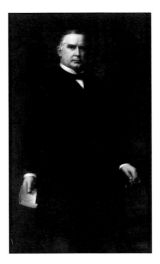

Murphy, Harriet Anderson Stubbs (1852–1935)
William McKinley (1843–1901)
1902, oil on canvas
60¼ x 36¼ in (153 x 92.1 cm)
Signed and dated lower left:
W.D. Murphy/NY 1902
U. S. government purchase
903.1413.1

Nast, Thomas (1840–1902)
Hungry Office Seekers
1861, pencil, ink, and wash on paper
10 x 14 in (25.4 x 35.6 cm)
Signed and dated lower right:
1861/Thomas Nast/March 6ᵗʰ 1861;
inscribed at top: Sketch in the Lobby of
Willards Hotel/"Hungry Office Seekers" & c.
Gift of Mr. and Mrs. Walter Fillin
964.537.1

Nichols, Henry Hobart (1869–1962)
Gloucester Dock
c. 1915, oil on panel
12¾ x 15¹³⁄₁₆ in (32.4 x 35.1 cm)
Signed lower left: Hobart Nichols;
inscribed on reverse: Gloucester Dock/by/
Hobart Nichols/Bronxville/N.Y.
Gift of John Morrin
990.1670.1

Nicholson, Lillie May (1884–1964)
*Fishing Boats: Fisherman's Wharf,
Monterey, California*
c. 1923–33, oil on board
11¹³⁄₁₆ x 15¹³⁄₁₆ in (30 x 40.2 cm)
Signed lower right: L M Nicholson
Gift of the Nicholson family and
Mrs. Nellie K. Evey in memory of
Lillie May Nicholson
984.1564.1

Nicholson, Lillie May (1884–1964)
Walk to the Sea
c. 1923–33, oil on board
11⅞ x 15⅞ in (30.2 x 40.3 cm)
Signed lower right: L M Nicholson
Gift of Walter A. Nelson-Rees and
James L. Coran
984.1563.1

Niehaus, Charles Henry (1855–1935)
Benjamin Harrison (1833–1901)
late 19th century, bronzed plaster
24¾ x 17½ x 12¼ in (62.9 x 45.4 x 31.1 cm)
Signed on right: C.H. NIEHAUS/SC.;
inscribed on base front: .HARRISON.
Gift of Marie J. Niehaus
947.3068.1

Niehaus, Charles Henry (1855–1935)
Abraham Lincoln (1809–1865)
late 19th century, bronzed plaster
29 x 26¼ x 15¾ in (73.7 x 66.7 x 40 cm)
Signed on base rear: C.H. NIEHAUS.. SCULPTOR.;
inscribed on base front:
18/.ABRAHAM..LINCOLN./18 [incomplete dates]
Gift of Marie J. Niehaus
947.3069.1

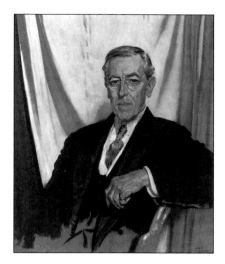

Nini, Giovanni Battista (1717–1786)
(Jean-Baptiste)
Benjamin Franklin (1706–1790)
1777, terra-cotta medallion
4⅜ (diam.) x ⅞ in (11.1 x 2.2 cm)
Signed and dated under left shoulder:
NINI/F 1777/[armorial emblem];
relief on border: .B.FRANKLIN./.AMERICAIN.
Gift of Mrs. Stanley M. Straus
963.478.1

O'Connor, Andrew, Jr. (1874–1941)
Fortunata
c. 1923, marble
12 x 6¼ x 5⅞ in (30.5 x 15.9 x 14.9 cm)
Gift of the artist
923.1216.1

Orpen, William Newenham (1878–1931)
Woodrow Wilson (1856–1924)
1919, oil on canvas
36 x 30⅛ in (91.4 x 76.5 cm)
Signed and dated lower right:
ORPEN/PARIS 1919
Gift of Bernard M. Baruch, Jr.,
in honor of Bernard M. Baruch
962.329.1

Otis, Bass (1784–1861), attributed to
Dolley Payne Todd Madison (1768–1849)
(Mrs. James Madison)
mid-19th century, oil and ink on paper
9⅞ x 8 in (25.1 x 20.3 cm)
Gift of Steven Straw Company, Inc.
978.1370.1

Otis, Bass (1784–1861), attributed to
Daniel Webster (1782–1852)
c. 1830–40, oil on canvas
30 x 25 in (76.2 x 63.5 cm)
Gift of Earle W. Newton
962.342.1

Paris, Walter (1842–1906)
A Stroll by the Capitol
1897, watercolor on paper
10⅝ x 6¾ in (27 x 17.2 cm)
Signed and dated lower left: W.PARIS 1897
White House Acquisition Fund
973.992.1

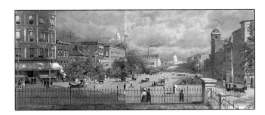

Paris, Walter (1842–1906)
View of Pennsylvania Avenue From the Treasury Building Looking Toward the Capitol
1895, watercolor on paper on paperboard
9⅛ x 21 in (23.2 x 53.3 cm)
Signed and dated lower right: W.PARIS/1895;
inscribed on reverse: Walter Paris Esqr./
9-E-17th Str./New York City/
By U. S. Esp Chg, Pa
Gift of Mrs. Marguerite Carden and
Mr. and Mrs. J. H. Hodge
971.690.1

Parker, Edgar (1840–1892)
after **Gilbert Stuart** (1755–1828), c. 1825
John Adams (1735–1826)
1878, oil on canvas
30½ x 25⅛ in (77.5 x 63.8 cm)
Inscribed on reverse:
J. Adams./From the portrait by Stuart/
by Edgar Parker./Boston Oct 1878
U. S. government purchase
878.1500.1

Parker, Edgar (1840–1892)
after **Gilbert Stuart** (1755–1828), c. 1810–15
James Madison (1751–1836)
1878, oil on canvas
30¼ x 25⅛ in (76.8 x 63.8 cm)
Inscribed on reverse: Madison
U. S. government purchase
879.2553.1

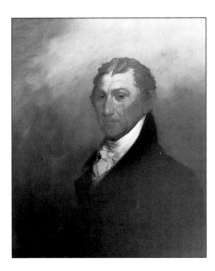

Parker, Edgar (1840–1892)
after **Gilbert Stuart** (1755–1828), c. 1817
James Monroe (1758–1831)
1878, oil on canvas
30⅛ x 25⅛ in (76.5 x 63.8 cm)
U. S. government purchase
878.1210.1

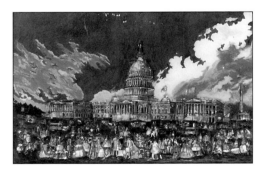

Parkes, W. S. (?–?)
U. S. Capitol
c. 1866, watercolor, mother-of-pearl, and
gold leaf on glass
25 x 39 in (63.5 x 99.1 cm)
Inscribed lower right: W H…[illegible]
Gift of Mr. and Mrs. Samuel Schwartz
963.412.1

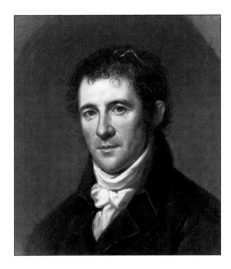

Peale, Charles Willson (1741–1827)
Benjamin Henry Boneval Latrobe (1764–1820)
c. 1804, oil on canvas
22½ x 19½ in (57.2 x 49.5 cm)
Gift of The Morris and Gwendolyn Cafritz
Foundation
973.1032.1

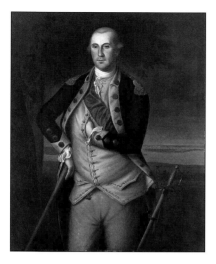

Peale, Charles Willson (1741–1827)
George Washington (1732–1799)
1776, oil on canvas
50 x 39¹⁵⁄₁₆ in (127 x 101.4 cm)
Gift of the collection of
Mr. and Mrs. Lansdell K. Christie
979.1405.1

Peale, James (1749–1831)
Grapes and Apples
c. 1825–31, oil on canvas
16¼ x 22 in (41.3 x 55.9 cm)
Gift of an anonymous donor
962.189.1

Peale, Rembrandt (1778–1860)
Thomas Jefferson (1743–1826)
1800, oil on canvas
23⅛ x 19¼ in (58.7 x 48.9 cm)
Gift of Mr. and Mrs. Paul Mellon
962.395.1

Peale, Rembrandt (1778–1860)
George Washington (1732–1799)
c. 1823, oil on canvas on panel
36 x 29⁷⁄₁₆ in (91.4 x 73.87 cm) oval
Gift of Mrs. John N. M. Howells
962.313.1

Peale, Rubens (1784–1865)
after **James Peale** (1749–1831), 1827
Still Life With Fruit
c. 1862, oil on canvas
20 x 26½ in (50.8 x 67.3 cm)
Signed lower right: Rubens Peale.
Gift of S. S. Spivack and
the White House Acquisition Fund
962.190.1

Pellegrin, Honoré (c. 1800–1870)
American Bark **Samson**
c. 1854–64, watercolor on paper
19 x 26⅜ in (48.3 x 67 cm)
Gift of Mr. and Mrs. Joel Barlow
971.808.4

Pennell, Joseph (1860–1926)
Corner of East Room
1881, ink on paper on board
16⅝ x 12⅞ in (42.2 x 32.7 cm);
board—18⅜ x 15 in (46.7 x 38.1 cm)
Signed lower left: Pennell Oct 1881;
inscribed lower right: Corner of East Room
Gift of the White House Historical Association
984.1562.1

Perry, Lilla Cabot (1848–1933)
Boy Fishing
1929, oil on canvas
40⅛ x 30½₆ in (101.9 x 76.4 cm)
Signed and dated lower right:
Lilla Cabot Perry/1929
Gift of Mrs. Cecil B. Lyon,
Mrs. Albert Levitt, and Mrs. Anita English
979.1399.1

Pope, Alexander (1849–1924)
Gorham Company (foundry)
Our Vanishing Wildlife
c. 1915–24, bronze
16⅝ x 34¼ x 15⅛ in (42.2 x 87 x 38.4 cm)
Signed on ground front right:
ALEXANDER POPE;
signed on ground right side front: © A.P.;
foundry stamp on base edge right rear:
GORHAM. CO. FOUNDERS.
Gift of The Barra Foundation, Inc.
991.1696.1

Powers, Hiram (1805–1873)
Martin Van Buren (1782–1862)
modeled 1836, carved 1840, marble
24⅛ x 21⅜ x 13½ in (61.3 x 54.3 x 34.3 cm)
Inscribed on rear of socle:
HIRAM POWERS./*Sculp.*
Bequest of Travis C. Van Buren
890.3751.1

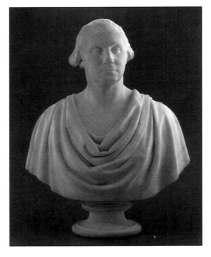

Powers, Hiram (1805–1873)
George Washington (1732–1799)
modeled 1838, carved 1860, marble
31 x 24 x 14 in (78.7 x 61 x 35.6 cm)
Inscribed on rear of socle:
H POWERS/Sculp 1860
Gift of the White House Historical Association
981.1444.1

Prendergast, Maurice Brazil (1858–1924)
Boston Harbor
c. 1907–10, oil on panel
9⁹⁄₁₆ x 12³⁄₁₆ in (23.6 x 31 cm)
Signed lower right: Prendergast
Gift of Mrs. Charles Prendergast
962.383.1

Prendergast, Maurice Brazil (1858–1924)
Revere Beach
c. 1896–97, watercolor and pencil on paper
9½ x 12 in (24.1 x 30.5 cm)
Signed lower right: Maurice B. Prendergast.
Gift of Arthur G. Altschul, in memory of
Stephanie Wagner Altschul
962.280.1

Prior, William Matthew (1806–1873)
after **S. H. Brooke** (?–?), 1838
Washington's Tomb at Mount Vernon
c. 1853, oil on canvas
19 x 25 in (48.3 x 63.5 cm)
Stenciled on reverse: PAINTING GARRET/
No.36 TRENTON ST./EAST BOSTON./W.M. PRIOR.
Gift of Maxim Karolik
962.240.1

Ranney, William Tylee (1813–1857)
Boys Crabbing
1855, oil on canvas
23¼ x 36⅜ in (59.1 x 92.4 cm)
Signed and dated on left side of dock:
WmRanney 55
Gift of The Charles E. Merrill Trust
972.940.1

Rauschner, John Christian (1760–?),
attributed to
James Hoban (c. 1758–1831)
c. 1800, wax bas-relief on glass
3½ x 2 x ⁹⁄₁₆ in (8.9 x 5.1 x 1.4 cm)
Gift of the White House Historical Association
976.1275.1

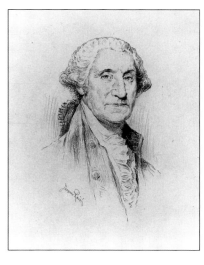

Reich, Jacques (1852–1923)
after **Gilbert Stuart** (1755–1828), 1795
George Washington (1732–1799)
late 19th century–early 20th century,
pencil on paper
11⁷⁄₁₆ x 9⅛ in (29 x 23.2 cm)
Signed lower left: Jacques Reich
Gift of Mr. and Mrs. Clement E. Conger
977.1349.1

Reid, Robert Lewis (1862–1929)
The Blue Vase
c. 1890–1910, oil on canvas on board
23 x 16 in (58.4 x 40.6 cm)
Signed lower left: R Reid
Gift of Mr. and Mrs. Lloyd G. Wineland
978.1389.1

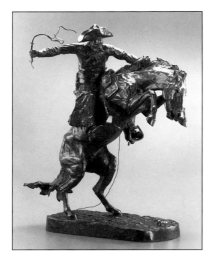

Remington, Frederic Sackrider (1861–1909)
Roman Bronze Works (foundry)
The Bronco Buster
modeled 1895, cast c. 1903, bronze
23⅜ x 19⅞ x 12¼ in (59.4 x 50.5 x 31.1 cm)
Signed on base top front right:
Frederic Remington.;
inscribed on base rear edge:
COPYRIGHTED BY/Frederic Remington 1895.;
foundry stamp on base front edge:
ROMAN BRONZE WORKS/N.Y./CIREPERDUECAST;
marked on base top left: 23
Gift of Miss Virginia Hatfield and
Mrs. Louise Hatfield Stickney
in memory of James T. Hatfield
973.1019.1

Remington, Frederic Sackrider (1861–1909)
Roman Bronze Works (foundry)
Coming Through the Rye
modeled 1902, cast 1918, bronze
20 x 28 x 27 in (50.8 x 71.1 x 68.6 cm)
Inscribed on base right front corner:
Copyrigh [*sic*] by./Frederic Remington;
inscribed on base rear edge:
ROMAN BRONZE WORKS N.Y.;
marked base underside: No 13.
Gift of Amon Carter, Jr., and
Mrs. J. Lee Johnson III
962.270.1

Remington, Frederic Sackrider (1861–1909)
Hands Up!—The Capture of Finnigan
c. 1888, oil on panel
14³⁄₁₆ x 16⅞ in (36 x 42.9 cm)
Signed lower right: Remington.
Gift of Mrs. John Palfrey,
J. Willard Roosevelt, and Kermit Roosevelt
970.687.1

Richardson, Theodore J. (1855–1914)
Sitka Bay, Alaska
1889, watercolor on paper
7⅞ x 14⅛ in (20 x 35.9 cm)
Signed lower left: TJ Richardson. [TJ in monogram]
Gift of the White House Historical Association
977.1344.1

Richardt (Reichardt), Joachim Ferdinand
(1819–1895)
Independence Hall in Philadelphia
c. 1858–63, oil on canvas
37¼ x 65⅝ in (94.6 x 166.7 cm)
Signed lower right: Ferd: Reichardt.
Gift of Mr. and Mrs. Joseph Levine
in memory of President John F. Kennedy
963.508.1

Richardson, Theodore J. (1855–1914)
Alaskan Landscape
1889, watercolor on paper
14 x 10⅛ in (35.6 x 25.7 cm)
Signed lower left: TJRichardson. [TJR in monogram]
Gift of the White House Historical Association
977.1344.2

Richardt (Reichardt), Joachim Ferdinand
(1819–1895)
*View on the Mississippi Fifty-Seven Miles
Below St. Anthony Falls, Minneapolis*
1858, oil on canvas
31¼ x 48¹³⁄₁₆ in (79.4 x 124 cm)
Signed and dated lower right: Ferd: Richardt
1858~
Gift of Mr. and Mrs. Donald G. Dayton
971.655.1

Robinson, Theodore (1852–1896)
Landscape
late 19th century, oil on canvas
18⅞ x 14¼ in (47.9 x 36.2 cm)
Signed lower left: TH. ROBINSON.
Gift of Mr. and Mrs. John Dimick
981.1462.1

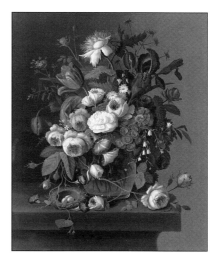

Roesen, Severin (c. 1815–1872)
Floral Still Life With Nest of Eggs
c. 1851–52, oil on canvas
26⅞ x 22⅛ in (68.3 x 56.2 cm)
Gift of the White House Historical Association
976.1234.1

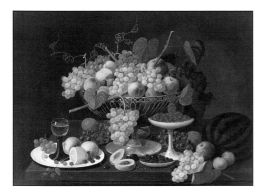

Roesen, Severin (c. 1815–1872)
Still Life With Fruit
1850, oil on canvas
29⅝ x 39¾ in (75.2 x 101 cm)
Signed and dated lower left: S. Roesen/1850.
Gift of Mr. and Mrs. Wickersham June
961.165.1

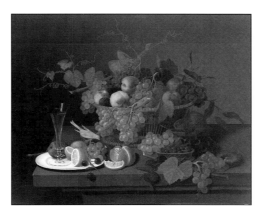

Roesen, Severin (c. 1815–1872)
*Still Life With Fruit, Goblet, and Canary
(Nature's Bounty)*
1851, oil on canvas
28¾ x 36 in (73 x 91.4 cm)
Signed and dated lower right:
S. Roesen. 1851.
Gift of Mr. and Mrs. Wickersham June
and the J. M. Kaplan Fund, Inc.
962.188.1

Rogers, John (1829–1904)
Neighboring Pews
1883, plaster
18¾ x 16 x 11½ in (47.6 x 40.6 x 29.2 cm)
Signed and dated on base left:
JOHN ROGERS/NEW YORK/1883;
inscribed on base front: NEIGHBORING PEWS
Gift of Miss Stella Matthews, Miss Elsie
Matthews, and Mrs. Bertha Matthews Harrison
961.58.1

Rogers, William Allen (1854–1931)
Trying to Lower the White House Temperature
c. 1922, ink and charcoal on paper
15 x 11 in (38.1 x 27.9 cm)
Signed lower left: W.A. Rogers.;
inscribed page top: A WORLD WORTHWHILE;
page bottom: 3¾ wide/Halftone Vignette
Gift of Mr. and Mrs. Milton B. Allman
981.1439.1

Rothermel, Peter Frederick (1812–1895)
The Republican Court in the Days of Lincoln
c. 1867, oil on canvas
23⅜ x 37⅛ in (60 x 94.3 cm)
Gift of Mr. and Mrs. Winslow Carlton
in memory of Maj. William J. Carlton
962.294.1

Russell, Charles Marion (1864–1926)
Fording the Horse Herd
1900, oil on canvas
24 x 36 in (61 x 91.4 cm)
Signed and dated lower left:
CM Russell [and buffalo skull emblem] 1900
Gift of Dr. and Mrs. Armand Hammer,
Dr. and Mrs. Ray Irani,
Mr. and Mrs. John Kluge,
Mr. and Mrs. Carl Lindner,
the Armand Hammer Foundation,
and the Milken Family Foundation
987.1595.1

Russell, Charles Marion (1864–1926)
Roman Bronze Works (foundry)
Meat for Wild Men
1956, bronze
11½ x 36 x 22½ in (29.2 x 91.4 x 57.2 cm)
Signed on base front right: CM Russell/
© [and buffalo skull emblem];
foundry mark on base right edge:
ROMAN BRONZE WORKS. INC. N.Y.
Gift of Dr. Armand Hammer
967.608.1

Saint-Auben, Gabriel de (1724–1780)
Benjamin Franklin (1706–1790)
1777, oil on panel
6⅜ x 5⁵⁄₁₆ in (16.2 x 13.5 cm)
Gift of Mr. and Mrs. H. S. Schaeffer
in memory of President John F. Kennedy
964.524.1

Saint-Gaudens, Augustus (1848–1907)
Roman Bronze Works (foundry)
Abraham Lincoln (1809–1865)
late 19th century, bronze
20¾ x 10 x 11⅝ in (52.7 x 25.4 x 29.5 cm)
Signed under left shoulder:
AVGVSTVS SAINT GAVDENS ©;
inscribed rear lower edge:
ROMAN BRONZE WORKS N.Y.
Gift of the White House Historical Association
975.1201.1

Salisbury, Frank O. (1874–1962)
Franklin Delano Roosevelt (1882–1945)
1947, oil on canvas
50¼ x 40⅜ in (127.6 x 102.6 cm)
Signed lower right: Frank O. Salisbury;
inscribed on reverse: PRESIDENT/FRANKLIN D.
ROOSEVELT/Painted By/FRANK O. SALISBURY./
AT THE WHITE HOUSE. 1934.
Gift of Myron C. Taylor
947.2233.1

Sargent, John Singer (1856–1925)
The Mosquito Net
1912, oil on canvas
22⅝ x 28½ in (57.5 x 72.4 cm)
Gift of Whitney Warren
in memory of President John F. Kennedy
964.530.1

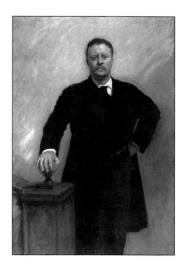

Sargent, John Singer (1856–1925)
Theodore Roosevelt (1858–1919)
1903, oil on canvas
58⅛ x 40 in (147.6 x 101.6 cm)
Signed and dated upper right:
John S. Sargent 1903
U. S. government purchase
903.1328.1

Sawnor, Danute (?–?)
after **Jozef Grassi** (1755–1838), c. 1792
Tadeus Kosciuszko (1746–1817)
1974, oil on canvas
46¼ x 37¾ in (117.5 x 95.9 cm)
Gift of the Polish United Workers Party
974.1116.1

Serin, Hendrick Jan (1678–1765)
John Hampden (1594–1643)
c. 1725, oil on canvas
35 x 26¹⁵⁄₁₆ in (88.9 x 68.4 cm)
Inscribed on reverse: John Hampden/
AETATES 24./H: SERIN. FECIT./-1725
Gift of John McGregor
857.1842.1

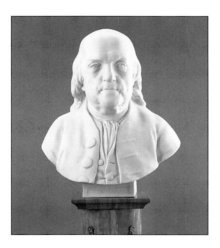

Sèvres, National Porcelain Factory of
after **Jean-Antoine Houdon** (1741–1828), 1778
Benjamin Franklin (1706–1790)
c. 1810, unglazed porcelain
17⅝ x 8⅝ x 6 in (44.8 x 21.9 x 15.2 cm)
Stamped on rear center: SEVRES [boxed] G L;
inscribed on plinth front: FRANKLIN
Gift of the Richard King Mellon Foundation
971.803.1

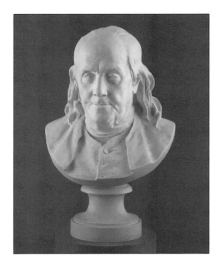

Sèvres, National Porcelain Factory of
after **Jean-Antoine Houdon** (1741–1828), 1778
Benjamin Franklin (1706–1790)
1905, unglazed porcelain
14 x 13 x 10 in (35.6 x 33 x 25.4 cm)
Stamped on left shoulder rear:
S/1905 [in triangle] G L;
signed and dated on right shoulder:
Houdon A. 1778;
inscribed on rear center: Franklin
Gift of the French Republic
905.1322.1

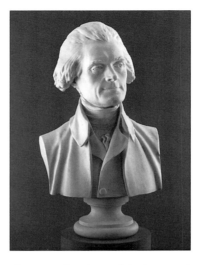

Sèvres, National Porcelain Factory of
after **Jean-Antoine Houdon** (1741–1828), 1789
Thomas Jefferson (1743–1826)
1908, unglazed porcelain
22 x 12 x 9 in (55.9 x 30.5 x 22.9 cm)
Stamped on right shoulder: SEVRES [boxed]/
[V-like mark] S/1908 [in triangle]
Gift of the French Republic
908.1324.1

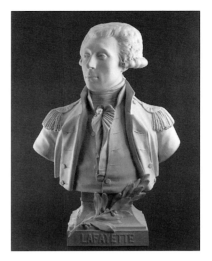

Sèvres, National Porcelain Factory of
after **Jean-Antoine Houdon** (1741–1828), 1790
Marie Joseph Paul Yves Roch Gilbert du Motier,
Marquis de Lafayette (1757–1834)
1904, unglazed porcelain
29½ x 20½ x 10½ in (74.9 x 52.1 x 26.7 cm)
Stamped on pedestal rear:
S/1904 [in triangle];
signed and dated on left shoulder:
houdon/an 1790;
inscribed on pedestal front: LAFAYETTE
Gift of the French Republic
905.1867.1

Sèvres, National Porcelain Factory of
after **Jean-Antoine Houdon** (1741–1828), c. 1786
George Washington (1732–1799)
1905, unglazed porcelain
14½ x 12 x 9 in (36.8 x 30.5 x 22.9 cm)
Stamped on rear center:
S/1905 [in triangle] G L
Gift of the French Republic
905.1323.1

Sèvres, National Porcelain Factory of
after **Leonard Volk** (1828–1895), 1860
Abraham Lincoln (1809–1865)
1909, unglazed porcelain
22¼ x 12 x 9 in (56.5 x 30.5 x 22.9 cm)
Stamped on left shoulder rear:
S/1909 [in triangle] SEVRES [boxed]
A.C. [boxed]
Gift of the French Republic
910.1325.1

Sèvres, National Porcelain Factory of
Women and Cherubs
1920, unglazed porcelain
12⅛ x 10⅛ x 7⅜ in (30.8 x 25.7 x 18.7 cm)
Stamped on base rear:
SEVRES [boxed] MANE DE L'ETAT./1920/ON/
.SEVRES [double oval]/C R O
Gift of the Women of France
921.1176.1

Shikler, Aaron (1922–)
John Fitzgerald Kennedy (1917–1963)
1970, oil on canvas
50 x 34 in (127 x 86.4 cm)
Signed and dated lower left: Shikler '70
Gift of the White House Historical Association
971.684.1

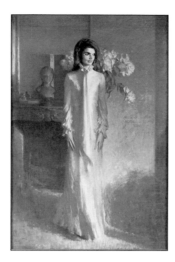

Shikler, Aaron (1922–)
Jacqueline Bouvier Kennedy Onassis (1929–)
(Mrs. John F. Kennedy)
1970, oil on canvas
48 x 32 in (121.9 x 81.3 cm)
Signed and dated lower left: Shikler '70
Gift of the White House Historical Association
971.685.1

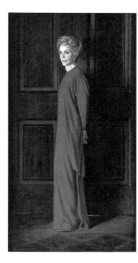

Shikler, Aaron (1922–)
Nancy Davis Reagan (1921–)
(Mrs. Ronald W. Reagan)
1987, oil on canvas
44⅛ x 24 (112.1 x 61 cm)
Signed and dated lower left:
Aaron Annie Shikler '87
Gift of the White House Historical Association
and the Petrie Foundation
989.1664.1

Shikler, Aaron (1922–)
Ronald Wilson Reagan (1911–)
1989, oil on canvas
50¹/₁₆ x 34⅛ in (127.2 x 86.7 cm)
Signed and dated lower right:
Aaron Annie Shikler '89
Gift of the White House Historical Association
and the Petrie Foundation
989.1663.1

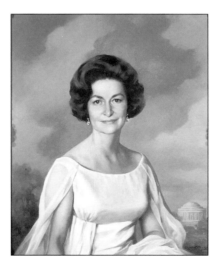

Shoumatoff, Elizabeth (1888–1980)
Claudia (Lady Bird) Taylor Johnson (1912–)
(Mrs. Lyndon B. Johnson)
1968, oil on canvas
31⅝ x 26½ in (80.3 x 67.3 cm)
Signed and dated lower right:
Elizabeth Shoumatoff/1968.
Gift of the White House Historical Association
968.617.1

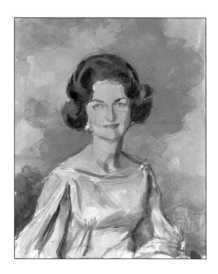

Shoumatoff, Elizabeth (1888–1980)
Claudia (Lady Bird) Taylor Johnson (1912–)
(Mrs. Lyndon B. Johnson)
1968, watercolor on paper
11½ x 9¼ in (29.2 x 23.5 cm)
Gift of the artist
971.702.3

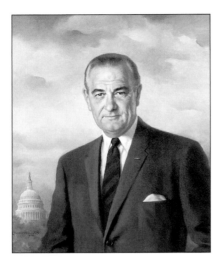

Shoumatoff, Elizabeth (1888–1980)
Lyndon Baines Johnson (1908–1973)
1968, oil on canvas
31⅛ x 26½ in (80.3 x 67.3 cm)
Signed and dated lower left:
Elizabeth Shoumatoff. 1968
Gift of the White House Historical Association
968.624.1

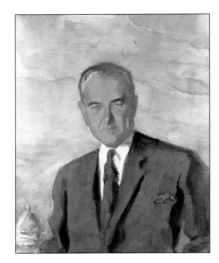

Shoumatoff, Elizabeth (1888–1980)
Lyndon Baines Johnson (1908–1973)
1968, watercolor on paper
10½ x 8⅝ in (26.7 x 21.9 cm)
Gift of the artist
971.702.2

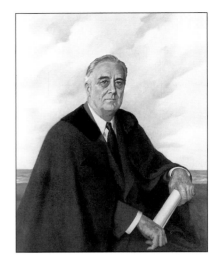

Shoumatoff, Elizabeth (1888–1980)
Franklin Delano Roosevelt (1882–1945)
1966, oil on canvas
42 x 34⅛ in (106.7 x 86.7 cm)
Signed lower right: Elizabeth Shoumatoff
Gift of the artist
966.594.1

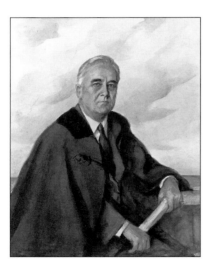

Shoumatoff, Elizabeth (1888–1980)
Franklin Delano Roosevelt (1882–1945)
1966, watercolor on paper
12⅝ x 10¼ in (32.1 x 26 cm)
Gift of the artist
971.702.1

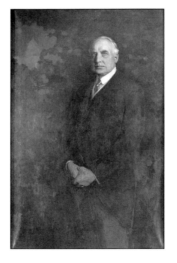

Smart, Edmund Hodgson (1873–1942)
Warren Gamaliel Harding (1865–1923)
1923, oil on canvas
58⅜ x 37⅞ in (148.3 x 96.2 cm)
Signed and dated lower left: E. Hodgson
Smart./1923./© 147.;
inscribed on reverse:
No. 147 - 1923/President of the U. S.A./
Warren G. Harding/by/E. Hodgson Smart;
President Harding/with great... [illegible]
Gift of Mrs. Elizabeth Talbot-Martin
971.761.1

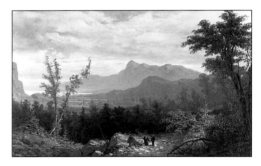

Sonntag, William Louis (1822–1900)
In the White Mountains, New Hampshire
1876, oil on canvas on panel
23 9/16 x 37⅜ in (59.2 x 94.9 cm)
Signed and dated lower right:
W. Sonntag./1876
Gift of the White House Historical Association
976.1222.1

Spencer, Robert (1879–1931)
May Breezes
early 20th century, oil on canvas
25 x 30 in (63.5 x 76.2 cm)
Signed lower left: Robert Spencer.
Gift of Adm. Neill Phillips
976.1258.1

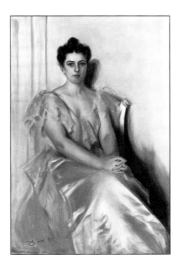

Stapko, Casimir Gregory (1913–)
after **Anders Leonard Zorn** (1860–1920), 1899
Frances Folsom Cleveland (1864–1947)
(Mrs. Grover Cleveland)
1952, oil on canvas
54¹⁄₁₆ x 36¹⁄₁₆ in (137.3 x 91.6 cm)
Signed lower left:
Zorn 99/COPY BY STAPKO AFTER ZORN;
inscribed on reverse at lower edge:
COPY BY C.G. STAPKO/FROM THE ORIGINAL
BY ZORN
Gift of the National League of American
Pen Women
952.3410.1

Steele, Theodore Clement (1847–1926)
Benjamin Harrison (1833–1901)
1901, oil on canvas
40 x 50 in (101.6 x 127 cm)
Gift of Woodward & Lothrop
989.1646.1

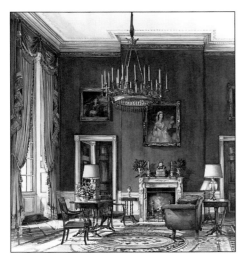

Steinmeyer, James (1950–)
Red Room at the White House
1982, gouache on paper
15½ x 14⅜ in (39.4 x 36.5 cm)
Signed lower right: JSteinmeyer 1982
Gift of the artist
988.1638.1

Stephens, Thomas Edgar (1886–1966)
Dwight David Eisenhower (1890–1969)
1960, oil on canvas
50 x 40 in (127 x 101.6 cm)
Signed and dated lower right:
Thos. E. Stephens/60
Acquisition undocumented
961.3434.1

Stephens, Thomas Edgar (1886–1966)
Mamie Geneva Doud Eisenhower (1896–1979)
(Mrs. Dwight David Eisenhower)
1959, oil on canvas
42⅜ x 34⅜ in (107.6 x 87.3 cm)
Signed and dated lower left:
Thos. E./Stephens/59
Acquisition undocumented
961.3411.1

Stilwell, James (?–?)
First Action of War of 1812
c. 1812, watercolor on paper
6⅟₁₆ x 8⁹⁄₁₆ in (15.7 x 21.8 cm)
Inscribed on reverse lower center: Design for
the Belvideras'/Action by James Stilwell/
The American Frigate Congrefs/is omitted
Gift of Mrs. Marshall Field
962.195.2

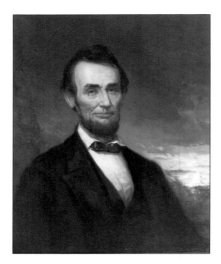

Story, George Henry (1835–1923)
Abraham Lincoln (1809–1865)
c. 1915, oil on canvas
30¼ x 25¼ in (76.8 x 64.1 cm)
Signed lower right: G.H. Story. ©
Gift of the White House Historical Association
981.1445.1

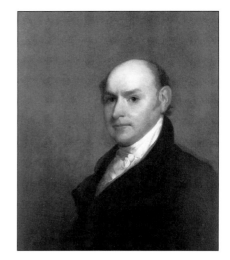

Stuart, Gilbert (1755–1828)
John Quincy Adams (1767–1848)
1818, oil on panel
26¾ x 22 in (68 x 55.9 cm)
Gift of John Q. Adams
970.664.1

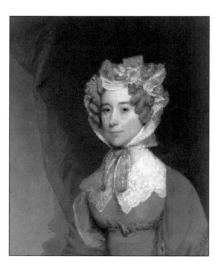

Stuart, Gilbert (1755–1828)
Louisa Catherine Johnson Adams (1775–1852)
(Mrs. John Quincy Adams)
1821–26, oil on canvas
30⅟₁₆ x 25 in (76.4 x 63.5 cm)
Gift of John Q. Adams
971.676.1

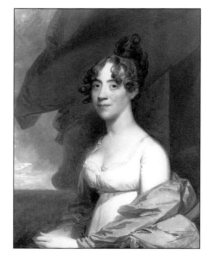

Stuart, Gilbert (1755–1828)
Anna Payne Cutts (1779–1832)
(Mrs. Richard Cutts)
c. 1804, oil on canvas
29⅟₁₆ x 24⅛ in (73.8 x 61.3 cm)
Gift of the Allegheny Foundation
972.824.1

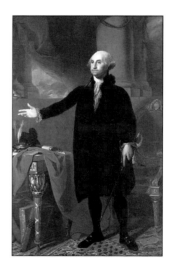

Stuart, Gilbert (1755–1828)
George Washington (1732–1799)
1797, oil on canvas
95 x 59¹³⁄₁₆ in (241.3 x 151.9 cm)
U. S. government purchase
800.1290.1

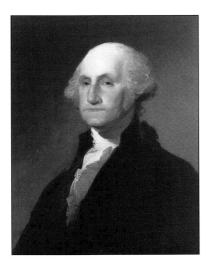

Stuart, Gilbert (1755–1828)
George Washington (1732–1799)
c. 1805, oil on canvas
30 x 25 in (76.2 x 63.5 cm)
Gift of Mr. and Mrs. Charles Payson
in memory of Pvt. Daniel Carroll Payson
949.3496.1

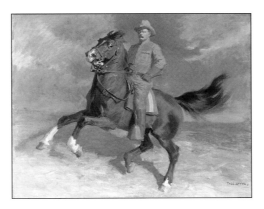

Styka, Tadé (1889–1954)
Theodore Roosevelt (1858–1919)
c. 1909, oil on canvas
39⅞ x 51½ in (101.3 x 130.8 cm)
Signed lower right: Tadé. Styka.
Gift of the White House Historical Association
974.1076.1

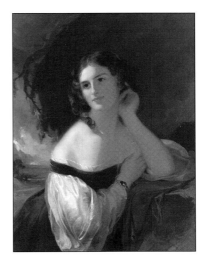

Sully, Thomas (1783–1872)
Fanny Kemble (1809–1892)
1834, oil on canvas
36⅛ x 27¹⁵⁄₁₆ in (91.8 x 71 cm)
Signed and dated lower right:
TS [in monogram] 1834.
Gift of The Daniel W. Dietrich Foundation
965.566.1

Suydam, Edward Howard (1885–1940)
The Main Corridor, The White House
c. 1929, pencil on paper
10¾ x 14³⁄₁₆ in (27.3 x 36 cm)
Signed lower right: EH Suydam./
The Main Corridor/The White house
White House Acquisition Fund
979.1396.1

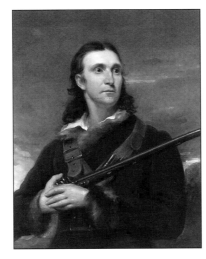

Syme, John (1795–1861)
John James Audubon (1785–1851)
1826, oil on canvas
35½ x 27½ in (90.2 x 69.8 cm)
Gift of Roland S. Bond, Mrs. Alex Camp,
Mrs. Maxine S. Carr, Mrs. Nenetta Burton
Carter, Miss Nina J. Cullinan, Bert Fields,
Mrs. William P. Hobby, Mrs. John Leddy Jones,
J. W. Link, Jr., Mr. and Mrs. Roy R.
Neuberger, Mr. and Mrs. John M. Olin,
Mae Caldwell Rovensky Trust,
Miss Margaret Batts Tobin, M. Knoedler & Co.,
and an anonymous donor
963.385.1

Tarbell, Edmund Charles (1862–1938)
Woman Standing With an Oar
1891, oil on canvas
22⅛ x 18¹⁄₁₆ in (56.2 x 45.9 cm)
Signed lower right:
To my friend Benson/Tarbell
Gift of Mr. and Mrs. William S. Brewster
991.1703.1

Taylor, Emily Drayton (1860–1952)
Ida Saxton McKinley (1847–1907)
(Mrs. William McKinley)
1899, watercolor on ivory
3³⁄₁₆ x 2½ in (8.1 x 6.4 cm) oval
Signed and dated lower right:
E D Taylor/1899;
inscribed on reverse of backing card:
MRS. WILLIAM MCKINLEY/WIFE OF/
PRESIDENT WILLIAM MCKINLEY/
PAINTED BY/EMILY DRAYTON TAYLOR/
AT THE EXECUTIVE MANSION/
WASHINGTON/D. C./1899
Gift of the White House Historical Association
968.630.2

Taylor, Emily Drayton (1860–1952)
William McKinley (1843–1901)
1899, watercolor on ivory
3¼ x 2½ in (8.3 x 6.4 cm) oval
Signed and dated lower right:
E.D. Taylor/1899;
inscribed on reverse of backing card:
WILLIAM MCKINLEY/PRESIDENT OF/THE UNITED
STATES OF AMERICA/PAINTED BY/EMILY
DRAYTON TAYLOR/AT THE EXECUTIVE
MANSION/WASHINGTON/D. C./1899
Gift of the White House Historical Association
968.630.1

Thomas, Stephen Seymour (1868–1956)
Woodrow Wilson (1856–1924)
1913, oil on canvas
46⅛ x 35¹⁄₁₆ in (117.2 x 89.1 cm)
Signed lower right:
© S. SEYMOUR THOMAS
Acquisition undocumented
915.2555.1

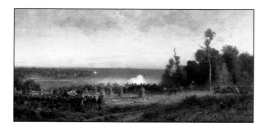

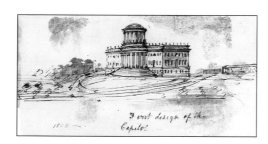

Thompson, Alfred Wordsworth (1840–1896)
Cannonading on the Potomac, October, 1861
c. 1868–70, oil on canvas
33³⁄₁₆ x 70⁹⁄₁₆ in (84.3 x 179.2 cm)
Signed lower right: Wordsworth Thompson;
inscribed on reverse: "Cannonading on the
Potomac/October, 1861"/Painted by-/A.
Wordsworth Thompson./Near Edward's Ferry
and/Ball's Bluff, Virginia. 21 Oct 1861/
Battery B, Rhode Island Artillery/Col. E.D. Baker,
Commanding,/was killed in this action.
Gift of the Edward and Mary Warburg Fund
962.182.1

Thornton, William (1759–1828), attributed to
First Design of the Capitol
c. 1800, ink and wash on paper
5⅛ x 9¹¹⁄₁₆ in (13 x 24.6 cm)
Dated lower left: 1800.;
inscribed lower center:
First design of the/Capitol.–
Gift of The Sack Foundation
971.753.1

Tregor, Nison H. (1904–)
Dwight David Eisenhower (1890–1969)
1957, bronze
11½ x 8¾ x 8 in (29.2 x 22.2 x 20.3 cm)
Gift of Mr. and Mrs. Ralph E. Becker
970.643.1

Troye, Edward (1808–1874)
John Hartwell Cocke of Bremo (1780–1866)
1859, oil on canvas
54⅜ x 40¹⁵⁄₁₆ in (138.1 x 104 cm)
Signed and dated lower right:
E Troye/Feb. 1859
Gift of The Charles W. Engelhard Foundation
962.288.1

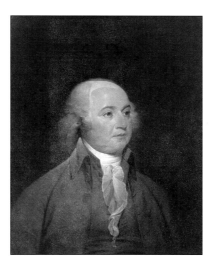

Trumbull, John (1756–1843)
John Adams (1735–1826)
c. 1792–93, oil on canvas
30¹⁄₁₆ x 24 in (76.4 x 61 cm)
Gift of the White House Historical Association
986.1582.1

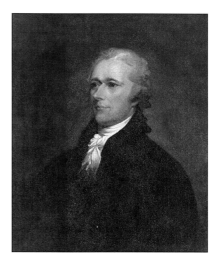

Trumbull, John (1756–1843)
Alexander Hamilton (1755–1804)
c. 1805, oil on canvas
30 x 24⅞ in (76.2 x 63.2 cm)
Gift of the Ford Motor Company
962.203.1

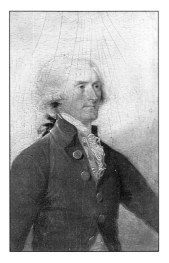

Trumbull, John (1756–1843)
Thomas Jefferson (1743–1826)
1788, oil on panel
4¾ x 3 in (12.1 x 7.6 cm)
Gift of the Italian Republic
976.1262.1

Twachtman, John Henry (1853–1902)
Captain Bickford's Float
1900, oil on paper on panel
18⅜ x 12⁵⁄₁₆ in (46.7 x 31.3 cm)
Signed lower left: J H Twachtman;
signed lower right: J H T -
Gift of Mr. and Mrs. Raymond J. Horowitz
979.1418.1

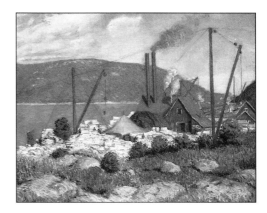

Tyson, Carroll Sargent, Jr. (1878–1956)
Hall's Quarry
1906, oil on canvas
25⅛ x 30⅛ in (63.8 x 76.5 cm)
Signed and dated lower left:
Carroll S. Tyson 1906
Gift of Mrs. Louis C. Madeira
983.1537.1

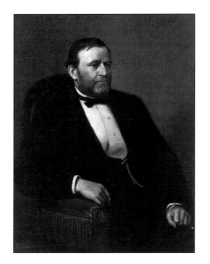

Ulke, Henry (1821–1910)
Ulysses Simpson Grant (1822–1885)
1875, oil on canvas
45¼ x 35¼ in (114.9 x 89.5 cm)
Signed and dated lower left: H. Ulke. 1875.
U. S. government purchase
879.1527.1

Vanderlyn, John (1775–1852)
James Madison (1751–1836)
1816, oil on canvas
26 x 22³⁄₁₆ in (66 x 56.4 cm)
Gift of Mrs. Vincent Astor,
the George Brown Foundation, Inc. ,
The Charles W. Engelhard Foundation,
The Ruth P. Field Fund, Inc. ,
Laurence Rockefeller, and
the White House Historical Association
968.627.1

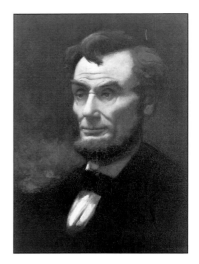

Volk, Stephen Arnold Douglas (1856–1935)
Lincoln, The Ever-Sympathetic (1809–1865)
1931, oil on canvas
24¼ x 18⅜ in (61.6 x 46.7 cm)
Signed and dated lower right:
Douglas Volk. N. A./© '31.
Gift of Mrs. Howard E. Hebble and
Mrs. Robert B. Jarvis
966.589.1

Waldron, G. A. (?–?)
Three-Masted American Ship Expounder
1873, oil on canvas
24¹⁄₁₆ x 36³⁄₁₆ in (61.1 x 91.9 cm)
Gift of Mr. and Mrs. Joel Barlow
971.808.5

Warner, Miskey, Merrill
Patrick Henry (1736–1799)
c. 1860, spelterware
13½ x 8¾ x 5¼ in (34.3 x 22.2 x 13.3 cm)
Marked on base right: WARNER MISKEY &
MERRILL;
inscribed on base front: PATRICK HENRY
Gift of Mrs. William S. Paley
962.213.2

Waugh, Frederick Judd (1861–1940)
Rough Sea at Bailey's Island, Maine
1909, oil on canvas
25⅜ x 30⅜ in (64.4 x 77.2 cm)
Signed lower right: /Waugh/;
signed and dated on reverse upper left:
FJWaugh/1909
Gift of Dr. Kenneth J. Maier
981.1487.1

Welch, Thaddeus (1844–1919)
Sunny Hills, California
late 19th century–early 20th century,
oil on canvas
24 x 36 in (61 x 91.4 cm)
Signed lower left: T. Welch
Gift of Mrs. Jeane Dixon
974.1128.1

Weinman, Adolph Alexander (1870–1952)
Roman Bronze Works (foundry)
Descending Night
modeled c. 1914, cast c. 1915–23, bronze
25½ x 21¾ x 10 in (64.8 x 55.2 x 25.4 cm)
Marked on base top rear:
©/.A .A. WEINMAN. FECIT.;
on base rear edge: ROMAN BRONZE WORKS N.Y.;
on base underside: No 5
Gift of the artist
923.1169.1

Weinman, Adolph Alexander (1870–1952)
Roman Bronze Works (foundry)
Rising Day
modeled c. 1914, cast c. 1915–23, bronze
26¾ x 24⅞ x 9¼ in (68 x 63.2 x 23.5 cm)
Marked on base top rear:
©/A A WEINMAN FECIT;
on base rear edge: ROMAN BRONZE WORKS N.Y.;
on base underside: No 38
Gift of the artist
923.1031.1

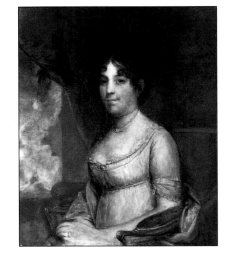

Whistler, James Abbott McNeill (1834–1903)
Nocturne
c. 1870–77, oil on canvas
19¹⁵⁄₁₆ x 30³⁄₁₆ in (50.6 x 76.7 cm)
Gift of Mr. and Mrs. W. Averell Harriman
962.303.1

White, Stanford (1853–1906)
Porch of the Maidens at the Erechtheum
c. 1900, watercolor on paper
10¹⁵⁄₁₆ x 16¹⁵⁄₁₆ in (27.8 x 43 cm)
Illegible notations on lower edge
Gift of Robert Winthrop White
962.293.1

Whitlock, Mary Ursula (1860–1944)
after **Gilbert Stuart** (1755–1828), 1804
Dolley Payne Todd Madison (1768–1849)
(Mrs. James Madison)
c. 1908, oil on canvas
25¹⁄₁₆ x 21¹⁄₁₆ in (63.7 x 53.5 cm)
Stenciled on reverse (twice): COPIED/
From the Original/in the Gallery of the
Pennsylvania Academy/of the Fine Arts.
Gift of the National Society of the
Colonial Dames of America, State of Virginia
912.1502.1

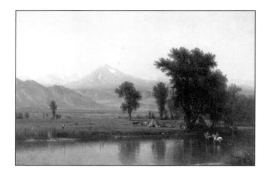

Whittredge, Thomas Worthington (1820–1910)
Crossing the River Platte
c. 1871, oil on canvas
40⁵⁄₁₆ x 60⁵⁄₁₆ in (102.4 x 153.2 cm)
Signed lower right: W. Whittredge
Gift of C. R. Smith
967.602.1

Whittredge, Thomas Worthington (1820–1910)
Thatcher's Island off Rockport, Massachusetts
early 20th century, oil on canvas
12³⁄₁₆ x 21¹³⁄₁₆ in (31 x 55.4 cm)
Signed lower left: W. Whittredge
Gift of the White House Historical Association
and Berry-Hill Galleries
976.1303.1

Wiggins, Guy Carleton (1883–1962)
Brooklyn Bridge, Winter
1920–30, oil on canvas
30 x 25 in (76.2 x 63.5 cm)
Signed lower left: Guy Wiggins N A
Gift of the White House Historical Association
975.1193.1

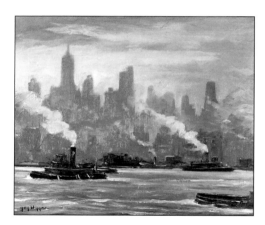

Wiggins, Guy Carleton (1883–1962)
East River, New York
1920–30, oil on canvas
19¾ x 23 in (50.2 x 58.4 cm)
Signed lower left: Guy Wiggins–
Gift of the White House Historical Association
975.1184.1

Wills, James Anthony (1912–)
Dwight David Eisenhower (1890–1969)
1967, oil on panel
48 x 38 in (121.9 x 96.5 cm)
Signed lower left: J. Anthony Wills
Gift of Harry Darby
967.609.1

Wills, James Anthony (1912–)
Richard Milhous Nixon (1913–)
1984, oil on panel
45¾ x 34⅞ in (116.2 x 88.6 cm)
Signed lower right: J. Anthony Wills
Gift of Richard M. Nixon
984.1560.1

Wilson, Benjamin (1721–1788)
Benjamin Franklin (1706–1790)
1759, oil on canvas
30 x 25 in (76.2 x 63.5 cm)
Signed and dated lower right:
B. Wilson/1759.;
inscribed on reverse: Doct Franklin/
Philladelphia [*sic*]/America
Gift of Albert Henry George Grey
906.3501.1

Wood, Enoch (1759–1840)
George Washington (1732–1799)
1818, basalt ware
8½ x 6¼ x 3 in (21.6 x 15.9 x 7.6 cm)
Medallion on rear: WASHINGTON/Born 1732/
Died 1799/ENOCH WOOD, SCULP./1818;
marked on base rear: 31
Gift of Dr. and Mrs. A. Noe Horn
963.474.1

Wood, John Warrington (1839–1886)
John Bright (1811–1889)
1864, marble
22½ x 13½ x 9½ in (57.2 x 34.3 x 24.1 cm)
Signed and dated on rear left: J Wood Sc/1864
Gift of Thomas G. Blain
866.1535.1

Wores, Theodore (1860–1939)
Golden Gate, Lands End
c. 1911–12, oil on canvas
16 x 20 in (40.6 x 50.8 cm)
Signed lower right: Theodore Wores.
Gift of Drs. Ben and A. Jess Shenson
972.851.3

Wores, Theodore (1860–1939)
Lands End and Lighthouse
c. 1911–12, oil on canvas
20 x 30 in (50.8 x 76.2 cm)
Signed lower left: Theodore Wores.
Gift of Drs. Ben and A. Jess Shenson
972.851.1

Wores, Theodore (1860–1939)
Lands End Looking Towards the Golden Gate
c. 1911–12, oil on canvas
16 x 20 in (40.6 x 50.8 cm)
Signed lower left: Theodore Wores.
Gift of Drs. Ben and A. Jess Shenson
972.851.2

Wright, Charles W. (1850–c. 1950)
Frances Folsom Cleveland (1864–1947)
(Mrs. Grover Cleveland)
1887, oil on canvas
26¹³⁄₁₆ x 21⅞ in (68.1 x 55.6 cm)
Signed and dated lower right:
CHAS. W. WRIGHT,/BOSTON, 1887.
Gift of Mrs. George C. Owens
971.779.1

Wyant, Alexander Helwig (1836–1892)
A Glimpse of Lake Champlain
late 19th century, oil on canvas
17½ x 14¼ in (44.4 x 36.2 cm)
Signed lower right: AHW
Gift of Winsor French
962.202.1

Wyeth, Andrew Newell (1917–)
Mrs. Charlie Stone
1942, watercolor on paper
16½ x 29⅜ in (41.9 x 74.6 cm)
Signed lower right: Andrew Wyeth.
Gift of an anonymous donor
972.847.1

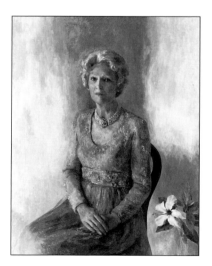

Wyeth, Henriette (1907–)
Patricia Ryan Nixon (1912–)
(Mrs. Richard M. Nixon)
1978, oil on canvas
45⅞ x 36 in (116.5 x 91.4 cm)
Signed lower right: Henriette Wyeth
Gift of the White House Historical Association
981.1472.1

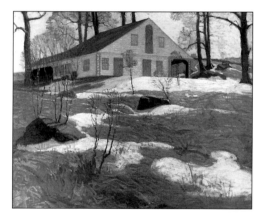

Wyeth, Newell Convers (1882–1945)
Barn in Winter
c. 1907, oil on canvas
25 x 30 in (63.5 x 76.2 cm)
Gift of Richard Manoogian
978.1372.1

Zakharov, Feodor (1882–1968)
Grace Goodhue Coolidge (1879–1957)
(Mrs. Calvin Coolidge)
1928, pencil on paper
17¹³⁄₁₆ x 14 in (45.2 x 35.6 cm)
Signed and dated lower right:
Feodor/Zakharov/1928
Gift of Mr. and Mrs. Charles Babcock
965.576.1

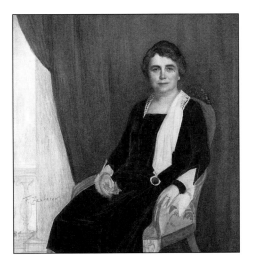

Zakharov, Feodor (1882–1968)
Edith Bolling Galt Wilson (1872–1961)
(Mrs. Woodrow Wilson)
early 20th century,
watercolor and pencil on paper
15⅞ x 13¾ in (40.3 x 34.9 cm)
Signed lower left: F. Zakharov
Gift of Mr. and Mrs. Charles Babcock
965.575.1

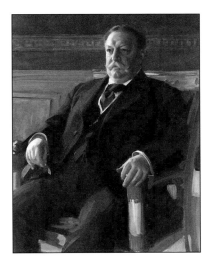

Zorn, Anders Leonard (1860–1920)
William Howard Taft (1857–1930)
1911, oil on canvas
46⅜ x 35⅛ in (117.8 x 89.2 cm)
Signed and dated upper right:
Zorn/1911/Zorn
U. S. government purchase
912.1415.1

Unknown Artist
Abigail Smith Adams (1744–1818)
(Mrs. John Adams)
c. 1810, ink silhouette on paper
3½ x 2⅞ in (8.9 x 7.3 cm)
Inscribed lower right: Mrs. Adams
Gift of Mrs. W. H. Whitridge
908.3004.1

Unknown Artist
Boys Resting in Woods
c. 1900, oil on canvas
18 x 29 in (45.7 x 73.7 cm)
Gift of Mrs. Elizabeth L. Williams
977.1321.1

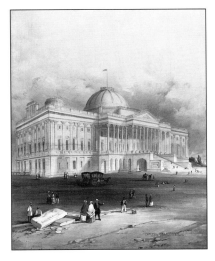

Unknown Artist
after **William Henry Bartlett** (1809–1854),
c. 1836–37
for **Jennens & Bettridge**
Capitol, Washington
c. 1850–60, oil on tin
20⅞ x 16¹³⁄₁₆ in (53 x 42.7 cm)
Inscribed lower left on rock:
Jennens & Bettridge;
lower right: CAPITOL, WASHINGTON.
Gift of Lawrence Fleischman
962.184.1

Unknown Artist
Centaur Lifting a Woman
c. 1870, bronze
17¾ x 18¾ x 12¾ in (45.1 x 47.6 x 32.4 cm)
U. S. government purchase
960.1168.1

Unknown Artist
Classical Male and Female
c. 1870, bronzed metal
23¼ x 16½ x 8⅝ in (59.1 x 41.9 x 21.9 cm)
Inscribed on base left front: Moreau [?]
U. S. government purchase
870.1446.1

Unknown Artist
Classical Male Figure
c. 1870, bronze
14⅛ x 6½ x 3¼ in (35.9 x 16.5 x 8.3 cm)
U. S. government purchase
960.1448.1

Unknown Artist
Defeat of the English Boat Guerriere *by the
American Boat* Constitution
c. 1820–40, oil on canvas
27⅞ x 36 in (70.8 x 91.4 cm)
Gift of Mr. and Mrs. Ray W. Smith
981.1486.1

Unknown Artist
Diane De Gabies
c. 1870, bronzed metal
30¼ x 9⅛ x 7⅜ in (76.8 x 23.2 x 18.7 cm)
Inscribed on base front: DIANE DE GABIES
U. S. government purchase
870.1444.1

Unknown Artist
Charles Hector, Comte d'Estaing (1729–1794)
c. 1800, marble
27½ x 20 x 14 in (69.8 x 50.8 x 35.6 cm)
Gift of Mrs. Louis Bruguiere,
Mrs. John Jay Ide, Mrs. John Barry Ryan,
George Henry Warren, and
Mrs. George H. Warren
962.234.1

Unknown Artist
Female With Cupid
c. 1870, bronze
22¼ x 6¼ x 11 in (56.5 x 15.9 x 27.9 cm)
Illegibly inscribed on base
left rear: Mi Pins [?]
U. S. government purchase
960.1447.1

Unknown Artist
Abigail Powers Fillmore (1798–1853)
(Mrs. Millard Fillmore)
mid-19th century, oil on canvas
27 x 22 in (68.6 x 55.9 cm)
White House Acquisition Fund
972.875.1

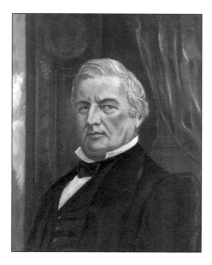

Unknown Artist
after **Alonzo Chappel** (1828–1887)
Millard Fillmore (1800–1874)
late 19th century, watercolor on photograph
on ivory
3 x 2½ in (7.6 x 6.4 cm)
Signed center right: A. Chappel
Gift of Dr. and Mrs. Henry C. Landon III
982.1527.1

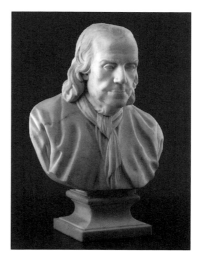

Unknown Artist
after **Jean-Jacques Caffieri** (1725–1792), 1777
Benjamin Franklin (1706–1790)
early 19th century, marble
28 x 20 x 11½ in (71.1 x 50.8 x 29.2 cm)
Gift of Joseph Hennage
976.1204.1

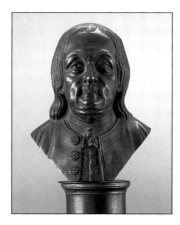

Unknown Artist
Benjamin Franklin (1706–1790)
c. 1820, bronze
13⅜ x 4¾ x 4½ in (34.6 x 12.1 x 11.4 cm)
Gift of Dr. and Mrs. J. S. Ritter
962.214.1

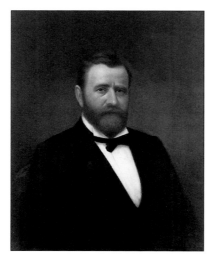

Unknown Artist
Ulysses Simpson Grant (1822–1885)
late 19th century, oil on canvas
30 x 25⅛ in (76.2 x 63.7 cm)
Bequest of Agnes Brooks Young
974.1112.1

Unknown Artist
Hadrian's Tomb (Castel Sant' Angelo), Rome
late 19th century, micro-mosaic and malachite
on slate
12 x 16 in (30.5 x 40.6 cm)
Gift of the Latta family
948.4101.1

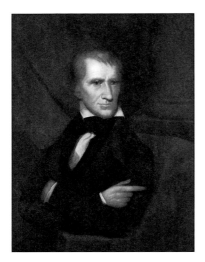

Unknown Artist
after **Abel Nichols** (1815–1860), c. 1840
William Henry Harrison (1773–1841)
c. 1840, oil on canvas
34⅛ x 27⅝ in (86.7 x 70.2 cm)
Inscribed lower left: R.E. Earl
Gift of Mr. and Mrs. John C. Fischer
984.1558.1

Unknown Artist
William Henry Harrison (1773–1841)
c. 1841, plaster of Paris bas-relief
11¼ x 9¹⁵⁄₁₆ x 1½ in (28.6 x 25.2 x 3.8 cm)
Gift of Homer J. Oman
965.568.1

Unknown Artist
A Hartford Family
c. 1840–50, oil on canvas
23⅜ x 28¾ in (60 x 73 cm)
Inscribed lower left on stool:
S.W./Hartford.
Gift of E. and A. Silberman Galleries, Inc.
961.9.1

Unknown Artist
Andrew Jackson (1767–1845)
c. 1837, chalkware
14¼ x 9½ x 6 in (36.2 x 24.1 x 15.2 cm)
Gift of Mrs. William S. Paley
962.213.1

Unknown Artist
Miss Kennedy
c. 1840–50, ink silhouette on paper
4⅛ x 3⅜ in (10.5 x 8.6 cm)
Inscribed lower left: Miss Kennedy
Gift of the Good Neighbor Commission of Texas
962.220.1

Unknown Artist
Marie Joseph Paul Yves Roch Gilbert du Motier,
Marquis de Lafayette (1757–1834)
early 19th century, oil on glass
13¼ x 10 in (33.7 x 25.4 cm)
Inscribed lower edge: Lafayett: [*sic*]
Gift of Dr. C. P. Meek
961.89.1

Unknown Artist
Marie Joseph Paul Yves Roch Gilbert du Motier,
Marquis de Lafayette (1757–1834)
c. 1850, glass and sulphide medallion
Diam. 3½ in (8.9 cm)
Gift of Mrs. Stanley M. Straus
963.478.5

Unknown Artist
Marie Joseph Paul Yves Roch Gilbert du Motier,
Marquis de Lafayette (1757–1834)
c. 1930, plaster
17 x 6 x 6 in (43.2 x 15.2 x 15.2 cm)
Gift of Laurence G. Hoes
930.1175.1

Unknown Artist
(formerly attributed to John H. Twachtman)
Landscape With Houses
c. 1890, oil on canvas
20¼ x 24⅜ in (51.4 x 61.9 cm)
Inscribed lower right: J H Twachtman.
Gift of the White House Historical Association
975.1170.1

Unknown Artist
Laying of the Atlantic Cable
c. 1850, oil on canvas
25 x 30⁄₁₆ in (63.5 x 76.4 cm)
Gift of Dr. and Mrs. Paul Rich Dinsmore
976.1267.1

Unknown Artist
Abraham Lincoln (1809–1865)
c. 1870, watercolor on ivory
3⁵⁄₁₆ x 2⁷⁄₁₆ in (8.4 x 6.2 cm)
Gift of Kenneth Garcia
963.440.1

Unknown Artist
after **Michelangelo Buonarroti** (1475–1564),
1524–34
Giuliano de' Medici (1479–1516)
c. 1869, bronze
21½ x 10¾ x 9⅝ in (54.6 x 27.3 x 24.4 cm)
U. S. government purchase
869.1472.1

Unknown Artist
after **Michelangelo Buonarroti** (1475–1564),
1524–34
Lorenzo de' Medici (1492–1519)
c. 1869, bronze
20¾ x 10¾ x 9⅝ in (52.7 x 27.3 x 24.4 cm)
Inscribed at left on seat:
R[?]tion S[?]auivage
U. S. government purchase
869.1473.1

Unknown Artist
James Monroe (1758–1831)
late 19th century, ivory
8 x 2½ x 2¾ in (20.3 x 6.3 x 7 cm)
Gift of Mr. and Mrs. J. P. Flock
962.386.1

Unknown Artist
Horatio Nelson (1785–1805)
1905, bronze/oak and copper
7 x 5½ x 4 in (17.8 x 14 x 10.2 cm)
Presentation inscription on plinth:
NELSON/THIS BUST CONTAINS/
VICTORY COPPER./FOR NELSON
CENTENARY/OCT. 21, 1905./
PRESENTED BY/British & Foreign
Sailors Society/E.R. VII.
Gift of the British and Foreign
Sailors Society
905.1440.1

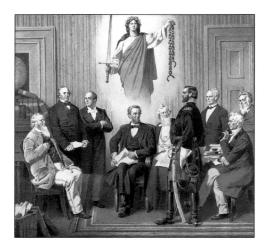

Unknown Artist
President Lincoln and His Cabinet
1865–1900, watercolor and pencil on paper
14¼ x 15¼ in (36.2 x 38.7 cm)
List of sitters inscribed on reverse:
M. Blair/Wm H Seward/Gideon Welles/
President Lincoln/Salmon P Chase/
Caleb Smith/Edwin M. Stanton
Gift of Mr. and Mrs. Stuart P. Feld
973.1021.1

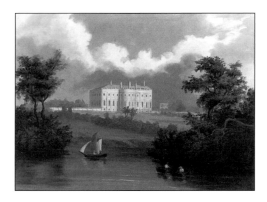

Unknown Artist
after **William Henry Bartlett** (1809–1854),
c. 1836–37
The President's House
mid-19th century, oil on canvas
24 x 32⅛ in (61 x 81.4 cm)
Gift of Mr. and Mrs. Hawley S. Simpson
967.611.1

Unknown Artist
after **William Henry Bartlett** (1809–1854),
c. 1836–37
The President's House From the River
mid-19th century, oil on panel
7⅞ x 9⅞ in (20 x 25.1 cm) oval
Gift of the White House Historical Association
987.1601.1

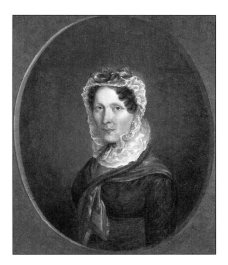

Unknown Artist
Sara Strother Taylor (1788–1852)
(Mrs. Richard Taylor)
1822, oil on canvas
19⅝ x 15½ in (49.8 x 39.4 cm)
Dated lower right below oval image: 1822;
inscribed on upper stretcher:
MRS TAYLOR/MOTHE ZACKERY TAYLOR [*sic*]
Gift of Dr. and Mrs. Michael Kraus
962.221.1

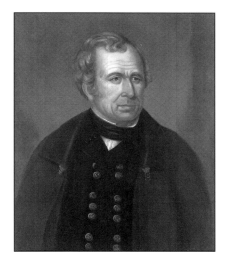

Unknown Artist
Zachary Taylor (1784–1850)
c. 1835–45, oil on canvas
29¹⁵⁄₁₆ x 25¼ in (76 x 64.1 cm)
Gift of Mrs. Thomas M. Waller
978.1388.1

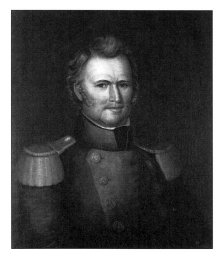

Unknown Artist
Zachary Taylor (1784–1850)
c. 1847, oil on canvas
30 x 25 in (76.2 x 63.5 cm)
Gift of Mrs. Hubbard Buckner
972.855.1

Unknown Artist
Three-Masted American Barque **Samar**
1875–90, oil, silk, velvet, and cotton
on canvas
18 x 31⅛ in (45.7 x 79.1 cm)
Gift of Mr. and Mrs. Joel Barlow
971.808.2

Unknown Artist
Unidentified Subject—Female
early 19th century, cut paper silhouette
on silk
7¾ x 5⅜ in (19.7 x 13.6 cm)
Embossed stamp below image:
Peale's Museum [beneath spread-winged eagle]
Gift of Mrs. Stanley M. Straus
967.598.2

Unknown Artist
Unidentified Subject—Male
early 19th century, cut paper silhouette
on silk
7⅞ x 5¼ in (20 x 13.3 cm)
Embossed stamp below image:
Peale's Museum [beneath spread-winged eagle]
Gift of Mrs. Stanley M. Straus
967.598.1

Unknown Artist
Unidentified Subject—Male
c. 1820–25, cut paper silhouette on
watercolor on paper
11⅛ x 7¹¹⁄₁₆ in (28.3 x 19.5 cm)
Embossed oval stamp at lower left:
TAKEN AT/THE HUBARD/GALLERY
Gift of Mrs. Stanley M. Straus
967.598.8

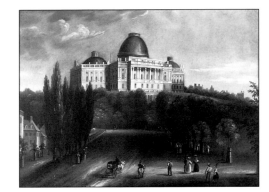

Unknown Artist
after **William Henry Bartlett** (1809–1854),
c. 1836–37
U. S. Capitol
c. 1840, oil on tin
11 x 15 in (27.9 x 38.1 cm)
Gift of Lawrence Fleischman
962.183.1

Unknown Artist
View of the Harbor at Canton
c. 1847–56, oil on panel
18⅛ x 31 in (46 x 78.7 cm)
White House Acquisition Fund
972.917.1

Unknown Artist
View of Harbor of Hong Kong
c. 1847–56, oil on panel
18¼ x 30¾ in (46.4 x 78.1 cm)
Gift of an anonymous donor
972.917.2

Unknown Artist
View of Hong Kong
c. 1853, oil on canvas
17¹⁵⁄₁₆ x 30¹⁵⁄₁₆ in (45.6 x 78.6 cm)
Gift of the White House Historical Association
973.963.2

Unknown Artist
View of the Hudson From West Point
c. 1850, oil on canvas
14⅟₁₆ x 22⅟₁₆ in (35.7 x 56 cm)
Gift of Dr. and Mrs. A. Noe Horn
963.473.1

Unknown Artist
View of Macao
c. 1853, oil on canvas
18 x 31⅗₆ in (45.7 x 79.2 cm)
Gift of the White House Historical Association
973.963.1

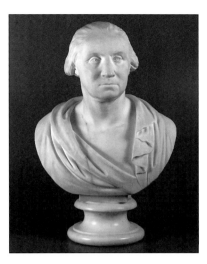

Unknown Artist
after **Jean-Antoine Houdon** (1741–1828), c. 1786
George Washington (1732–1799)
c. 1790, marble
27 x 18 x 10¼ in (68.6 x 45.7 x 26 cm)
Gift of Mrs. Albert Lasker
961.8.1

Unknown Artist
George Washington (1732–1799)
c. 1795, oil on canvas
23¾ x 19¹⁵⁄₁₆ in (60.3 x 50.6 cm)
Bequest of David Gray
968.629.1

Unknown Artist
George Washington (1732–1799)
early 19th century, oil silhouette on glass
5⅗₆ x 4½ in (13.5 x 11.4 cm)
Inscribed lower edge: George Washington 1791.
Gift of Mrs. Stanley M. Straus
963.478.3

Unknown Artist
George Washington (1732–1799)
early 19th century, cut paper silhouette
on silk
5¹¹⁄₁₆ x 5⅝ in (14.4 x 14.3 cm)
Embossed stamp below image:
Peale's Museum [beneath spread-winged eagle]
Gift of Mrs. Stanley M. Straus
967.598.3

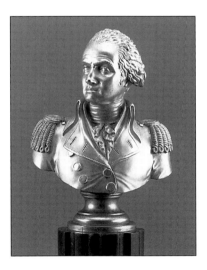

Unknown Artist
George Washington (1732–1799)
c. 1810, gilded bronze
5¼ x 3¾ x 2¼ in (13.3 x 9.5 x 5.7 cm)
Gift of an anonymous donor
968.615.1

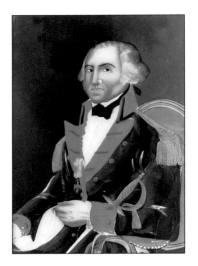

Unknown Artist
George Washington (1732–1799)
c. 1830, oil on glass
9¹⁵⁄₁₆ x 7⅜ in (25.2 x 18.7 cm)
Gift of Mrs. J. Monroe Hewlett
962.215.2

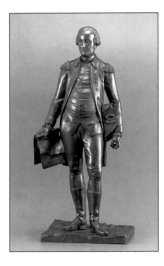

Unknown Artist
George Washington (1732–1799)
c. 1830–50, bronze
15¼ x 6⅛ x 4⅝ in (38.7 x 15.6 x 11.8 cm)
Marked on base rear right: 174/4
Gift of Hugh D. Auchincloss, Jr.
961.101.1

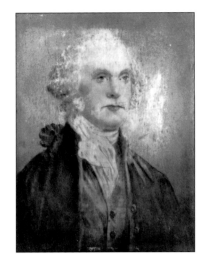

Unknown Artist
George Washington (1732–1799)
c. 1870, watercolor on ivory
3³⁄₁₆ x 2⁷⁄₁₆ in (8.4 x 6.2 cm)
Gift of Kenneth Garcia
963.440.2

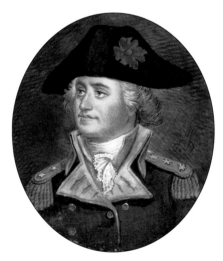

Unknown Artist
George Washington (1732–1799)
late 19th century, watercolor on ivory
2¹³⁄₁₆ x 2⁷⁄₁₆ in (7.1 x 6.2 cm) oval
Signed at right: J.T
Gift of Mrs. S. A. Horvitz
962.346.1

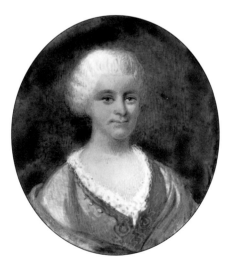

Unknown Artist
Martha Dandridge Custis Washington
(1731–1802)
(Mrs. George Washington)
late 19th century, watercolor on ivory
2¾ x 2½ in (7 x 6.4 cm) oval
Signed at left: J.T
Gift of Mrs. S. A. Horvitz
962.346.2

**Photographs in this catalogue
are credited to the following
individuals and institutions:**

Erik Kvalsvik

John Tennant

Joel Breger

Helga Studios

National Gallery of Art

National Geographic Society
(Steve Adams)

National Museum of
American History

National Portrait Gallery

White House Photo Office
(Bill Fitz-Patrick)

Acknowledgments

Many of those who helped establish the White House collection have been acknowledged elsewhere. Those who shaped this work have likewise made a valuable contribution. With the publication of *Art in the White House: A Nation's Pride,* they have built an enduring monument to the collection.

Authors William Kloss, Doreen Bolger, David Park Curry, John Wilmerding, and Betty C. Monkman merit particular tribute, for each served in a dual role: that of writer and of adviser. All generously shared of their time, knowledge, and talent.

Rex W. Scouten, curator of the White House; Bernard R. Meyer, executive vice president of the White House Historical Association; and Donald J. Crump, the Association's director of publications, offered support and expertise as the project moved to fruition. Gary Walters, White House chief usher, provided advice and encouragement.

Erik Kvalsvik, with Niamh McQuillan, skillfully photographed most of the works of art in the collection for the purposes of reproduction here. Throughout the project, an outstanding contribution of time and talent was made by Lydia S. Tederick, of the Office of the Curator. Special contributions were also made by William G. Allman and Angela G. Horton, of that office.

Lending expert assistance as well were Cecilia H. Chin, of the National Museum of American Art–National Portrait Gallery Library; George Gurney, of the National Museum of American Art; Frances P. Smyth, of the National Gallery of Art; Marion Mecklenberg and Justine Wimsatt, of the Washington Conservation Studio; K. Ruth Corcoran, Gloria J. Hunter, and John F. Trump, of the White House Historical Association; and the staff of the operations and carpenter shops of the Executive Residence.

At the National Geographic Society Michela English, senior vice president; William R. Gray, vice president and director of the book division; and David P. Johnson, director of the publications magazine division, supported the project by allocating staff and resources. Managing editor Jane R. McGoldrick supervised the undertaking, and with art director Viviane Y. Silverman, gave the book its form, grace, and style. Philip B. Silcott, formerly of the Geographic's executive staff, served as consulting editor. Richard M. Crum, H. Robert Morrison, and Lori Davie Price made additional editorial contributions. Administrative assistance was provided by Sandra F. Lotterman and Karen Dufort Sligh. Typographic expertise came from Phillip E. Plude, Martin G. Anderson, and Kenneth G. Florence. Susan G. Zenel prepared the index, with Jolene M. Blozis. Printing and production were handled by the Society's division of engraving, printing, and product manufacture, including George V. White, director; Robert W. Messer, production manager; and Heather Guwang, production project manager; with the assistance of Michael E. Ventola, art reproduction consultant.

William Seale, author of *The President's House: A History,* graciously read portions of the manuscript and provided helpful comments.

Special thanks are due to The Henry Luce Foundation, Inc., and Mrs. John C. Newington for helping to fund the publication of *Art in the White House: A Nation's Pride.*

ROBERT L. BREEDEN

Chairman and Chief Executive Officer
The White House Historical Association

Index

369

370

Composition by the Typographic section of Production Services of the National Geographic Society, Washington, D. C. Printed by Peake Printers, Inc., Cheverly, Maryland. Color separations by Lincoln Graphics, Inc., Cherry Hill, New Jersey. Binding by Horowitz/Rae, Inc., Fairfield, New Jersey.

This book is printed on 80-pound Signature Gloss by Mead Paper Company. Designed on a Macintosh IIfx using Pagemaker and Quark XPress. Typography: text set in Palatino; titles, Zapf Chancery Medium Italic. Text composition done on an Atex 8000 editorial system and output from a Linotronic 300 laser imagesetter.

Library of Congress CIP Data
Kloss, William.
 Art in the White House, a nation's pride / William Kloss.
 p. cm.
 Includes bibliographical references and index.
 ISBN 0–912308–46–X
 1. Art, American—Catalogs. 2. Art, European—
Catalogs. 3. Art—Washington (D.C.)—Catalogs.
 4. White House (Washington, D.C.)—Catalogs.
 I. White House Historical Association. II. Title.
N6505.K56 1992
708.153—dc20 91-68463
 CIP

LTSS Lineberger Memorial Library
N6505 .K56 1992 Gen. Coll.
Kloss, William/Art in the White House :

3 5898 00015 8481

N 6505 .K56 1992
Kloss, William.
Art in the White House

946 73

N 6505 .K56 1992
Kloss, William.
Art in the White House

946 73

**LINEBERGER
MEMORIAL LIBRARY
LUTHERAN THEOLOGICAL
SOUTHERN SEMINARY
COLUMBIA, SOUTH CAROLINA 29203**

DEMCO